Textiles

*Isabella Stewart
Gardner Museum*

*Hardcover edition is distributed
by Northeastern University Press,
Boston*

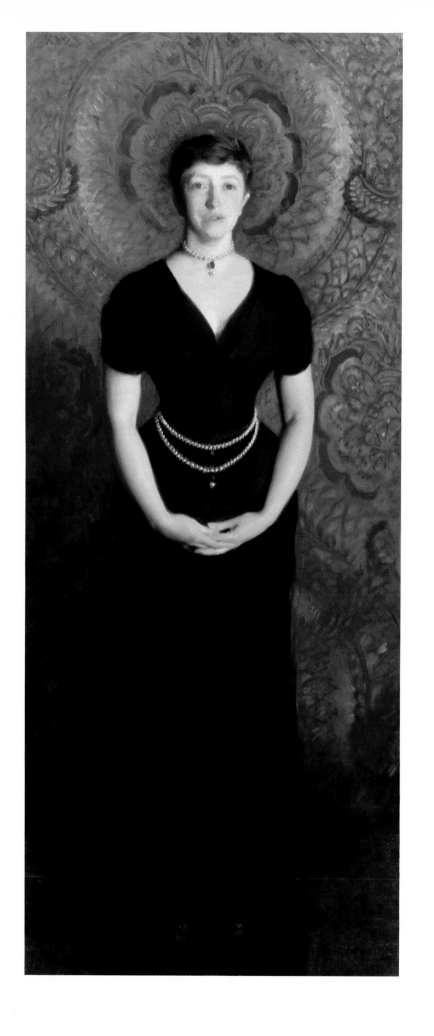

Textiles

*Isabella Stewart
Gardner Museum*

Adolph S. Cavallo

Published by the Trustees
Boston, 1986

Copyright © 1986 Isabella Stewart Gardner Museum
Library of Congress Catalogue Card Number: 85-51863
ISBN 0-914660-09-8 (hardbound)
ISBN 0-914660-10-1 (softbound)

Designed by Helen Hadley
Photographs by Greg Heins
Typeset by Monotype Composition Company
Printed by LaVigne Press Inc.

The Trustees acknowledge with gratitude the assistance of the National
Endowment for the Arts in this publication.

Cover: *Garment Fabric,* Japanese, 1800–1900 (Catalogue No. 171)
Frontispiece: *Isabella Stewart Gardner,* by John Singer Sargent (Inv. No. P30w1)

Contents

Note to the Reader

Inventory Numbers assigned to each object may be read in this way: T31e6 means textile, gallery 31 (Third Floor Stair Hall), east wall, sixth object moving from left to right. A preliminary F stands for furniture; an -s at the end signifies that the object is part of a set. A -B. at the end stands for Bainbridge (see Author's Acknowledgments) and is followed by a number (given by that researcher) to identify individual laces in the Veronese Room. Catalogue entries without Inventory Numbers refer to textiles in storage. The *Checklist* includes all pieces on view not otherwise catalogued. A list of galleries and their numbers is given below.

1	The Yellow Room	17	The Short Gallery
2	The Entrance Lobby	18	The Little Salon
3	The Blue Room	19	The Tapestry Room
4	The Main Entrance Passage	20	The Second Floor Passage
5	The Court	21	The Dutch Room
6	The Spanish Chapel	22	The Second Floor Stair Hall, South
7	The Spanish Cloister	23	The Stairway, Second to Third Floor
8	The Chinese Loggia	24	The Third Floor Stair Hall, North
9	The East Cloister	25	The Veronese Room
10	The North Cloister	26	The Titian Room
11	The Macknight Room	27	The Long Gallery
12	The West Cloister	28	The Chapel
13	The Stairway, First to Second Floor	29	The Third Floor Passage
14	The Second Floor Stair Hall, North	30	The Gothic Room
15	The Room of Early Italian Paintings	31	The Third Floor Stair Hall, South
16	The Raphael Room		

Foreword

It is a great pleasure to see all the textiles together for the first time and to be able to appreciate the importance of the Museum's holdings. The richness of other parts of the collection has been made known in the past decade with the publication of catalogues on paintings, sculpture, drawings, and Islamic and Oriental objects. The Trustees' commitment to research and publication has been a guiding light in our efforts to produce catalogues such as this one as well as scholarly articles for the annual report. Work will continue for many years to come before the collection has been fully published, and even then, any work embracing large numbers of objects must be revised periodically.

Many of the tapestries are famous but most of the textile collection is little known. Because textiles are displayed throughout the Museum, and certain fine pieces have been placed in storage to preserve them, it has been almost impossible for the visitor or visiting scholar to survey the collection until the appearance of this catalogue. The conservation and restoration of textiles has been greatly enhanced in recent years by the industry and ingenuity of the textile workroom, set up originally by Yvonne Cox at the suggestion of my predecessor, George Stout. We are exceedingly fortunate to have a professional staff dedicated to textile conservation. So demanding is the specialized nature of their work on rare and fragile objects that their efforts will continue far into the future. Marjorie Bullock and Betsy Gould, who are responsible for the success of this work, are to be congratulated.

The Museum has been exceedingly fortunate again in choosing an author. Adolph S. Cavallo spent many years in Boston as Curator of Textiles at the Museum of Fine Arts, and later on as Assistant Director. Quite naturally, he was familiar with the Museum's textiles, and on occasion he taught, using them as a resource. More recently, he wrote an excellent article on the collection for the 1981 annual report, *Fenway Court*.

His experience outside of Boston, including appointments at The Metropolitan Museum in New York and the Philadelphia Museum of Art, has made him one of the foremost authorities in his field.

The work of editing the manuscript and coordinating the photography with the conservators has been done almost daily for the last year by the Curator, Kristin A. Mortimer, who assumed all of the curatorial duties in March 1984, succeeding Deborah A. Gribbon. The success of the book is in large part due to their efforts.

Rollin van N. Hadley

Frequently Cited Sources

Asselberghs, 1974 J.-P. Asselberghs, *Les tapisseries flamandes aux États-Unis d'Amérique,* Brussels, 1974 (Artes Belgicae series of the Musées Royaux d'Art et d'Histoire)

Baldass, 1920 L. Baldass, *Die Wiener Gobelinssammlung,* 3 vols., Vienna, 1920

Boccara D. Boccara, *Les belles heures de la tapisserie,* n.p., 1971

Colloquium, 1959 "Het herfsttij van de vlaamse tapijtkunst," International Colloquium, 8–10 October, 1959 (also published as "La tapisserie flamande au xviie–xviiie siècles,"), Brussels, 1959

Colloquium, 1969 "De bloetijd van de vlaamse tapijtkunst," International Colloquium, 23–25 May, 1961, Brussels, 1969

Crick-Kuntziger, 1956 M. Crick-Kuntziger, *Catalogue des tapisseries (xive au xviiie siècle),* Musées Royaux d'Art et d'Histoire de Bruxelles, Brussels, 1956

Fenaille M. Fenaille, *État général des tapisseries de la manufacture des Gobelins depuis son origine jusqu'à nos jours 1600–1900,* 6 vols., Paris, 1903–23

Ffoulke C.M. Ffoulke, *The Ffoulke Collection of Tapestries,* New York, 1913

General Catalogue G.H. Longstreet, *Isabella Stewart Gardner Museum, Fenway Court, General Catalogue,* Boston, 1935; rev. 1964

Göbel, 1923 H. Göbel, *Wandteppiche: I. Teil: Die Niederlande,* 2 vols., Leipzig, 1923

Göbel, 1928 H. Göbel, *Wandteppiche: II. Teil: Die romanischen Länder,* 2 vols., Leipzig, 1928

Hadley R. Hadley, *Museums Discovered. The Isabella Stewart Gardner Museum,* New York, 1981

Hendy P. Hendy, *European and American Paintings in the Isabella Stewart Gardner Museum,* Boston, 1974

Markowsky B. Markowsky, *Europäische Seidengewerbe des 13–18 Jahrhunderts,* Kunstgewerbemuseum der Stadt Köln, Cologne, 1976

Mayer C.C. Mayer, *Masterpieces of Western Textiles from the Art Institute of Chicago,* Chicago, 1969

Stout G.L. Stout, *Treasures from the Isabella Stewart Gardner Museum,* New York, 1969

Thomson, 1930 W.G. Thomson, *A History of Tapestry from the Earliest Times until the Present Day,* London, 1930 (rev. ed.)

Thornton P. Thornton, *Baroque and Rococo Silks,* London, 1965

Wandtapijten I and *II* *Wandtapijten I, Late gotiek en vroege renaissance,* Rijksmuseum, Amsterdam, 1962 *Wandtapijten II, Renaissance, manierisme en barok,* Rijksmuseum, Amsterdam, 1971

Weibel A.C. Weibel, *Two Thousand Years of Textiles...,* New York, 1952

Explanatory note to citations other than to the references listed above:
Sources that refer to the object in a given entry will be cited in full in that entry's bibliography and cited briefly in relevant footnotes.
Sources that refer to related material in a given entry will not appear in that entry's bibliography, but will be cited in full in their first occurrence in the footnotes, and briefly cited thereafter.

Author's Acknowledgments

The advantages of producing a museum catalogue with the help of a visiting specialist accrue unfairly to the author, while to the resident staff fall most of the details and drudgery that the fortunate scholar would have had to see to himself had he been working on home turf. In the case of this book, the tasks of dealing with arrangements for production, financing, and curatorial matters fell to the lot of the Director, Rollin van N. Hadley, the then-incumbent Curator, Deborah A. Gribbon, neither of whom ever let the author know how much trouble the project (and he himself) were, for which he is eternally grateful. They were aided in their efforts by a staff of outstandingly able and willing administrative, curatorial, and custodial specialists, including the present Curator, Kristin A. Mortimer. The warm and selfless support these people gave to the author enabled him on one hand to work at a distance with minimum effort and concern, and also to feel completely at home when studying on site. In the area of technical and artistic concerns, his special thanks are expressed to Marjorie R. Bullock and her staff in the Textile Conservation Laboratory, who measured textiles, checked technical details, and matched up numbers, photographs and records (the text that follows is largely their work), and also to Greg Heins, whose photographs make the subjects of the entries look as good on film as they do in reality. Finally, these acknowledgments would be incomplete without mention of the important earlier work on the collection by Mrs. Ella S. Siple (textiles, 1927–28) and Mrs. Mabel Foster Bainbridge (laces, 1931–35).

Adolph S. Cavallo

Author's Introduction

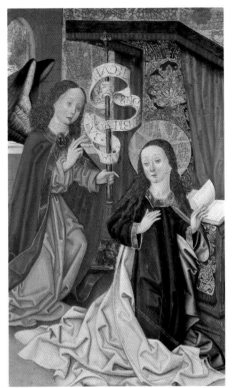

fig. 1 German, 1450–1500, *The Annunciation*, Chapel, Isabella Stewart Gardner Museum.

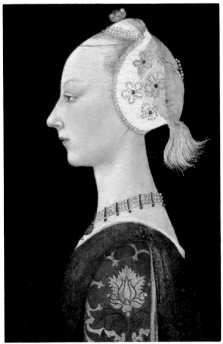

fig. 2 Attributed to the Master of the Castello Nativity, *A Young Lady of Fashion*, ca. 1450, Long Gallery, Isabella Stewart Gardner Museum.

It was inevitable that Fenway Court should become a repository for sumptuous textiles. No enlightened connoisseur of the period, subject as they all were to the nineteenth-century taste for historicism and nostalgia of place, approached the problem of arranging a major art collection with the heart of a purist—least of all Isabella Stewart Gardner, who had a keen sense of atmosphere. Theirs was not a taste for encyclopedic museum galleries, each concerned with its own discipline, shunning the delights beyond the threshold, the pariah of a different time or medium.

The turn of the century was a pivotal moment in the history of taste relating to textiles. Women of fashion valued fine fabrics: they were still wearing rich brocaded silks, intricate white embroideries, and delicate laces. As though in reaction to the final triumph of the Industrial Revolution, with its mass production and marketing methods, and in sympathy with the Arts and Crafts movements that were springing up both here and abroad, these people regarded the richness of fine textiles as a metaphor for the richness of human culture and as a tribute to the infinite potential of that fabulous tool, the human hand.

Since Mrs. Gardner began her activity as a collector in this field somewhat earlier than in others, it may be fair to look for a special motive that inspired her interest. It might have grown out of a visit to Paris in the summer of 1867. Mr. and Mrs. Gardner saw in the French section of the International Exposition some gowns designed by the Empress's favorite dressmaker, Charles Frederick Worth. Admiring these confections as ardently as they deserved to be, the Gardners visited Worth's shop on the rue de la Paix and bought a number of ensembles. The shop was set up in such a way that patrons walked through several rooms filled with superb French, Italian and English silks and woolens before they reached the room where gowns were shown on live models. It is easy to imagine that this experience aroused in Isabella Gardner, proud of a figure that had already excited admiration in New York and Boston, a very personal appreciation of the beauty to be found in well-designed and well-made luxury fabrics. Later years brought more visits to Worth's shop; thus it is probably significant that when Mrs. Gardner installed the rooms at Fenway Court she chose to place under Titian's magnificent *Rape of Europa* a length of pale green figured silk that once had served as part of an evening gown (see No. 164).

The Museum's archives contain statements from and correspondence with some of the European and American dealers from whom Mrs. Gardner bought works of art. There are also supplementary papers—shipping and customs invoices and related documents—that give details about certain pieces she acquired. These, together with entries in her travel diaries, tell us a great deal about Mrs. Gardner's activities as a collector of textiles.

The records indicate that by 1872 Mrs. Gardner began to acquire textiles as works of art that could stand on their own merit rather than simply as part of a sumptuous setting. In that year she bought for a very low price two or three tapestries from Leonard and Company in New York. Mrs. Gardner continued to acquire tapestries during the next thirty years. In 1903 she paid almost two hundred times Leonard and Company's bill for the set of four enchanting *Château and Garden* tapestries (No. 14). Two years after that, when she bought one of the *Abraham* tapestries (No. 11) together with the set illustrating the *Story of Cyrus the Great* (No. 9), Mrs. Gardner paid twice the price of the garden tapestries. Fine textiles were not cheap, but that did not stop Mrs. Gardner from paying the same amount for two textiles (a piece of embroidery and some lace) that she paid for a parcel-gilt iron door, when she visited Moisè dalla Torre, one of her favorite dealers in Venice, in 1899.

Meanwhile, Mrs. Gardner was scouring the stores of dealers in Italy, France, Germany and New York for fine weavings, embroideries, laces and vestments, first for her house on Beacon Street and later, after 1896, for the galleries at Fenway Court. While these pieces attracted Mrs. Gardner's attention for their own sake, many have proven to have interesting historical associations, particularly with the papal court. The records also indicate that Mrs. Gardner bought damasks and brocatelles by the meter or yard to use as wall coverings or upholstery material. There is, for example, an invoice dated December 1914, for twenty-two meters of red damask, thirty-two meters of one brocatelle and two hundred meters of another bought from the firm of Karl J. Freund of New York. Other documents prove that Mrs. Gardner sometimes bought seat furniture that was already upholstered ("2 *poltrone in damasco verde*" from Arturo Laschi, Florence, 1905) and in other cases she bought the frames and had them upholstered with fabrics of her choice (a statement from M. Jesurum of Venice, 1897, for textiles to cover 21 pieces of furniture plus the cost of springs and the upholsterer's labor).

Other textiles in the collection entered Mrs. Gardner's possession when she traveled in the Orient. Some of these are recorded in the diary she kept during a visit to Shanghai and Cambodia in 1883, as on November 22 when "the compradore brought Cambodian silks and sarongs, which we bought," and during a visit to Japan that summer when she bought some brocades for Maud Howe and herself. Visits to Egypt, Jerusalem, Syria, Greece, Constantinople, China and Indonesia as well as to the great cities of Europe are memorialized not only in her diaries, but also in the galleries and storerooms of Fenway Court where textiles made in these places have been preserved. The pieces speak not only of place but of taste, a very personal and highly cultivated taste. For although Joseph Lindon Smith, Dodge Macknight and other professionally trained artists and connoisseurs advised her on some of her major purchases of textiles, or gave her fine pieces, there still is a consistency about the collection that exists only because one spirit made the final decision.

Nowhere is this remarkable discrimination more evident than in the collection of laces. Exercising unusual skill in selection, Mrs. Gardner chose from among the thousands of examples available to her some two hundred pieces of lace whose varied character, high quality and broad representation of the history of European lacemaking must excite the admiration (and envy) of every textile collector and the delight of every visitor to the Museum.

Unfortunately for us, some of the textiles that Mrs. Gardner chose for Fenway Court did not survive the ravages of time and their own inherent weaknesses. Textile materials contain physical and chemical properties that cause them to deteriorate rapidly when they are exposed to light, humidity, temperature changes and abrasion—conditions that could not be avoided if the galleries at Fenway Court were to maintain their original character. In those places where the textile was an integral part of a setting—the covering for walls and important seat furniture—the deteriorated fabric was replaced with fabric of the same kind and period when such could be found in the hands of the dealer or, if not, with a modern reproduction woven to order and designed after the original textile. For example, when the original hangings of the Yellow Room needed to be replaced in 1974 a modern damask showing the same color and kind of pattern as one of the original late eighteenth-century yellow damasks was used to cover the walls. On the other hand, it was possible to find enough red silk damask of eighteenth-century manufacture in a dealer's stock to replace the original when it became necessary in 1952 and 1953 to re-cover the east and west walls of the Raphael Room. The same kinds of substitutions have been made for most of the seat furniture in the galleries, replacing the original material with similar period fabrics or modern reproductions. Carefully documented records and samples are kept so that every replacement can

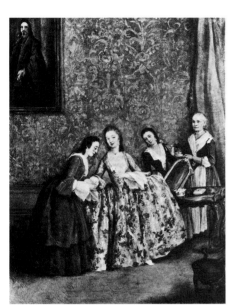

fig. 3 Pietro Longhi, *Early Morning with Venetian Women*, 1741, Galleria dell'Accademia, Venice; photograph: Alinari/Art Resource.

be identified. Some of these samples are described in the catalogue entries that follow, each with a note telling how and where the textile was used in the original installation of the galleries. The collection of samples also includes pieces of table, desk and other covers, and entire furniture covers that had to be removed from the galleries over the years and replaced with others made of original fabrics taken either from the stock in the Museum or from outside sources.

Traditionally, people have used luxury textiles in two ways. Such fabrics served either to decorate interior (and occasionally exterior) spaces or to cover and decorate the human body. Both plain and patterned, light and heavy, fabrics were produced, but the whims of time and the preferences of descendants favored the survival of pieces that were primarily sturdy and sumptuous. Consequently, we have a somewhat unbalanced notion of what kinds of textiles were available to our ancestors.

Especially in the middle ages and early Renaissance, heavy luxury fabrics like plain or patterned velvets and gold-brocaded damasks were used both for furnishing and for dress. Compare, for example, the patterned velvet represented as a wall hanging in fig. 1 with the similar velvet or damask that was used for the gown of the sitter shown in fig. 2. In both cases the textiles show large-scale patterns with motifs that have definite tops and bottoms. Small-scale, non-directional patterns were also being woven during this period, but it seems that designers and consumers did not begin to distinguish consistently between patterns for furnishing fabrics and those for dress until the end of the sixteenth century. Paintings and prints show that by the middle of the seventeenth century the two classes of patterns were firmly established and a hundred years later they were totally unrelated: large-scale, unidirectional patterns for furnishing; small-scale, usually non-directional patterns for dress (fig. 3).

A second consideration affected the use of metallic threads in the two kinds of fabric. Since silver and gilt yarns were neither pleasant to sit on nor resistant to abrasion, and also were extremely expensive, they were used less frequently in furnishing fabrics than they were for dress. Nevertheless, the evidence of paintings and of surviving covers for chairs, cushions, beds and walls proves that the very rich did use furnishing fabrics sparkling with silver and gilt yarns.

As for the scale and direction of the pattern, upholsterers knew that large motifs were more impressive than small ones when viewed across wide spaces, often in candlelight, and that clearly defined tops and bottoms complemented the logic of architecture. On the other hand, tailors and dressmakers knew that since the human body is small, the silhouettes of their confections would be affected adversely by large-scale patterns. Also, when the pattern had to be matched across seams joining several widths of the same fabric, small-scale patterns required less material for the match than did larger patterns. Furthermore, non-directional patterns allowed the tailor or dressmaker to use left-over pieces of fabric upside down and thus save on material.

Until the latter years of the eighteenth century, when the French passion for English riding clothes turned the taste of fashionable men away from silks and metal brocades toward unpatterned fabrics—a taste that rising egalitarian feelings in society also nurtured—men as well as women of fashion wore rich silks and fine laces. Men, however, tended to wear bolder patterns and lace textures than women did.

Lace was not reserved for use on costume alone (fig. 4). Depending on the scale and texture of the piece, it might be used to enrich the edges of a table

cover, sheet or cushion. Sometimes the same or similar lace was used both for furnishing and for dress (see the edges of the bed sheet and the collar and cuffs of the seated woman in fig. 5).

Tapestry fabrics were used to cover not only walls but also seat furniture, beds, doorways, windows, tables and sometimes floors. When an entire room was upholstered in tapestry, silk, or another kind of fabric, the textiles were designed and made *en suite;* that is, with matching or related patterns. However, most surviving "tapestries" (*tapestry* is the name of both the weave and the made-up fabric) were produced as wall covers that could be hung or moved about easily when the owner changed residence. These hangings provided color and warmth and could also be used to partition off large rooms and to cover unfinished or unattractive walls; they could also be hung out of doors to decorate the path of some state or religious procession, or to give the façade of a building, or a street, a festive air. By the eighteenth century, tapestry hangings were often mounted permanently on the wall and treated more like paintings than portable hangings.

Upholsterers who did not use tapestry to decorate a splendid interior still often followed the fashion for designing a room *en suite.* They had designers prepare plans in which the walls, windows, doors, seat furniture, beds and miscellaneous covers were shown upholstered with woven or made-to-order needleworked fabrics, or a combination of the two, all coordinated in color and pattern (fig. 6). Other upholsterers and cabinetmakers prepared drawings, prints and books showing precisely what kinds of textiles and patterns they intended for use on certain kinds of seat and other furniture (fig. 7).

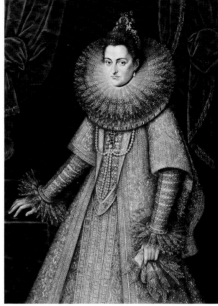

fig. 4 Frans Pourbus II, *Isabella Clara Eugenia, Archduchess of Austria*, ca. 1600, Dutch Room, Isabella Stewart Gardner Museum.

fig. 5 David Des Granges, *The Saltonstall Family*, ca. 1636/7, The Tate Gallery, London.

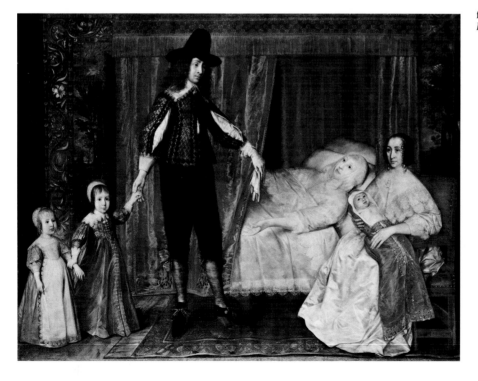

fig. 6 *En suite* decorative scheme from a set of engravings by the designer Daniel Marot of about 1690.

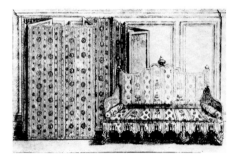

fig. 7 *Design for a French sofa of the 1690's described as a 'Grand canapée pour se reposer'; covered in Chinese satin and flanked by a nine-leaved screen of Chinese silk.*

Technical Notes:

The yarns used to manufacture the textiles described in this catalogue were made with natural fibers, either silk, wool, cotton, linen or other bast fibers like hemp. Some textiles combine yarns of different fibers, like those having a silk warp and linen or hemp main wefts (*brocatelle*) or needleworked pieces whose foundation fabric might show warp and wefts of the same or different fibers and embroidery yarns of still other fibers. Metallic yarns were also made from natural materials, usually of thin, flat silver or gilt wire (normally a thin layer of gold over a silver base, but sometimes a copper or other metal base). The wire was used either by itself ("tinsel") or wrapped spirally around a core of twisted silk—white silk for silver yarns, orange or yellow silk for gilt yarns. Gilt yarns in Chinese and Japanese textiles invariably show these same structures but with gilt paper taking the place of the gilt wire.

Dyestuffs used to color the yarns and fabrics before about 1850 (found in almost all the textiles treated in this catalogue) were also made of natural materials. Some of the dyes were extracted from plants like woad, indigo, madder and the saffron-yielding crocus; others came from the animal kingdom, like the red dyes made from the bodies of the insects kermes and cochineal. Certain so-called "painted" textiles from the Orient (No. 196) were actually painted with mordants (solutions of mineral salts) that fixed dyes of one or more colors to the fibers. Other "painted" textiles were indeed painted in the conventional sense with opaque pigments or with transparent textile pigments (No. 29).

All of the woven textiles described in this catalogue were made on a loom. This is a hand-powered machine that enables the weaver to set up a series of yarns under tension, lying parallel to each other; these yarns eventually run the length of the finished fabric (the *warp*). The loom is fitted with one or more devices that allow the weaver to lift certain warp yarns in sequence, leaving other warp yarns in place on the original, lower, level. To construct a fabric or *web* the weaver passes a shuttle holding yarns representing a second structural system (the *weft*) through the space now opened up between the lifted warp yarns and those that remained in their original positions; the shuttle passes completely across the width of the warp at right angles, from one side of the loom to the other. When the weaver releases the raised warp yarns, they too return to their original positions and thus lock into place the weft yarn that has just been deposited across the warp, from one edge of the fabric to the other (the *selvage*).

By varying the places where the warp and weft intersect, the weaver can create fabrics showing different structures and thus different surfaces. When the warp is controlled so that every other warp yarn passes over and then under every other weft yarn in a regularly repeating sequence, the finished fabric will resemble simple cloth and show a smooth, even surface like that of modern sheeting. This is *tabby* or *cloth* weave. By causing the weft (or warp) yarns to pass under or over one or more warp (or weft) yarns in such a way that the points of intersection do not occur under each other, as they do in tabby weave, but move to one side or the other progressively in each row of weaving, the weaver can produce a *twill* weave, e.g. one having a surface showing intersections arranged to form parallel lines running diagonally across the web from selvage to selvage. *Satin* weave is simply a variant of twill: the weaver causes each pass of the weft yarn to travel over one warp yarn and then under several adjacent warp yarns before it intersects with another, thus producing a fabric in which the points of binding are spaced so widely apart and so irregularly as to become almost invisible. The finished fabric differs from ordinary twill in presenting to the viewer the almost unbroken, apparently smooth surface that we associate with satin.

Tapestry weave is simply a variant form of tabby weaving; there happen to be no examples in the collection of twill tapestry (best known from its use in Kashmir shawls). When applied to weaving, the term tapestry refers to a fabric whose pattern is created simultaneously with its structure. Weft yarns are woven into the warp not from selvage to selvage but only in those places where the pattern calls for the color of each yarn. Then the weaver introduces wefts of a different color where required and so on, until the pattern and the fabric itself are built together in tabby weave, almost like a mosaic of weft yarns of different colors held together by the skeleton of the warp. The dyed weft yarns are pressed close together during weaving, completely covering the undyed warp yarns. Therefore, the back of the tapestry shows the same (reversed) pattern as the front.

Although some historical textiles show large areas of unrelieved tabby, twill or satin weave, most of them show patterns created in the weave by variations or combinations of the simple weaves or by the addition of supplementary warp and weft systems. Any of the basic weaves can be elaborated by combining two or more of the weaves in a single fabric and using the different surfaces they present as the medium for conveying a pattern. Furthermore, since the front of a twill or satin weave differs from the back of the same weave, it is possible to create patterns by reversing the faces of a single weave in certain parts of the fabric. *Damask* fabrics are created in this way by combining the fronts and backs of satin or twill weaves in a single web. When this is done, the pattern is rendered in only one color but with two textures, and it shows to best advantage when the textile is in motion or when light strikes it at an angle, since the two textures reflect light differently. Damask also can be made with warp and weft systems of different colors; in these fabrics the pattern stands out boldly in one color against a ground of the other.

Other fancy textured weaves are produced by introducing extra warp or weft systems or both into a web showing one of the basic weaves. The extra yarns convey the pattern by virtue of their difference in texture, size, color or position from the yarns in the basic web. The simplest of these *compound* structures is *velvet* weave, in which an extra warp system is interwoven with the base weave (tabby, twill or satin) but passed over fine metal rods after every few passes of the weft. The rods may then be withdrawn, leaving rows of looped pile warp standing above the level of the ground weave, or the tops of the loops may be cut before the rods are withdrawn, leaving the characteristic fur-like surface that we associate with velvet fabrics. If only some loops are cut, the surface of the fabric shows two textures that may or may not be exploited to convey a pattern; in either case the fabric is known as *ciselé velvet*. In another variation of velvet weave, rods of two heights are used to create the pile loops and by controlling the shapes of high-pile or low-pile areas the weaver can create patterns in two heights of pile, usually cut pile. This is known as *pile-on-pile velvet* (No. 126). Velvets can also show patterns through the contrast of areas of pile and areas of exposed ground weave (usually satin or twill); these are *voided velvets* (Nos. 123, 130). By using pile warp systems of different colors the weaver can produce multicolored pile patterns in solid cut or uncut, pile-on-pile, or voided velvets (Nos. 134, 199).

Other textiles in this collection show patterns that were produced with the aid of extra warp or weft systems that contrast with the ground weave, not through a dramatic difference in height or surface as in velvet, but through differences in size, color or texture. These extend from selvage to selvage and run the full length of the piece; the extra yarns are brought to the surface of the fabric only where their color or texture is needed to define the pattern; in other places they remain hidden under the surface of the basic tabby, twill or satin weave, or on the back of the fabric. Textiles showing similar kinds

of patterns, but that have extra pattern wefts extending only across the width of the motif that they render in the pattern, are generically known as *brocaded* fabrics.

Embroidered or *needleworked* fabrics differ from brocaded textiles in that the pattern yarns are introduced into the ground weave (or non-woven foundation fabric—paper, felt, etc.) by using a needle to pull the yarns through the foundation *after* the foundation web has been removed from the loom (brocading is done on the loom as the fabric is being constructed). The needle may penetrate the foundation in any number of ways, and each procedure is characterized by the name of a stitch. If the stitches themselves do not make a pattern but only serve to hold bits of other textiles in place on the surface of the foundation, the procedure is called *applied work*; if the stitches hold only extra yarns to the surface it is known as *couched work*.

The earliest forms of lace were evolved from woven fabrics decorated with needlework. In one form, the needleworker cut away parts of the foundation fabric to create open spaces in the pattern (*cutwork embroidery;* see No. 51). In another kind of early lacemaking the worker pulled selected groups of warp and weft yarns out of the foundation web, leaving an openwork grid that she stitched over and across to create a pattern (*withdrawn element work*; see No. 56). There is a closely related class of early laces that shows a similar kind of work, but the stitches are made on a ground of woven gauze or knotted netting (*buratto* or *darned filet*) rather than on a thinned-out foundation web (No. 52). Another related kind of openwork embroidery that closely resembles lace is *deflected element embroidery*, in which the worker uses a very fine linen or cotton foundation web whose warps and wefts she spreads apart with the aid of pattern stitches, thus creating stitched and openwork patterns simultaneously (No. 63).

More sophisticated laces represent a class of work in which lacemakers did not start with a woven or netted fabric but constructed a fabric and pattern in one and the same operation, creating a textile that depended for its substance only on the plaiting of bobbins (*bobbin lace;* see Nos. 76, 82), or stitches made with a needle on a system of skeleton yarns (*needlepoint lace;* see Nos. 68, 70). Some of these advanced lace forms show a mixture of bobbin and needle techniques (*mixed lace*; see No. 87). Each type of bobbin, needlepoint and mixed lace has come to be known by a special name in one or more languages, names that refer to the method of construction (*punto in aria*, or "stitch in the air"; see No. 49), a characteristic pattern (*point de neige*; see No. 69), or the place where it was made (*Point de France, Burano, Mechlin;* see Nos. 70, 75, 83). The entries in this catalogue specify both the generic type of lace under consideration and also the specific name by which it is known.

detail of No. 1
Amazons Preparing for a Joust

Tapestries

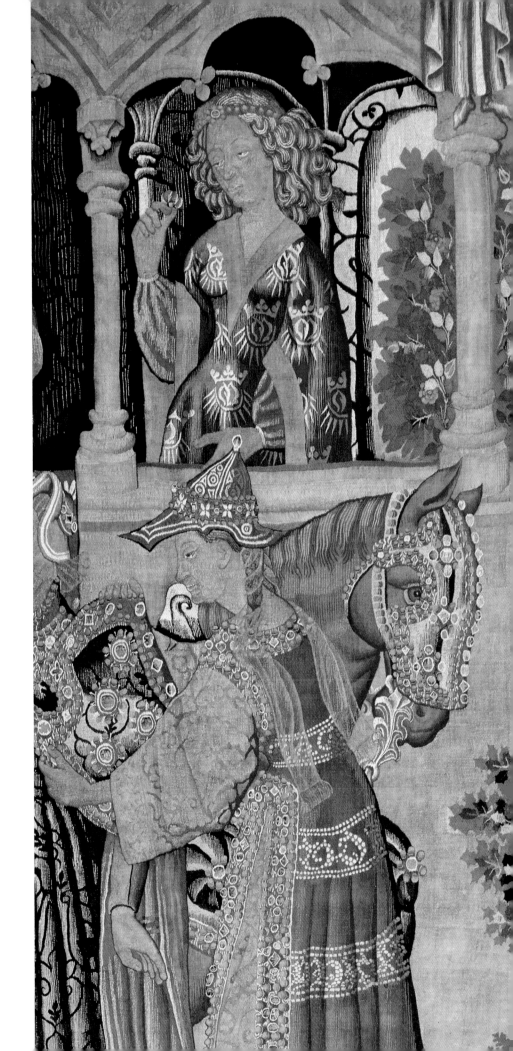

1
*Amazons Preparing for a Joust** T24w2

Flemish, Tournai(?), 1450–75
Wool warp (7 yarns per cm.), wool and silk wefts. H. 13'1", W. 16'4" (3.98 x 4.97 m.)
Purchased from Emile Peyre, Paris, July, 1897

The tapestry has suffered considerable damage, particularly in the lower left
quarter where much of the fabric has been restored and the drawing is for the
most part not original. There are also large and small repairs, by darning or
by couching bare warp yarns, over the rest of the surface. These account for
the relatively large number of inconsistencies in drawing and modeling that
make some details difficult to read. The fabric has been cut along all four
sides; while it is impossible to determine the extent of the losses, it is clear
that the main composition has survived in its entirety.

Siple attributed the tapestry to Franco-Flemish weavers working in the late
fifteenth century.[1] Asselberghs suggested that the hanging might have been
woven in Tournai in the third quarter of the fifteenth century.[2] Wells suggested
that a thematically and stylistically related *Hercules* tapestry in the Burrell
Collection, Glasgow, dates from roughly the same period, perhaps as early
as 1450–60.[3]

Comparisons between the *Amazons* and still other tapestries for which the
date is fairly secure only support these three opinions. For example, the details
of the Amazons' costumes—particularly the coiffures and headdresses, the
bodices, necklines and ballooning sleeves caught tightly at the wrists—were
fashionable at the time and correspond to similar details in a *Paris Returning to
Troy with Helen* in the Burrell Collection that has been dated convincingly in
the middle of the fifteenth century.[4] Similar costumes also appear in a frag-
ment of the *Story of the Swan Knight*, now in the Österreichisches Museum für
Angewandte Kunst, Vienna, which dates from around 1462.[5] This fragment,
together with the larger piece of the *Swan Knight* in Wawel Castle near Cracow,
and the closely related *Alexander* tapestries in the Palazzo Doria, Rome, have
been identified, at least tentatively, with sets of hangings that Philip the Good
bought from the Tournai tapestry merchant, Pasquier Grenier: the *Alexander* in
1459 and the *Swan Knight* in 1462.[6]

Furthermore, there is some justification for attributing the *Amazon* tapestry to
Burgundian territories (Tournai, Arras or Bruges) on iconographic grounds.
The Amazons figure in stories dealing with Hercules. Wells has shown that
the Dukes of Burgundy, celebrating a tradition perpetuated by Olivier de la
Marche (*Mémoires*, ed. 1883, I, ch. x), traced their lineage to Hercules through
his marriage with the Burgundian noble lady Alise, and favored representa-
tions of the ancient hero and of subjects associated with his life.[7] Numbers of
Hercules tapestries were woven for the court of Burgundy during the fifteenth
century. Some are known to have hung on the walls of a hall at Lille in which
Philip the Good gave a banquet in 1453. Wells also refers to a passage in
Olivier de la Marche's *Mémoires* (III, p. 143) where it is recorded that the festivi-
ties presented in celebration of the marriage of Charles the Bold and Margaret
of York at Bruges in 1469 included a mime based on the labors of Hercules.
One of those labors involved the hero's winning the girdle of Hippolyte, one of
the Amazon queens who is arming for the joust in the tapestry at the Gardner
Museum. While this relationship between subject matter and court is clear
and important, the somewhat provincial look of the Gardner piece compared
to the others cited above suggests that it was designed or woven somewhere
other than in the most fashionable workshops patronized by the ducal court.

The tapestry shows seven women standing in a gallery atop a masonry wall
that extends across the back of the shallow space. The figures look through
trefoil arches in the front of the gallery. On the field before them eleven
women are engaged in preparing for a joust. The two contestants' horses
stand in the background at either end of the wall, parts of their bodies appear-
ing intermittently in the spaces between the women's figures. The animals
have been fitted with jewelled armor for their heads, chests and flanks. Their
riders, the women standing third from the left and second from the right,

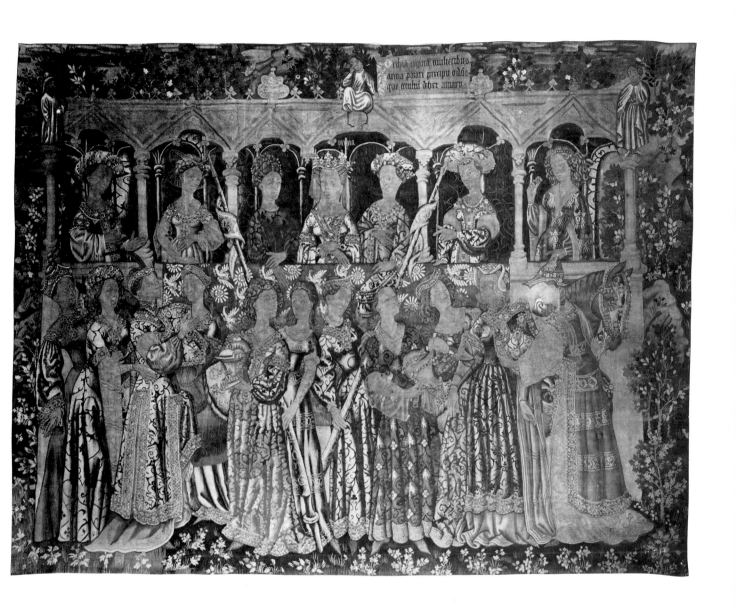

wear jewelled gorgets and are receiving equally splendid pieces of plate armor for their arms, as well as shields and jousting helmets. Both contestants and the woman at the far right, dressed as a squire with an open helmet on her head, wear long surcoats bordered with jewelled bands. Trees and flowering shrubs rise from the hilly ground at the sides of the viewing stand and in the distance above and beyond it; small flowering plants grow above the grass of the jousting field.

Along the top of the gallery, at each end and in the middle, appear sculptured finials in the form of men wearing flowing robes. These may be intended to represent the ancient or medieval poets and historians who wrote about the Amazons. (The chief among these are Homer, Herodotus, Apollodorus, Domitius Marsus, Giovanni Boccaccio and Raoul Lefèvre.) Similar figures holding scrolls and standing in like relationship to a similar masonry canopy appear in a fragment of the *Seven Sacraments* tapestry now in the Burrell Collection; they represent prophets.[8]

A scroll bearing the following inscription appears above the gallery just right of center:

Orchia regina mulieribus
arma parari precipit odña
que multũ debet amary

The following reading is recorded in the Museum archives: "Queen Orchia orders arms to be prepared for the women, and obedience deserves to be much loved." (Professor Mason Hammond, who suggested this translation, acknowledged that the meaning of the last part of the text is not entirely clear.) Until a literary source for the composition comes to light the precise meaning of this inscription will remain equivocal; nevertheless, it is clear that the author or designer is explaining that the women are being armed at Orchia's command.

The early accounts of these mythical or near-mythical female warriors vary considerably in detail. However, they agree that Orchia (or Orytheia, as she is sometimes called) was queen of the Amazons. Her daughter, Hippolyte, was ruling in her absence when Hercules came to their dwelling place in the Caucasus region to steal Hippolyte's girdle, one of the seven labors that had been imposed upon him. Theseus, who accompanied Hercules, took for his prize another of Orchia's daughters, Menalippe, sometimes call Antiope, and carried her with him back to Athens. When Orchia returned from her distant campaign and discovered Hercules' intrusion, she stormed Athens in retaliation but her attack failed and Menalippe, now allied through her love for Theseus with the Athenians, was killed by her sisters. In addition to these two encounters with Athenians, the literary sources tell of another battle waged by the Amazons, this time led by Penthesileia, another of Orchia's daughters, who attempted to defend Troy against Agamemnon, but succumbed to defeat at the hands of Achilles or Pyrrhus.

Three of these Amazons appear in this tapestry. *Orchia,* so labeled by an inscription placed above and to the right of her head, stands in the center of the gallery; she wears a royal crown. The two contestants about to joust are *Ipolite* at the left, so identified by an inscription on her right sleeve, and *Menalipe* at the right; the inscription with her name extends across her right breast and shoulder. Presumably, these two lesser queens are preparing to joust as an exercise suitable for warriors, just as knights were doing at the time the tapestry was designed and woven. Soon Hippolyte and Menalippe will be called up to pit their martial skills against those of the great Hercules and Theseus, and the designer (or author of the poem or romance on which his work was based) is preparing them and us for the next incident in the story.

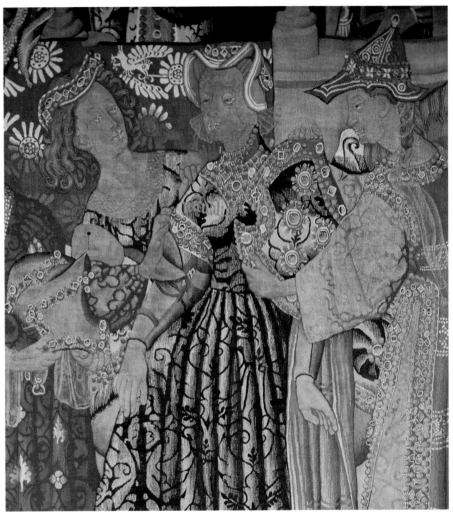

The image of Amazons jousting clearly could not have been inspired directly by any of the ancient writers; it must have developed from late medieval accounts of the Amazons' exploits, accounts tinged with the chivalric flavor of the times. Boccaccio wrote of the Amazons in his *De Genealogiis Deorum* (book xv) and also in his *De Casibus Virorum et Feminarum Illustrium* (book ix), both written in the third quarter of the fourteenth century. Lefèvre mentioned the struggle with Hercules and Theseus in his *Recueil des Histoires de Troyes*, first published about 1469.

These texts do not refer to Amazons jousting, but it would seem logical to postulate the existence of derivative texts making such references at this time when jousting was at the peak of favor as a noble sport and martial exercise. King René of Anjou celebrated jousting in a lavishly illustrated manuscript, entitled *Traictié de la form et devis comme on fait les tournois* and written about 1460.[9]

While it is tempting to think that this subject of women jousting might bear a relationship to the French troubadours' "tournoiements des dames" composed in the twelfth and thirteenth centuries, the surviving texts dealing with these fanciful battles refer to ladies actually living at the time, and not to ancient women like the Amazons.[10] However, the balletic poems may have established a taste for such fancies that survived into later periods.

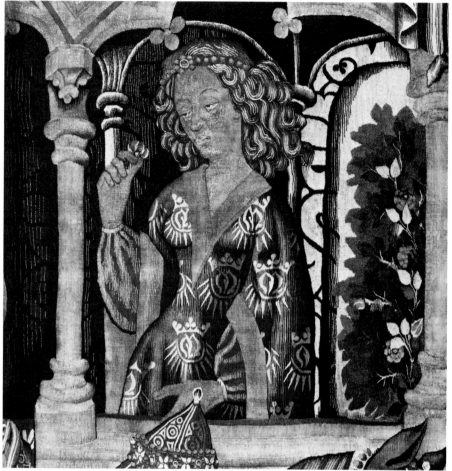

Wells suggested that the presence of the three Amazon queens in the *Hercules Initiating the Olympic Games* tapestry in the Burrell Collection derives from Lefèvre's mention of their battle with Hercules and Perseus (*Recueil*, book ii).[11] The "games" in that tapestry take the form of a tournament and thus the three women are actually shown in such a context. However, it is unlikely that the Gardner tapestry is associated with the Burrell *Hercules* as Wells[12] and Asselberghs[13] suggested it might be. Apart from the fact that the Amazons are armed with clubs in the latter and sharp lances in the former, the two tapestries are dissimilar in style and execution and the fashions of coiffure and clothing do not tally. Furthermore it was not common practice at this time for a tapestry designer to devote an entire hanging to what can only be regarded as an incidental scene, as the Boston composition would be in this context. Such supplementary incidents—two Amazons preparing to joust in anticipation of a battle—were normally relegated to a corner or other subsidiary position of the field, leaving the crucial composition in the center. That the Amazons' preparations constitute the main subject of the Gardner tapestry argues in favor of its belonging to a series that specifically concerns the bellicose activities of the Amazons.

No other tapestries showing the subjects of the Burrell or Gardner tapestries, or others directly related to them, are known to have survived. Clearly, the subject might have involved the labors of Hercules or the Trojan War, as has been indicated already. However, there are specific references to Amazon tapestries in the fifteenth century. The Duke of Alba's marriage contract of

1485 mentions two tapestries of the story of the Amazons[14] and the inventory of Ewelme Almshouse, Oxford, taken in 1466, lists among other tapestries a "Bed of Aras of Orchia."[15]

Still another possibility is that the Gardner tapestry may be associated with a series of hangings devoted to the Nine Female Worthies, counterparts to the Nine Worthies who were often treated in the art of tapestry weaving. At least five of the Amazons—Orchia, Lampedo, Hippolyte, Menalippe and Penthesileia—were usually listed among these Nine Worthies. The inventory of Charles VI of France (1422–35) mentions among some "tappiz bien vielz" certain pieces showing Hippolyte, Menalippe, Penthesileia and Semiramis among other women.[16] A fragment of a late fifteenth- or early sixteenth-century Flemish tapestry in the Musée des Arts Décoratifs, Paris (hitherto unpublished, Inv. no. DP 7385 B), is of particular interest here since it shows part of an armored female figure identified as Hippolyte and an inscription referring to the battle waged by Hercules and Theseus against Hippolyte and Menalippe. A closely related tapestry celebrating Penthesileia is preserved at Angers.[17]

Three other tapestries showing compositions related in a general way to the Gardner piece may be cited here. Of particular interest is the presence in all four of a curiously clear horizontal organization of the pictorial elements, a style of composition that differs dramatically from the usual style of the period in which diagonal lines thrust across the surface and into depth. A row of figures in a gallery appears prominently along the top of the *Joshua and David* piece of the *Nine Worthies* in the Cloisters, a composition some sixty to seventy years earlier than the *Amazons*. A tapestry called *Worship of Cupid*, formerly in the possession of Duveen Brothers, New York, shows a row of women in a gallery above a jousting field.[18] Another tapestry in the late fifteenth-century style treating a *"Tournament Scene"* shows men and women sitting in a gallery watching a tournament in progress below.[19]

1 Siple, p. 241.

2 Asselberghs, 1974, p. 12.

3 W. Wells, "An Unknown Hercules Tapestry," *Scottish Art Review,* VIII, 3, 1961, p. 30.

4 Wells, *Colloquium,* 1969, pp. 441, 444, 448, fig. 7.

5 D. Heinz, *Europäische Wandteppiche,* Braunschweig, 1963, I, p. 78, fig. 46.

6 J.-P. Asselberghs, *La tapisserie tournaisienne au XV^c siècle,* Tournai, 1967, pp. 23, 24, 28, 29.

7 Wells, 1961, pp. 13ff.

8 Wells, *Colloquium,* 1969, fig. 15.

9 See a facsimile publication, "Le Livre des Tournois du Roi René," *Verve,* VI, 1946.

10 See A. Pulega, *Ludi e spettacoli nel medioevo: i tornei di dame,* Milan, 1970; and H. P. Dyggve, "Personnages historiques figurant dans la poésie lyrique française des xii^e et xiii^e siècles: III—Les dames du 'Tournoiement' de Huon d'Oisi," *Neuphilologische Mitteilungen,* XXXV, 1935, pp. 5–84.

11 Wells, 1961, p. 15.

12 Wells, *Colloquium,* 1969, p. 449, no. 20.

13 Asselberghs, 1974, p. 12.

14 G. L. Hunter, *The Practical Book of Tapestries,* Philadelphia and London, 1925, p. 80.

15 W. G. Thomson, *Tapestry Weaving in England from the Earliest Times to the End of the 18th Century,* London, 1914, pp. 25, 27, 28.

16 Göbel, 1923, p. 72.

17 G. T. Van Ysselsteyn, *Tapestry, the Most Expensive Industry of the XVth and XVIth Centuries,* The Hague and Brussels, 1969, fig. 35.

18 H. C. Marillier *et al., Ms. Subject Index of Tapestries,* Department of Textiles and Dress, Victoria and Albert Museum, London, n.d., I, p. 62, illus.

19 Hotel Drouot, Paris, Salle No. 2, June 14, 1976, lot 107, illus.

Bibliography: E. S. Siple, "Some Recently Identified Tapestries in the Gardner Museum in Boston," *Burlington Magazine,* LVII, 1930, pp. 236–42. *General Catalogue,* pp. 194, 195. Wells, *Colloquium,* 1969, p. 449, no. 20. Asselberghs, 1974, p. 12.

*The author, on the basis of new evidence, has recently redated the tapestry to ca. 1420–50.

2
The Fulfillment of the Curse on Ahab T24e5

Flemish, Tournai or Arras, ca. 1460–70
Wool warp (6 yarns per cm.), wool and silk wefts. H. 11'11", W. 15'1½" (3.63 x 4.61 m.)
Purchased from Bachereau, Paris, 1897

The present outer guard is modern. The fabric has suffered considerably; the weft yarns that deteriorated and fell out were replaced by darning and by couching bare warp yarns. These repairs have altered the drawing appreciably, especially in the treatment of the hatching, and have thickened the modeling of forms.

The incomplete state of the inscriptions along the top, and of the figures and animals along the left side and bottom, indicate that the tapestry has been cut down on those three sides. The right side seems to have been preserved relatively intact; the setting is complete and the incidents depicted bring the story of Ahab to a close.

King believed that the loss in height amounted to only a few inches,[1] but a closer estimate of that loss may be made by comparing this piece to one of two almost identical *Story of Jephtha* hangings preserved in the Cathedral of Saragossa,[2] whose stylistic affinity with this tapestry was first noted by H. C. Marillier[3] and, later, by Weigert[4] and King.[5] The *Jephtha* hanging is approximately forty-three inches taller than the *Ahab*. Even though it has lost some fabric along the top where the present edge bisects the uppermost line of an inscription, its composition looks correctly proportioned in the space it occupies, rather than stunted and cramped as the *Ahab* composition appears. Since all three tapestries may have been designed by the same artist, perhaps for a single set of compositions, it seems likely that the *Ahab* was originally as tall as the *Jephtha*, or perhaps as much as four feet taller than it is now.

King also noted that the inscriptions along the top of the *Ahab* have been moved.[6] The fragmentary inscription in the upper right corner belongs at the start of the incomplete text in the upper left, and all three inscriptions are probably farther to the left now than they were originally.

On the left side of the *Jephtha* hanging, a narrator stands in a window; an open scroll inscribed with a text of the story of Jephtha hangs below the window. The narrator points to the scroll with his right hand and gestures with his left hand toward the figures enacting the story. Since the *Ahab* and *Jephtha* tapestries are closely related, and the left end of the former is incomplete, it is reasonable to suggest that such a narrator may be missing from the left of the Gardner hanging and that other incidents in the Ahab story, like the murder of Naboth and Elijah uttering the Lord's curse on Ahab, may have been included there.

The scenes that are depicted illustrate later events in the story as recounted in the *Book of Kings* (I *Kings* 21; II *Kings* 9, 10). Ahab succeeded his father as king of Israel early in the ninth century B.C. He displeased the Lord by worshipping Baal and with his wife, Jezebel, inflicted injustice on his people. When Jezebel stood accused of having Naboth murdered so that Ahab could take possession of his vineyard, Elijah, leader of the orthodox Jews, uttered the Lord's curse on Ahab and his wife:

Thus saith the Lord, In the place where dogs licked the blood of Naboth shall dogs lick thy blood. . . . And of Jezebel also spake the Lord, saying, The dogs shall eat Jezebel by the wall of Jezreel.

When Ahab heard this, he repented; and Elijah announced that God would withhold fulfillment of the curse but would inflict it upon Ahab's son, Joram. The fulfillment of the curse through Jehu during Joram's reign is the subject of the tapestry.

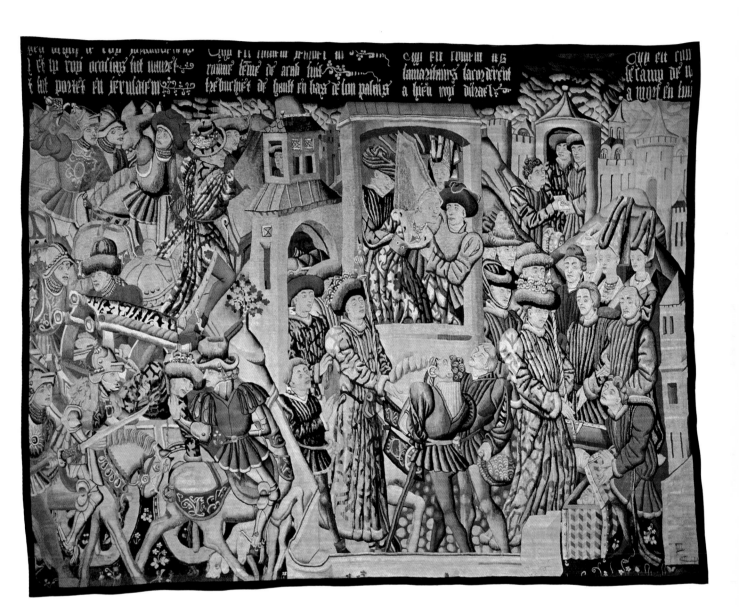

The story is told in five scenes, to be read top left, bottom left, center, top right and bottom right. Restoring the displaced fragment to its proper place and beginning at the left, the first inscription reads:[7]

Chy est co[ment] hieu ochist le roy joram dedens
le camp de [nabot]h et ly roy ocosias fut navret
a mort en fui[yant] et fut portet en jerusalem

This inscription in Picard dialect (*chy = ci, camp = champ*) may be translated as follows:

Here is how Jehu slew king Joram in
the field of Naboth and king Ahaziah was wounded
to death while fleeing and was carried to Jerusalem.

The horsemen in the upper left have been identified as the army of King Ahaziah, Joram's cousin, fleeing before Jehu's soldiers.[8] The two men below may represent Jehu ordering his captain, Bidkar, to throw Joram's body into Naboth's field. At the bottom, a horseman turns to see Joram, Jehu's arrow in his back, slump down in his chariot, while an enemy soldier seizes his shoulder. Below the chariot a dog licks Joram's blood, and thus the first part of the curse is fulfilled.

The middle of the tapestry has the following inscription:

Chy est coment jesabel la
roinne feme de acab fuit
trebuchiet de hault en bas de son palais

Here is how Jezebel the
queen, wife of Ahab, was
tumbled from top to bottom of her palace.

Below the inscription is the watchman in the tower of the city gate who warned Joram of Jehu's approach. The victorious Jehu now enters Jezreel through the gate. He has commanded the two eunuchs who hold Jezebel to cast her from the window to the street, fulfilling the second part of the curse.

The third inscription appears today somewhat farther to the left than it did originally. It reads as follows:

Chy est coment les
samaritains sacorderent
a hieu roy disrael

Here is how the
Samaritans came to terms
with Jehu king of Israel.

In the upper right, Jehu's messenger delivers to a Samaritan one of many letters ordering those people who would follow Jehu to decapitate the seventy sons of Ahab. Below, surrounded by loyal Samaritans, Jehu inspects the severed heads in a basket, evidence that the Lord's curse on the house of Ahab has taken its full toll.

King noted the stylistic links between this and other Flemish tapestries surviving from the period around 1460,[9] particularly the *Alexander* tapestries in the Palazzo Doria, Rome,[10] the *Death of Herkinbald* in the Historisches Museum, Bern,[11] the *Swan Knight* pieces in Cracow and Vienna[12] and the *Saints Peter and Paul* series, some in the church of St. Peter at Beauvais, others dispersed.[13] There are also striking parallels between the Ahab tapestry and other tapestries from the third quarter of the fifteenth century, particularly four hangings from the *Story of the Redeemer* series found in several collections,[14] and the *Crucifixion* tapestry in the Musées Royaux d'Art et d'Histoire, Brussels.[15] However, aside from the *Jephtha* tapestries at Saragossa, perhaps the closest stylistic parallels can be made by comparing the Gardner hanging with a fragment of a *Charlemagne* tapestry in the Musée des Beaux-Arts, Dijon.[16]

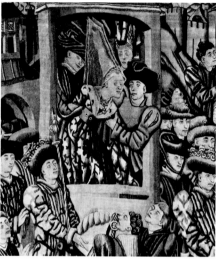

detail, 2

It is on the basis of these comparisons that King,[17] Asselberghs[18] and others attributed the tapestry to Flanders in the third quarter of the fifteenth century. King noted that the inscriptions are rendered in Picard dialect and offered this as further evidence that the tapestry was woven either in Tournai or another tapestry-weaving center in the Picard region, perhaps Arras.[19] Bertaux made a similar observation concerning the inscription in the *Jephtha* tapestry at Saragossa.[20]

Similarities of composition, style and detail relate the *Ahab* and *Jephtha* hangings so intimately that it has been rightly suggested that one artist may have designed both compositions. However, as King pointed out, the execution of the tapestries is so different that, even taking into account the heavily restored condition of the *Ahab* tapestry, one cannot regard the two hangings as belonging to one set of weavings.[21]

Three *Ahab* tapestries (one single piece and a suite of two pieces) were bought by Borso d'Este in 1461 and 1469 from Rinaldo Boteram, a Brussels merchant selling tapestries in Italy at that time. King suggested that since the story of Ahab was an unusual subject, the Gardner *Ahab* may have been one of those hangings or, more likely, woven from the design that served for the Este tapestries.[22]

The series from which the Gardner tapestry comes may not have dealt only with the story of Ahab. The existence of the closely related *Jephtha* tapestry in Saragossa suggests that it and the *Ahab* may have come from a suite of tapestry compositions portraying the lives of several Old Testament figures. The Gardner *Ahab* is the only one with this subject known to have survived from the fifteenth century.

1 King, p. 3.

2 E. Bertaux, "Les tapisseries flamandes de Saragosse," *Gazette des Beaux-Arts*, LI, 1909, pp. 219–39 and F. Abbad Ríos, *Catálogo monumental de España, Zaragoza*, Madrid, 1957, II, fig. 208. The two tapestries are virtually duplicate pieces since they were woven after the same cartoon; for the purposes of this catalogue they will be treated as one piece.

3 Letter in Museum archives, dated December 1, 1930.

4 Weigert, p. 63.

5 King, pp. 8, 9.

6 *Ibid.*, p. 3.

7 King (pp. 4–6) transcribed and translated all three inscriptions.

8 *Ibid.*, pp. 5, 6.

9 *Ibid.*, pp. 7ff.

10 Göbel, 1923, pl. 201.

11 *Ibid.*, pl. 210.

12 *Ibid.*, pl. 200.

13 *Ibid.*, pl. 217.

14 *Ibid.*, pls. 212–15.

15 *Ibid.*, pl. 219.

16 *Masterpieces of Tapestry from the Fourteenth to the Sixteenth Century*, Grand Palais and Metropolitan Museum of Art, 1973, p. 67, illus. pp. 67, 68.

17 King, pp. 3ff.

18 Asselberghs, 1974, p. 12.

19 King, pp. 4, 7.

20 Bertaux, p. 235.

21 King, pp. 8, 9.

22 *Ibid.*, p. 9.

Bibliography: E.S. Siple, "Une tapisserie inédite, à Boston," *Gazette des Beaux-Arts*, XII, 1934, pp. 65, 66, illus. p. 65. *General Catalogue*, pp. 196, 197. R.-A. Weigert, *French Tapestry*, London, 1962, p. 63. Stout, pp. 170, 171, illus. D. and M. King, "A Fifteenth Century Tapestry of *The Story of Ahab*," *Fenway Court 1975*, 1976, pp. 3–9. Asselberghs, 1974, p. 12. Hadley, pp. 146, 147, illus.

3
Proverbs T24w1

Flemish, 1475–1500
Wool warp (5 yarns per cm.), wool and silk wefts. H. 9′3″, W. 7′3″ (2.82 x 2.20 m.)
Purchased through Joseph Lindon Smith from Seligman, Paris, March 10, 1905

This is a fragment of a larger tapestry; it has been cut down on all four sides and extensively repaired by darning and by couching bare warp yarns; this has changed the character of the hatching to some degree and also the rendering of the transparent fabrics of the women's veils. The repairs seem to have affected the original drawing very little.

Asselberghs considered the tapestry to be of Flemish origin and dated it at the end of the fifteenth century.[1] As all the proverbs but one have been found in both the French and Flemish languages, Grauls, following Duverger, concluded that the tapestry was designed and made in a border town, perhaps Tournai or Arras.[2] While Grauls and Siple have explained the meanings with a phrase and have made some comments on early literary sources,[3] no one has actually identified the entire proverb in each case. These proverbs exist in many languages, with variations from country to country. Further research may help to clarify the actions depicted on the tapestry and their national associations.

The field shows a hilly landscape in the foreground thickly covered with flowering plants, a so-called *millefleurs* ground. Each figure or pair represents a proverb. In the upper left corner a young man eats ears of wheat—stalk, leaves and all—representing the man who "eats wheat in the raw" (*manger son blé en herbe*) or who spends his wealth (harvest) before he gets (reaps) it. Next to him, moving toward the right, one sees another young man kneeling before a small demon holding a candle and perched on a pillar; the man hands the creature a second candle. According to Siple and Grauls, this represents the man who "holds two candles to the devil" or who countenances wrongdoing. However, there is another French proverb, "*donner une chandelle à Dieu et l'autre au diable,*" which suggests hypocrisy rather than outright evil intent. Further to the right, a young man wearing a shirt of mail under his tunic prepares to "bell the cat"; that is, according to Siple and Grauls, to perform a heroic deed. However, the expression also refers to one who takes the first step in a difficult undertaking. A young man standing in the upper right corner of the tapestry holds a firebrand in his right hand and a bucket of water in his left. This is the man who "blows hot and cold" or speaks good and evil of the same thing.

In the middle range, at the left, a young man "falls between two stools" into the ashes; he can't make up his mind. At the right a youth in a sumptuous robe "bites the pillar" indicating that he is a hypocritical church-goer.

In the lower left corner of the hanging a woman slips a blue, hooded cloak on a man's shoulders; she has cuckolded her husband. In the center of the bottom a fashionably dressed young woman places her hand on the purse of the young man who is about to embrace her; she is marrying him for his money. This is the one scene that represents a proverb in Flemish for which it is said there is no exact counterpart in French. The last figure in the tapestry is a small, older man who looks in consternation at a figure, now missing, whose right hand holds an unidentified object under the man's chin. No meaning has been suggested for this fragmentary group.

Presumably, other hangings illustrating proverbs once accompanied this tapestry. Neither duplicates nor tapestries associated with this piece in a suite of hangings are known to have survived.

1 Asselberghs, 1974, p. 12.

2 Grauls, pp. 14–26.

3 *Ibid.*, and Siple, pp. 29–35.

Bibliography: E.S. Siple, "A 'Flemish Proverb' Tapestry in Boston," *Burlington Magazine*, LXIII, 1933, pp. 29–35, pl. A. *General Catalogue*, pp. 197, 198. J. Grauls, "Een vijftiendeeuws spreekwoordentapijt," *Artes Textiles*, III, 1956, pp. 14–26, pl. 6. Asselberghs, 1974, p. 12. Hadley, pp. 162, 163, illus.

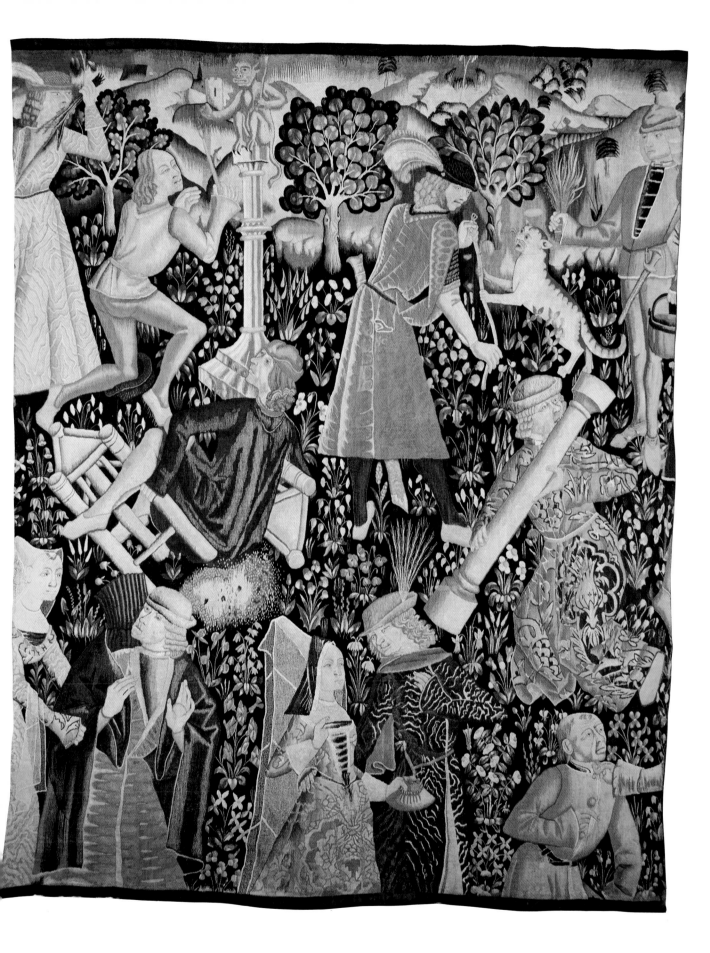

4
Field of Flowers T30n10

Flemish, 1475–1550
No city or weaver's mark present
Wool warp (5 yarns per cm.), wool and silk wefts. H. 2'11½", W. 4'1" (.90 x 1.25 m.)
Purchased from Julius Böhler, Munich, 1897

The tapestry is a patchwork taken from different parts of one or more hangings that in their original state probably showed human figures, creatures, allegorical personifications, personal or religious devices or symbols, or coats of arms against a ground densely covered with flowering plants (*millefleurs*). Some of the patches have been turned upside down so that the plants seem to be growing downward. There are some repairs by darning, primarily in the blue-green ground.

The fashion for tapestries showing this kind of *millefleurs* setting as a foil for figures or devices lasted from about 1450 to 1550. For some time, specialists had regarded these tapestries as a group apart from other pictorial hangings and believed that they were woven by established or itinerant weavers in the Loire valley. More recently, it has been shown that they were produced at Brussels and Bruges;[1] other attributions have been made to Tournai and Audenarde. However, we have not yet got reliable stylistic criteria to use in attributing any one piece to a particular weaving center, or even to a limited period of time.

The *millefleurs* (or *verdures* as they are sometimes called) vary essentially in terms of two major considerations: the naturalism with which the plant forms are rendered, and the degree to which they are spread out or crowded together on the ground. No correlation has been established between these considerations and the date and place of manufacture.[2] A *millefleurs* with the coat of arms of Philip the Good of Burgundy is probably the earliest hanging of this kind that has been dated (ca. 1466) and attributed convincingly to Brussels.[3]

1 S. Schneebalg-Perelman, "La tenture armoriée de Philippe le Bon à Berne," *Jahrbuch des bernischen historischen Museums in Bern*, XXXIX and XL, 1959 and 1960, pp. 136–63 and J. Duverger and J. Versyp, "Brugs tapijtwerk in het Paleis van het Brugse Vrije en het belang ervan voor de kennis van de Brugse tapijtkunst," *Album Albert Schouteet*, Bruges, 1973, pp. 75–84.

2 For a summary of recent opinion concerning this question see G. Souchal's observations in *Masterpieces of Tapestry from the Fourteenth to the Sixteenth Century*, Grand Palais and Metropolitan Museum of Art, 1973, pp. 108, 109. For typical examples of *millefleurs* tapestries of this period, see *ibid.*, pp. 75ff., 95ff., 119ff.

3 Schneebalg-Perelman, figs. 1, 2.

Bibliography: *General Catalogue*, p. 275.

5
The Landlord and the Woodcutters T30w4

Flemish, probably Tournai, ca. 1510–20
Wool warp (5 yarns per cm.), wool and silk wefts. H. 11'8¼", W. 10'11½" (3.56 x 3.34 m.)
Believed to have been purchased from Charles Rafard, Paris, May 9, 1892

The tapestry has been cut on all four sides and the border has been sewn to the edges; it is not intact. The left border is later than the right, and there is some repair along the top edge at the right that dates from the later period. At the lower left, the field has been patched with pieces from this or another tapestry; the patching involves the figure of the hound as well as some of the flora. There are small repairs by darning throughout.

Asselberghs considered that in terms of both style and technique this tapestry is a product of the looms of Tournai and that it was woven at the beginning of the sixteenth century.[1] The costumes of the fashionably dressed men at the left and the couple in the lower right corner point, however, to a moment approaching the third decade of the century.

The main action is set on a circular plot of land bounded by a picket fence with a locked gate. A narrow bridge leads across a stream or moat, connecting the enclosure to the surrounding terrain. A man dressed in fine clothes stands in the center of the enclosed plot. A low wattle fence runs in front of him, and behind him stands a tree with a wide, shallow bowl carried on its short branches.

The man, perhaps a steward, reads from a sheet of paper or parchment he holds in his right hand while gesturing with his left toward a group of woodcutters. Behind him, three elegantly dressed men stand in back of a fourth who leans against a wooden barrier, his right hand resting on the structure, his left hand holding a staff. A stone house stands in the middle distance to the left and a town rises among the hills in the far distance to the right. Farther to the right, in the middle distance, a gentleman holding a hawk on his upraised right hand leans toward a seated shepherdess; she places her hand on his purse. Another gentleman holding a hawk, with a lady at his side, stands in the right foreground and watches the activity in the enclosure. The narrow border contains scrolling vines bearing two kinds of blossoms tied at the centers and at the corners with bows.

Considered in isolation, the tapestry does not reveal the meaning of its subject matter except in the most general terms. If one compares it to a number of similar hangings, several possible meanings suggest themselves. Asselberghs suggested that the composition may have been inspired by that of a closely related tapestry formerly in the Figdor collection and now in the Kunstindustrimuseet, Copenhagen.[2] He attributed the latter to Tournai, about 1450–75. It shows another scene in which a steward reads a message to a group of country laborers in the presence of the landlord or a judge.[3] The steward stands in virtually the same pose as the corresponding figure in the Gardner tapestry. The two men in the foreground of the enclosure, one placing his hand on the other's shoulder, are essentially the same in both tapestries.

However, there are significant differences between the two hangings: all the workmen in the Copenhagen tapestry carry pruning knives rather than axes; there are no courtly couples stationed outside the enclosure; and the picket fence is missing. Asselberghs suggested that the Copenhagen example may have derived its subject from the *Parable of the Workers in the Vineyard (Matthew 20:1–16)* in which a landlord pays the workers who came to the job only an hour before the end of the workday the same salary as the men who worked all day.[4] He cited two early sixteenth-century tapestries in the Cathedral at Zamora as the only ones known to represent this subject.[5] On the other hand, Kurth believed that the Copenhagen tapestry shows a landlord collecting taxes or rental fees from his protesting tenants.[6] The young man in civilian clothes standing opposite the steward in the Gardner tapestry seems to be a bursar. His right hand is placed in a large purse hanging from his waist; clearly, this action concerns either the distribution or the taking in of money.

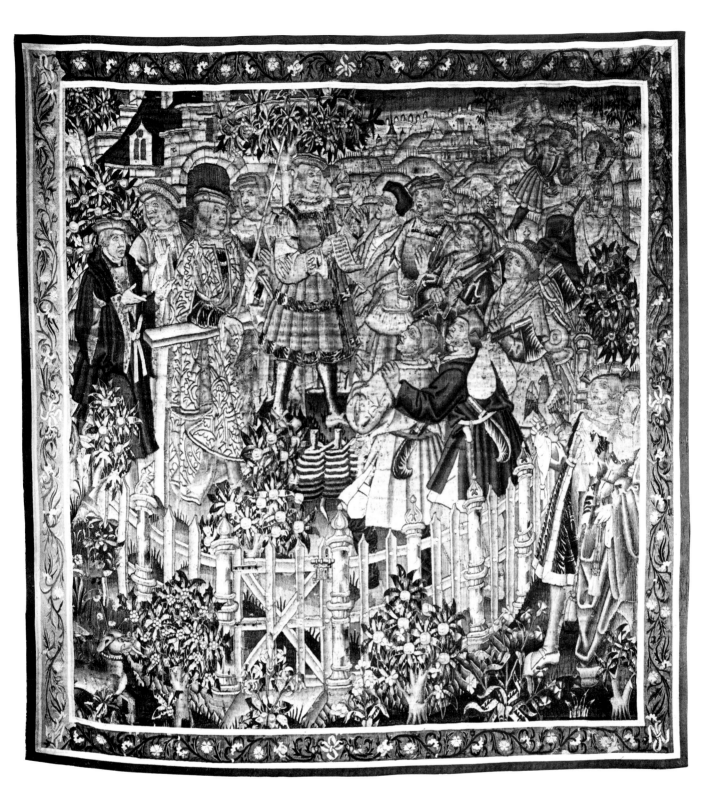

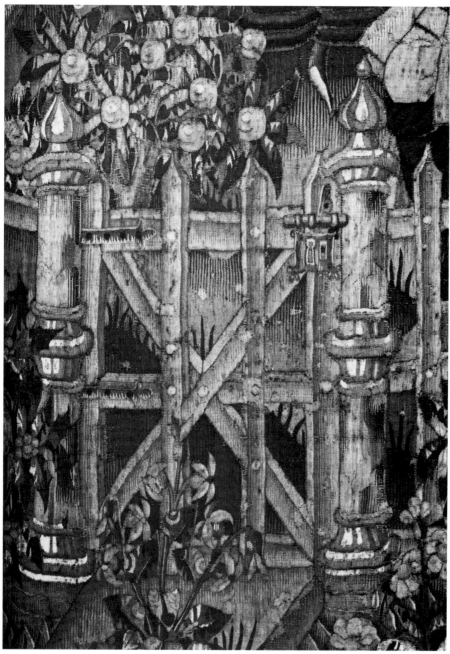

detail, 5

A small group of Flemish, perhaps Tournai, tapestries of the late fifteenth or early sixteenth century shows similarly fenced enclosures in which real or fantastic animals disport themselves, usually around a fountain in the center. In one of these a gentleman holding a hawk stands outside the enclosure.[7] It has been suggested, with some justification, that the fenced enclosure refers to the *hortus conclusus;* the fountain to the mythical fountain of life; and the whole setting to Christian life.[8]

Whatever the specific interpretation, the composition itself reflects the fashion for country life tapestries that seems to have swept western Europe during the second half of the fifteenth century and the early years of the next. Hangings showing shepherds and shepherdesses and courtly figures indulging in rural pastimes and pleasures are too numerous to list here, but a few woodsmen tapestries must be cited. One example is in The Metropolitan Museum of Art[9] and two others are in the Musée des Arts Décoratifs, Paris.[10] These hangings show men and women chopping down trees, cutting shoots off trunks or limbs and sawing logs into lengths for firewood. There is no suggestion in any of these of an allegorical content. Another example, formerly in the collection of Dario Boccara, shows the same kind of activity and also a woodman near the center working on a wattle fence like the one in the Gardner hanging.[11] This tapestry has a border that appears to be identical to the one that now enframes the composition in the Gardner tapestry. Since that border may not be original to the field, one cannot assume that the Boston and Boccara pieces were once part of a single set.

1 Asselberghs, 1974, p. 12.

2 *Ibid.*

3 B. Kurth, "Ein frankoflämischer Bauernteppich der Sammlung Figdor," *Belvedere,* IX, 1930, pp. 45–47, figs. 36, 37.

4 Asselberghs, 1974, p. 12.

5 Asselberghs, *Colloquium,* 1969, pp. 15ff., figs. 1–3.

6 Kurth, pp. 45ff.

7 Boccara, p. 50, illus.; and another related piece, p. 54, illus.

8 *Ibid.;* J.-P. Asselberghs, *Tapisseries héraldiques de la vie quotidienne,* Tournai, 1970, nos. 31, 32; *Wandtapijten,* I, pl. 24.

9 G.L. Hunter, *Tapestries: Their Origin, History and Renaissance,* New York and London, 1912, illus. opp. p. 400.

10 Göbel, 1923, pl. 234; G.L. Hunter, *The Practical Book of Tapestries,* Philadelphia and London, 1925, pl. xxi-h.

11 Boccara, illus. p. 43.

Bibliography: *General Catalogue,* p. 270. Asselberghs, 1974, p. 12.

Esther Fainting before Ahasuerus, **from a** *Story of Esther* **series** T24w3

Flemish, Brussels, 1510–25
Wool warp (6.5 yarns per cm.), wool and silk wefts. H. 11′ 4½″, W. 11′ (3.47 x 3.35 m.)
Believed to have been purchased from Mlle. Rousset, Paris (?), 1897

It appears that the tapestry was never cut down or otherwise significantly altered. There are extensive repairs by darning throughout, especially in the lower left section. The border is part of the main fabric and appears to have suffered little or no damage.

Ever since 1860, when Van Even published documents proving that the great *Legend of Herkinbald* tapestry in the Musées Royaux d'Art et d'Histoire, Brussels,[1] was conceived, designed and woven by Brussels artists and finished in 1513, scholars have had good reason to assign that attribution to certain stylistically and technically related hangings. Both the field and border of the Gardner tapestry show the style, texture and detail characteristic of this considerable group of weavings. The typical "Brussels" border of this period incorporates cut lengths of stalks or vines bearing grapes, roses, daisies and occasionally other blossoms.[2] The border of the Gardner tapestry shows sections of grape vines, rose stalks and daisy stalks, set end-to-end and bounded along both sides by guard bands comprising narrow red, yellow and blue stripes.

The scene represented here derives from the Greek text of the *Book of Esther* in the *Apocrypha* (Authorized Version of the Bible, 15:7), rather than from the Hebrew text of the *Old Testament*. The setting is the throne room of the Persian King Ahasuerus. Esther, his beloved queen, learned that at Haman's bidding the king had issued a decree ordering all Jews within the kingdom to be slain and their property confiscated. Esther went to Ahasuerus with two handmaidens, to plead for her people. Knowing that he had ruled that anyone coming to him unbidden would be put to death unless he held out the golden scepter to the visitor, Esther approached him in fear. He glanced at her in rage and she swooned on the shoulder of one of her handmaidens. But God softened the king's heart and he embraced his queen with assurances of love.

The two royal figures appear in the center of the composition, at upper right and lower left, with courtiers around them. A young man, perhaps a court eunuch, rushes toward the fainting Esther. The figure of an imposing, richly clad man appears behind Esther. This is probably meant to represent Haman, a favorite courtier of Ahasuerus who had urged the king to issue his decree out of anger against the Jew Mordecai, Esther's cousin and foster father, because Mordecai had refused to kneel to him.

The scene in the upper left corner shows a courier presenting a letter to a man surrounded by three women and a younger man. The central figure stands in an attitude of prayer or thanksgiving and two of the women gesture in wonder or relief. It seems likely that this represents a composite moment when word of Ahasuerus' recension of his decree reaches his provincial governors and later, the Jews residing in the kingdom, rather than a moment earlier in the story when the original decree reaches the governors. That episode, shown in three sections, appears in the upper corners of a closely related tapestry in the Victoria and Albert Museum.[3]

Because the story of Esther offered rich opportunity for the representation of dramatic gesture and movement, as well as the display of sumptuous and exotic settings, costumes and props, it made an ideal subject for tapestry designers. European weavers produced *Esther* hangings from at least the fifteenth through the eighteenth century; the compositions constantly changed, reflecting successive styles in the art of painting. A number of *Esther* pieces have survived from the last quarter of the fifteenth century, among them the *Vashti Refusing Ahasuerus' Summons* in the Louvre[4] and the *Esther Inviting Ahasuerus to her Banquet* in the Minneapolis Institute of Arts.[5] Henry VIII's inventories list a number of late fifteenth- or early sixteenth-century *Esther* tapestries.[6] The most sumptuous and dramatic compositions ever designed

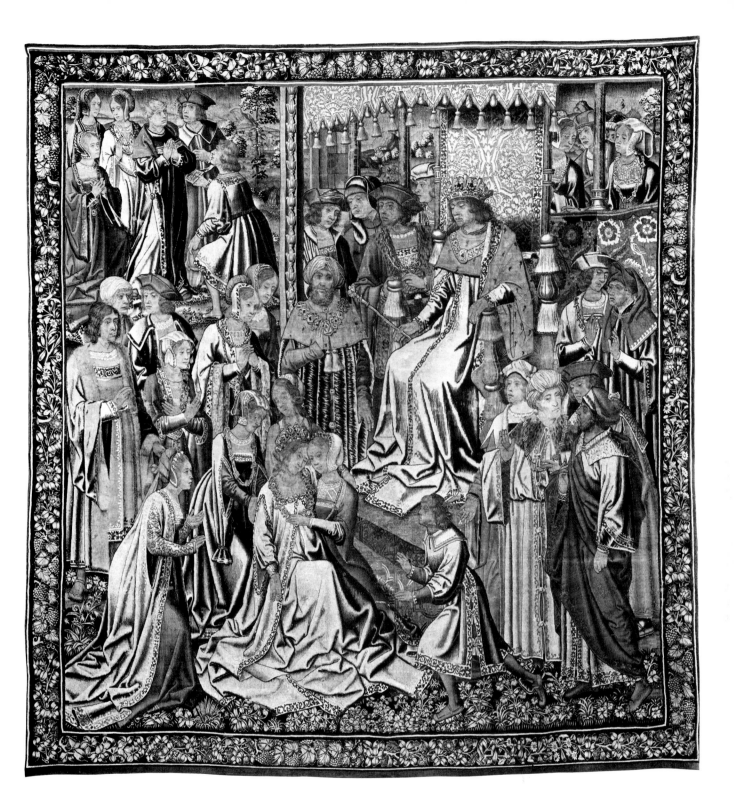

detail, 6

for the subject, in full-blown Baroque style, were created by Jean-François de Troy for the weavers at the Gobelins manufactory in Paris; the first examples were woven between 1738 and 1745.[7]

Numbers of Flemish *Story of Esther* tapestries, closely related to the Gardner piece, have survived from the first quarter of the sixteenth century. Perhaps the most closely related ones are the two pieces now preserved in the Victoria and Albert Museum, London.[8] One piece represents *Esther Hearing of Haman's Plot;* the other shows *Esther Approaching Ahasuerus.* The kinship to the Gardner *Esther* appears in the figure and facial types, the gestures, setting and border. While hundreds of Brussels tapestries that have survived from this period show generic similarities, the total effect of the London and Boston *Esther* pieces is so similar as to suggest the possibility that all three compositions belong to a single set of cartoons. Esther is shown swooning before Ahasuerus in the Boston piece and pleading before him in one of the London hangings; clearly, both subjects might have been treated in one set of cartoons. Digby expressed the opinion that the two London tapestries, which differ in height and certain other respects, come from two different sets of weavings rather than one.[9] The *Esther Hearing of Haman's Plot* is the same height as the Gardner tapestry and this, together with the other similarities, might suggest that these two came from the same set of hangings. However, the two are not executed with the same degree of finesse and in all likelihood belong to different suites.

1 Crick-Kuntziger, 1956, pp. 27, 28, pl. 16.

2 For another classic example of the type see Göbel, 1923, pl. 266.

3 Digby, p. 42 and pl. 50.

4 Göbel, 1923, pl. 222.

5 *Handbook of Decorative Arts and Sculpture,* Minneapolis Institute of Arts, 1931, pp. 83ff., illus. p. 84.

6 Thomson, 1930, pp. 240, 245 and *passim.* For some other Esther pieces of this period, see references in Digby, p. 43.

7 Fenaille, IV, pp. 1–39. See also J. Jobé, ed., *Le grand livre de la tapisserie,* Paris, 1965, illus. pp. 138, 139.

8 Digby, pp. 42, 43, pls. 50, 51.

9 *Ibid.,* p. 42.

Bibliography: *General Catalogue,* p. 195. Stout, pp. 168, 169, illus. Asselberghs, 1974, p. 12.
G. Wingfield Digby assisted by W. Hefford, *Victoria and Albert Museum: The Tapestry Collection, Medieval and Renaissance,* London, 1980, p. 43.

7

Trumpeters and *Ladies Conversing with a Gentleman* T19s3, T19s10

Flemish, probably Brussels, 1510–25
Wool warp (6 yarns per cm.), wool and silk wefts. *Trumpeters:* H. 6'9", W. 4'2" (2.06 x 1.27 m.);
Ladies Conversing with a Gentleman: H. 6'10", W. 4'1" (2.08 x 1.24 m.)
Believed to have been purchased through Charles Rafard, Paris, 1892 or 1893

Each hanging is a patchwork of fragments, perhaps from more than one origi-
nal tapestry. The fact that the two pieces correspond in size almost exactly
suggests that they were made up at the same time to fit two specific spaces.
None of the figures in the hanging showing ladies conversing with a gentle-
man is complete, and the upper part of the female figure standing in the
center foreground is missing entirely. The figures of the four trumpeters in
the other piece are comparatively whole, but the part of a female figure that
appears along the left edge has been patched in, as has the fragment with the
inscription at the bottom. The floral borders of both pieces have been added to
the composite fields and appear to be modern. Both hangings show extensive
repair by darning throughout.

The style of the compositions and the fine quality of the weaving suggest an
attribution to Brussels in the early sixteenth century.

One of the hangings shows three ladies and the lower part of a fourth stand-
ing in an outdoor space; the woman at the right turns, apparently in order
to speak to the man beside her. The other hanging shows four male figures,
three of them sounding trumpets while walking from right to left, and the
left side of a composite female figure standing just inside the left border.
The fragment inserted at the bottom of the field shows a scroll or banner flut-
tering against the ground of oak boughs; it bears an inscription that reads:
"...[illegible]...EIS...ET...IVSTI...ĀBVVT...[B, P or R]VT̄..." The
inscription is too fragmentary to be interpreted.

The figures in both hangings have been taken from one or more larger tapes-
tries whose subject or subjects probably involved the arrival of an important
personage. A hanging in the collection of Dario Boccara in 1972 illustrates part
of such a procession.[1] In that example, at the bottom of the composition a
group of trumpeters moves with a procession across the tapestry from right to
left. Immediately to the trumpeters' left stands a group of ladies and gentle-
men. All of these figures bear a generic resemblance to the figures shown in
the Gardner pieces. Boccara entitled his tapestry *Le Cortège* and attributed it to
Brussels, about 1515.[2]

1 *Tapisseries anciennes,* Musée des Beaux-Arts, Lyons, 1972, no. 3, illus.
2 *Ibid.*

Bibliography: *General Catalogue,* p. 162.

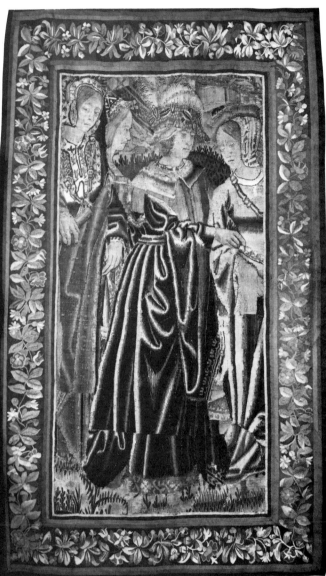

The Education of the Prince of Peace T30w13

Flemish, probably Tournai, 1525–50
No city or weaver's mark present
Wool warp (7 yarns per cm.), wool and silk wefts. H. 12' 7", W. 9' 8" (3.84 x 2.95 m.)
Purchased from the Galerie de l'Universelle, Paris, 1892

The tapestry has been cut along the top and left side. Very little of the field seems to be missing at the left but if, as seems likely, this is the tapestry that Henri Havard illustrated in the form of a line drawing in 1929, a wide band of weaving has been cut from the top of the field. According to Havard's illustration, the missing piece showed more of the wall behind the main figures and also an inscription of two lines, illegible in the illustration.[1] There are repairs by darning throughout and some patching in the upper right corner. While the inner guard or border—with its range of what appear to be stumps framing the right and bottom edges of the field—is original, the entire upper border and the outer guard on all four sides are replacements.

The scene takes place in a throne room. The king, labeled "le roy vertueu" by an inscription running across the hem of his tunic, is seated on his throne at the back of the room. Next to him, at his own left, sits "la pri[n]cesse de pays" (undoubtedly intended as paix).

A spotted hound wearing a jewelled collar sits on the apron of a dais, at the king's feet. Above, to the left, two musicians playing harp and lute stand in a gallery or corridor. Two other musicians, one playing a stringed instrument with a bow, the other playing a horn and a drum, appear in a corresponding window at the right. Two male courtiers stand under the window at the left. A male and a female courtier stand under the other; a mutilated inscription ending in ". . .ce" appears under the woman's left elbow.

The chief character in the action, labeled by an inscription above his head "pri[n]ce de pays" (to be read as paix) appears as a young boy in long skirts in the center foreground, standing amidst nine allegorical figures who are identified by inscriptions over their garments. In the background at the right, the female "pitie" is having a discussion with a man labeled "AMOVR" while "force" and "prudence" carry on another discussion in front of them. "Charite" places her hands on the Prince's back and shoulder, urging him forward toward "jonesse." Youth in turn introduces the boy to the kneeling figure of "concorde" behind whom the female "espera[n]ce" and the male "passetemp" stand, their left hands joined. The letters, I, H, N, R, and S, in various combinations, appear as part of the compartmented floor pattern.

Two coats of arms appear in the tapestry, one in each of the upper corners. The shield at the left bears the arms of de la Viefville; the one at the right bears de la Viefville impaling de Neufville. It has been suggested that the arms are those of François de la Viefville and his wife Anne de Neufville who lived in the region of Tournai in the late fifteenth and early sixteenth centuries.[2] It is not clear whether the coats of arms are part of the original fabric or whether they have been let into it at a later time. Since the men's costumes in the court scene could not antedate about 1525, the identification of the arms with this generation of the de la Viefville family is open to question.

Since the couplet that once appeared in a cartouche at the top of the tapestry is now missing, the meaning of the scene must be deduced from internal evidence, as well as from the evidence of related tapestries. The Prince of Peace is apparently an allegorical figure representing Jesus Christ; the Virtuous King, God the Father; and the Princess of Peace, either the Virgin Mary or the Christian Church. Through Charity and Youth the young Christ becomes acquainted with Concord, Pity, Love, Strength and Prudence, while Hope and the Passing of Time await him.

The existence of two closely related hangings confirms the assumption that the Education of the Prince of Peace is one in a series of hangings designed to illustrate the theme of Christian morality. A fragmentary tapestry representing the Birth of the Prince of Peace precedes this one in the suite; it is preserved in the Denver Art Museum.[3] In this hanging, "leaulte" (Loyauté) hands the

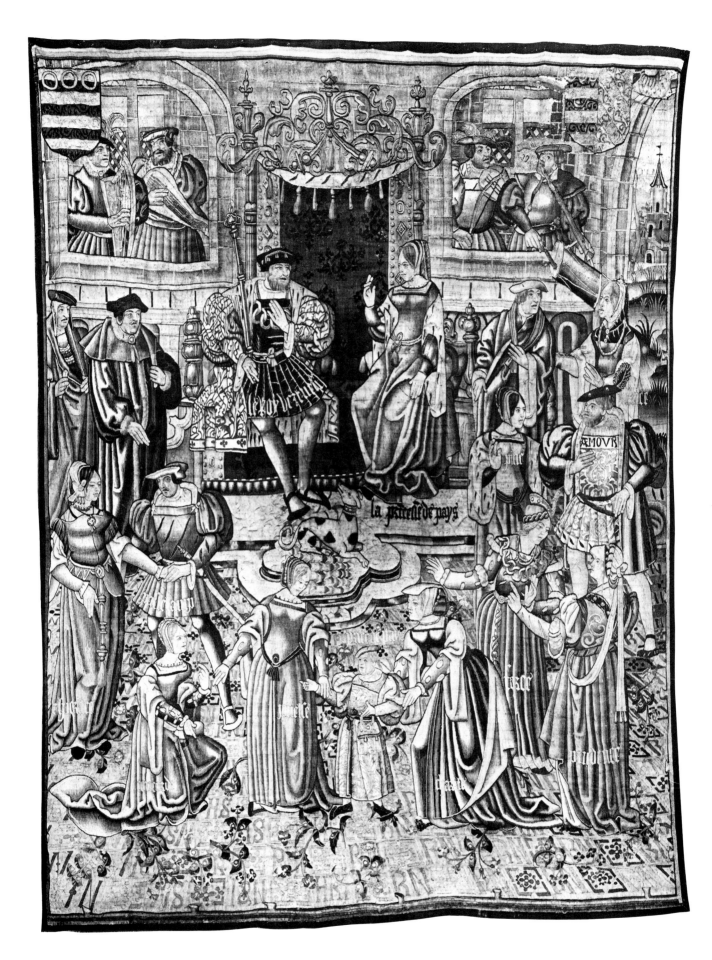

detail, 8

detail, 8

new-born infant *"prince de paiy"* to his mother in bed, labeled *"paix."*[4] Another tapestry, in the collection of M. Joseph Philippart, Tournai, has as its subject the *Rape of Concord;*[5] it also shows the two coats of arms that appear in the Gardner piece. Regardless of whether the shields were part of the original fabrics or added to both hangings at a later time, Asselberghs rightly observed that the presence of the armorial bearings in both of these tapestries indicates that they once belonged together in a single suite of hangings.[6] The sermon, morality play or other literary work from which the iconography of the tapestry series was taken has not yet been identified.

1 H. Havard, *La tapisserie,* Paris, 1929, fig. 63.

2 See Asselberghs, 1974, p. 12 and *Tapisseries d'occident,* Halles aux Draps, Tournai, 1958, no. 16.

3 *Guide to the Collection,* Denver Art Museum, 1971, p. 29, illus.

4 See Havard, p. 129, fig. 62 for a contemporary tapestry in which virtually the same composition is used for a *Death of the Virgin.*

5 *Tapisseries d'occident,* no. 16.

6 Asselberghs, 1974, p. 12.

Bibliography: *General Catalogue,* p. 272. Asselberghs, 1974, p. 12, fig. 2.

Five Episodes from the *Story of Cyrus the Great*

Flemish, Brussels, 1535–50

Purchased from Mrs. Charles M. Ffoulke, 1905–06; formerly in the Barberini collection, Rome

Two of the tapestries (c, e) show the same weaver's mark, but one of them is reversed. Another (a) shows what appears to be a mutilated version of the same mark in a heavily repaired area; the fourth tapestry with a mark (b) shows the mark of another, unidentified weaver. When Asselberghs referred to these hangings, the identical mark on two of the tapestries (c, e) was believed to be that of Marc Crétif.[1] In a later study of the same mark, Guy Delmarcel demonstrated that it refers not to Marc Crétif (who was a dealer in tapestries rather than a manufacturer) but to Jan der Moyen, an important tapestry weaver in Brussels.[2] Asselberghs dated the tapestries ca. 1535, which is correct both for the style of the compositions and of the fashionable costumes represented in them;[3] however, the hangings would have remained in style at least until the middle years of the century.

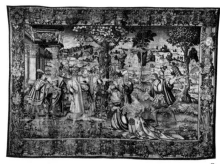

9a

There is some confusion as to whether these pieces, together with a duplicate (of d) passed from the Barberini collection, Rome, through the de Somzée collection before entering the Ffoulke collection.[4]

When Mrs. Gardner bought these five pieces they still were titled the *Archduke Albert and Archduchess Isabella* series, a misconception that was corrected in the catalogue of the Ffoulke collection.[5] Ffoulke stated that the old linings on the tapestries showed the monogram of Cardinal Francesco Barberini and the word CIRO which he regarded as being indecipherable. *Ciro* is simply the Italian for Cyrus. In the absence of the original linings, one can only speculate about the mark referred to as a monogram. What appear to be monograms of Francesco Barberini and of his brother, Antonio, have been preserved on part of an early linen lining attached to one of the *Story of Coriolanus* tapestries that passed from the Barberini to the Ffoulke collection and ultimately to the Brooklyn Museum.[6] The inventory of Cardinal Barberini's personal effects taken in Rome in December, 1608, lists "9 *Pezzi Tappezzeria – storia di Ciro*," and the inventory of Cardinal Carlo Barberini's inventory, taken 1692–1704, lists six pieces of the "*Historia di Ciro.*"[7]

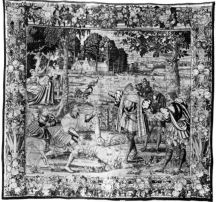

9b

All five tapestries show considerable amounts of repair by darning, but the drawing has not been seriously affected and the images appear today essentially as they were designed.

The five episodes represented in the tapestries were drawn from the text of Herodotus' *History* (book i) in which he tells the story of Cyrus the Great, founder of the Persian Empire. The first tapestry shows Astyages, King of the Medes, standing before his palace, attended by two courtiers and a boy. His daughter Mandane, holding her child Cyrus, kneels before him while her husband, the Persian Cambyses, stands beyond Mandane's maid. Astyages addresses his kinsman Harpagos who stands behind Mandane and heeds his king's command, which is to take the infant Cyrus, who Astyages believes will one day usurp his throne, and put him to death. In the middle distance at the left a companion walking with Harpagos gestures toward two figures on the other side of the scene; these represent Harpagos at a later moment in the story and the shepherd to whom he gives the infant Cyrus with instructions to expose him to the beasts on a desolate mountain and so let him die.

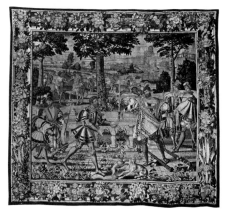

9c

The second tapestry in the series shows Cyrus, now grown to manhood, standing to the right of center in a wooded landscape, attended by two richly dressed men. Two messengers that Harpagos has sent to him approach from the left. The forward one holds out to Cyrus a dead hare inside of which the disgruntled Harpagos has concealed a message informing Cyrus that he has prepared the Medes to revolt against Astyages and to support Cyrus when he comes with his Persian forces to unseat Astyages. Two couples appear among the trees in the middle distance at the left and watch a hunt with hounds that is taking place in the distance, near a great house.

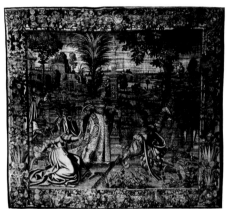

9d

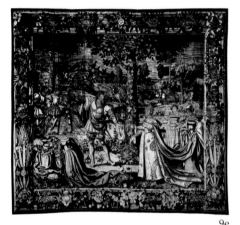
9e

It is not clear whether the third tapestry shows Astyages or Cyrus appointing Harpagos commander of the army. Both the elder Medean (Herodotus, *History,* book i, chapter 127) and the young Persian (chapter 162) made this appointment at different times in the course of Cyrus' battle to usurp the Medean throne. Harpagos, attended by a man and a boy, approaches from the left; either Astyages or Cyrus, attended by two courtiers at the right, extends his right arm toward Harpagos, handing him a sword. Cavalrymen ride in the far distance at the left beyond a turbaned horseman who greets another entering from the right with a mounted retinue.

The fourth tapestry shows Tomyris, Queen of the Massagetai, receiving a messenger on the steps of her palace. Three ladies-in-waiting attend her at the left; at the right stand the messenger's two men and a horse. Cyrus, now king, had sent the men to ask for her hand. Tomyris, understanding that the Medean king meant to win her kingdom rather than herself, rejects his proposal. Various standing or mounted figures appear in the middle and far distance. The towers of a city rise against the low horizon.

In the fifth tapestry Queen Tomyris, walking in her garden and attended by four women, learns from a messenger that her son, Spargapises, has been taken captive by Cyrus' forces. The young man, who appears in the middle distance at the left, restrained by two others, had overindulged with his soldiers in food and wine after they slew part of Cyrus' army. Soon afterward the Persians launched a counterattack and took Spargapises prisoner. One or both of the battles between the Massagetai and the Medeans rages in the far distance.

Each of the tapestries shows a wide floral band bordering the scene. Bunches and bouquets of fruits and flowers punctuate the course of a thick laurel-covered stalk set against a slightly concave frame bordered with simple straight mouldings.

The *Story of Cyrus* was a favorite one in the history of tapestry art because it affords the opportunity to exploit the visual appeal of rich costumes and settings, to tell its story in terms of pageantry and simple gesture, and certainly also because of its air of political intrigue. At the time this series was woven, European weavers were using at least two different sets of compositions whose authors remain anonymous. The Gardner series represents one of these. Duplicate or near-duplicate weavings exist of the first four subjects but not of the fifth. In 1930 French and Company owned duplicate weavings of the second and fourth pieces and a fragmentary example of the first. The complete pieces appear to be the same as those sold from the collection of Mrs. Renée Maldow, New York.[8] Another duplicate of the fourth piece, with the subject of Queen Tomyris refusing Cyrus' proposal of marriage, was in the possession of Mr. and Mrs. Gordon Rentschler, New York, who gave it in 1948 to the Princeton University Library. This is believed to be the duplicate piece referred to in 1913 in the Ffoulke collection, having come from the Barberini collection.[9] A fragment of another duplicate of the second subject, the delivery of the hare containing a message to Cyrus, showed the right half of the composition, without a border, and was in the collection of Frank Gair Macomber, Boston.[10] A near duplicate of the third weaving in the Gardner series, with the subject of the commissioning of Harpagos, was in the possession of Dario Boccara, Paris, in 1972.[11] If there were more than five subjects in the original series of compositions, no weavings made from them appear to have survived.

We cannot be sure these five pieces were among the nine or six *Cyrus* tapestries listed in Barberini inventories of 1608 and 1692–1704 (see note 7 above) or that those nine or six hangings were woven after this set of compositions. A

different suite of sixteenth-century compositions illustrating the *Story of Cyrus* has survived in a number of woven editions. There were at least ten subjects in this series, examples of which are preserved in the Royal Collection at Madrid.[12] In the same collection there are yet other weavings after the same cartoons but with different borders. A series of four pieces, with a different border but with fields after the same series of compositions, that formerly belonged to the Countess of Clanwilliam, was sold in 1979.[13] Two other pieces woven after these cartoons somewhat later, about 1600, were in the possession of Mr. and Mrs. Daniel C. Jackling who gave them to the M. H. de Young Museum, San Francisco, and there are yet others elsewhere.[14]

1 Asselberghs, 1974, p. 12.

2 G. Delmarcel, review of "Jules Romain: l'histoire de Scipion. Tapisseries et dessins," *Bulletin Monumental*, CXXXVI, 1978, p. 369.

3 Asselberghs, 1974, p. 12.

4 Ffoulke, pp. 89, 90.

5 *Ibid.*, p. 88, n.

6 A.S. Cavallo, "The History of Coriolanus as Represented in Tapestries," *The Brooklyn Museum Bulletin*, XVII, 1955, pp. 18ff.

7 M.A. Lavin, *Seventeenth Century Barberini Documents and Inventories of Art*, New York, 1975, pp. 64, 427, 428.

8 Christie, Manson and Woods, Ltd., London, March 19, 1964, no. 152, incorrectly titled *Hunts of Maximilian*.

9 Ffoulke, pp. 89, 90.

10 P. Ackerman, *A Catalogue of the Tapestries in the Collection of Frank Gair Macomber*, n.d., no. 9, illus. and captioned *Hunting Scene*.

11 *Tapisseries anciennes*, no. 5, p. 14.

12 Valencia de Don Juan, 1903, pp. 79, 80, nos. 117–26, illus.

13 Christie, Manson and Woods, Ltd., London, November 8, 1979, no. 150, illus.

14 A.G. Bennett, *Five Centuries of Tapestries from the Fine Arts Museums of San Francisco*, 1976, pp. 139–43, illus.

Bibliography: Ffoulke, pp. 88–90, illus. opp. p. 90 (*Queen Tomyris Receives Cyrus' Proposal of Marriage from a Messenger*). E.S. Siple, "Some Recently Identified Tapestries in the Gardner Museum in Boston," *Burlington Magazine*, LVII, 1930, pp. 241, 242, pl. II (*King Astyages Commands Harpagos to Take the Infant Cyrus and Slay Him* and *King Astyages Places Harpagos in Command of his Army*). General Catalogue, pp. 150–52. Sotheby & Co., London, May 26, 1967, p. 14. Stout, pp. 140, 141, illus. (*King Astyages Commands Harpagos to Take the Infant Cyrus and Slay Him*). *Tapisseries anciennes*, Musée des Beaux-Arts, Lyons, 1972, p. 14. Asselberghs, 1974, p. 12. Hadley, pp. 176, 177, illus. (*Queen Tomyris Learns that her Son, Spargapises, Has Been Taken Captive by Cyrus*).

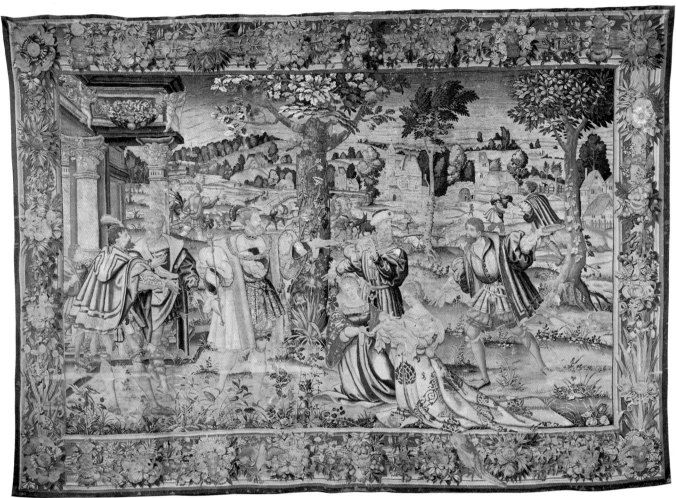

9a

King Astyages Commands Harpagos
to Take the Infant Cyrus and Slay

Him T19w2–s

Brussels mark at the left of the bottom outer
guard; Jan der Moyen's (?) mark at the bottom
of the right outer guard

Wool warp (6 yarns per cm.), wool and silk
wefts. H. 13′9″, W. 19′ 8½″ (4.19 x 6.01 m.)

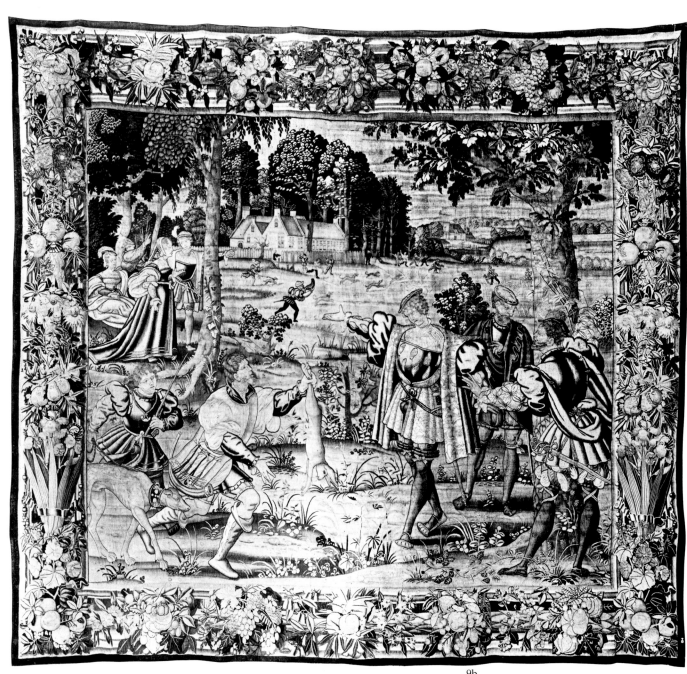

9b
A Messenger from Harpagos Brings Cyrus a Letter Concealed in a Hare T19e4–s

No city mark present (the bottom outer guard is modern); unidentified weaver's mark at the lower end of the right outer guard

Wool warp (6 yarns per cm.), wool and silk wefts. H. 13'11", W. 15' (4.24 x 4.57 m.)

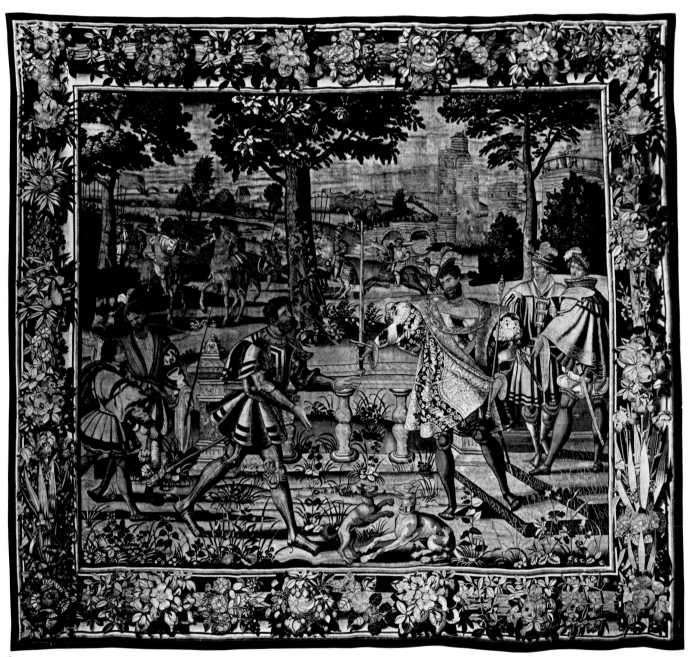

9c

**King Astyages Places Harpagos in
Command of his Army** T19w18–s

Brussels mark at the left end of the bottom
outer guard; Jan der Moyen's mark at the lower
end of the right outer guard

Wool warp (5 yarns per cm.), wool and silk
wefts. H. 14′1″, W. 15′3″ (4.26 x 4.65 m.)

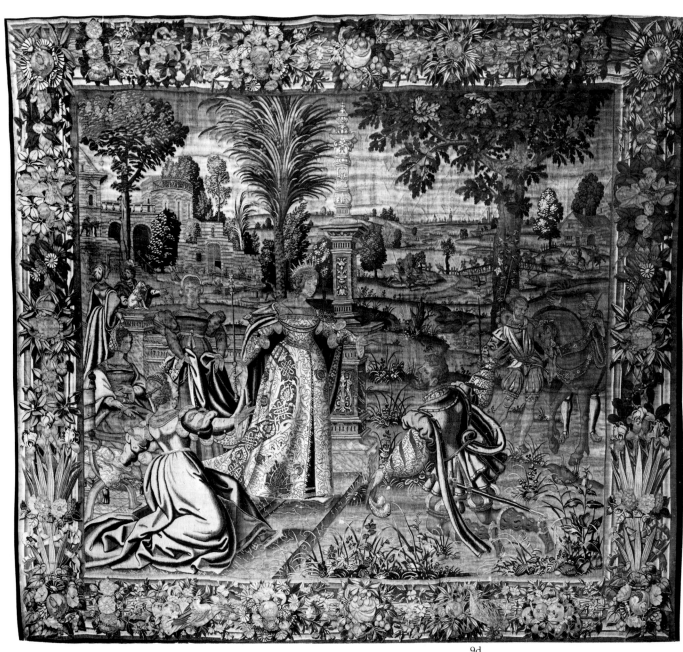

9d
***Queen Tomyris Receives Cyrus' Proposal
of Marriage from a Messenger*** T19e57–s

No city mark present (the bottom outer guard
is modern); no weaver's mark present

Wool warp (6 yarns per cm.), wool and silk
wefts. H. 14'2", W. 15'6" (4.32 x 4.73 m.)

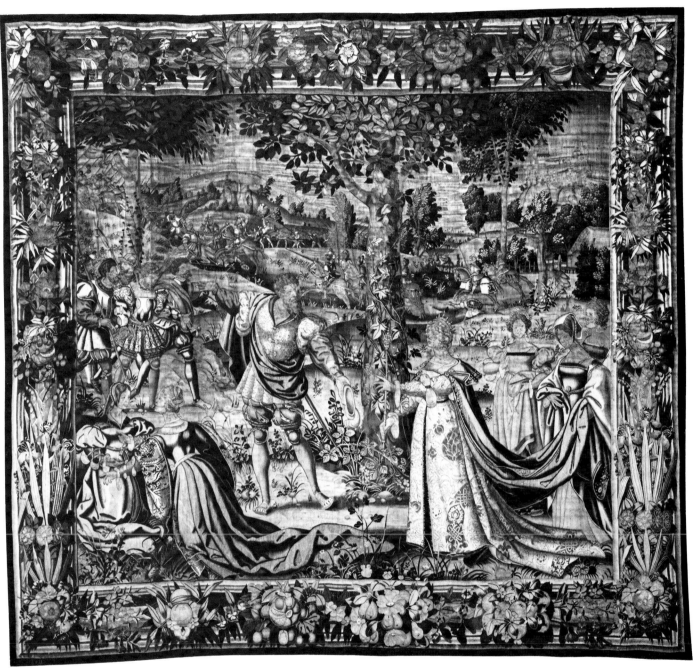

9e
***Queen Tomyris Learns that her Son,
Spargapises, Has Been Taken Captive
by Cyrus*** T19e36–s

Brussels mark at the left end of the bottom
outer guard; Jan der Moyen's mark at the bot-
tom of the right outer guard

Wool warp (6 yarns per cm.), wool and silk
wefts. H. 13′4¾″, W. 15′4¼″ (4.02 x 4.61 m.)

10

Spring T22s3

Flemish, Brussels, woven by Andreas Mattens (?), 1535–50
Brussels mark at the left end of the bottom outer guard; Andreas Mattens' (?) mark near the bottom of the right outer guard
Wool warp (7 yarns per cm.), wool and silk wefts. H. 13'5", W. 7'4" (4.09 x 2.24 m.)
Purchased from Mrs. Charles M. Ffoulke, 1906

The weaver's mark has been attributed to the Brussels weaver Andreas Mattens.[1]

The hanging shows wear and many repairs by darning, but the drawing has not been significantly altered. The border and outer guards appear to be intact.

The field shows figures and animals engaged in occupations or pastimes associated with spring in the country. In the foreground a shepherd, shepherdess and second young man look at a pair of lovers sitting and embracing in the middle distance at the left. A young boy climbs to the top of the tree around which the shepherds peek; he is about to pick cherries from the plentiful crop growing there. Between the interlopers and the lovers, there is a boy, and beyond the lovers a man, both absorbed in the work of catching birds in traps. Beyond this, a shepherd leads his flock along a path at the left, while a shepherd and shepherdess stand close together and converse at the right. The distant landscape is dotted with buildings, bridges and trees. In the extreme foreground an antlered stag is resting on the ground and a pair of rabbits is mating.

Many series of tapestries representing characteristic activities of the months or seasons were designed during the sixteenth century. Among the most frequently woven and best known are the so-called *Months of Lucas*,[2] the *Hunts of Maximilian*[3] and the *Medallion Months*.[4] In addition to these, there were suites of hangings devoted to subjects celebrating pastoral life and some of these also suggest seasonal occupations.[5] These prototypes, woven mostly in Brussels, inspired copies and versions that were produced with great popular success at the Gobelins during the late seventeenth and early eighteenth century and also in England.[6]

Neither the prototypes nor the versions are known to show the composition used for this tapestry. In the same way, the border design, showing bunches of fruits and flowers punctuating the course of a thick stock covered with laurel leaves, suggests but does not duplicate numbers of borders enframing other Brussels tapestries of this period, including the *Story of Cyrus* in this Museum (No. 9). Just as the field composition differs in many details from others so closely related to it, so the border pattern shows the particular and unusual feature of ornamental birds perched among the flora in the side borders and a weasel or squirrel-like quadruped crawling in the center of the top and bottom borders. A tapestry said to be a "replica" of this one was sold from French and Company, New York, in or after 1932; its present location is unknown.

1 Göbel, 1923, p. 7 of appendix of marks.
2 *Ibid.*, pl. 61.
3 S. Schneebalg-Perelman, *Les chasses de Maximilien*, Brussels, 1982.
4 Göbel, 1923, pls. 144–47.
5 See particularly a series in Vienna: *ibid.*, pl. 303.
6 See Fenaille, II, pp. 299ff., 337ff., illus.; H.C. Marillier, *English Tapestries of the Eighteenth Century*, London, 1930, pp. 61ff., pls. 21–25.

Bibliography: *General Catalogue*, p. 192.

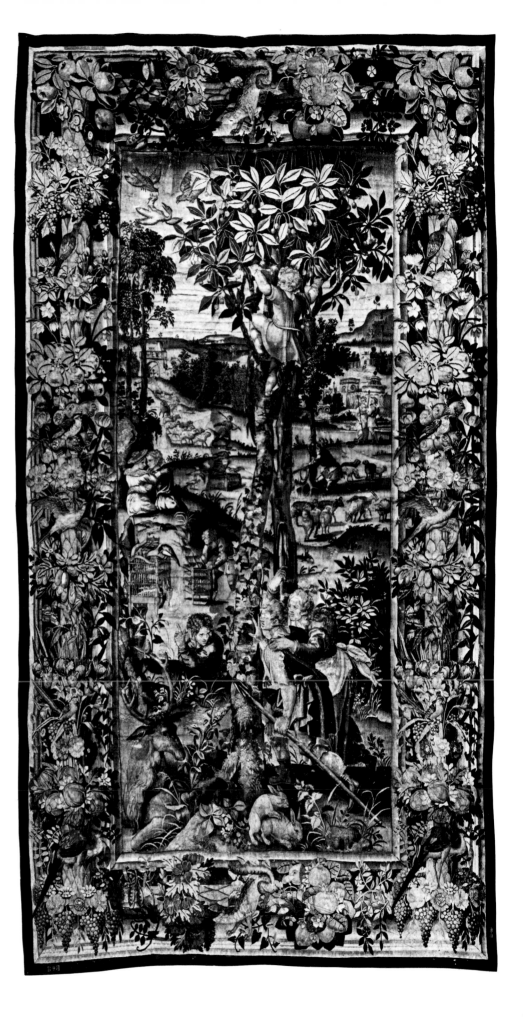

11
Five Episodes from the *Story of Abraham*

Flemish, Brussels, 1550–1600
Purchased from Mrs. Charles M. Ffoulke, 1905–06; formerly in the Barberini collection, Rome

The weaver's mark (which, because of distortion through repair, appears in three seemingly different forms in this set) has been attributed to Jan van Tieghem,[1] an attribution that Asselberghs repeated in connection with this suite of hangings.[2] Erik Duverger suggested that the mark may be that of Frans Geubels who may have been the only weaver at that time to use this border design.[3] Asselberghs suggested a date in the third quarter of the sixteenth century for this series;[4] the dating is valid on stylistic grounds as well as on the evidence of a curious detail of costume found in the first tapestry. In that scene, the upper half of Abimelech's coat is drawn in such a way as to reflect the shape of the peascod doublet (peak over the stomach) that was the height of fashion among European gentlemen from a little after 1550 until late in the century. Thus, this series could be dated equally well toward the end of the century.

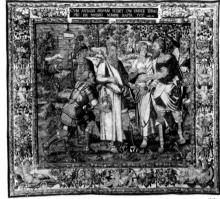

11a

Although all five hangings show appreciable amounts of repair by darning, the drawing of the figures has not been impaired, nor have the inscriptions been altered. The most intrusive replacements appear in the region of Abraham's and Ishmael's faces and arms in the second piece, the highlights in many of the draperies in the fourth hanging, and the faces of the servant, his two attendants and Isaac in the last tapestry.

The five episodes have been drawn from the *Book of Genesis.* The first tapestry illustrates the moment when Abimelech, King of Gerar, having discovered that Sarah is Abraham's wife, restores her to her husband along with sheep, oxen, servants and silver and an invitation to live where they choose in his land (*Genesis* 20:1–16). The group of figures in the far distance, in the space between the heads of Abimelech and Sarah, probably represents the same characters at an earlier moment in the story when Abimelech, believing Sarah to be Abraham's sister, took her as his wife. The group in the distance at the extreme left probably represents shepherds and cowherds who are driving the livestock that Abimelech will present to Abraham. The cartouche in the center of the upper border reads as follows: *CUM AUSTRALES ABRAHAM PETERET CUM CONIUGE TERRAS / HEC* (for *HAEC) IPSI INVERSO NOMINE RAPTA FUIT. GENE[SIS].* 20 (While Abraham sought after southern lands with his wife, she, with her identity changed, was taken away).

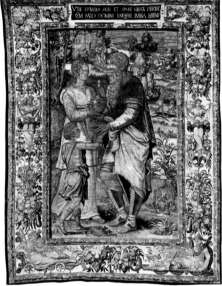

11b

The second tapestry shows Abraham sending Hagar and their son Ishmael away from home and giving them a loaf of bread and a bottle of water for their journey (*Genesis* 21:14). Between them, in the distance, three figures appear near the door of a great house; the man and woman farthest from the door probably represent Sarah urging Abraham to dismiss Hagar and her son. The two figures seem to be watching a pair of young men engaged in hand-to-hand combat in the distance toward the right; these may be intended to illustrate Sarah's warning that Abraham's two sons, Isaac and Ishmael, would argue over their succession, a concern attendant on Isaac's later birth but avoided by Abraham's decision to dismiss Ishmael, his son by Hagar (*Genesis* 21:9–18). The inscription in the border reads as follows: *UTRE HUMEROS AGAR ET PANE ONERATA RECEDIT / CUM NATO DOMINI LINQUERE IUSSA LAREM* (Ordered to leave home Hagar, laden with bread and a bottle on her shoulders, departs with the master's son).

The third tapestry illustrates the story of the encounter between Rebecca and Abraham's servant, who had been sent to the city of Nahor in Mesopotamia to find a wife for Isaac (*Genesis* 24:3–25). At the left, Rebecca, having given the servant a pitcher of water, seems to be speaking to the man, perhaps identifying herself in answer to his questions, as one of his men draws forth a bracelet for her. In the far distance an attendant approaches with two camels; this is probably Abraham's servant at an earlier moment in the story, when he came to the well with ten of his master's camels. The inscription in the upper border

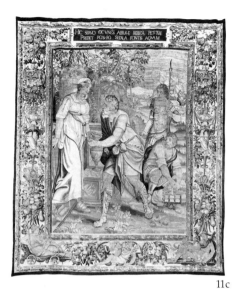

11c

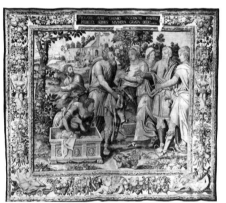

11d

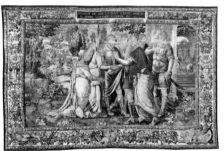

11e

reads as follows: *HIC SERVO OCCUNĒS* (for *OCCURRENS*) *ABRAE REBECCA PETITAM / PREBET POTURO SEDULA FONTIS AQUAM* (Here the solicitous Rebecca, going to meet him, offers Abraham's thirsty servant the water he requested from the fountain).

The fourth hanging illustrates the moment when Abraham's servant, having been assured that Rebecca's father and brother would allow her to leave with him to become Isaac's wife, gives jewels and costly raiment to Rebecca and members of her family (*Genesis* 24:49–53). In the far distance at the left Rebecca's brother Laban and others of her household give Abraham's servant and his attendants water for washing their feet. The inscription above reads as follows: *PROLATIS AURI GREMIO FULGENTIS INAURES / REBECCE SERVUS MUNERA GRATA DEDIT. GEN[ESIS].* 24 (Having placed on her lap earrings of glittering gold, the servant gives Rebecca an agreeable gift).

The fifth tapestry shows Abraham greeting Rebecca, his servant and their attendants, while Isaac, dressed in armor and standing at the right, looks at Rebecca with admiration. The party escorting Rebecca to her new home appears in the distant landscape at the left, while the wedding feast takes place in a distant hall at the right. The subject is drawn from *Genesis* 24:61–67; but in the tapestry it is Abraham, and not Isaac, who greets Rebecca. The inscription in the border reads as follows: *DUCITUR HIC REBECCA DOMŪ COMITĀTE MINISTRO / IN DOMINI THALAMOS EXCIPIENDA SUI GENE-SIS* 24 (Here Rebecca is led courteously homeward by the servant to be received into her master's chamber).

All five tapestries show borders with fruits, flowers and vegetables arranged as festoons in the upper sections and as bouquets in urns or strapwork baskets in the other three segments. Those in the two side borders are elements in slender girandole-like stands involving standing female figures at the centers; a semi-recumbent female figure nursing a child obscures the base of the stand at the left, balanced by a semi-recumbent male figure accompanied by a child holding grapes at the right. Except in the second tapestry, which is considerably narrower than the others, another semi-recumbent male figure appears in the center of the lower border.

These five compositions belong to a series of tapestry designs that include at least two more subjects, the *Separation of Abraham and Lot*[5] and the *Circumcision of Isaac.*[6] Another sixteenth-century tapestry suite illustrating the *Story of Abraham* is believed to have been designed by Bernard van Orley and shows some of the subjects treated in the Gardner series but in grander, more histrionic style. Hangings woven after these cartoons exist today in many collections, but the most splendid examples, comprising two sets of ten tapestries each, woven by a number of fine Brussels weavers including Pieter van Aelst and Willem de Pannemaker and incorporating gilt and silver as well as wool and silk wefts, are to be found in the state collections at Vienna.[7] A third set after the van Orley designs, comprising seven pieces, also incorporating metal yarns, is now in the Royal Collection at Madrid.[8] A fourth series, of ten pieces, is preserved at Hampton Court Palace, Richmond, where it has remained since the time of Henry VIII in whose inventory of 1548 it is listed.[9]

The simpler compositions used for the Gardner pieces are less frequently encountered today. Two of them, the *Abraham Dismissing Hagar and Ishmael* and the *Rebecca Giving Water to Abraham's Servant* (in reverse) accompany the *Separation of Abraham and Lot* cited above, in Munich.[10] According to von Schneider, the Hagar tapestry shows a fragmentary weaver's mark which seems to be that of Jan van Tieghem, the putative weaver of the Gardner series.[11] The *Rebecca Giving Water* composition, again reversed, was sold with the *Circumcision* cited above from the de Somzée collection in 1901.[12]

1 Göbel, 1923, p. 4 of appendix of marks.

2 Asselberghs, 1974, p. 13.

3 Duverger, *Colloquium,* 1969, pp. 92, 110.

4 Asselberghs, 1974, p. 13.

5 One example known, in the Bayerisches Nationalmuseum, Munich: A. von Schneider, "Bemerkungen zu einigen niederländischen Wirkteppischen des bayerischen Nationalmuseums," *Münchner Jahrbuch der bildenden Kunst,* I, 1924, pl. 6.

6 One example known, formerly in the de Somzée collection, Brussels: L. de Somzée Sale, Brussels, May 20–25, 1901, no. 542, pl. XXXV; later in the Ffoulke collection, see Ffoulke, pp. 73, 74.

7 E. Ritter von Birk, "Inventar der im Besitze des allerhöchsten Kaiserhauses befindlichen niederländer Tapeten und Gobelins," *Jahrbuch der kunsthistorischen Sammlungen des allerhöchsten Kaiserhauses,* I, 1883, pp. 216, 217, pls. II, 1–10; II, 1884, pp. 175, 176. The *Hagar and Ishmael* tapestry in this second series was woven after a different cartoon from that used for the first series.

8 Valencia de Don Juan, 1903, II, pls. 75–81.

9 H.C. Marillier, *The Tapestries at Hampton Court Palace,* London, 1962, pp. 7–11, pls. 1–10.

10 von Schneider, pls. 7, 9.

11 *Ibid.,* pp. 61ff.

12 de Somzée Sale, no. 543, pl. XXXIV; Ffoulke, pp. 73, 74.

Bibliography: *General Catalogue,* pp. 157–60. Duverger, *Colloquium,* 1969, p. 110. Stout, pp. 142, 143, illus. *(Abimelech Restoring Sarah to Abraham).* Asselberghs, 1974, p. 13.

Within the tapestry, the inscription reads:

CVM AVSTRALES ABRAAM PETERET CVM CONIVGE TERRAS
HEC IPSI INVERSO NOMINE RAPTA FVIT · GENE · 20

11a
***Abimelech Restores Sarah to
Abraham*** T19w56–s

Brussels mark at the left end of the bottom
outer guard; Jan van Tieghem's (?) mark at the
bottom of the right outer guard

Wool warp (7 yarns per cm.), wool and silk
wefts. H. 11'4", W. 13' (3.45 x 3.96 m.)

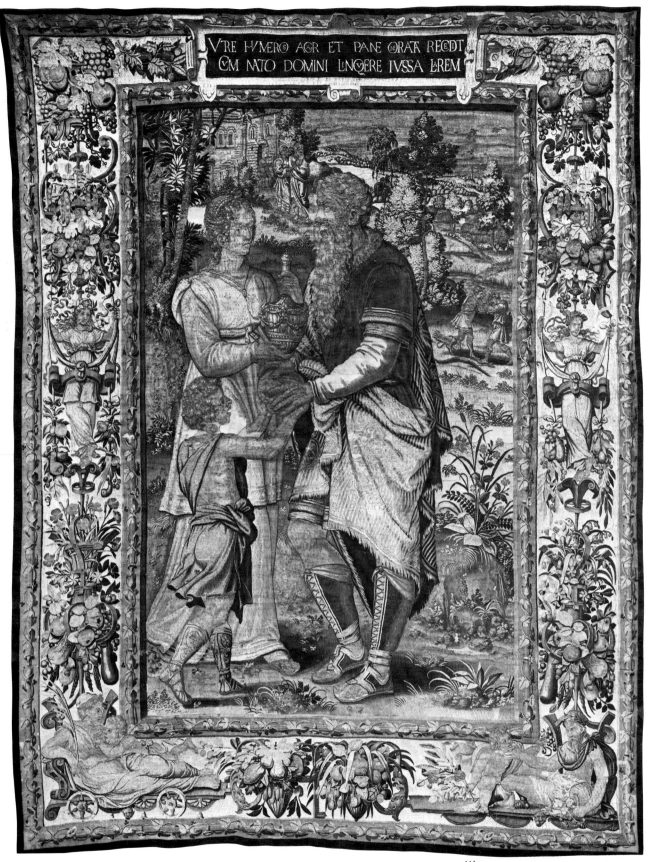

11b
***Abraham Dismisses Hagar and
Ishmael*** T19w26–s
No city or weaver's mark present (bottom outer
guard may not be original)
Wool warp (8 yarns per cm.), wool and silk
wefts. H. 11'3", W. 8'9" (3.43 x 2.67 m.)

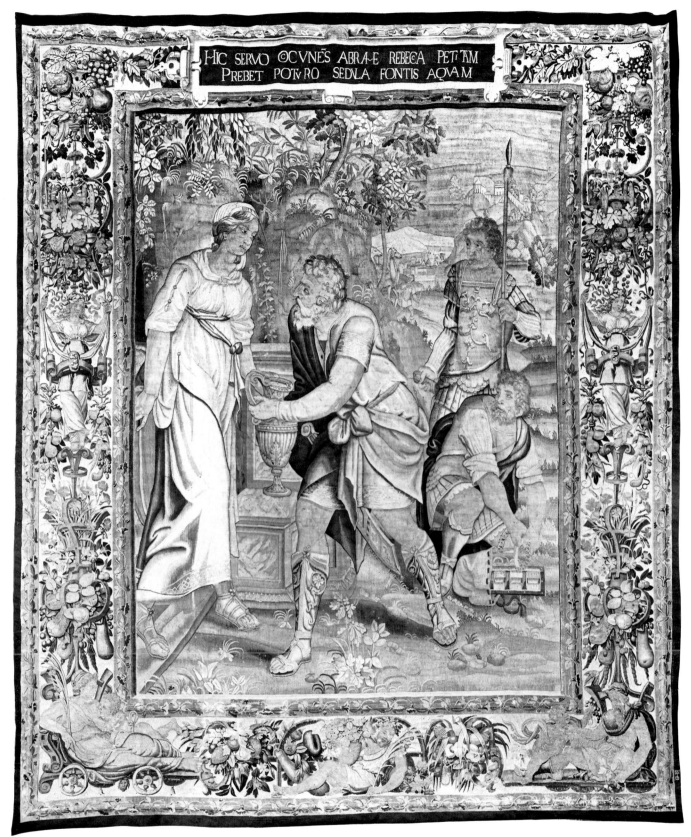

HIC SERVO ©CVNES ABRA·E REBECA PET·AM
PREBET POTVRO SEDLA FONTIS AQVAM

11c
Rebecca Gives Water to Abraham's
Servant T19w48–s

No city mark present (bottom outer guard is
not original); Jan van Tieghem's (?) mark (dis-
torted by repair) in the lower end of the right
outer guard

Wool warp (6 yarns per cm.), wool and silk
wefts. H. 11′6½″, W. 9′9½″ (3.43 x 2.98 m.)

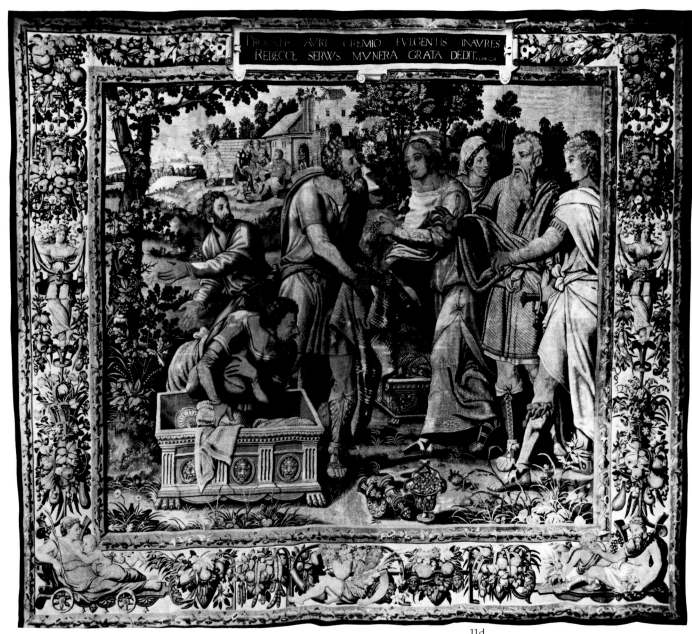

11d
Abraham's Servant Presents Jewels and Raiment to Rebecca T19e52–s

Brussels mark at the left end of the bottom outer guard; Jan van Tieghem's (?) mark (distorted by repair) at the bottom of the right outer guard

Wool warp (7 yarns per cm.), wool and silk wefts. H. 11′4¼″, W. 12′10¼″ (3.47 x 3.92 m.)

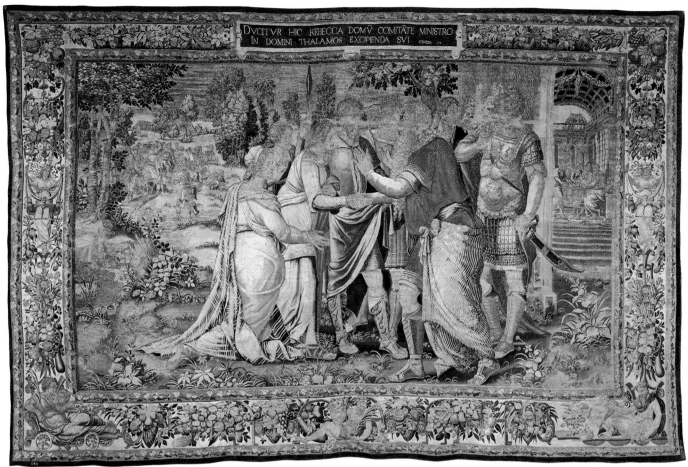

11e

Abraham Receives Rebecca T19n21–s

Brussels mark at the left end of the bottom
outer guard; Jan van Tieghem's (?) mark (dis-
torted by repair) at the bottom of the right
outer guard

Wool warp (6 yarns per cm.), wool and silk
wefts. H. 11'4", W. 17'9" (3.46 x 5.41 m.)

12
Fragment from the Side Border of a Tapestry T18s1

Flemish, probably Brussels, 1550–1600
Brussels mark at the left center of the lower outer guard; no weaver's mark
Wool warp (8 yarns per cm.), wool and silk wefts. H. 4'5", W. 1'6½" (1.34 x .46 m.)
Provenance unknown

The left outer guard band is original; the bands at the top and bottom seem to be old but from other parts of this or another hanging. The band at the right is a strip of modern tape. There are small areas of repair by darning throughout the field and left outer guard.

The fragment has fruits, scrolls, paired cherubs holding birds, paired herms (one holding a shovel, the other a rake) and, at the bottom, part of a medallion containing a landscape view. These motifs are all arranged symmetrically on the vertical axis. An inner band at the left contains blossoms, laurel leaves and berries bound by a spiraling ribbon.

Since the guard band containing the Brussels mark may not have been taken from the same larger hanging, it cannot be used as evidence of an origin in that city. However, the character of the design and execution of this fragment suggests that the tapestry from which it was taken was, indeed, woven in Brussels. Borders showing related symmetrical compositions, based on the exquisite grotesque borders decorating the finest Brussels tapestries of the middle and second half of the sixteenth century[1] appear on a number of Brussels pieces dating from the second half of the century or the early years of the seventeenth century.[2]

1 See, for example, Göbel, 1923, pls. 278, 279.
2 *Ibid.*, pl. 385; Crick-Kuntziger, 1956, pls. 52, 53.

Bibliography: *General Catalogue,* p. 147.

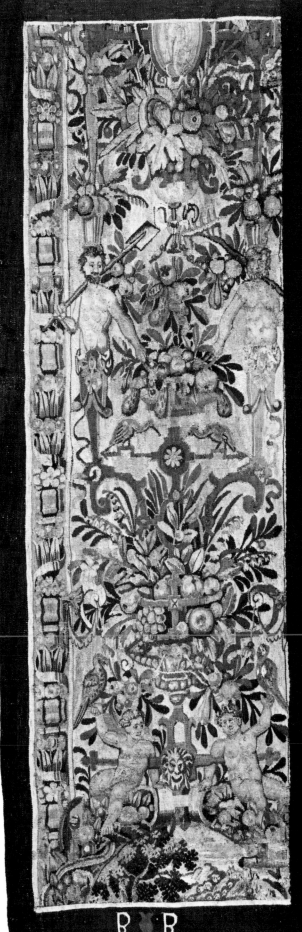

13
The Warriors' Consultation T22w1

Flemish, probably Brussels, 1575–1625
No city or weaver's mark present
Wool warp (5 yarns per cm.), wool and silk wefts. H. 9'6", W. 8'6" (2.9 x 2.59 m.)
Provenance unknown

The entire surface shows considerable wear and repair by darning; the drawing is consequently blurred or distorted in many places. The original outer guard is missing and has been replaced on all sides by strips of modern weaving.

A bearded man in armor suggesting that of ancient Rome stands in the foreground at the right. He holds a spear in his right hand. With his left hand he gestures toward the right while turning his head in the other direction to converse with a man in armor who stands at the left. Behind these men, in a clearing in a wooded landscape, stand five other warriors who are engaged in conversations.

The border shows bunches of fruits, flowers and vegetables forming a dense background against which appear six seated allegorical figures: a female in the center of the top border (almost obscured by a repair), a female above the center of each side border, another in the center of the bottom border, a semi-recumbent female at the left end of the bottom border and a man seated at an anvil opposite her. Guard bands decorated with spiraling ribbons enclosing blossoms flank the floral segments of the border.

The composition recalls any number of tapestries dealing with military subjects from ancient history, mythology or the Bible. These enjoyed great popularity from the middle of the sixteenth century onward; most of them were first produced in Brussels and sometimes copied later in other parts of western Europe. Among the most familiar of these, and most closely related to this one, are certain tapestries in the *Story of Scipio Africanus* series[1] and some in the *Story of Alexander the Great* series.[2] The border is also reminiscent of those used by a number of Brussels weavers for these and other compositions during this period.[3]

Longstreet suggested that the scene may show Sinon persuading Priam to allow the wooden horse to be brought into Troy.[4] In the absence of any inscription in the border to help with the identification of the subject, this can only remain a conjecture; however, we do not know of any surviving tapestries that would seem to complete such a series. A tapestry from a *Story of Samson* shows similar main figures and a similar border, but the resemblance is probably fortuitous.[5] For the present, the subject remains unidentified.

1 See *Jules Romain: l'Histoire de Scipion, tapisseries et dessins*, Grand Palais, 1978.
2 A.S. Cavallo, *Tapestries of Europe and of Colonial Peru in the Museum of Fine Arts, Boston*, 1968, pp. 120ff., pl. 34.
3 See, for example, *ibid.* or, in more elaborate form, Crick-Kuntziger, 1956, pls. 50, 52, 53.
4 *General Catalogue*, p. 192.
5 Sotheby & Co., London, October 26, 1962, no. 83, illus.

Bibliography: *General Catalogue*, p. 192.

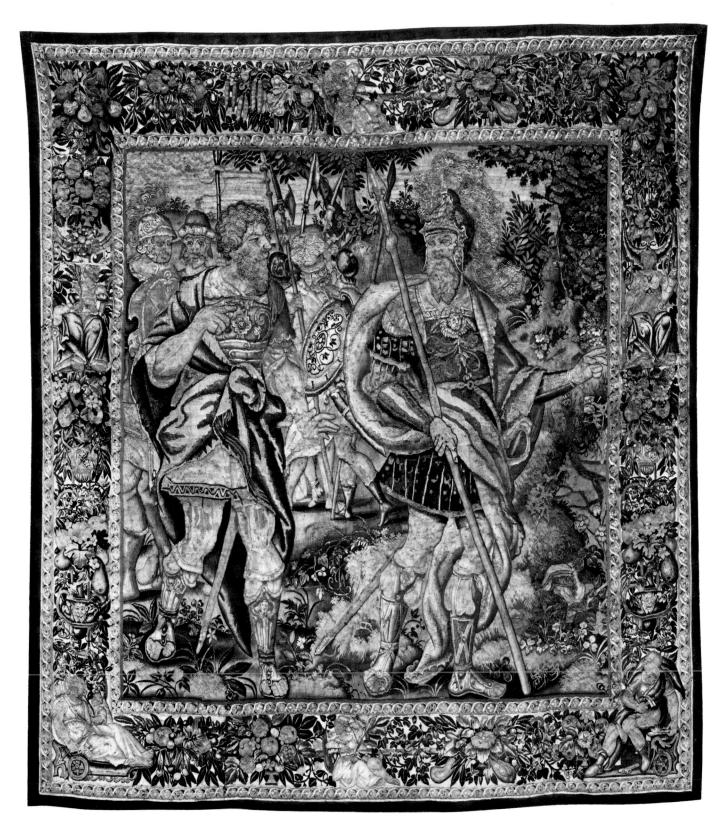

14
Gardens with Figures

Flemish, Brussels, 1585–1600
French, Paris, 1625–50
Purchased from Charles M. Ffoulke, November 16, 1903; formerly in the Barberini collection, Rome

The first tapestry shows the Brussels mark and the mark of the shop established in Brussels by Jacob Geubels and continued by his son Jacob and his widow Katharine van den Eynde; the shop was active from 1585 to 1629. The second tapestry has lost its original outer guard and thus its marks; however, since it resembles the first in all respects it may be attributed to the Geubels shop. The third and fourth pieces show the Paris mark and a weaver's mark that has hitherto been identified as that of Raphael de la Planche, son of the Audenarde weaver François de la Planche who, with his brother-in-law, Marc de Comans, established a tapestry-weaving shop in Paris in 1607, under a patent granted by Henry III. The mark has been read as the letters R D P interwoven.[1] But it can also be read as a variant of one of several marks used by another Flemish weaver working in Paris, Philippe de Maecht.[2]

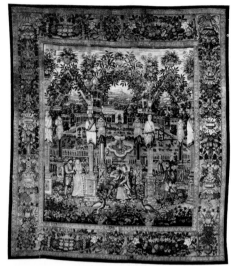

14a

The weaver's mark in the first tapestry fixes the outside dates of its manufacture to about 1585 to 1629, and the second piece was, in all likelihood, woven to accompany it. The costumes of the aristocratic figures in both of these hangings may be dated in the last quarter of the sixteenth century, thus fixing the terminal date of these two pieces at about 1600. On the other hand, the costumes and also the style of the gardens[3] represented in the two Paris tapestries fix the date of these pieces in the second quarter of the seventeenth century, or some twenty-five to fifty years after the date of the two Brussels hangings. Ffoulke suggested that Cardinal Antonio Barberini, among whose collateral descendants the tapestries were preserved, commissioned the two later tapestries in Paris to accompany the two Flemish pieces that he had acquired earlier.[4] However, Ffoulke offered no evidence associating these tapestries with Cardinal Antonio Barberini, rather than with his brothers, Francesco or Taddeo, or their uncle, Maffeo, Pope Urban VIII. As Cardinal, Maffeo Barberini ordered tapestries for Cardinal Montalto from the "royal workers" in Paris in 1606, during his term as Nuncio in that city.[5] The Pope and his nephews had close connections with the court of France during most of the seventeenth century and any one of them might have ordered the two later garden tapestries to complement the two earlier Flemish pieces.

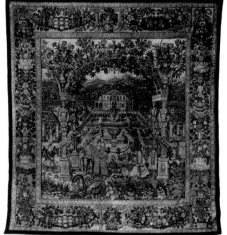

14b

Aside from the loss of the original outer guard bands from all sides of the second tapestry and parts of the bands from the first and third, the tapestries have not been altered. All of the hangings show repairs by darning, but the drawing has not been adversely affected.

A Musical Party shows a great pergola rising in the foreground as a screen beyond which one sees a formal garden with a gate and fine house at the end. Four pairs of alternating male and female terms, set on plinths, carry entablature blocks from which spring the three latticework arches that support lemon vines. The pergola's central arch is round; two pointed arches flank it. Bouquets of flowers in urns decorate the springings and crests of the three arches. Barrel-vaulted pergolas bearing grape vines border the far end and sides of the garden and beyond, at the foot of a range of hills, stands a group of great houses set far apart. A fountain rises from a lobed pool at the near end of the garden where fashionably dressed figures take their leisure. Two peahens and a peacock are near the pool; another pair of peacocks occupies the central foreground. Beyond them, in the three bays of the pergola, appears a pair of lovers standing at the left, another fashionably dressed couple seated on a settee in the center, the man playing a lute-like instrument, and a hunter or gamekeeper leading two hounds into the scene from the right.

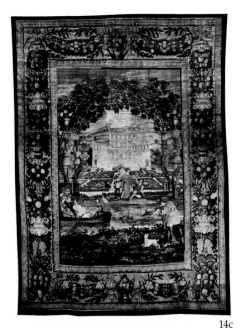

The wide border shows a yellow ground against which are displayed festoons of fruits, flowers and oak boughs cupped at the ends with acanthus leaves and tied in place with bows. An urn of flowers finishes the base of each side border. Guard bands of stylized acanthus leaves arranged in rows flank the four segments of the border.

In the *Strolling and Seated Lovers* two pairs of terms carry a single curved latticework arch in the center and the springing of two more arches at the sides. The arches carry pomegranate vines; urns of flowers stand at the points of springing and the figure of an eagle decorates the crest of the central arch. Great formal gardens entirely fill the middle distance, with a Palladian villa across the end of the central garden. A large fountain stands near the pergola. Women take water from the fountain while fashionably dressed figures stroll through the garden. In the immediate foreground stand turkeys and another ornamental bird. Beyond them, and under the pergola, one pair of lovers stands left of center while another pair sits at the right, the man leaning back on his lady's breast. A gamekeeper or hunter approaches from the left with a hound. The border of this tapestry duplicates that of the first.

The third hanging in the series, the *Boating and Hunting Parties,* shows a single latticework arch in the center, supported by two pairs of female terms; there are suggestions of the springing of other arches at the sides with urns of flowers set at the points of springing. The latticework of this arch supports grape vines. A formal garden extends from the middle of the plain beyond to the foot of a palace that rises at the bottom of a range of hills. In the foreground, under the pergola, a fashionably dressed couple pauses to talk to a fisherman kneeling at his net; he holds up a fish for them to admire. A river separates this group from a man, standing in the extreme right foreground, who aims a cross-bow at a hare. A canopied barge floats down the river; it bears a lady and gentleman with a child, an oarsman, and a man seated in the bow who plays a lute-like instrument. The border pattern matches that of the first two hangings in a general way, but there are two major differences: the festoons and bouquets show less energetic outlines, and laurel boughs rather than oak boughs fill the interspaces.

The conformation of the scene in the fourth tapestry, here called *The Surprise,* is similar to that in the third; but in this case the arches of the pergola rest on female terms grouped in fours rather than in pairs and the latticework arch carries lemon vines rather than grapes. A hedged formal garden stretches into the distance toward a Renaissance palace set high on a stepped podium. In the foreground, two women at the left watch a couple standing at the right near a fountain rising from a square pool. The man pulls his companion away from the fountain that seems suddenly to have sent jets of water up from the ground at the periphery of the pool, catching the woman unaware. The culprit, a fashionably dressed young man kneeling and manipulating a lever set in the ground in the extreme left foreground, laughs as he sees the woman's alarm. Another woman nearby shares the joke. Two hounds wrestle in the right foreground. The border of this piece duplicates that of the third tapestry in the series.

14c

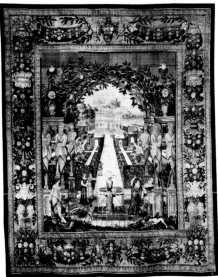

14d

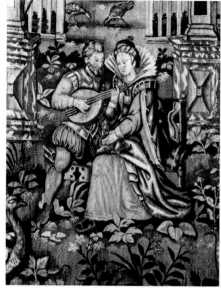

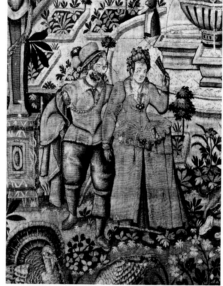

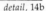
detail 14a

detail, 14b

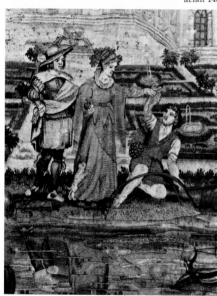

detail, 14c

detail, 14d

Although a large number of generically similar tapestries has survived, there
appear to be no duplicates of these pieces, nor any other hangings that seem
to have formed a suite with them. When he published these tapestries,
Ffoulke[6] suggested that their design derived from the great *Mois* or *Maisons
Royales* series that was woven at the Gobelins manufactory in Paris in several
editions beginning after 1668.[7] However, the two earlier Gardner pieces ante-
date these by some hundred years. Clearly, the compositions of both series
derive from earlier sources. Perhaps the earliest prototypes to be signaled in
the art of tapestry—and the true source may perhaps be found in still earlier
prints—are two suites designed by Battista Dossi and Leonardo da Brescia for
Ercole II, Duke of Ferrara (1534–59), and woven in Ferrara by Giovanni

Karcher about 1545–59. One series shows pergolas screening and enframing views of gardens and great houses.[8] The other suite dealt with the subject of Ovid's *Metamorphoses*.[9]

Whenever it may have originated, and in whatever medium, this class of composition found its richest development in the hands of Flemish tapestry weavers. Among the hundreds of park, garden or pergola tapestries known to have survived, the following pieces show the closest parallels to details used in the Gardner pieces: a Brussels pergola tapestry of the first quarter of the seventeenth century, preserved in the church of Notre-Dame de la Couture, Le Mans,[10] a Flemish tapestry of the late sixteenth or early seventeenth century sold at Parke-Bernet in 1942[11] and a pergola with garden tapestry formerly in the possession of George W. Childs Drexel, now in the Philadelphia Museum of Art. The last was woven, like the two earlier Gardner pieces, in the Geubels shop in Brussels late in the sixteenth or early seventeenth century.[12] Although its order is quite different, the field of the Philadelphia tapestry is more like that of the Gardner pieces than is that of any of the others cited above.

All of these pergola and garden tapestries are generically related to the most celebrated series of the type, the *Vertumnus and Pomona* tapestries designed by Jan Cornelisz. Vermeyen and woven in several editions in Flanders from the middle of the sixteenth to the middle of the seventeenth century. The most complete series has been preserved in the state collections at Vienna.[13] They show the typical elements in this kind of composition: large figures in the foreground, a pergola screen behind them, smaller figures beyond and formal gardens with fountains still farther in the distance. The variety of pergolas in another famous suite of garden tapestries in Vienna, the six *Galleries* or *Views of Gardens*, woven by Willem de Pannemaker for Cardinal Antonio Perrenot de Granvella in 1564,[14] stands as a link between the *Vertumnus and Pomona* series, whose pergolas lead not only across the space but also into the distance, and the Philadelphia and Boston tapestries in which the pergolas count only as a series of arches placed parallel to the surface of the hangings.

1 *General Catalogue*, p. 137.

2 See Göbel, 1928, appendix of marks, p. 2.

3 Unpublished communication from Edith Welch.

4 Ffoulke, pp. 104, 105.

5 Vatican Library, Barb. Lat. 6539, ff. 11v, 13v-14r, 15r, 27r.

6 Ffoulke, pp. 104ff.

7 Fenaille, II, pp. 128–66.

8 See *Le XVIe siècle européen: tapisseries*, Mobilier National, Paris, 1966, no. 35, illus. p. 60, a piece after da Brescia, now in the Musée des Arts Décoratifs, Paris.

9 For the *Heliades* tapestry in this series after Dossi, now at the Louvre, see *ibid.*, no. 36, illus. p. 61. Concerning both series, see C. Adelson, "Cosimo I de'Medici and the foundation of tapestry production in Florence," *Firenze e la toscana dei Medici nell' Europa del '500*, Florence, 1983, pp. 917–18, n. 52.

10 *Chefs-d'oeuvre de la tapisserie flamande, 11e exposition du Château de Culan*, 1971, no. 18, illus.

11 Parke-Bernet, New York, October 10, 1942, no. 512, illus.

12 See the *Philadelphia Museum Bulletin*, XLIV, 1949, p. 36, illus.

13 Baldass, 1920, pls. 146–54.

14 *Ibid.*, pls. 140–45.

Bibliography: Ffoulke, pp. 140ff., *A Musical Party*, illus. *General Catalogue*, pp. 136, 137. Asselberghs, 1974, p. 13. L. Ehret, "*Château and Garden* Tapestries at Fenway Court," *Fenway Court 1977*, 1978, pp. 24–33, illus. pp. 24, 26–28.

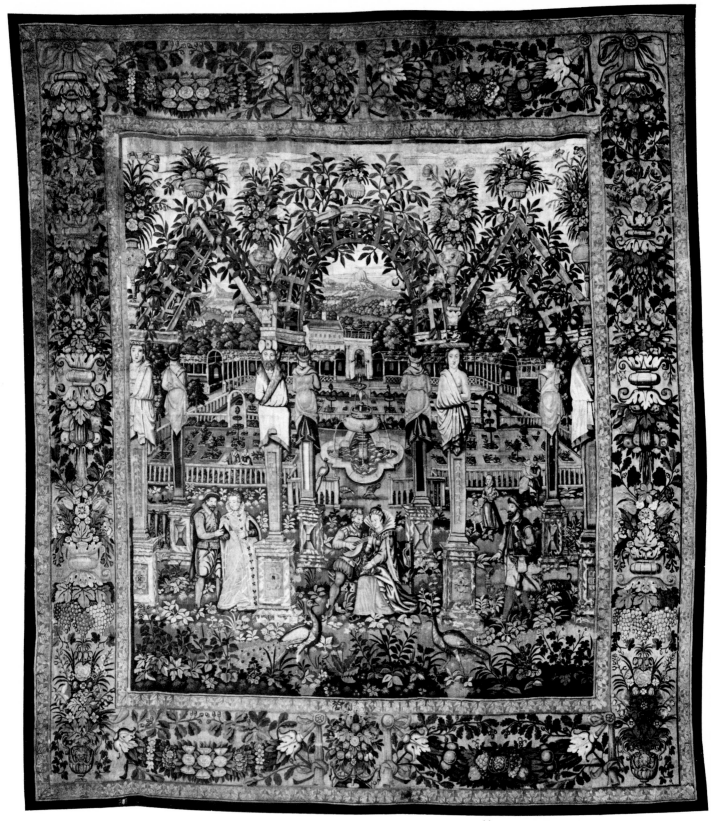

14a
A Musical Party T18s5–s

Flemish, Brussels, 1585–1600

Brussels mark contained in a fragment of the
original bottom outer guard near the left end,
flanked by strips of modern weaving; Geubels
shop mark in the lower part of the right outer
guard

Wool warp (7 yarns per cm.), wool and silk
wefts. H. 15'5", W. 13'10" (4.70 x 4.21 m.)

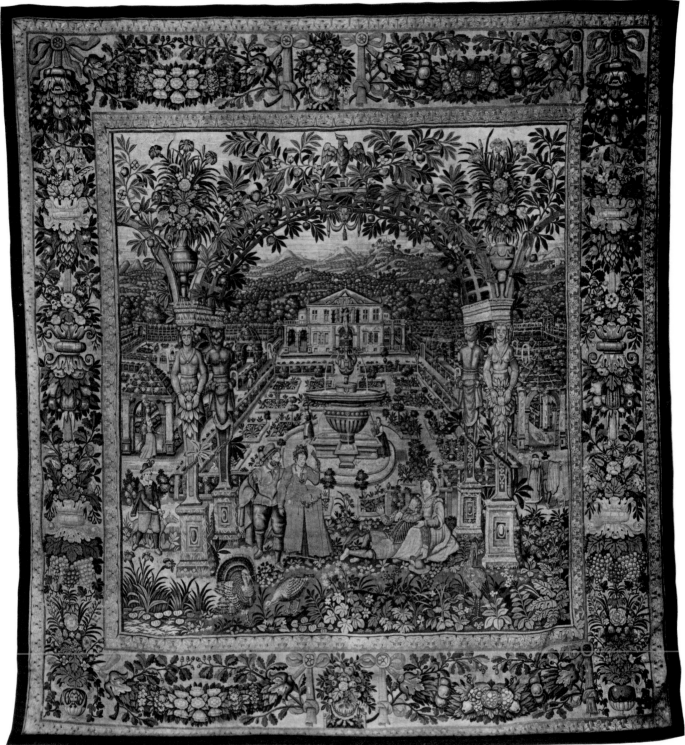

14b
Strolling and Seated Lovers T18w1–s

Flemish, Brussels, 1585–1600

No city or weaver's mark present (the original outer guards are missing and have been replaced by strips of modern weaving)

Wool warp (6 yarns per cm.), wool and silk wefts. H. 15'5", W. 14'1" (4.70 x 4.29 m.)

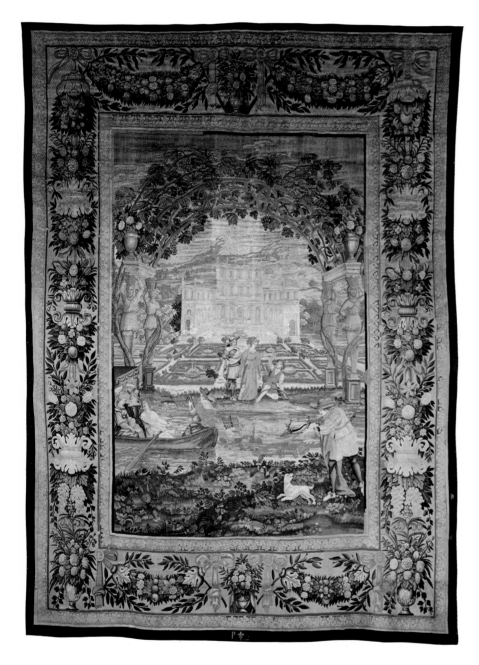

14c
Boating and Hunting Parties T18e5–s
French, Paris, 1625–50

Paris mark contained in a fragment of the original bottom outer guard in the center, flanked by strips of modern weaving; weaver's mark in the lower part of the right outer guard

Wool warp (8 yarns per cm.), wool and silk wefts. H. 15′3″, W. 11′ 6″ (4.65 x 3.51 m.)

14d
The Surprise T18e35–s

French, Paris, 1625–50

Paris mark at the right end of the bottom outer guard; weaver's mark at the lower part of the right outer guard

Wool warp (9 yarns per cm.), wool and silk wefts. H. 15′4″, W. 12′6″ (4.67 x 3.81 m.)

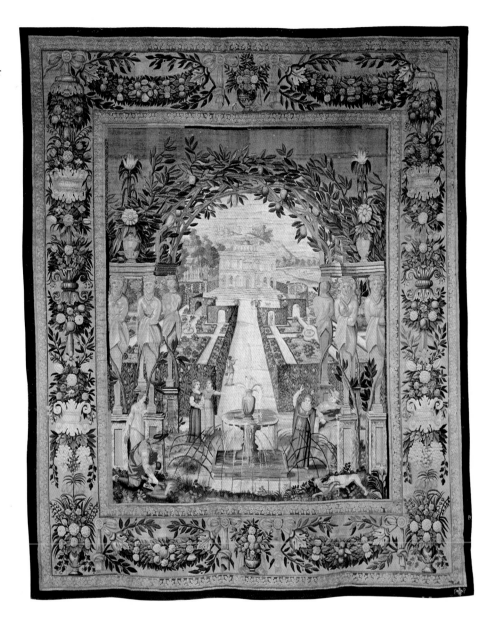

15
Boar Hunt T22s1

Flemish, probably Brussels, ca. 1575–1625
No city or weaver's mark present
Wool warp (5 yarns per cm.), wool and silk wefts. H. 7′, W. 4′2″ (2.10 x 1.25 m.)
Provenance unknown

The tapestry, which is a fragment of a larger hanging, has been extensively patched along the left side. Its worn surface and areas of repair by darning have blurred the drawing in many places. The figures of the hound and of the prancing horse in the lower left section have suffered particularly from the patching and repairs.

Tapestries of this kind seem to have been in favor during the late sixteenth and early seventeenth century. The man standing in the middle distance at the right wears clothes that were fashionable during these years. Similar hunting tapestries preserved in Rome and Ghent (see below) show the Brussels mark.

The composition shows a clearing in a forest where, in the middle distance, two men with spears attack a wild boar, one behind, the other in front, while two hounds attack the creature. A man sprawled on the ground struggles to escape the boar's forelegs and snout. A doe seems to be watching this action from her vantage point at the right. In the foreground a duck swims in a pool of rippling water; opposite this, a horse prances toward the right but looks left and a hound standing in the left foreground looks upward and to the left. The hanging has no border; strips of weaving serve as a finishing edge on all four sides.

Many individual hangings and some suites of tapestries showing hunts in game parks have survived. One suite, divided today between the Palazzo di Venezia, Rome, and the Château de Laarne, near Ghent, is particularly like this piece.[1] The tapestries show men hunting various kinds of game—deer, fox, bear, wild boar and birds—with falcons, hounds, bows and arrows or spears. These scenes are represented in the middle distance with great houses and sometimes also gardens leading the eye into the far distance, where ranges of mountains close the view at the back. In the foreground, mythological figures take their ease, leaving a clear view open back to the hunting scenes, either in the middle of each composition or at one side.[2] The Gardner piece might have been taken out of the upper central or side section of such a hanging, the largest of which in the Rome-Ghent series measures some ten by twelve feet. Indeed, the posture of the hound in the left foreground of the Boston tapestry suggests that he once may have been looking at a figure standing at the left side of the field.

Other game hunt tapestries show men and hounds attacking beasts in the foreground while others hunt in the distance.[3] If the upper sections of such a piece were cut and reassembled, they would produce a hanging very much like that in the Gardner.

1 See J. Versyp, "Zestiende-eeuwse jachttapijten met het wapen van de Vidoni en aanverwante stukken," *Artes Textiles*, VII, 1971, pp. 23–46, pls. 1–10.

2 *Ibid.*, pls. 1–3.

3 See, for example, a *Boar Hunt* illustrated in Thomson, 1930, opp. p. 218.

Bibliography: *General Catalogue,* p. 191. Asselberghs, 1974, p. 13.

16
Construction of the Tower of Babel T22e4

Flemish, Brussels, ca. 1590–1620
Brussels mark at the end of the bottom outer guard; Martin Reymbouts' (act. 1590–1619) mark at the lower end of the right outer guard band
Wool warp (7 yarns per cm.), wool and silk wefts. H. 11′2″, W. 12′11″ (3.35 x 3.94 m.)
Purchased from Gaetano Pepe, Naples, October 26, 1897; said by Pepe to have come from "Caserta (Real Casa)"

The surface of the hanging shows wear and areas of repair by darning, but the drawing has not been affected significantly.

Like the *Story of Noah* tapestries in this collection (No. 17), this hanging belongs to the suite of *Genesis* compositions whose designer has been identified as Michel Coxie.[1] A painting showing another version of this composition, as it appears in a hanging in Wawel Castle (see below), is preserved in the Gemäldegalerie, Stuttgart. Baldass published the painting as the composition after which the tapestry was woven,[2] but Crick-Kuntziger advanced the more convincing argument that the Stuttgart painting, along with ten companion panels that also show scenes from the *Genesis* tapestry series, were painted from the finished tapestries, rather than serving as models for them.[3]

A regal male figure stands in the foreground, right of center. He holds an axe in his right hand. A great scimitar hangs from his belt, against his left thigh. A workman or messenger approaches from the right and addresses this man who is probably intended to represent Nimrod, King of Babel, great-grandson of Noah. A woman holding a small keg in her left hand and a sleeping baby on her right arm sits in the foreground at the left, turning to look out at the observer. She seems to have come to visit one of the masons who works a slab of stone beyond her. A bearded man in splendid garb and a turban stands beyond these figures and appears to be directing other masons and workmen whose ranks extend into the far distance where, at the left, the tower is being built.

The border shows segments of sky, land and sea in the upper, side and bottom portions, respectively. Against these backgrounds have been arranged suitable creatures and figures. Jupiter, astride his eagle and holding thunderbolts in his right hand, appears in the center of the upper border surrounded by attendants and various birds. At the left end of this border a female figure symbolizing Air sits on a bank of clouds. At the other end is a pendant figure symbolizing Fire. Below, at each side, hills, plains and rivers fill the width of the border from top to bottom and serve as the setting for a variety of land creatures, including deer, rabbits, an elephant, a camel and lions, among others. A female figure symbolizing Earth sits at the bottom of the left border; opposite her, at the bottom of the right border, sits a female figure representing Water. Between these two figures stretches the ground of the bottom border, a vista of clouds and waves among which sea creatures, mermen and mermaids engage in various pursuits, while in the center Neptune appears in a chariot drawn by seahorses. Guard bands showing strapwork arabesques and masks flank the main sections of the border.

Although the border design incorporates personifications of and celebrates the four Elements, it represents, in fact, a reference to the first five days of Creation, as recounted in the *Book of Genesis*. The design seems to have been used first to border a suite of *Story of Noah* tapestries that Philip II of Spain ordered from Willem de Pannemaker, who wove them in Brussels between 1563 and 1566; some pieces from that suite are preserved in the Royal Collection at Madrid.[4] It is believed that the original design for the border was based in part on illustrations in the Spanish king's collection of zoological manuscripts and printed books and that it was designed at his behest for the *Noah* tapestries. A tapestry from another *Story of Noah* series that belonged to Philip II, a *Sacrifice of Noah*, shows a version of the border that virtually duplicates that used for the Gardner *Tower of Babel*.[5] Reymbouts used the border again for a *Noah Constructing the Ark* and a *Triumph of Judith* in the Contini Bonacossi collection, Florence.[6]

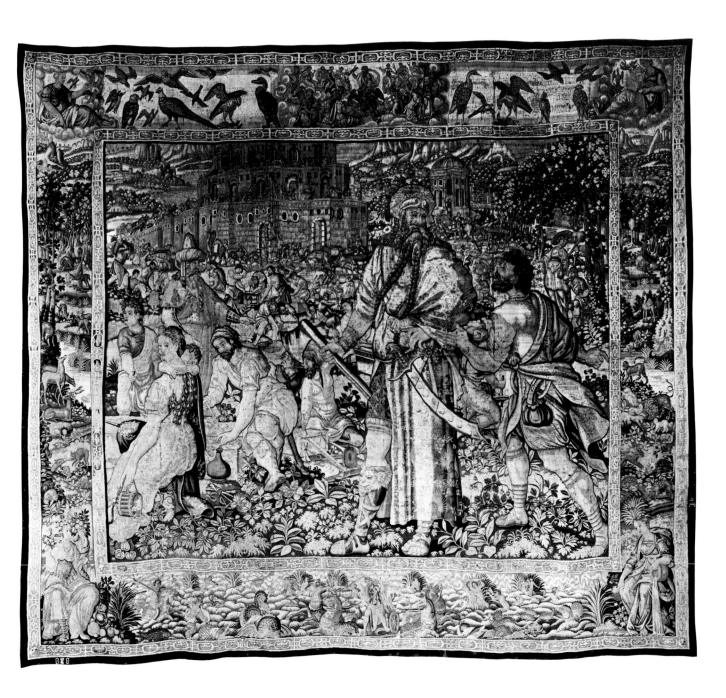

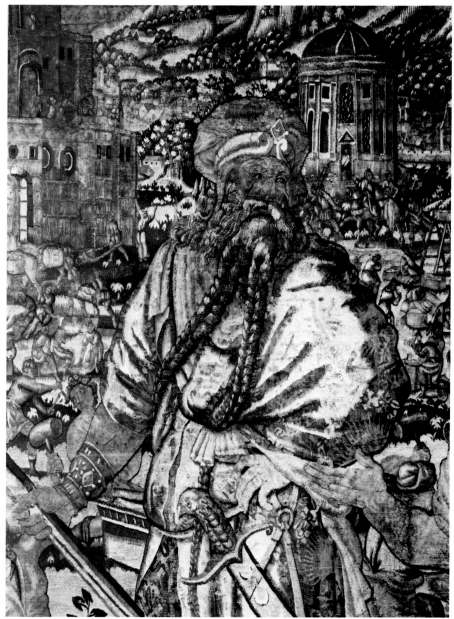

The border was used with some variation frequently during the latter part of the sixteenth century and the first third of the seventeenth century, and not always in relation to subjects associated with the *Book of Genesis.* It was used to enframe subjects from ancient history[7] and the Old Testament,[8] as well as pergola subjects.[9]

The earliest weaving of the composition used for the Gardner tapestry appears to be the one now preserved in Wawel Castle, near Cracow.[10] It was woven about 1560 for King Sigismund Augustus. Only two other editions of the subject are known to have survived. One is in fragmentary condition and preserved in the Museum of Art, Barcelona.[11] The other is in a private collection in this country. The example in Wawel Castle shows no marks; the

seamed piece in Barcelona was woven by Willem de Pannemaker; the third piece has neither border nor marks. A comparison of the whole hanging in Cracow with the abbreviated version in the Gardner shows that the weaver of the latter used the same two main figures and the three largest figures in the middle distance at the left; but he eliminated the entire central third of the full composition, altered the shape of the tower and moved it to the left. At the same time he moved the domed building in the background to the right, thereby reversing the relative positions of those two buildings as they appear in the wider version at Cracow.

The suite of *Genesis* hangings in Wawel Castle shows that Coxie designed at least three other compositions to accompany the *Tower of Babel* sequence in the iconographical scheme. The subjects are as follows: *The Wrath of God* (woven, perhaps, by Frans Ghieteel), *The Confusion of Tongues* (woven by Jan van Tieghem) and *The Dispersal of Mankind* (woven by Catherine van Hildenberghe, widow of Nicolas Leyniers).[12]

1 Crick-Kuntziger, 1938, p. 5.

2 L. Baldass, "Tapisserieentwürfe des niederländischen Romanismus," *Jahrbuch der kunsthistorischen Sammlungen in Wien*, n.s., II, 1928, pp. 247, fig. 314.

3 Crick-Kuntziger, 1938, pp. 7, 8.

4 See P. Junquera de Vega, "Les séries des tapisseries de 'Grotesques' et 'l'Histoire de Noé' de la Couronne d'Espagne," *Bulletin des Musées Royaux d'Art et d'Histoire*, XLV, 1973, pp. 162ff.

5 A.F. Calvert, *The Spanish Royal Tapestries*, London and New York, 1921, pl. 45, mislabeled *Sacrifice of Abraham*.

6 See M.F. Viale, "Tapisseries flamandes inédites en Italie," *Artes Textiles*, VII, 1971, pp. 59ff., figs. 6, 7.

7 G.L. Hunter, *Tapestries: Their Origin, History and Renaissance*, New York and London, 1912, pl. 401.

8 *Wandtapijten*, II, p. 28, fig. 15.

9 Viale, *Colloquium*, 1959, pp. 273, 298. For notes on other tapestries using this border, see Versyp, *Colloquium*, 1959, p. 216, figs. 1, 2.

10 J. Szablowski *et al.*, *The Flemish Tapestries at Wawel Castle in Cracow*, Antwerp, 1972, pp. 75 and *passim*, 460, 461, illus. pp. 164–66, 169, 171, 173.

11 M. Puig y Cadafalch, "Les tapisseries du Palais de la Généralité de Barcelone et celles du Palais Royal de Madrid," *Annales de l'Académie Royale d'Archéologie de Belgique*, LXXI, 1923, pp. 145ff., fig. 8.

12 Szablowski, pp. 460, 461, illus. 174, 175, 180, 181, 183, 184, 186; *The Dispersal of Mankind* not illus.

Bibliography: *General Catalogue*, pp. 192, 193. M. Crick-Kuntziger, "Tapisseries de la Genèse d'après Michel Coxie," *Bulletin de la Société Royale d'Archéologie de Bruxelles*, I, 1938, p. 16, fig. 5. Asselberghs, 1974, p. 13.

Three Episodes from the *Story of Noah*

Flemish, Brussels, 1650–75

Believed to have been purchased from L. Marcotte & Co., New York, October 6, 1880

The tapestries have lost their original outer guard bands, and the weaver's and city marks now present are contained in bits of original weaving that have been patched into strips of modern weaving that serve as guard bands at the bottom of each hanging. The weaver's marks refer to Jasper van Bruggen, a tapestry weaver who was active in Brussels from about 1640 to about 1665. Although the patches containing the marks could have come from an entirely different set of weavings, the fact that van Bruggen's mark appears as part of the fabric in another suite of *Noah* tapestries preserved in the Cathedral at Cuenca in Spain[1] argues in favor of accepting the patched marks in the Boston tapestries as having been preserved in their original context. As for the date, the fully developed Baroque interpretation of Coxie's High Renaissance compositions (see below), the use of a proscenium-like bay with engaged columns to enframe the scenes rather than a flat border, and the dates of van Bruggen's active years all point to the middle or third quarter of the seventeenth century as the most likely time during which these tapestries were woven.

17a

The first piece in the series seems to have lost a bit of fabric along the upper edge of the top border before the modern guard band was added. All of the hangings may have lost some fabric along the bottom where the borders seem to end in a sill that extends from the base of one column to the other. The "sill" might in fact be the top of a low wall or front of a dais that occupies this space in some tapestries of the period.[2] If that is so, then it is clear that rather than just one or two inches, more is missing along the bottom of each hanging. All three pieces show appreciable wear and also repair by darning, as well as areas of unintended lightness of tone where deteriorated black or dark brown weft yarns have broken off and left the bare warp visible. Although the original color range must have tended toward neutral tones, the palette appears now almost monochromatic owing to the fading of dyes.

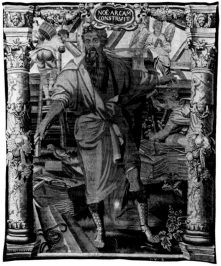

17b

The three incidents represented here are drawn from the *Book of Genesis* (6–9). The first tapestry shows God, represented as a bearded man standing at the left, conversing with Noah who stands at the right, his back toward the observer. A landscape setting extends far into the distance beyond the figures. A Latin inscription appears in an oval cartouche set into the center of the top border. It reads as follows: *DIXIT DEVS NOË FAC TIBI ARCAM* (God says to Noah, "Make an ark for yourself").

In the second tapestry, Noah stands in the center foreground of the space, a tool in his right hand, his left hand gesturing toward the background where a man and woman are busily working on the ark while an angel, hands raised in prayer, sits on the upper part of the unfinished vessel. A bird perches on the end of a plank behind Noah and near timbers that are being worked into parts of the ark. The inscription in the border above reads as follows: *NOË ARCAM CONSTRVIT* (Noah builds the ark).

The third hanging illustrates a later moment in the story, after Noah with his family and the animals had left the ark and made a sacrifice to God. Then the Lord showed Noah a rainbow as a sign of covenant, promising that he would never again let loose a devastating flood on earth. Noah kneels in the center of the space and gazes upward toward an aura in the sky at the center of which appear Hebrew characters and around which hover cherubim and an angel. Noah's wife and his three sons kneel at his right while the sons' wives kneel at the left and peer upward toward the rainbow. The ark, aground on Mount Ararat, appears in the distance at the right. The inscription in the border above reads as follows: *DEVS NOË MONSTRAT IRIDEM FOEDVS* (God shows Noah the rainbow as a covenant). Except for the example of the same subject in the suite of hangings woven by Jasper van Bruggen and now in the Cathedral at Cuenca[3] and possibly also the piece that was sold from the collection of

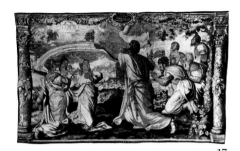

17c

the Marquess of Northampton in London in 1898,[4] all other versions of this composition show the figure of God in the aura above the rainbow.

The three scenes in the Gardner tapestries are contained within structures resembling proscenia. Pairs of engaged Corinthian columns serve as the sides of the proscenium, the shafts of each column decorated with relief carvings representing an arabesque of leaves within which cupids armed with bows and arrows or spears hunt in the company of hounds. The centers of each shaft show a band of spiral fluting topped by a boy's head and girded at the bottom with a garland of fruits and pods. The shafts rise from low plinths and carry entablature blocks that in turn support an architrave from which hang swags of fruit and flowers and, in the center, the strapwork cartouches bearing the Latin inscriptions.

These *Story of Noah* compositions derive from those in the *Genesis* compositions that Michel Coxie designed some hundred years earlier and that also include the composition for the *Tower of Babel* tapestry in this Museum (No. 16). The entire *Genesis* series, of which the most complete edition to have survived is represented in the series of hangings in Wawel Castle at Cracow,[5] begins with scenes of the Creation, followed by the story of Adam and Eve, of Noah and of the tower of Babel. Those tapestries, which are considered to be the first ones woven after the Coxie designs, date from about 1560.

The segment of the *Genesis* series that deals with the *Story of Noah* contains eight hangings. The subjects are as follows: *God Commands Noah to Build the Ark, Noah Builds the Ark, The Animals and Noah's Family Enter the Ark, The Deluge, The Animals and Noah's Family Leave the Ark, Noah's Sacrifice in Thanksgiving, God Shows Noah a Rainbow as a Pledge* and *Noah's Drunkenness.*[6] We know from other sources that the *Story of Noah* may have contained more subjects. In 1567 Philip II of Spain received from the Brussels weaver Willem de Pannemaker a set of ten *Story of Noah* pieces that he had ordered some years before.[7] A few pieces from this series are preserved in the Royal Collection at Madrid and parts of two or three other *Story of Noah* suites are also there.[8]

A duplicate edition of the first series at Madrid, the one woven for Philip II, with similar borders celebrating air, earth and water and showing the royal arms, has survived in part and is now in the Museum of Art, Barcelona.[9]

The *Story of Noah* compositions had not lost their appeal a hundred years later; indeed more seventeenth- than sixteenth-century editions have survived. A set of six hangings, with the subjects of God's command to Noah, construction of the ark, deluge, Noah's sacrifice in thanksgiving, the rainbow covenant, and Noah's drunkenness, all woven by Paul van Nieuwenhove in Brussels, was sold by the Marquess of Northampton in 1898.[10] It is not clear whether four of these pieces were identical with four van Nieuwenhove weavings of the second, third, fourth and sixth of these subjects that were noted as being in the collection of Viscount Eveden at Pyrford Court.[11] The suite of seven pieces woven by Jasper van Bruggen and preserved in the Cathedral at Cuenca has already been mentioned above.[12] Six subjects from the *Story of Noah*, woven by Gillam van Cortenberg of Brussels, are dispersed today among three collections; three pieces are in the Castello Sforzesco, Milan, one piece is in the Château de Sychrov in Czechoslovakia, and two pieces are in the Hermitage, Leningrad.[13] According to Wauters, there were two *Story of Noah* tapestries with the mark of Brussels weaver Niclaes Van de Sinnen in the Château de Sully in Burgundy.[14] A set of four hangings bearing the mark of another Brussels weaver, Jan Raes, was sold in 1937.[15] Another set of four hangings, with inscriptions in English rather than Latin and signed by the

Brussels weaver Jan van Rottom, was sold in 1919.[16] It is thought that these were woven specifically for export to England, and this is probably also true in the case of two other *Story of Noah* hangings noted by Marillier as being in the collection of the Duke of Buccleuch.[17] A few single hangings from the seventeenth century have also survived: an example of the animals entering the ark, no weaver noted, in the Musée de la Société Archéologique de Nivelles, and an example of the deluge woven by Jan de Melter in Brussels.[18]

Of the surviving sixteenth-century hangings, there are many examples that show the three subjects that appear in the Gardner series. The composition showing God commanding Noah to build the ark appears among the tapestries in the Royal Collection at Madrid,[19] at Wawel Castle[20] and in the Museum of Art, Barcelona.[21] Versions of the scene showing the construction of the ark are to be found in Wawel Castle,[22] in the Museum at Barcelona[23] and in the Contini Bonacossi collection, Florence.[24] Of the covenant between God and

detail, 17a

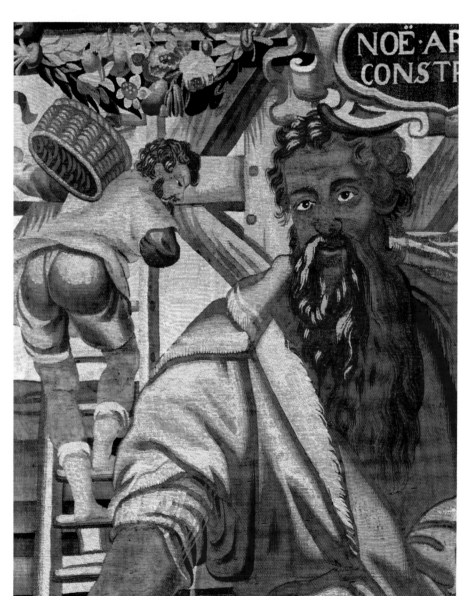

detail, 17b

detail, 17c

Noah there are examples in Wawel Castle,[25] in the Rijksmuseum, Amsterdam,[26] in the Royal Collection, Madrid,[27] and in a private collection in Germany.[28]

Among the seventeenth-century examples, there are versions of God commanding Noah to build the ark in the Cathedral at Cuenca[29] and in the Castello Sforzesco, Milan,[30] as well as among the six pieces sold by the Marquess of Northampton in 1898.[31] Of the composition showing the ark under construction there was an example among the Marquess of Northampton's tapestries; another is preserved in the Cathedral at Cuenca[32] and another is in the Château de Sychrov in Czechoslovakia.[33] The scene showing the covenant between God and Noah was also among the Marquess of Northampton's tapestries and there is an example in the Cathedral at Cuenca.[34]

The Gardner tapestries differ from all the others in that the fields show abbreviated versions of the Coxie compositions. While the Boston version of the

subject dealing with God's command to Noah shows the same two figures as the others, it places them in a simpler, different landscape. The composition showing the construction of the ark represents only a detail of the left-central quarter of the entire Coxie composition. The Boston version of the rainbow covenant shows the same key figures but the height of the composition has been so diminished that there is no room for the figure of God above the rainbow. The inscriptions in the upper borders of the Boston pieces are different and simpler than the Latin inscriptions in the borders of the mid-sixteenth- century weavings in Wawel Castle.

1 See M. Gebarowicz and T. Mankowski, "Arasy Zygmunta Augusta," *Rocznik Krakowski, XXIX,* Cracow, 1937, p. 65, pls. 32, 33.

2 See, for example, Crick-Kuntziger, 1956, pl. 62.

3 Gebarowicz and Mankowski, fig. 32.

4 Christie, Manson and Woods, Ltd., London, July 26, 1898, not illus.; see brief verbal description in Thomson, 1930, p. 393.

5 J. Szablowski *et al., The Flemish Tapestries at Wawel Castle in Cracow,* Antwerp, 1972.

6 *Ibid.,* pp. 111, 115; 118–20, 123; 126–28, 131, 134, 135; 138–40, 143, 144; 147; 148, 149, 151–53, 155; 158–61; all illus.

7 E. Tormo Monzó and F.J. Sanchez Cantón, *Los tapices de la casa del Rey N.S.,* Madrid, 1919, pp. 109ff.

8 There is some confusion on this point in the pertinent literature: compare Tormo Monzó and Sanchez Cantón with Gebarowicz and Mankowski, figs. 29–31; Crick-Kuntziger, 1938, pp. 5, 11; P. Junquera des Vega, "Les séries des tapisseries de 'Grotesques' et 'l'Histoire de Noé' de la Couronne d'Espagne," *Bulletin des Musées Royaux d'Art et d'Histoire,* XLV, 1973, pp. 162ff.

9 Three whole hangings and two parts of a fourth survive; see M. Puig y Cadafalch, "Les tapisseries du Palais de la Généralité de Barcelone et celles du Palais Royal de Madrid," *Annales de l'Académie Royale d'Archéologie de Belgique,* LXXI, 1923, pp. 145ff., figs. 2–5, 9.

10 Christie, Manson and Woods, Ltd., London, July 26, 1898.

11 Crick-Kuntziger, 1938, p. 9, fig. 2; reference from H.C. Marillier.

12 See also Gebarowicz and Mankowski, figs. 32, 33.

13 See J. Blažková, "Une tapisserie de l'histoire de Noé au château de Sychrov en Tchécoslovaquie," *Bulletin des Musées Royaux d'Art et d'Histoire,* XLV, 1973, pp. 9ff., figs. 1, 2; M. and V. Viale, *Arazzi e tappeti antichi,* Turin, 1952, pl. 53.

14 A. Wauters, *Les tapisseries bruxelloises,* Brussels, 1878, p. 287.

15 Altkunst Margraf, Berlin, September 30, October 1, 2, 1937, nos. 380 a-d, illus.

16 Christie, Manson and Woods, Ltd., London, November 20, 1919, no. 100; sold again in the same rooms, April 15, 1924.

17 Crick-Kuntziger, 1938, p. 14.

18 *Ibid.,* pp. 9ff.

19 Gebarowicz and Mankowski, fig. 29.

20 Szablowski, illus. pp. 111, 112.

21 Puig y Cadafalch, fig. 2.

22 Szablowski, illus. pp. 118, 119.

23 Puig y Cadafalch, pp. 145ff., not illus.

24 M. Viale, "Tapisseries flamandes inédites en Italie," *Artes Textiles,* VII, 1971, fig. 6.

25 Szablowski, illus. pp. 152, 153.

26 *Wandtapijten,* II, p. 17, fig. 7.

27 Gebarowicz and Mankowski, fig. 31.

28 Göbel, 1923, pl. 275.

29 Gebarowicz and Mankowski, p. 65.

30 *Ibid.,* pl. 34.

31 Thomson, 1930, p. 393.

32 Gebarowicz and Mankowski, p. 65, not illus.

33 Blažková, fig. 1.

34 Gebarowicz and Mankowski, pl. 33.

Bibliography: *General Catalogue,* pp. 85, 247, 280. M. Crick-Kuntziger, "Tapisseries de la Genèse d'après Michel Coxie," *Bulletin de la Société Royale d'Archéologie de Bruxelles,* I, 1938, p. 8, fig. 1. Asselberghs, 1974, p. 13.

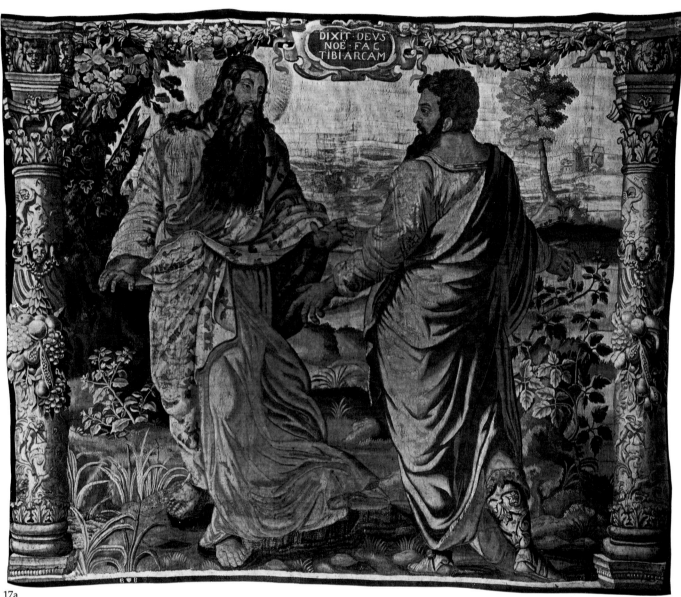

The inscription in the tapestry reads:

DIXIT·DEVS
NOE·FAC
TIBI·ARCAM

17a
*God Commands Noah to Build the
Ark* T31e4–s
Brussels mark at the left end of the bottom
outer guard; no weaver's mark present

Wool warp (8 yarns per cm.), wool and silk
wefts. H. 9′1″, W. 10′9″ (2.77 x 3.27 m.)

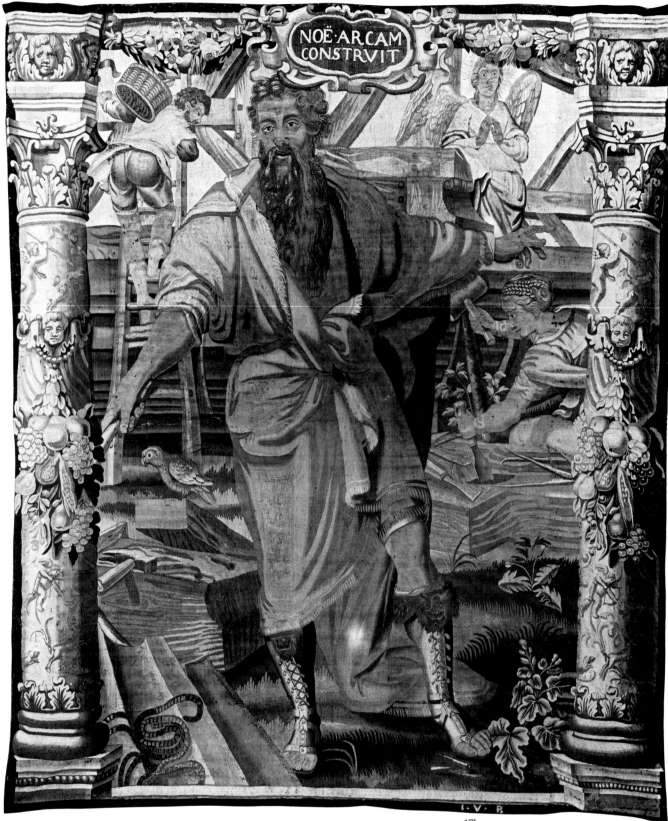

17b

Noah Builds the Ark T14w5–s

No city mark present; Jasper van Bruggen's
mark at the right end of the bottom outer
guard

Wool warp (7 yarns per cm.), wool and silk
wefts. H. 9′, W. 7′8″ (2.75 x 2.34 m.)

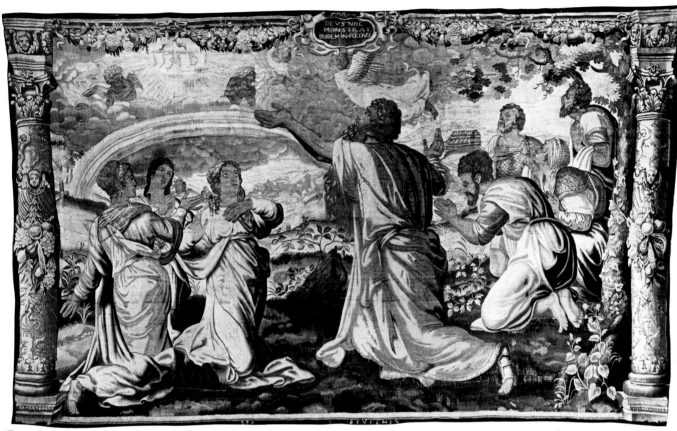

17c

God Shows Noah a Rainbow T27e31–s

Brussels mark at left of center in the bottom
outer guard; Jasper van Bruggen's mark at
right of center in the bottom outer guard

Wool warp (6 yarns per cm.), wool and silk
wefts. H. 9′2″, W. 14′10″ (2.80 x 4.53 m.)

18
Pleasures of Winter T14e4

Probably Flemish, ca. 1675–1700
No city or weaver's mark present
Wool warp (6 yarns per cm.), wool and silk wefts. H. 8'6½", W. 6'2" (2.61 x 1.85 m.)
Provenance unknown

This fragment from a larger hanging has been cut on all four sides, and strips of modern weaving have been sewn along the edges. The weaving has been patched and coarsely darned in many places and this, together with the application of paint to heighten details, has distorted much of the drawing and seriously disfigured the faces of the woman and two of the men.

In the foreground, a smartly dressed lady is being drawn from left to right in an elaborately carved and gilded sleigh. A horse draws the sleigh over the surface of a frozen river. The woman turns to look at the young man driving the horse. Another young man, a skater, has fallen to the ice in the right foreground. A man on the far shore bends over to help a woman to her feet.

Although no duplicate weaving has been identified, three versions of the subject are known. One of these, a complete hanging, was in the collection of Mrs. Phoebe A. Hearst.[1] In this example, which was attributed, probably incorrectly, to France, late eighteenth century, the sleigh is being drawn in the opposite direction from the sleigh in the Gardner piece. Another large piece, without a border, was published as being in a private collection in Spain.[2] It shows the sleigh being driven from right to left. According to Boccara, a similar tapestry is to be found in the Château de Courances, Seine-et-Oise.[3] A third version of the subject, attributed by H.C. Marillier to English looms, is in the Barbican Museum at Lewes, Sussex.[4] The sleigh moves from left to right and, in other ways as well, the details of this piece relate more positively to the Gardner example than to any of the other related tapestries.

Boccara attributed the composition of the similar tapestry in Spain[5] to the Flemish painter Louis van Schoor, who designed at least the figures in numbers of stylistically related allegorical tapestries that were woven mostly in Brussels, but also in Amsterdam and London;[6] see, for example, his *Four Parts of the World*.[7]

Whoever designed the figures in this piece, it is clear that they may have been superimposed on a setting designed for another context, since the same setting serves as the background for a completely different group of figures in a *Winter* tapestry woven about the same time in Brussels by Jan Frans van den Hecke.[8] Clearly, the figures and setting in the Gardner tapestry were combined, recombined and altered in different weaving shops in Flanders, England, and possibly also in Holland.

In the absence of border, weaver's and city marks, the attribution to Flanders can be offered only as a tentative one. Marillier asserted that the composition of the closely related tapestry in the Barbican Museum was taken from one used for a *Seasons* series woven by "van den Hecke" in the collection of the Crown Prince of Bavaria at Bayreuth.[9]

1 J. N. Laurvik, ed., *Catalogue of the Mrs. Phoebe A. Hearst Loan Collection*, San Francisco, Palace of the Legion of Honor, 1917, p. 49, illus. ff. p. 34.

2 Boccara, p. 146, illus.

3 *Ibid.*

4 H.C. Marillier, *English Tapestries of the Eighteenth Century*, London, 1930, pp. 71, 72, pl. 27a.

5 Boccara, p. 146.

6 A. S. Cavallo, *Tapestries of Europe and of Colonial Peru in the Museum of Fine Arts, Boston*, Boston, 1968, pp. 154, 155.

7 Göbel, 1923, pls. 148, 339.

8 *Ibid.*, and Göbel, 1923, pl. 167.

9 Marillier, p. 71.

Bibliography: *General Catalogue*, p. 86.

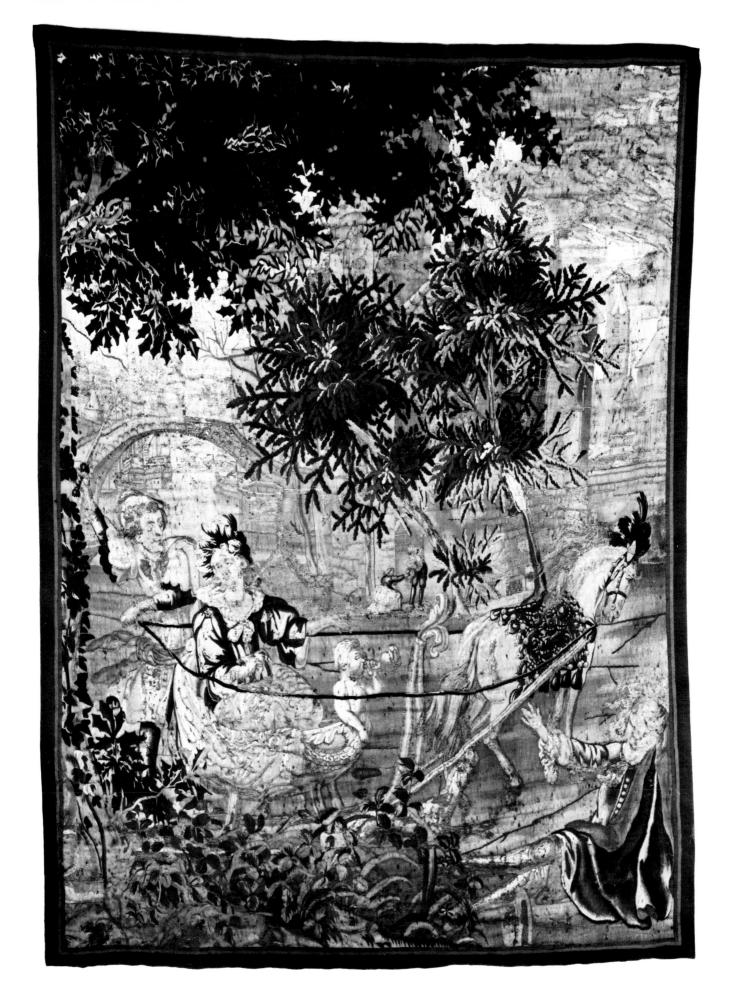

19

Messenger Delivering a Letter T22e3

Flemish or French, 1675–1700
No city or weaver's mark present
Wool warp (8 yarns per cm.), wool and silk wefts. H. 8′6½″, W. 5′7″ (2.60 x 1.70 m.)
Purchased in Paris, date and source unknown

The tapestry has been cut on all sides and appears to be part of a larger hanging. Strips of modern weaving have been sewn along the edges to serve as a guard band. The hanging shows a good deal of wear and a number of very coarsely darned repairs, especially in the region of the woman's nose and mouth and the man's hair.

In the foreground of a clearing in a wooded dell a young man enters from the left and with his left hand offers a letter to a woman standing in the center of the space. Trees, plants and shrubs fill the foreground and middle distance. A castle rises above a cliff in the far distance at the right.

The meaning of the action is clear but the context is too general to allow a convincing identification of the subject. Since the woman has none of the attributes of a queen, she is probably not meant to represent Queen Tomyris as she received Cyrus' proposal of marriage (No. 9 in this catalogue). The other possible identifications are too numerous to speculate upon.

Although the man and woman wear clothes that were current during the middle years of the sixteenth century, the garments are drawn in such a way as to reflect the fashionable lines of the late seventeenth century, the period suggested by the drawing and modeling of the flora in this composition and also by its overall design in terms of *chiaroscuro*. The man's jerkin has not been drawn correctly and his outer garment has been interpreted as a cloak but not a mid-sixteenth century one (see the man standing to the left in *King Astyages Commands Harpagos . . .* in this collection, No. 9a). The woman's costume also shows details that belong to the late seventeenth century. Although her waistline is drawn high, as it would be for the earlier period, the designer has brought the ends of her girdle to the front and used them to create a lower waistline. The edges of the overskirt are drawn upwards and toward the back, as they would be if this were a fashionable gown of about 1680–1700.

Numbers of tapestries showing sixteenth-century compositions, or interpretations of them, were in fact woven more than a hundred years later. During the early years of activity at the newly established tapestry shops at the royal Gobelins manufactory in Paris, from about 1680 onward, celebrated sixteenth-century Brussels suites were used as models for new weavings: the *Story of Scipio,* the *Fructus Belli,* the *Hunts of the Emperor Maximilian* and the *Months of Lucas.*[1] Even earlier in the century the shops operating in Paris under royal patents were using other sixteenth-century Brussels hangings as models: the *Hunts of King Francis,* the *Acts of the Apostles* and the *Months of the Year.*[2] Of these, only the hunt and season subjects showed characters in civilian dress. Viewed in this context, the appearance of sixteenth-century personages in seventeenth-century weavings is not surprising, and one may assume that this tapestry represents a revival or interpretation undertaken in a French or Flemish shop to correspond to the fashion created by the revivalist Gobelins weavings. Those continued to be manufactured at least as late as 1720 and it is even possible, though given its dark tonality unlikely, that the Boston piece was woven then. In any case, it is very unlikely that this fragment could have been woven at the end of the eighteenth century or later as Longstreet suggested.[3]

1 See Fenaille, II, pp. 279ff., 290ff., 299ff., 337ff.
2 *Ibid.,* I, pp. 241ff., 279ff., 301ff.
3 *General Catalogue,* p. 193.

Bibliography: *General Catalogue,* p. 193.

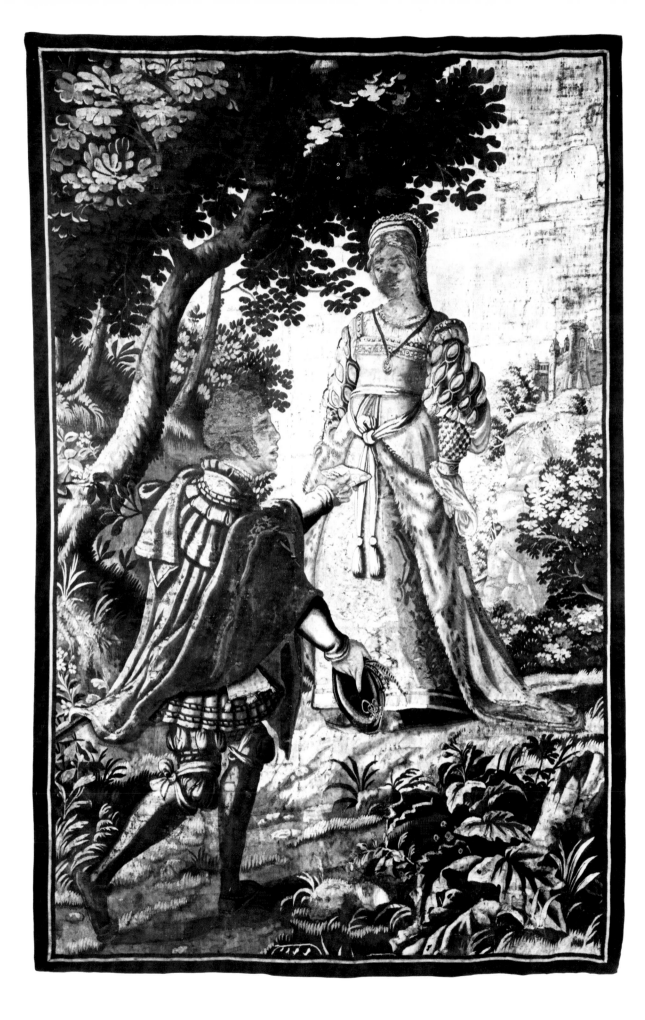

20
Melintus and Ariane Fleeing from Rome T27w11
Probably Flemish, 1675–1710
No city or weaver's mark present
Wool warp (9 yarns per cm.), wool and silk wefts. H. 8', W. 9'1" (2.44 x 2.77 m.)
Provenance unknown

The tapestry has been cut down on all four sides and shows a long, narrow patch from this or another tapestry along the bottom edge at the right. The surface shows wear and there are some repairs by darning, but the drawing has not been distorted.

Although neither the design nor the weaving represents the best Brussels work of the period, the tapestry recalls products of the lesser Brussels shops or shops staffed by good Flemish weavers in other parts of western Europe, especially France, England and Italy. Also, its style relates this piece to a class of more splendid mythological and allegorical tapestries that were being woven in Brussels during the last quarter of the seventeenth century.[1] For this reason, and also because the heroine's costume, exotic though it is, reflects the lines of fashionable clothes worn by European women during the late seventeenth and early eighteenth centuries, the tapestry should be dated in that period.

In the past, this tapestry was referred to as *Oriental Chieftain Carrying Away his Bride*,[2] *Oriental Chieftain, The Abduction*, or *The Capture of Cassandra by Agamemnon*.[3] Marillier[4] called attention to a remarkably similar composition woven at Paris by Marc de Comans around the middle of the seventeenth century, whose subject is the flight of Melintus and Ariane.[5] Allowing for some differences of detail and setting, the composition is essentially that of this tapestry; the subject is certainly the same.

Jean Desmarets de Saint-Sorlin wrote a heroic romance entitled *Ariane*, based on the story of Ariana, a queen of Syracuse who lived during the time of Nero. The book was first published in 1632. The edition of 1639, published by Mattieu Guillemot in Paris, included eighteen plates engraved by Abraham Bosse after paintings by Claude Vignon. The composition on which this tapestry is based appears in the 1639 edition as the frontispiece to the fourth chapter of the book.[6] Like the print, though with considerable difference of detail and setting, the tapestry shows the mounted Melintus charging past three Roman warriors, clutching Ariane to his side as they rush away from the house that Nero had had set afire.

Although the series seems not to have been woven frequently, two near duplicates of this piece have survived. One, also without a border, was offered for sale in 1928 by Lord and Taylor, New York.[7] The other, with a border, was offered for sale by Turner Lord Company, London, in 1929.[8] Marillier erroneously placed that hanging among tapestries illustrating the *Story of Zenobia* and attributed it, without expressed reason, to the looms of the Mortlake manufactory in England.[9] Since these compositions were disseminated in the form of Bosse's original prints in the 1639 edition of *Ariane* and also through copies of Bosse's prints, at least two of which have been documented, one by François de Hegher at Leyden (1644) and another by J.-B. Scotin at Paris (1724), any tapestry shop in Europe could have produced hangings based on them.[10]

1 See, for example, Göbel, 1923, pls. 288, 307–10, 358.

2 Museum archives.

3 *General Catalogue*, p. 250.

4 H.C. Marillier *et al.*, *Ms. Subject Index of Tapestries*, Department of Textiles and Dress, Victoria and Albert Museum, London, n.d., III, p. 3.

5 Göbel, 1928, pp. 99, 100, pl. 65.

6 See G. Duplessis, *Catalogue de l'oeuvre d'Abraham Bosse*, Paris, 1859, no. 1119.

7 *The Art News*, XXVI, April, 1928, supplement, section 1, illus.

8 Marillier *et al.*, II, p. 55, illus.

9 *Ibid.*

10 See A. Blum, *L'Oeuvre gravé d'Abraham Bosse*, Paris, 1924, nos. 177–93.

Bibliography: *General Catalogue*, p. 250.

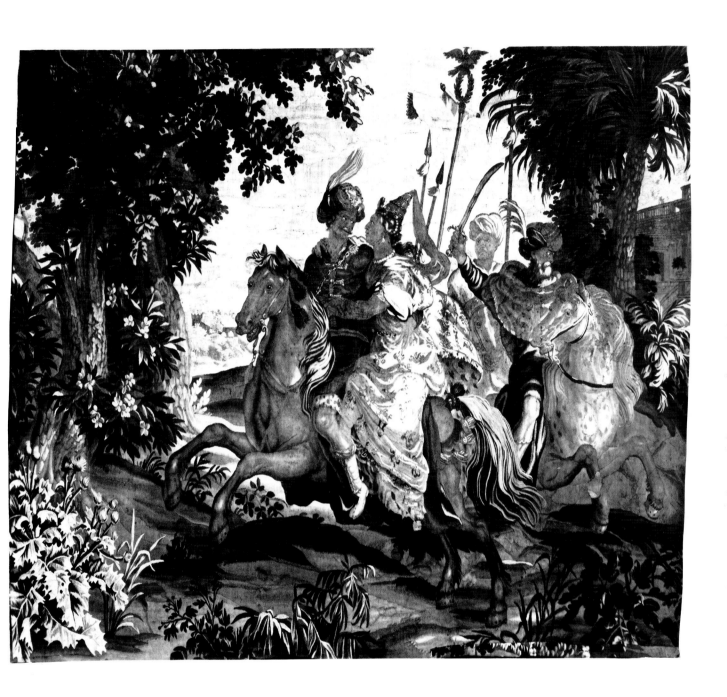

21
Shepherds Playing Music T24e1

Probably Flemish, ca. 1725–50
No city or weaver's mark present
Wool warp (6 yarns per cm.), wool and silk wefts. H. 9′4″, W. 9′11″ (2.84 x 3.03 m.)
Provenance unknown

The hanging is composed of at least four separate pieces of tapestry weaving sewn together. The individual parts appear to belong to one larger hanging but it is equally possible to regard them as fragments taken from different pieces in a single suite of tapestries. The border and the original outer guard bands are missing. There are repairs by darning throughout, but the drawing has not been seriously affected.

Tapestries of this type are classed for convenience among the general category known as "Teniers tapestries," although only certain ones were in fact designed after rustic genre scenes by David Teniers II. Teniers-like compositions were woven frequently during the entire eighteenth century, particularly in Brussels but also in Lille, Aubusson and Beauvais, as well as in England, Spain and probably also in weaving centers of lesser importance. The most closely related hangings appear to be those produced in the shop of G. Werniers at Lille (see below) and the Gardner piece may with some justification be regarded as a product of that manufactory. However, an attribution to the looms of Beauvais or of various English shops must also be considered. Neither the drawing nor the weaving is fine enough to justify an attribution to Brussels where Teniers-like tapestries of the first order were produced.

As the piece is now composed, five figures, a cow and two sheep appear at the edge of a stream in the center of the space. At the left a woman sits and plays a pipe while a man approaches from behind and prepares to embrace her. Another man, clearly a shepherd, sits at the girl's feet and turns his head away from the bagpipes he holds in order to look at her. Another shepherd and shepherdess sit at the right and converse. Each has a shepherd's crook and the man also holds a pipe like the one that the first shepherdess is playing. The figures and animals standing or lying in the grass behind them occupy a clearing in a forest. In the center, the landscape opens to show farm buildings in the middle distance, a town on a hill in the far distance, and mountains on the horizon.

The three figures at the left appear again in a tapestry signed by G. Werniers, now or formerly in the collection of the Earl of Erne, and there is another edition of it at Hunstanton Hall.[1] The setting is not identical to that in the Gardner example, but it is similar, as is the setting in another G. Werniers tapestry in the collection of the Earl of Erne, to a hanging showing a milking scene in which appear a similar cow and sheep.[2] It is likely that the weaver of the Gardner tapestry had access to cartoons used by Werniers and combined elements from different pieces of a rustic life series to create a new scene. Given the great popularity of this class of tapestries it is not surprising to find such variations and the practice was not rare.

1 See H.C. Marillier, *Handbook to the Teniers Tapestries*, London, 1932, pp. 73, 85, pl. 57b.
2 *Ibid.*, p. 85, pl. 58.

Bibliography: *General Catalogue*, p. 196.

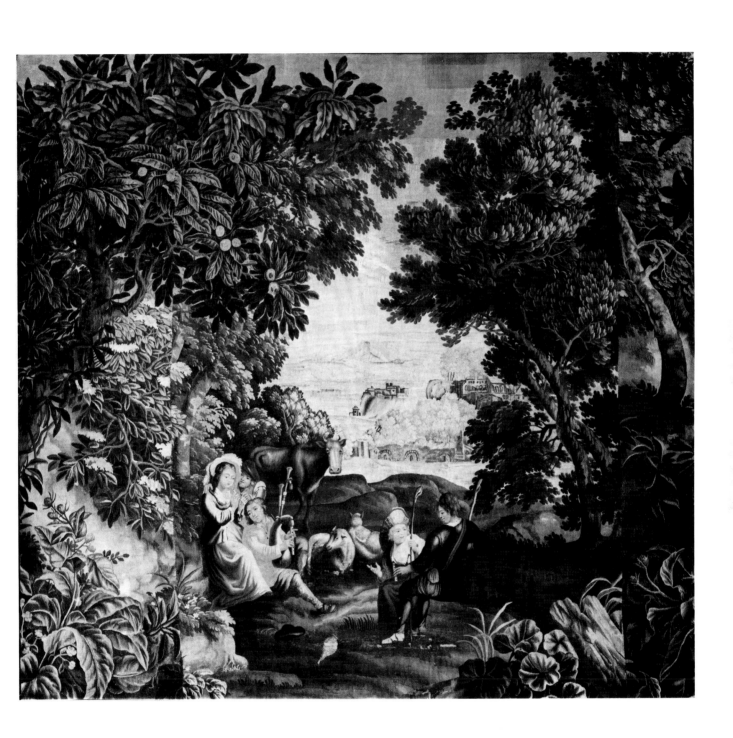

22
Two Men Handling Cargo T19w36
Probably Flemish, Brussels (?), 1750–75
No city or weaver's mark present
Wool warp (7 yarns per cm.), wool and silk wefts. H. 7'2½", W. 4'3" (2.20 x 1.30 m.)
Provenance unknown

The tapestry has been cut on all four sides and appears to be a fragment of a larger hanging. A narrow border or guard has been sewn to the edges of the fabric; it appears to be modern. The fabric shows some wear and repair but the drawing has not been affected.

A tree rises from the left foreground and its foliage occupies the upper half of the field. Beyond the base of the tree two men are engaged in moving a barrel and a bale, preparing to load them aboard a barge that is tied up at the river bank next to them. Part of a walled city or fortress rises in the middle distance at the right and beyond it the high land slopes down to the horizon where the river meets the sea in the far distance at the left.

This composition represents the right half of the left-most quarter of a wider composition that Boccara entitled *Le Marchand d'Epices* and dated about 1775.[1] That tapestry, formerly in Boccara's collection, shows a turbaned man standing at the right of the two figures loading the barge, apparently supervising their work. To his right, a man poles his barge down the river; at the right end of the composition a man standing in the river hauls in his net while a woman sits on the shore beyond him, apparently filling a keg with fish. The landscape is much wider and deeper than the Gardner fragment suggests. However, although the latter has been cut down from a larger piece, certain corrections in the cartoon indicate that the fabric never extended much farther to the right. Specifically, the figure of the turbaned supervisor was removed, and the bits of foliage and distant view that his body obscures in the full version of the composition have been restored in the Gardner version so that the deletion would not be noticed.

Boccara,[2] following Ffoulke,[3] considered this composition and two others like it[4] to have been derived from compositions by the celebrated marine painter Joseph Vernet and attributed them to Aubusson. Neither author supported these views with evidence. Göbel illustrated another version of one of the Boccara tapestries but did not attribute the design to Vernet.[5] Although similar kinds of scenes are to be found in Vernet's paintings, they are not uncommon among a class of Brussels *genre* tapestries that enjoyed great popularity during the second and third quarters of the eighteenth century.[6] The fine texture and quality of execution of the Gardner fragment are characteristic of Brussels work of this period and quite different from Aubusson work.

The narrow border surrounding this piece corresponds in design to the innermost band of the wider border that enframes the Boccara tapestries.[7] The former may have been copied from the latter or from a common source; there is no evidence that the four pieces ever belonged to a single set of hangings. One of the Boccara tapestries[8] shows the date 1776 on a barrel head and it seems likely that this represents either the date of the cartoon or the date of weaving.

1 Boccara, p. 207, illus.
2 *Ibid.*
3 Ffoulke, p. 297.
4 Boccara, pp. 210, 211, illus.
5 Göbel, 1928, pls. 288, 289.
6 See particularly a series of examples in Vienna: Baldass, 1920, pls. 293–99.
7 Boccara, pp. 207, 210, 211, illus.
8 *Ibid.*, p. 210.

Bibliography: *General Catalogue*, pp. 165, 166.

23
Amorino Offering Flowers to a Sleeping Nymph T18w14

French, Beauvais or Gobelins, 1755–75, or possibly later
No city or weaver's mark present
Wool warp (9 yarns per cm.), wool and silk wefts. H. 22″, W. 28½″ (55.88 x 72.39 cm.)
Purchased through Fernand Robert from Larcade, Paris, 1907

The tapestry is in nearly perfect condition. A dark blue border frames the composition, and the warp yarns, which run vertically, extend for some distance beyond the outer edge of this border. This indicates that the medallion was not cut out of a larger hanging or cover for the back of a sofa, but was indeed woven to shape and meant to be framed, perhaps in a wall panel or screen. Although it is rare to find European tapestries having a warp parallel to the height rather than the width, the orientation is not uncommon in small tapestries whose design depends for its effect on the exact rendering of small details, as this one does. A number of eighteenth-century tapestry portraits show this peculiarity; see, for example, a portrait of a fortune teller woven at the Gobelins in 1771.[1]

A female nude lies voluptuously asleep on cushions amidst draperies, her figure extending diagonally along the wide axis of the oval. From the back an amorino regards her adoringly and leans forward to offer her flowers with his right hand; his left clutches more flowers to his breast. Trees and shrubs rise against the sky in the upper right.

Although the figures, setting and palette evoke the mood of all the tapestries that François Boucher designed for Beauvais and also the Gobelins, this piece does not repeat any specific motif, even from the *Story of Psyche* or the *Loves of the Gods*, which the Gardner piece otherwise recalls. It is clear that one of the finest French manufactories commissioned a cartoon painter to draw on Boucher's work and create a new composition in his style. Either the Gobelins or Beauvais manufactories could have produced this piece but there is no known record of it. Both factories revived compositions in the Louis XV style at the end of the last century, including designs after Boucher or conceived in his style, often with the warp running vertically in the small furnishing pieces. However, the lack of any revivalist sentimentality in the rendering of the forms and the wide range of tints in the palette argue for a date in the third quarter of the eighteenth century but not before 1754, the date of one of the sources this designer used (see below). The figure of the nymph was taken from a lost painting that Boucher executed for M. le Normant de Tournehem and received payment for on December 26, 1748.[2] This canvas, referred to as *Deux Nymphes de Diane au retour de la chasse*, was part of the Royal Collection; it disappeared after 1847.[3] The composition is known from two painted copies, two engravings and two drawings. One of the latter shows Boucher's signature; it is also the one that most nearly resembles the tapestry, though in reverse.[4] One of the engravings, by J.-B. Michel, shows the setting with trees but with significant variations in the positions of the hands and the entire image reversed.[5] The figure of the amorino comes from another source in Boucher's *oeuvre*, a painting in the Wallace Collection, London, known as *Love Giving an Apple to Venus*.[6] Although there are slight variations, there can be no doubt that the cartoon painter drew on this composition for his design. In fact, he copied the painting so exactly that the little boy's eyes do not focus on the nymph's head but slightly above it, as they do in the painting. The composition, which dates from 1754, is also known from an engraving by Louis Marin Bonnet.[7]

1 Baldass, 1920, pl. 258.
2 A. Ananoff and D. Wildenstein, *François Boucher: Catalogue des peintures,* Lausanne and Paris, 1976, II, p. 8, no. 312.
3 *Ibid.*
4 *Ibid.,* p. 8, no. 312/2b, fig. 898.
5 *Ibid.,* no. 312/2a, fig. 897.
6 *Ibid.,* p. 123, no. 433, fig. 1242.
7 *Ibid.,* no. 433/1, not illus.

Bibliography: *General Catalogue,* p. 139.

detail of No. 138
Furnishing Fabric

Western Textiles

24
Upholstery for a Chest F26s6

Persian (?), XVII century or later
Silk velvet, voided and cut. H. 29¼", L. 26½",
D. 20" (74.2 x 67.25 x 50.8 cm.)
Purchased from M. Guggenheim, Venice, 1897

detail, 24

The chest is covered with a velvet fabric that shows medallions containing pomegranates growing from undulating stems among which also appear pairs of addorsed birds and affronted peacocks. The pattern is rendered in red and blue pile on a ground that is now white but that was originally silver, as the traces of the tarnished silver yarns still bound into the ground weave prove.

Similar furnishing velvets have been attributed to looms in Kashan, Persia, in the sixteenth or seventeenth centuries.[1] There is a piece of a similar velvet in the M.H. de Young Museum, San Francisco,[2] but it is not voided and the drawing is finer than that in the Gardner fabric. The drawing in both pieces seems more mannered than that usually found in Safavid velvets.

It has been suggested that the Gardner example may date from the nineteenth century; the possibility is worth considering given the technical difference from similar pieces, as well as the differences in drawing that distinguish it from a typical seventeenth-century Safavid velvet.[3] Longstreet's observation that the velvet might have been woven in Europe has some merit.[4] However, his suggestion that it was made in Venice during the seventeenth or eighteenth century is unlikely since the pattern was outmoded by then and Venice was still in the forefront of fashion as a weaving center. On the other hand, the oriental pattern would have found favor in fashionable European society—whether it was made in Europe or Persia—during the latter part of the nineteenth century or the early years of the twentieth.

1 *2,000 Years of Silk Weaving*, Los Angeles County Museum, Cleveland Museum of Art, and Detroit Institute of Arts, New York, 1944, No. 251, p. 34, illus. p. 60; also Weibel, Nos. 140 and 141, p. 122, figs. 140 and 141.
2 *Ibid.*, No. 140.
3 *Ibid.*, No. 141.
4 *General Catalogue*, p. 216.

Bibliography: *General Catalogue*, p. 216.

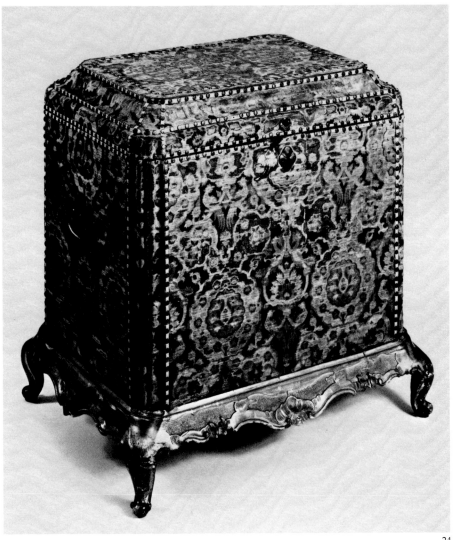

24

25
Covers for a Settee F21e23
French or Netherlandish, 1650–1725; the back possibly later
Linen tabby, embroidered with wool and silk yarns in large and small tent stitches. H. 43⅝", L. 74½", D. 22¼" (108.5 x 189.2 x 56.5 cm.)
Seat back: H. 28", L. 74½"
Seat cover: H. 28", L. 74½" (71.1 x 189.2 cm.)
Provenance unknown

The back shows two rows of figure compositions contained in ten rectangular compartments, five in each row. From left to right, the compartments in the upper row contain the following figures: two men in a garden, one sowing, the other ploughing; a man reaching up into the branches of an oak tree; a man sweeping a path (?) in a garden, followed by a woman; a woman kneeling beside a reclining man while swans draw a chariot in the sky above; a man looking upward into the sky where a bird attacks a crane. The lower compositions show, left to right: two men and a woman seated at a table in an interior; a young man and an old man wearing

a turban seated in a courtyard before a fire; a hunter with hounds pursuing a doe; men gathering wood; a man and woman seated in a garden. The backgrounds are rendered in light tones; the borders of the compartments have white grounds and contain undulating vines bearing leaves, fruits and flowers and harboring birds, rabbits, deer, boar, dogs, masks and dragons.

The seat cover, worked in the same technique and with the same materials, shows twelve rectangular compartments in two rows, the units separated by a border resembling, but not precisely the same as, the border used in the cover for the back. This border also has a white ground, but the grounds within the twelve compartments are black. Each compartment contains a single animal, some of them appearing on the seat twice; they include an ass, dog, elephant, fox, griffon, horse, leopard, squirrel, and stag.

While it is characteristic of furniture covers of the period to show human beings on the back but not the seats, the great discrepancy of style and workmanship between the back and seat covers of this piece (even taking into account that the back seems to have been reworked almost entirely) argues that they were not originally part of the same settee. The ears of the settee have been covered on their inside surfaces with pieces of needlework that resemble the seat cover so closely as to suggest that they might have been cut from the original back cover. Furthermore, the front edges of the ears are now covered with what appear to be center borders cut out of the height and width of the two sections covering the ears. Since these sections show vertical terminal borders at their inner edges, it seems clear that they were probably left and right ends of the original cover for the back. If the borders now covering the front edges of the ears were put back into place, the sections of needlework inside the ears would measure the same height as the back of the settee. This suggests that they were part of the original cover for the back. The present back cover, which in style, color and workmanship bears little relation to the seat cover, was either taken from another piece of furniture and heavily reworked or, possibly, made to order in modern times.

The subjects of the compositions on the back defy interpretation. Some of them suggest proverbs, others biblical subjects, and others occupations of the months or seasons. The designer took subjects from various print sources of emblem books and combined them to spell out an iconographic scheme that is now obscure. It is also possible that he or she selected the subjects entirely at random.

Bibliography: *General Catalogue*, p. 188, where the settee itself is ascribed to the nineteenth century, but such a date for the frame would not affect that of the needlework.

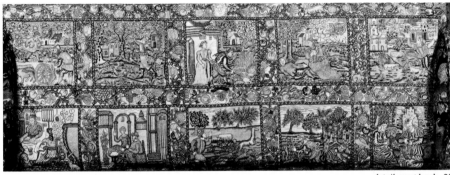

detail, seat back, 25

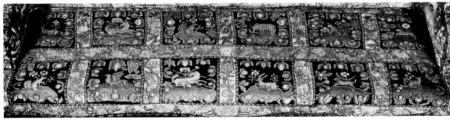

detail, seat cover, 25

26
Covers for a Settee F19w59

French or Netherlandish, 1675–1725
Linen tabby, embroidered with polychrome
wool and silk yarns primarily in large tent
stitches with touches of small tent stitches.
H. 41¼", L. 60¾", D. 27½" (104.7 x 154.2 x
69.8 cm.)
Provenance unknown

The back, two cushions, insides and
fronts of the ears, and the arms show
dark brown grounds (perhaps origi-
nally black) covered with figures and
floral motifs rendered in natural
colors. The yarns are wool with
touches of silk, worked in large
stitches, with human faces and some
other parts of the figures worked in
small stitches. The needlework is
faded, worn and much repaired with
later stitches and yarns.

The back shows a scattering of flow-
ering plants surrounding single fig-
ures and groups of figures. These
include a woman dancing with a man
dressed as Pantaloon, men seated or
standing, a man carrying two buck-
ets, a turbaned man in long robes rid-
ing a fabulous beast that is part turtle
and part camel, and a crowned man
and a woman seated at a table under
a gabled roof or canopy with pen-
nants flying from poles at its ends.
In the center, butterflies fly around
the figure of a displaying peacock.

The tops of the two square cushions
forming the seat each show a wreath
containing a rose bush. Flowers are
sprinkled around each wreath as well
as on the fronts of each cushion, the
front rail of the frame below, and on
the ears and arms.

The figure compositions on the back
were taken from various unidentified
sources; for example, the dancing
couple is from a source similar to the
pastoral engravings of Claudine
Bouzonnet Stella.[1]

1 See N.G. Cabot, "Engravings and
Embroideries," *Antiques,* XL, 1941, pp. 367–69;
idem, "Engravings as Pattern Sources,"
Antiques, LVIII, 1950, pp. 476–81.

Bibliography: *General Catalogue,* p. 169.

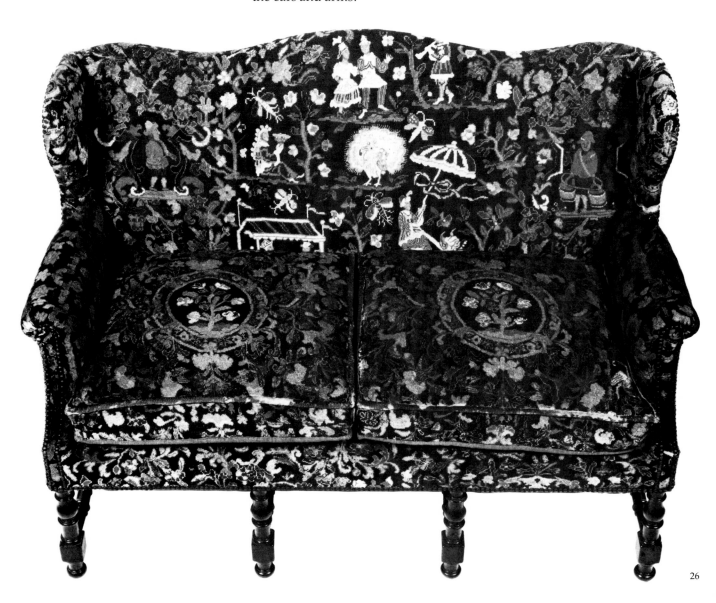

26

27
Covers for Stools F26n82, F26n83
French (?), 1675–1725
Linen tabby, embroidered with polychrome wool yarns with touches of silk, in large tent stitches and some small tent stitches.
a. F26n82: H. 16″, W. 21″ (40.6 x 53.3 cm.)
b. F26n83: H. 16″, W. 19½″ (40.6 x 49.5 cm.)
Provenance unknown

The embroideries cover only the top of each stool; the thickness of the padding is covered at the sides with modern velvet. Both tops are worn, discolored and much repaired.

One of the rectangular covers shows a black ground against which two couples dance at the base of an apple tree, accompanied by a man blowing a horn in the branches above; another male figure is in the lower right corner. Plants grow in the foreground and flowering trees rise at left and right. The women in this composition wear the high headdress *(fontange)* of the late seventeenth and early eighteenth centuries.

The other cover shows an open landscape surrounding a great fruit tree; there is a fountain at the left and a figure rushing toward the right. A lion leaps out of the scene in the lower right corner, and a shape obscured by the worn and repaired condition of the needlework lies on the ground between the figure and the lion. The presence of a fountain with a rushing figure, a lion and, perhaps, another figure on the ground suggests that this scene represents the final moment in the tragic story of Pyramus and Thisbe. If so, it is likely that the simple pastoral scene on the other stool cover was not originally a companion to this piece.

Bibliography: *General Catalogue,* p. 222.

28
Covers for Stools F17w31–s–1, F17w31–s–2
1800–48
Isabella Tod Stewart (American, 1778–1848)
Linen tabby embroidered with polychrome wool yarns and touches of silk, in large and small tent stitches.
a. F17w31–s–1. Top: L. 11⅞″, W. 11⅞″ (30.2 x 30.2 cm.); Edge: 4½″ (11.4 cm.)
b. F17w31–s–2. Top: L. 12¼″, W. 12¾″ (31.1 x 32.4 cm.); Edge: 4½″ (11.4 cm.)

The two covers show related patterns. The square tops of both feature a roundel in the center and leafy sprigs in the four corners. One of the roundels contains a basket of fruit, the other a basket of flowers. The grounds are worked with dark brown (perhaps originally black) large stitches. The centers of the roundels have small stitches in various colors, now faded to neutral shades of beige, brown and green. The same colors appear in the corner sprigs and in the conventionalized pattern on the covers for the side panels that show rows of leaves laid over straight ribbons.

According to the Museum archives, in 1919 Mrs. Gardner told Morris Carter, her secretary and, after her death, the first director of the Museum, that her grandmother (Isabella Tod Stewart) had embroidered these stool covers.

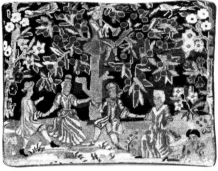

27a

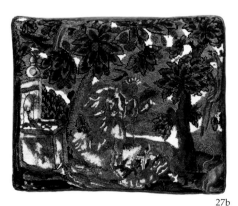

27b

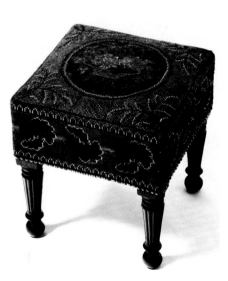

28a

28b

29
Cover or Scarf T19w24

Raymond Duncan (American, 1874–1967)
Silk tabby, printed and painted with dyes or transparent pigments. L. 23", W. 21⅝"
(58.4 x 54.9 cm.)
Gift of Louis Kronberg, 1921

Raymond Duncan, brother of Isadora, was born in San Francisco but emigrated first to London and then to Paris where he established a school for weaving and needlework. His aesthetic theories were based on a conviction that Greek art should be used as a primary inspiration for modern life; in Paris he affected dress in the classical style. This small scarf or cover, with its representation of a simple pastoral landscape repeated several times, may have been inspired by a late Hellenistic mosaic or painting.

The fabric is made of fine tabby-woven silk. The main contours have been printed in black by using a block, and the artist's signature in the lower right appears also to have been block-printed. The motif repeats irregularly in the wide border framing a plain yellowish center square, sometimes not rendering the full height or width of the pattern unit. It shows a tree with spreading branches and some shrubs in the foreground and two more trees in the distance. The tree trunks are painted tan, the clumps of foliage pinkish tan, a tone that is also used in the two guard bands of guilloche ornament that flank the border of trees.

Bibliography: *General Catalogue*, pp. 164, 165.

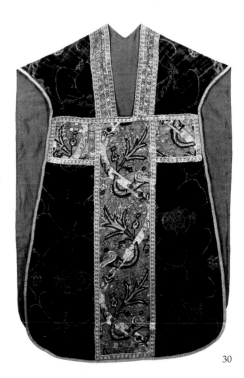

30

29

30
Chasuble T28w17

Italian or Spanish, 1500–50
Silk velvet, voided and cut; orphrey of linen tabby embroidered with polychrome silk yarns chiefly in Gobelins stitches with touches of stem and chain stitch. L. 41", W. 27¾" (104.1 x 70.5 cm.)
Provenance unknown

The vestment is covered with green velvet showing a pomegranate pattern of the *ferronerie* type; the fabric is used upright on the back and on its side on the front. The orphrey is in the form of a vertical band on the back and, on the front, a cross that bifurcates at the bottom of the neckline and sends arms upward and over the shoulders to meet in a chevron behind the neck. The embroidery, which is much worn, shows in the main sections two undulating systems of branches, one white and orange, the other green; the latter, bearing acanthus leaves, pomegranates and berries, occasionally penetrates the former. A green and white silk galloon borders all the embroidered elements. The vestment is lined with modern green sateen and edged with modern orange galloon.

Bibliography: *General Catalogue*, p. 255.

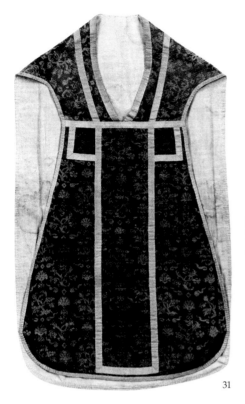

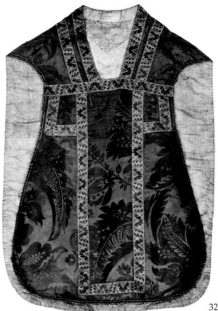

31

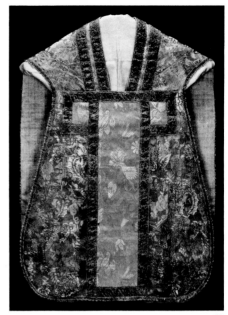

32

33

31
Chasuble

Italian, 1625–50
Silk damask. L. 40½", W. 24" (102.9 x 61 cm.)
Provenance unknown

The chasuble is covered with yellow-green damask showing a scatter of rose and carnation sprigs. Since the texture of the weave is rather coarse, the fabric is thick and causes the pattern motifs to rise slightly above the plane of the ground. Yellow silk galloon defines the orphrey cross on the front and the center strip on the back. Narrower galloon of the same kind trims all the edges of the vestment. It is lined with undyed linen cloth.

32
Chasuble

Italian, 1650–1750
Silk damask. L. 39⅜", W. 28½" (99.7 x 72.4 cm.)
Purchased from Moisè dalla Torre, Venice, September 10, 1897

Both the front and back of the chasuble are covered with pieces of the same green damask showing the standard large-leaf furnishing pattern of the period (see Nos. 153, 154). Strips of gilt galloon border the central panels of the damask; together these form the orphrey, which appears as a cross on the front and as a vertical strip on the back, below a chevron that passes behind the neck. A narrower, scalloped galloon is sewn to the edge of the vestment. The damask covering the back of the chasuble is worn but is repaired with long, double running stitches that hold the loose weft yarns in place. A stole and burse made of the same damask, and a maniple of the same or a very similar fabric, are also in the collection (T17w4, T17w20, T17w25).

33
Chasuble T16s17

Italian or French, 1700–25
Silk damask and fancy compound satin, both brocaded. L. 39½", W. 29" (100.4 x 73.7 cm.)
Provenance unknown

A damask fabric, showing a pink ground and polychrome and gilt floral pattern, is used for the body of the vestment. The satin, which is also pink with polychrome silk and metallic pattern yarns, serves as the orphrey and is bordered with wide gilt galloon. Narrower gilt galloon is sewn to the edge of the vestment. The chasuble is lined with plain blue linen cloth that appears to be old but only recently applied here.

Bibliography: *General Catalogue*, p. 110.

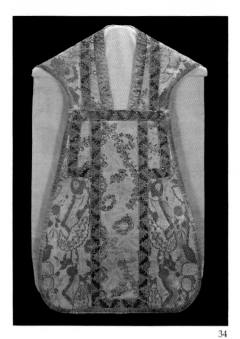

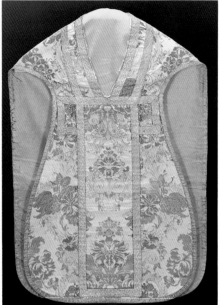

34

35

34
Chasuble

Italian or French, 1700–25
Silk fancy compound cloth, brocaded. L. 41,"
W. 29⅝" (104.1 x 75.2 cm.)
Provenance unknown

Both the front and the back of the chasuble are covered with three lengths of the same fabric, the pattern matching across the seams. The ribbed brocade shows an ivory ground decorated with silk yarns in shades of rust, green, blue, red and lavender. The yarns form a symmetrical floral pattern that was fashionable in the first quarter of the eighteenth century; it shows conventionalized leaves, blossoms and fruits along with scrolls and more naturalistically drawn tulips. Strips of gilt galloon delineate the shape of an orphrey on the front (a cross) and on the back (a strip below a chevron). The chasuble is lined with plain yellow silk cloth, now patched, and, at the neckline, with a narrow strip of bobbin lace. A stole and burse in the collection (in storage) are covered and lined with the same silks as the chasuble and appear to belong to the same set of vestments.

35
Chasuble T16s19

Italian or French, 1725–50
Silk fancy compound satins, brocaded.
L. 42½", W. 27" (108 x 68.6 cm.)
Provenance unknown

The body of the vestment is covered with pink satin, patterned with polychrome silk yarns and metal yarns in the style of the so-called "lace pattern" silks of the first quarter of the eighteenth century. The orphrey is made of yellow satin, patterned with the same materials, but in the style of the middle years of the century. It is bordered with gilt galloon on the front, and silver galloon on the back. Narrow silver galloon serves as an edging around the vestment. It is lined with plain linen cloth.

Bibliography: *General Catalogue*, p. 110.

36
Cope T27w30

Italian, 1475–1525
Silk velvet, voided and cut; orphrey of linen tabby embroidered with polychrome silk yarns and gilt yarns chiefly in long and short and split stitches and *or nué* and couched work.
L. 53½", W. 119" (135.8 x 302 cm.)
Purchased from Villegas, Rome, 1895

The cope is covered with five lengths of very fine bluish green velvet showing a delicate pomegranate pattern of the *ferronerie* type, not matched across the seams. The fabric is in excellent condition. It shows none of the wear, fading or deterioration that characterize the orphrey and hood that now adorn the vestment. Because of their comparatively poor condition, the orphrey and hood probably did not originally belong with this cope. Also, the figure style appears to be later in date than the velvet.

The orphrey shows six compartments, three on either side of the hood in the center, each of which contains the single figure of a saint or the Virgin, as follows (left to right): St. Anthony of Padua, St. Louis of France (?), the Madonna, St. John the Evangelist, St. Jerome, and St. Bernardino. The hood shows St. Francis receiving the stigmata; it is trimmed with narrow gilt fringe and a great gilt tassel. Its border shows one kind of couching, while the compartment borders of the orphrey show a different kind of fancy couching for the gilt yarns covering them.

Bibliography: *General Catalogue*, pp. 243, 244.

37
Cope T27w29

Italian, 1500–25
Silk velvet, voided and cut; orphrey of linen tabby embroidered with polychrome silk yarns and gilt yarns chiefly in long and short split stitches and *or nué* and couched work. L. 51", W. 108" (129.5 x 274.3 cm.)
Purchased from Villegas, Rome, 1895

The cope is covered with six lengths of velvet, showing rows of pomegranates in ogival compartments between undulating rows of rosettes. The

pattern is defined by the contrast between the dark green pile and the bright gilt ground.

The orphrey contains six rectangular compartments. Each shows a scene from the life of Christ, identified tentatively as follows (left to right): Christ healing the woman with an issue of blood; Christ healing Peter's mother-in-law; Christ about to be stoned; Christ driving the money-changers from the temple; Christ and the woman taken in adultery; and Christ blessing the children. The hood, which may have come from another vestment, shows the coronation of the Virgin. Identification of the other scenes is made difficult by the advanced deterioration of the materials used in the narrative compositions. However, the gilt yarns couched over high padding are better preserved. They render the details of the double-arched settings, which are richly ornamented with elaborately fluted column and foliate relief sculpture. The hood has a border of couched gilt yarns, knotted gilt fringe and a gilt tassel.

Bibliography: *General Catalogue,* p. 243.

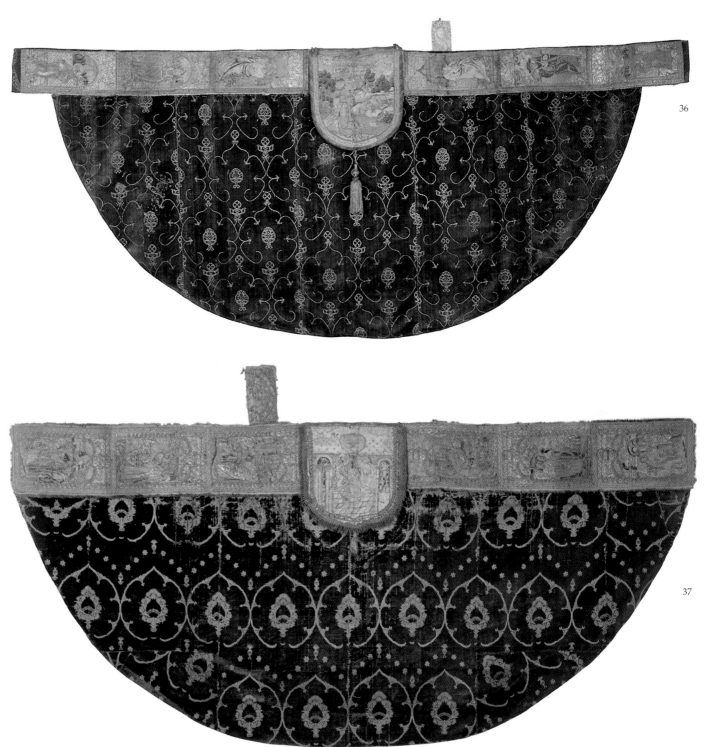

36

37

38
Cope T16s16

Italian, 1550–1600
Silk velvet, voided and ciselé. L. 51″, W. 108″
(129.5 x 274.3 cm.)
Purchased from Consiglio Ricchetti, Venice,
May 16, 1896, through R. W. Curtis

The vestment is covered with lengths
of velvet oriented vertically. The
orphrey is made of narrower lengths
of the same fabric used horizontally,
the pattern oriented inward from
each end toward the center, and bor-
dered with galloon. The hood is also
made of the same fabric and trimmed
with gilt galloon and gilt and red
fringe.

The pattern shows a network of bifur-
cating stems bearing two different
pomegranate motifs. These appear in
alternating rows within the ogival
compartments that the meandering
stems define. One pomegranate unit
shows a carnation at its top and prim-
roses at the sides; the other has a rose
at the top and six carnations at the
sides. Knots of spotted ribbon are
wrapped around the stems at inter-
vals. The motifs appear in crimson
cut and uncut pile against a white
ground that is now so worn and
repaired as to make it difficult to
determine whether silver yarns once
covered the silk ground weave.

Bibliography: *General Catalogue*, p. 110.

39
Cope T3s24

Italian or French, 1700–25
Silk: compound tabby brocaded with silk
yarns. L. 57″, W. 111″ (143 x 278 cm.)
Purchased from A. Clerle, Venice, September
18, 1894

The vestment is covered with lengths
of the silk; the pattern is oriented
upright on the body and horizontally
in the orphrey section. Wide gilt gal-
loon is used to trim the edges of the
garment and the orphrey. The silk
shows a rich pattern of counter-
undulating ribbons made of flowers,
leaves and lace. They are rendered
with white, pink, green and blue
yarns bound in weft twill weave
against the ground of pale blue
ribbed tabby.

Bibliography: *General Catalogue*, p. 30.

40
Cope T18w13

Italian or French, 1700–25
Silk compound satins, brocaded with silk
yarns. L. 52½″, W. 108″ (133.3 x 274.3 cm.)
Provenance unknown

Narrow strips of satin used upright
cover the body of the vestment. They
show a pattern of undulating, lacy
ribbons intertwined with fantastic
flowers and fruits in orange and
white against the dark green ground.
An orphrey made of a different com-
pound satin, showing polychrome
floral sprays against a light blue
ground, appears along the straight
edge. The outer edges of the vest-
ment and the inner edge of the
orphrey are trimmed with gilt gal-
loon. Also in the Museum is the hood
belonging to this cope (T17w19).

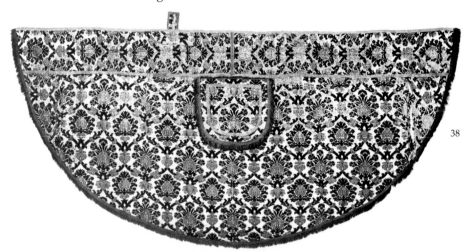

38

39

40

41
Dalmatic T27w4

Italian, 1450–1500
Silk velvet, voided and cut. L. 47″, W. 53½″
(119.4 x 135.9 cm.)
Purchased in Rome or Venice, 1895

The vestment is covered with lengths of red velvet showing a pomegranate pattern of the *ferronerie* type. A full width of velvet runs down the center of the front. It is flanked by narrower lengths of the fabric but the pattern is not matched with the units in the central portion. There are no orphrey or apparels, but all the edges are trimmed with narrow gilt galloon.

Bibliography: *General Catalogue*, p. 253.

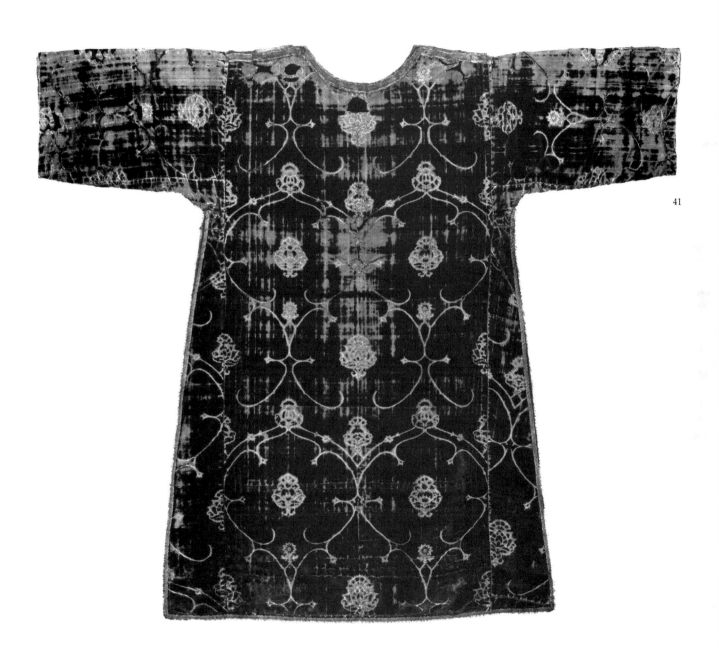

41

42
Stole T17w7

Italian or French, 1750–75
Silk fancy cloth. L. 90", W. 4⅜" (228.5 x 11.1
cm.)
Provenance unknown

The stole is faced with pink ribbed
silk showing a pattern of the same
color, bound in weft twill weave.
Large floral sprays appear among the
curves of a meandering ribbon com-
posed of leaves and blossoms. There
are no crosses on the stole, nor any
edge trimmings.

43
Maniple

Italian or French, 1725–50
Silk fancy compound cloth, brocaded.
L. 36⁹⁄₁₆", W. 4¼" (92.8 x 10.7 cm.)
Provenance unknown

The maniple is covered with ribbed
silk showing a pattern of scrolling
branches, leaves and flowers in
shades of pink, yellow, green, blue
and lavender against an ivory
ground. At each end there is a cross
made of bright gilt galloon; the edges
are trimmed with narrower gilt gal-
loon and fringe.

44
Gown for a Statuette of the Virgin T17w41

Italian or Spanish, 1575–1625
Silk fancy compound satin, brocaded. L. 18",
W. 20⅝"–32⅝" (45.7 x 52.4–82.9 cm.)
Provenance unknown

The gown has a pleated bodice, short
sleeves with "wings" at the shoulders
and a tapered skirt prepared for a
conical support; it is open at the back
and partially lined with yellow silk
cloth. It is made of the same fabric
that was used for the top of a bodice,
for a young woman or larger statue of
the Virgin, that is also preserved in
the collection (in storage), as well
as for a case lining in the gilt corner
cabinet in the Little Salon (F18s8).
Longstreet considered this to be a
baby's dress,[1] but its construction
and very small size indicate that it
was made for a miniature figure of
the Virgin to be used on festival
occasions.

1 General Catalogue, p. 122.

Bibliography: General Catalogue, p. 122.

45
Matador's Cape (Capa de Paseo)

Spanish, 1875–1900, altered later
Silk: satin embroidered with couched gilt cord,
purl, sequins and bosses, and with faceted bits
of mirrored glass. L. 74", W. 113½" (188 x
288.3 cm.)
Provenance unknown

The pinkish red cape is semi-circular
in shape and has a narrow standing
collar bordered by a cape-collar of
embroidered satin that conforms to
the semi-circular shape of the neck-
line. The cape was originally some
twelve inches shorter than it now is,
as the disposition of the embroidered
pattern and also the worn condition
of the original hemline indicate. A
band of the same pinkish red satin
has been pieced together and sewn
along the original hemline, and the
entire garment is lined with modern
changeable red/mauve silk tabby.
These alterations suggest that the
cape was converted for use as a wom-
an's evening cape.

Bands of gilt needlework border the
straight edges of the cape, the wide
collar, and both sides of the lower
part of the back center seam. They
come together halfway up this seam
to form a pointed arch. All embroi-
dered bands terminate at the original
hemline, and the two bands along the
straight edges of the semi-circle con-
tinue under the cape-collar to termi-
nate at the neckline itself. Each band
of needlework shows a leafy bifurcat-
ing vine along its center. The open
spaces between the branches of the
vine contain rosettes with centers of
mirrored glass; rows of guilloche
ornament flank the vine, and lines of
sequins in turn flank the guilloche
motifs. Along the inner edge of each
band there is a row of rosette sprigs.[1]

The capa de paseo was part of the cos-
tume that a matador wore for his cer-
emonial entrance into the bull ring.[1]

1 For similar examples, see M. Tilke, Kostüm-
schnitte und Gewandformen . . . Tübingen, 1948,
pl. 67, fig. 8, and pp. 32ff. Also see W. Bruhn
and M. Tilke, Kostümgeschichte in Bildern, Tüb-
ingen, 1955, pl. 130, fig. 1 and p. 50. For a red
cape with a similar ornament and a simpler
blue cape, shown over the edge of the lowest
stalls in a bull ring, see a painting by A. Liz-
cano, illustrated in N. Luján, Historia del toreo,
Barcelona, 1954, pl. opp. p. 208.

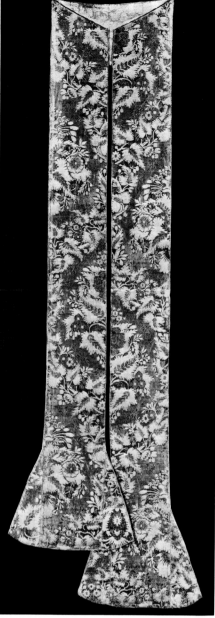

42

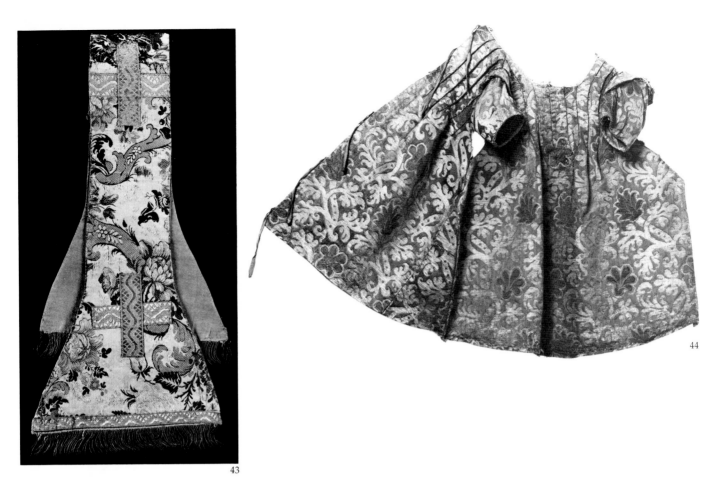

43

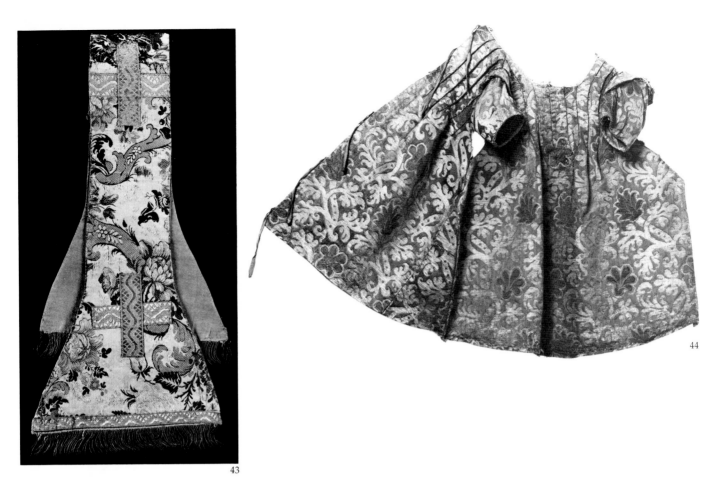

44

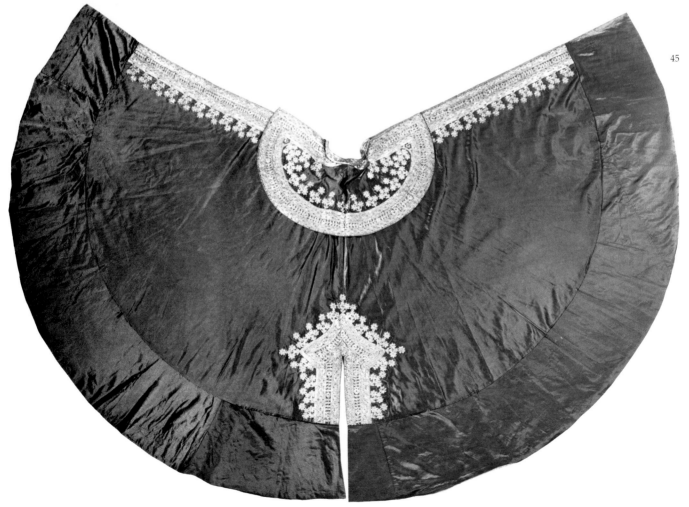

45

46

Sleeved Waistcoat and Matching Breeches from the Costume of a Litter-Bearer (Sedario) of Pope Leo XIII

Italian, 1878–90
Silk velvet, voided and ciselé.
a. Waistcoat: L. 37½″, W. 20″ (95.3 x 50.8 cm.)
b. Breeches: L. 34¼″, W. 21½″ (86.9 x 54.6 cm.)
Purchased in Italy, 1895

The waistcoat is cut in the style of the first half of the eighteenth century with long, wide skirts that are slit and deeply pleated at the sides and the center back, a high round neckline, a short standing collar, and slightly curved flat sleeves. Except for the sleeves, which are made of crimson satin matching the velvet, the

garment is made of patterned ciselé velvet. It differs from the eighteenth-century prototype in having shoulder "wings" of pleated velvet and lappets hanging from the back of each shoulder, also made of the same velvet. There are three silk-covered buttons at the bottom of each lappet; eight buttons flank the pleats at the sides of the skirts with eight silk loops corresponding to them on the other side of the openings. There are fourteen buttonholes (only the top three of which are cut through) along the front closing; eleven of the corresponding buttons remain. The waistcoat is lined with glazed linen cloth and has linen patch pockets at breast and hip height on the left side and hip height

on the right side. The front closing is faced with crimson silk cloth and the sleeves have short cuffs of machine-made Valenciennes lace.

The breeches also reflect the style of the first half of the eighteenth century. They have a drop front closing over two bands that button across the front and an adjustable waistband with a metal buckle at the back. The outer seams are slit for a short distance at the knees, backed with crimson silk cloth and closed with four silk-covered buttons and matching silk loops. The buttons on the front closing are made of bone or metal. The breeches are lined with linen cloth.

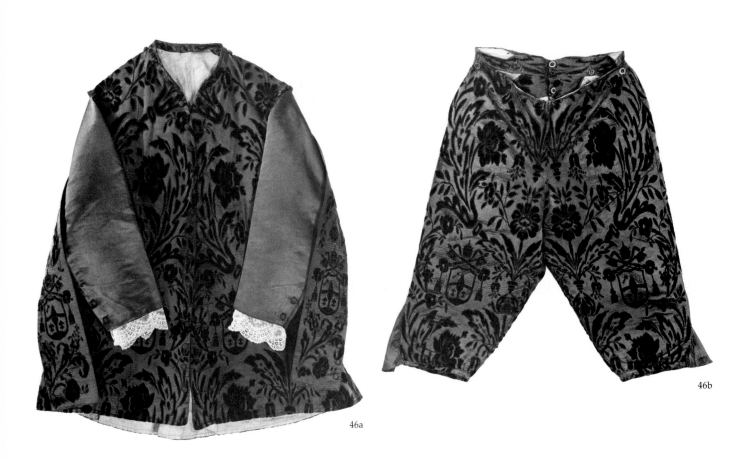

46a

46b

The crimson velvet used for both the waistcoat and the breeches shows a pattern of vases of roses set among undulating branches bearing acanthus leaves. In one row, the vases are replaced by a coat of arms showing the papal tiara and crossed keys surmounting a shield bearing the arms of Pecci, the family arms of Gioacchino Vincenzo Pecci (1810–1903), who was elected Pope as Leo XIII in 1878. Since the velvet pattern was based on a point repeat system, in which the left half of the fabric shows the mirror image of the pattern in the right half, one of the coats of arms in each repeat is rendered incorrectly in reverse.

Waistcoats and breeches like this were made for members of the papal court who served as litter-carriers when the Pope was carried on his chair of office (the *Sedia Gestatoria*) in solemn processions on great pontifical occasions, for example when the Pope carried the Sacrament in the procession of the Corpus Domini. The chair was set on the center of the litter, which was carried on the shoulders of twelve lower officers of the Papal Court, call *Sedari*. Eight other men walked with the *Sedari* and held the poles of a canopy over the Pontiff's head. The *Sedario's* costume was completed with a long-sleeved crimson coat, crimson stockings, black pumps with gold buckles at the instep and a white jabot falling from a narrow white collar.[1]

1 See P. Hélyot and G. Perugini, *Album ou collection complète et historique des costumes de la cour de Rome...*, 2nd ed., Paris, 1862, pl. 29 and accompanying text. For a more detailed view of the costume, which also shows the long coat colored like the waistcoat and breeches, a scheme that seems more reasonable than the scarlet coat shown in the Hélyot and Perugini plate, see F. Ferrari, *Costumi ecclesiastici civili e militari della corte di Roma...*, Rome, 1823, pl. for *Sedario*.

47
Sleeved Waistcoat from the Costume of a Litter-Bearer (Sedario) of Pope Leo XIII
Italian, 1878–90
Silk damask. L. 39³⁄₁₆", W. 42" (99.5 x 106.7 cm.)
Purchased in Italy, 1895

In cut and ornamentation the waistcoat resembles the velvet example in this collection (No. 46). The main part of this garment is made of crimson damask showing the same pattern in reduced scale; the sleeves are made of matching silk cloth. It is lined with coarsely woven glazed linen cloth and has patch pockets of the same material at the upper and lower left and

the lower right. The disposition of buttons is similar; this example has a pair of buttons on the shoulders flanking the collar and fifteen buttons at the front closing.

Although there are no matching breeches in the collection it seems likely that the suit was once complete. Perhaps the damask ensemble was worn in summer, and the velvet in winter, unless specific occasions called for the wearing of one or the other. Like the velvet costume, this one would have been completed with crimson stockings, a long crimson coat, a white jabot and black pumps with gold buckles at the instep.

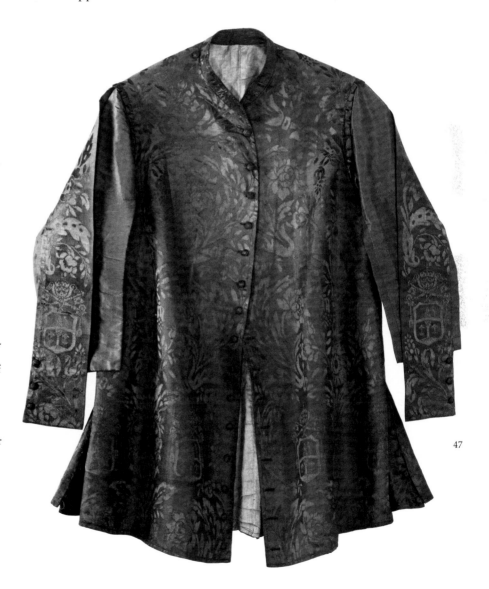

47

48
Garment or Furnishing Border

Italian, 1550–75
Needlepoint lace, *reticella*. L. 307", W. 3½"
(1080.3 x 8.9 cm.)
Provenance unknown

The border shows a wide band of stars with four points alternating with squares that have wheels at their centers; bars decorated with seed motifs connect the units. Along both edges there are narrow guard bands containing rectangular forms alternating with motifs resembling the letter N.

In making *reticella*, which is strictly speaking neither embroidery nor lace but a combination of the two, the needleworker started with a piece of plain linen cloth and withdrew all but a few of the warp and weft yarns, leaving the rest to form a sparse grid on which to work the pattern. The skeleton yarns were then covered with buttonhole stitches and other yarns were stitched across the open spaces of the grid in diagonal or curved lines; these in turn were ornamented with decorative stitches in relief. *Reticella* was, therefore, one of the early forms of openwork embroidery that led to the development of true laces made without the aid of a foundation of linen cloth (for another example of a *reticella* border, now used as a superfrontal on the altar in the Spanish Chapel, see T6n2).

49
Garment or Furnishing Border F25nw50–B.60

Italian, 1550–75
Needlepoint lace, *reticella* and *punto in aria*.
L. 62½", W. 3¾" (158.8 x 9.5 cm.)
Provenance unknown

The border shows a band containing regularly alternating rosettes and star-shaped blossoms drawn in frontal view and connected by a fine network of straight and curved bars. At the lower edge there is a scalloped band showing wheels alternating with leaves. Both motifs feature seed-shaped forms. Between these two bands there is a strip of rectilinear openwork decorated with seeds worked on the diagonal. Both of these outer borders were worked by the method known as *punto in aria* or "stitch in the air." To make this material, the worker fixed a series of skeleton yarns to the surface of a parchment pattern and then worked stitches over and between them, building up an openwork fabric. After being removed from the parchment, this fabric was the first form of true needle-made lace, worked without a foundation of plain linen cloth. Strips of *punto in aria* often served as outer borders for strips of *reticella*; the patterns used for one showed similarities and aesthetic sympathy with patterns used for the other.

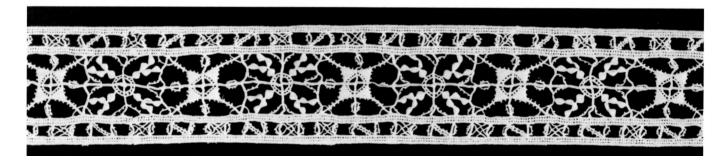

detail, 48

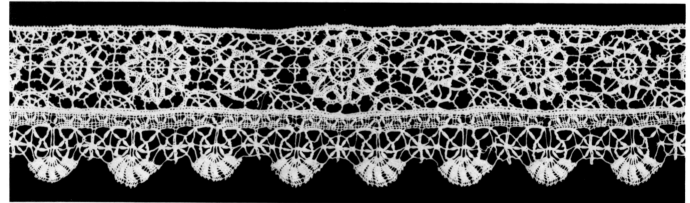

detail, 49

50
Table Cover

Italian, 1550–1600
Linen tabby with areas of cutwork embroidery.
L. 81″, W. 70″ (205.7 x 177.8 cm.)
Provenance unknown

The table cover is rectangular and all four sides are finished with triangular points. The field is of solid linen, scattered with urns and fanciful floral sprays executed in openwork. In these places the ground fabric has been cut away, sewn around the edges, and the open spaces then treated with supplementary stitches that form ornamental linear fillings. A wide border surrounds the field. It shows a repeating unit comprising a pair of undulating leafy branches issuing from a conventionalized blossom drawn in profile, all executed in the same kind of cutwork embroidery. Each of the points along the edges contains an openwork trefoil.

51
Cushion Cover F25nw50–B.63

Italian, 1600–50
Linen tabby with areas of cutwork embroidery.
L. 27″, W. 21¾″ (68.6 x 55.3 cm.)
Provenance unknown

One face of the cover shows a wide band of openwork running down the center length and narrow borders at each end; the other face shows a row of floral sprigs running down the center and along each end. Bainbridge (Museum archives) believed that the cover had been made up from a scarf, which indeed seems likely. The more elaborately decorated surface shows a complicated pattern of floral forms arranged within large and small interlaced lozenges, while the simpler side shows only a repeating row of relatively simple sprigs. On both sides the open spaces are decorated with fine filling stitches; the pattern on the solid cloth is worked chiefly in satin stitch with undyed linen yarn.

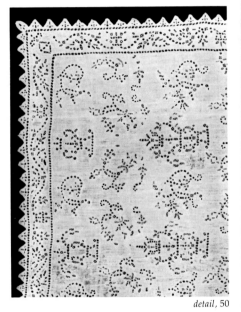

detail, 50

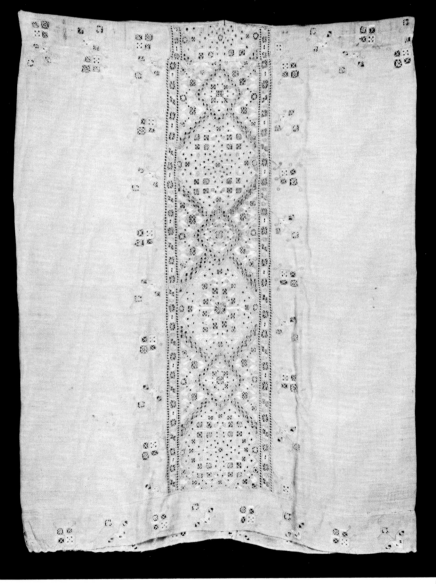

51

52–55

Four Examples of Darned Netting

Western Europe, 1550–1650

The Museum's collection of laces and lace-related embroideries contains a number of exceptionally important early examples. Four of the most interesting pieces are treated below; other examples are exhibited in various galleries or are preserved in storage.

In each instance the foundation fabric is a knotted netting with a square mesh made of linen yarns. The needleworker used more linen yarn to create patterns in the net by darning over certain holes in the mesh. The relative coarseness of the pattern depends on the size of the mesh, with small meshes allowing more delicate patterns to be worked than larger meshes. The collection also contains a few examples of darned gauze work *(buratto)* in which the same or a very similar effect is achieved by darning over the mesh of a foundation of gauze (crossed warp) weave rather than a foundation of net. Both kinds of work were made to serve as covers or hangings, particularly bed or altar hangings. The pieces in this collection appear to have been made only for secular use.

Although some of the pattern books from which these patterns were drawn date from around the middle of the sixteenth century, others did not appear until some fifty years later. For that reason, and also because these patterns did not pass out of fashion quickly, it is not unusual to find examples of darned netting of this kind dated in the first half of the seventeenth century.[1] Embroideries like these have usually been ascribed to Italy or Spain; however, some examples are believed to have been made in other parts of Europe as well, particularly Belgium, Germany and France.[2]

1 See M. Risselin-Steenebrugen, "Sources iconographiques de quelques filets brodés des Musées Royaux d'Art et d'Histoire," *Bulletin des Musées Royaux d'Art et d'Histoire*, 1960, pp. 2–29.

2 *Ibid.*

52

Curtain, Hanging or Cover

Linen. L. 133", W. 65½" (338.1 x 166.3 cm.) Provenance unknown

This fabric had been used as part of a curtain that hung in the central court window in the Gothic Room. In its original form, the curtain consisted of two sections; this one was at the right and at the left was a series of bands of darned netting and plain linen cloth that are now preserved separately in the Museum (in storage).

This large panel of darned netting shows a riot of figures, beasts and flowers that were rendered after patterns published in one or more pattern books and then combined, according to the needleworker's fancy, without regard for the logic of space or scale. Among the motifs is a group of figures representing Adam and Eve at the Tree of Knowledge, showing the serpent curling around the trunk and handing Eve the apple; men and women in mid-sixteenth-century costumes; a centaur drawing a bow; a griffon flanked on one side by a woman in late sixteenth-century costume and on the other by a mounted knight in armor; and dogs, deer, birds, a lion, trees and other figures and beasts.

Forming a border at the sides are oak branches interrupted at certain points by small scrolls bearing letters that do not spell words or names, as similar scrolls in other examples of this work do.

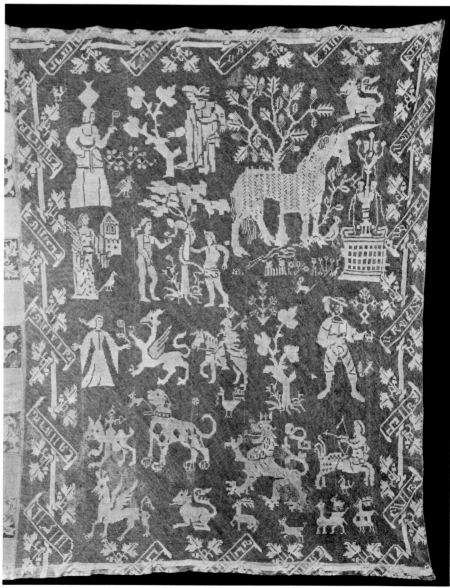

detail, 52

53
Curtain, Hanging or Cover
Linen. L. 140″, W. 32″, (356 x 81.3 cm.)
Provenance unknown

The panel consists of two sections sewn together. The larger portion shows at either end a woman flanked by dragons; a man stands in the center. The figures wear fashionable costumes of the late sixteenth century. A border of C-shaped serrated leaves appears at both the top and the bottom.

The narrower section at the left shows a vase of flowers flanked by birds in the upper register. A tree with curling branches enframing a pair of affronted dragons and the upper parts of two winged male figures appear in the lower section. The two sections are separated by a nar-row border containing a wave mean-der. This part of the panel was evi-dently cut from a longer pattern unit.

The entire textile is bordered at the sides and bottom with a linen fringe showing groups of alternately undyed and blue yarns.

54
Curtain, Hanging or Cover
Linen. L. 66″, W. 27½″ (167.64 x 69.85 cm.)
Provenance unknown

A great heraldic eagle facing right appears within a wreath against a strapwork cartouche at the center of the composition. Flanking this are two groups (one the mirror image of the other) showing Orpheus standing under a tree charming the beasts. He plays a violin; among the animals sur-rounding him are deer, dogs, a leop-ard, a fox, birds, and squirrels.

55
Cover F25w48–B.31
Linen. L. 56½″, W. 35″ (143.5 x 88.9 cm.)
Provenance unknown

The cover is made of plain linen cloth with darned net borders at each end. The two border panels show the same pattern. A strapwork shield in the center contains two heads, one male, the other female, back to back (an allegorical representation of *Pru-dence*); the shield is flanked by a pair of affronted unicorns as supporters. Between the unicorns and a pair of amorini at each end are scrolling grape and acanthus vines. Narrow guard bands containing rows of tre-foil sprigs enclose each border, and narrow linen fringe encloses the borders all around.

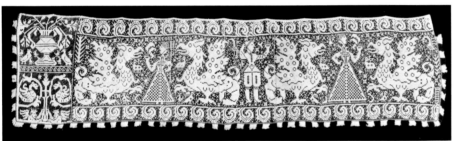

53

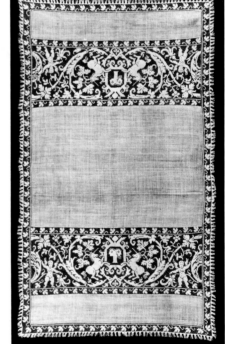

55

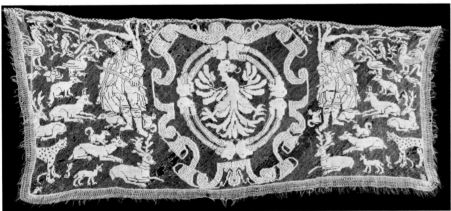

54

56–60
Five Examples of Withdrawn Element Work
Italian and Spanish, 1550–1625

Mrs. Gardner made a remarkable and representative collection of so-called "drawn work" embroidery. Five examples from the collection are listed here. Other pieces, similar to these in technique as well as generically in design, are either on exhibition or in storage. The first example is exhibited in rotation with another (T6n4r) on the altar in the Spanish Chapel. The others are either exhibited in the large wall case in the Veronese Room or stored in the cabinets below.

In each instance, the patterned portion of the textile was made by starting with plain linen cloth and then pulling out certain warp or weft yarns (withdrawn elements), leaving the rest of the yarns in place to form an open grid. In some cases, the worker left bits of the original cloth in place, cutting the yarns to be withdrawn at the edges of the reserved portions. If she was working with only the grid, the worker then darned the solid parts of the pattern into the grid, using some of the linen yarns that she had withdrawn, or similar yarns. She then covered the yarns of the grid with tight linen or silk threads, using the buttonhole stitch or another stitch to hold the loose warp and weft yarns in place. When working with bits of the original fabric left in place, she stitched over the cut edges of these reserved areas and then proceeded to cover the yarns of the grid as before. This kind of work, together with the closely related *reticella* work, led eventually to the development of true needlepoint lace, made without the aid of a foundation fabric.

56
Altar Frontal T6n4
Spanish, Alpujarra, 1550–1600
Linen tabby with areas of withdrawn element work. H. 24" (with fringe 28"), W. 117" (61 [71.1] x 297.2 cm.)
Purchased by Dodge Macknight in Granada and given by him to Mrs. Gardner on her birthday, April 14, 1909

The frontal shows a wide band of openwork running across the cloth with a narrow border of the same work below; it is finished at the sides and bottom with a strip of applied woven linen fringe. The larger border shows two major units alternating horizontally. One consists of a large vase containing stalks bearing eight-petaled blossoms without leaves, the base of the vase flanked by a pair of leaves or hearts. The other shows a smaller vase containing a stalk bearing three carnation blossoms. A crowned (?) quadruped walks along beneath this vase.

A letter (now in the Museum's archives) written by Dodge Macknight to Mrs. Gardner contains the following reference to this frontal: "I also send you by this mail a large piece of Spanish drawnwork — probably for an altar and evidently done in a monastery at some time or other — ... I hope you like it, if not you can exchange it at any time for anything I carry in stock." Another note in the files indicates that Macknight told Morris Carter in 1926 that the textile was made in the Alpujarra mountains near Granada.

Bibliography: *General Catalogue*, pp. 46, 47.

57
Furnishing Border F25nw50–B.2
Italian, 1575–1625
Linen tabby embroidered with gray and natural linen yarns. L. 110½", W. 13" (280.2 x 33 cm.)
Provenance unknown

The border shows a gnarled, undulating branch bearing large and small pomegranates and leaves. Small blossoms are scattered over the ground. A narrow strip of bobbin lace has been sewn to the ends and bottom of the piece.

58
Furnishing Border
Italian, 1575–1625
Linen tabby embroidered with undyed linen yarn. L. 159", W. 10" (404 x 25.5 cm.)
Provenance unknown

The border shows a pattern of meandering pomegranate vines that is similar to No. 57. However, in this cloth the solid parts of the pattern are part of the original foundation fabric rather than part of the warp/weft grid as they are in the other piece. There are pairs of linen cords sewn to the lower edge of the fabric at the center and left end and also in the middle of the left end. This indicates that it was once used as a valance. Bainbridge suggested that it was once the upper valance for a bed (Museum archives). The Museum has a piece of embroidered net (in storage) showing the same pattern.

59
Three Furnishing Borders
F25nw50–B.1
Italian, 1575–1625
Linen tabby embroidered with undyed linen yarn. L. 74¾", W. 40" (190 x 101.6 cm.)
Provenance unknown

When Bainbridge (Museum archives) described these borders, they were attached to the sides and bottom of a linen curtain that she described as a bed curtain. The pattern, which was created by leaving parts of the original linen cloth in place and withdrawing threads from around them, shows an ingenious repeat of units displayed upright and then inverted, alternately. Each unit shows a pair of cornucopiae issuing from the junction of a pair of curling branches and enframing a small tree. S-scrolls serve as the link uniting the upright and inverted units; pairs of birds and lizards (?) perch on the crests of the curves.

Bibliography: *General Catalogue*, p. 204.

60
Furnishing Border F25nw50–B.4
Italian, 1575–1625
Linen tabby embroidered with undyed linen yarn. L. 44", W. 8" (111.8 x 20.3 cm.)
Provenance unknown

The solid parts of the pattern retain the original foundation fabric; they are outlined with cords formed of yarns bundled together and sewn to the foundation.

In the center of the main section is a tree flanked by affronted monkeys holding mirrors. Next to the monkeys are herms holding basins of flowers aloft; beneath each herm is a rabbit. At either end of the main section are pairs of addorsed spotted and horned beasts flanking a tree. Rosettes and plants fill the interspaces.

A U-shaped border is connected to the main section with stitches. The pattern in the border features a row of animals alternating with trees, plants and pomegranate sprigs.

Two other borders showing the same pattern are also preserved in the collection (in storage).

Bibliography: *General Catalogue*, p. 205.

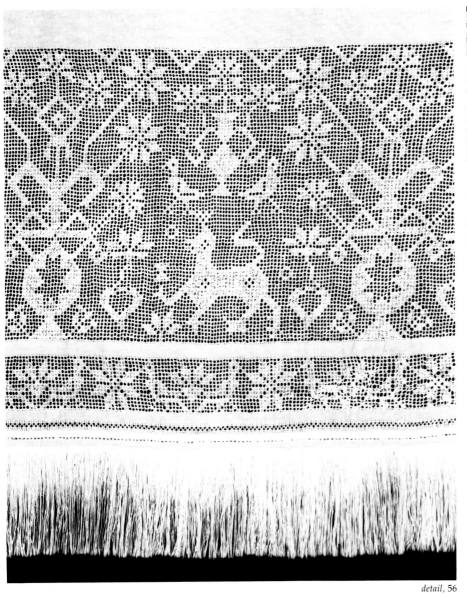

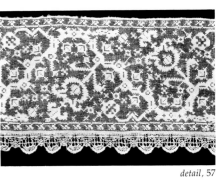

detail, 57

detail, 58

detail, 59

detail, 56

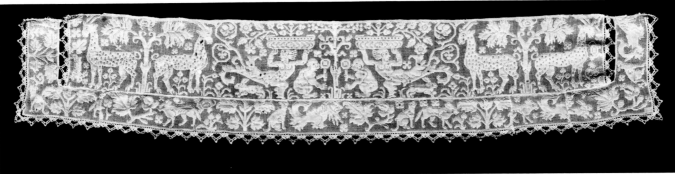

60

61
Altar Frontal

Italian, 1575–1625
Linen tabby embroidered with undyed linen
yarns. L. 123½", W. 36½" (313.3 x 92.7 cm.)
Provenance unknown

The body of the frontal is made of one
full width of the foundation fabric;
the wide border along the bottom was
worked on another foundation. The
body and border are joined by a nar-
row band of bobbin lace.

The foundation weave serves as the
substance of the pattern in both field
and border. The border contains an
alternately inverting unit comprising
a lily blossom flanked by curling
stalks; at top and bottom are guard
bands containing S-scrolls. The field
shows seven narrower strips of open-
work alternating with sections of
plain foundation fabric. The pat-
terned sections show vertical rows of
plants alternating with birds, flanked
by narrow guard bands containing
undulating vines. A strip of scal-
loped bobbin lace is sewn along the
bottom and both ends of the frontal.

detail, 61

62
Table Cover

Western Europe, probably 1800–1900
Linen: tabby embroidered with undyed linen
yarn, and plain tabby. L. 70¼", W. 66" (178.4 x
167.6 cm.)
Provenance unknown

The cover, planned by Denman Ross,
shows twenty-one withdrawn ele-
ment work squares that have been let
into open spaces cut out of the fabric
of a sheet. The motifs derive from
illustrations in sixteenth- and seven-
teenth-century pattern books, but
appear to have been worked later.
Each square shows a beast or human
figure or figures; among these are a
leopard, lion, horse, goat, deer, uni-
corn, and boar, men and women
dressed in fashionable clothes of the
period around 1600, figures repre-
senting Cain killing Abel, as well as
figures representing Ptolemy, Mer-
cury, Sol, Saturn, Venus, Harvest,
and Winter. Each of the animal
squares has a border containing an
undulating leafy vine.

62

63–66

Four Examples of Deflected Element Embroidery

Europe, 1650–1750

The collection includes a number of fine examples of deflected element embroidery. This work superficially resembles cutwork and withdrawn element work but is made by a different process; also, it imitates rather than anticipates the true laces.

The worker started with plain, rather loosely woven cloth of very fine, usually cotton, yarns. Using one or two layers of such material (depending on the sort of work she was doing), the worker embroidered the solid parts of the pattern on the cloth with matching yarn. She used more yarn of the same kind to create open spaces in the ground fabric by pulling certain warp and weft yarns out of their normal positions (deflected elements), securing them in their new places with the aid of tight stitches. The resulting mesh or grid looks superficially like the mesh of withdrawn element work but is much finer in scale and texture. In some cases (see No. 66) the worker also cut small sections of the foundation fabric away, creating larger openings than could be achieved by the deflected element method alone.

Most embroidery of this kind is attributed to northern Europe, particularly northern Germany and Scandinavia, although similar work has survived in Austria, Spain, France and Italy. The attribution to the north is based in part on historical fact but also on the assumption that this sort of openwork, which imitates so closely the appearance of certain delicate French and Italian needle and bobbin laces, would have been produced primarily in those parts of Europe where such laces were not made in quantity.

63

Pair of Cuffs for an Alb

Italian or French (?), 1650–1700
Linen tabby embroidered with linen yarns chiefly in buttonhole, stem, satin and chain stitches.
a. L. 32½–16¼", W. 16" (82.5–41.25 x 40.6 cm.)
b. L. 32½–16½", W. 16" (82.5–41.9 x 40.6 cm.)
Provenance unknown

The size and shape of the linen panels suggest that they were made as cuffs or as sleeves for a garment.

While the pattern contains no specific Christian symbols, the cuffs correspond most closely in size to the laces (whose patterns often held no religious meaning) that served as cuffs on the sleeves of albs (see Nos. 73, 78). The long upper edge would have been sewn to the bottom of the sleeve; the edges of the two tapered sides would have been sewn to each other, forming a truncated cone through which the priest's hand would have passed.

Each panel shows a field corresponding in shape to the contour of the piece itself. The panel contains a strapwork cartouche, in the center of which stands a vase of flowers under a canopy. A narrow border containing a scrolling vine that bears blossoms, leaves and grapes (perhaps as a symbol of the Eucharist) surrounds the field.

64

Handkerchief Border

North German or Scandinavian (?), 1650–1700
Cotton embroidered with cotton yarns chiefly in buttonhole, darning, back and stem stitches.
19" square (48.3 cm.); W. of border 5½" (14 cm.)
Provenance unknown

The border shows a scrolling vine bearing leaves and blossoms that resemble those found in contemporary rose point laces made in Venice. There are scallops along the outer edges of the border.

63a

64

127

detail, 65

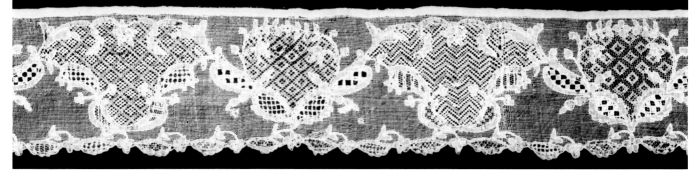

detail, 66

65
Furnishing Border or Flounce
F25nw50–B.126

North German or Scandinavian (?), 1675–1725
Cotton tabby embroidered with cotton yarns chiefly in buttonhole, satin, chain and darning stitches. L. 81″, W. 10¼″ (205.2 x 26 cm.)
Provenance unknown

A row of floral sprigs is arranged along the width of the fabric, each sprig bearing real or fanciful blossoms, chiefly daisies, roses and carnations. At the center of each sprig, within the C-curve, appear one or more figures engaged in different activities. They include a bird pecking at a serpent, a boy holding the paw of a dog that stands on its hind legs, a peacock displaying its feathers, a boy or small man in an exotic costume (which suggests Incan or Aztec garb) playing a pipe while sitting on the back of a goose, a plumed cock strutting forth, a woman with a fan balancing herself on the stalks, a boy with a stick playing on a reed, and a man in a pointed hat whose foot is caught in the beak of a bird's head growing from the end of the sprig. Some of the motifs repeat across the length of the fabric.

The ground behind the last three motifs, at the right end of the strip, has been embroidered but not treated with openwork. This indicates that the solid parts of the pattern were worked first, and the mesh afterward.

There is a narrow guard band containing a flame pattern along the top and a row of floriated scallops along the bottom.

Bibliography: *General Catalogue*, p. 206.

66
Furnishing Border

North German or Scandinavian (?), 1725–50
Cotton tabby embroidered with undyed cotton yarn chiefly in buttonhole, stem, and back stitches. L. 111″, W. 6″ (282 x 15.3 cm.)
Provenance unknown

The narrow band of embroidery shows an urn-shaped cartouche alternating with another cartouche shaped like an ovoid leaf along the length of the fabric. The cartouches and the lower edge of the band are bordered by flowering scrolls, some of which contain passages of rectangular cutwork. The patterns in the centers of the cartouches are based on variations of the lozenge and are executed in deflected element work.

67–75
Nine Examples of Needle-Made Lace
Italian and French, 1650–1875

The Museum's needle-made laces are of outstanding importance. Mrs. Gardner chose supreme examples of some of the most luxurious types and while the group is not fully representative of the needle-made laces made in Europe during the past four centuries, there are examples of the most familiar types. In addition to the nine fine pieces catalogued here, there are more of these and other types of needle-made lace on exhibition and in the storage cabinets in the Veronese Room.

With few exceptions, the fiber used in needle-made laces is linen, the fiber used for all nine laces listed here. The method of construction varied in detail, but essentially all of these laces were constructed by sewing over (usually with buttonhole stitches) a series of skeleton threads that were couched down on a parchment pattern. Filling stitches of various kinds were used to render details; in some cases more stitches were employed to achieve effects of relief. Sometimes the spaces between the major motifs were filled only by decorated bars (brides); in other cases, the needle made a mesh to fill in the spaces. When the structural and decorative work was finished, the couching stitches holding the skeleton yarns (now completely covered over with stitches) to the surface of the parchment pattern were cut away and the completed piece of lace was lifted off its temporary foundation.

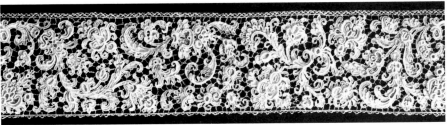

detail, 67

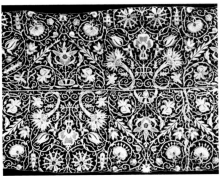

detail, 68

detail, 69

67
Border F25nw51–B.78
Italian, Venice, 1650–1700
Linen. L. 125″, W. 4″ (317.5 x 10.2 cm.)
Provenance unknown

The band shows a dense pattern of scrolling leaves and roses worked in high relief along their contours; the flat centers show delicate fancy openwork. The motifs are joined to each other by a sparse picoted mesh; they are also joined to a straight openwork strip along the top of the piece. The lower edge is finished with a cord along which have been worked delicate picoted scallops.

Bibliography: *General Catalogue*, p. 206.

68
Flounce for an Alb F25w48–B.70
Italian, Venice, 1675–1700
Linen. L. 144″, W. 11″ (365.7 x 27.9 cm.)
Purchased from M. Jesurum, Venice, July 27, 1892

The lace shows two main pattern units. One represents paired cornucopiae amidst scrolling stalks that bear roses, tulips, carnations, narcissi and fanciful blossoms. The cornucopiae alternate with another unit that shows paired lilies on either side

of an orchid plant. The individual motifs are joined sparsely by decorated brides so that the ground of the lace is exceptionally open. Each motif shows opaque, solid sections as well as areas of openwork filled with fine, fancy stitches of many varieties. The cuffs matching this flounce are also in the collection (in storage).

Bibliography: *General Catalogue*, p. 208.

69
Flounce for an Alb F25w48–B.69
Italian, Venice, 1675–1700
Linen. L. 143¼″, W. 11″ (358 x 27.9 cm.)
Purchased from M. Jesurum, Venice, October 21, 1894

The lace presents a riot of rose plants, sprigs, rosettes, scrolling branches and leaves worked in high relief with corded edges. In addition, tiny rosettes and points have been worked in the open parts of the larger roses, on the upper levels of the relief work and along the brides connecting the branches and plants. The lace is called *point de neige*, because of the snowflake effect of the minuscule motifs.

Bibliography: *General Catalogue*, p. 208.

70

Part of a Flounce or Furnishing Border F25w49–B.72

French, 1675–1700
Linen. L. 80", W. 16" (193 x 40.2 cm.)
Purchased from Lady Kenmare, 1897

The pattern shows figures, flowers, birds, and decorative motifs against a background of hexagonal mesh, arranged in two major groupings extending from the top of the fabric to the bottom; these alternate with each other and with minor groups of ornament across the width of the lace. The complete pattern is not present in the Gardner piece but can be derived from other pieces that preserve both the full height of the design as well as the uninterrupted sequence from side to side. One of the chief units, most of which is preserved in the Boston piece, shows two male actors or dancers in fanciful theater costumes with feathered headdresses. They stand on brackets that flank a seated female figure who also wears a feathered headdress. The two male figures support a canopy, topped by a royal crown, above the seated figure. The other major unit shows a pair of winged genii who hold a laurel wreath over the head of a male figure; the figure wears a cape and half-armor and carries a scepter in his hand. A canopy, on which a bird, with wings outspread, perches on a plinth, appears above the main figure; a pair of trophies and a pair of espaliered trees flank the pedestal on which the victorious figure stands. Single trees rising from low urns, and supporting trophies of banners or musical instruments near the top of the trunks, dominate the spaces between the major pattern units. At the left and right ends of the piece appear two more royal crowns, each surmounted by an arched window enframing a view of the moon and stars; a pair of owls perches on the flanking balustrades. Above, at either side of the top of the window, oval medallions contain profiled heads of men wearing helmets or laurel wreaths. Three other medallions like these, together with some trophies, a fleur-de-lys, and part of another window, appear along the top of the piece, their orientation inverted in relation to the rest. This apparent inconsistency results from the lace's having been made up from more than nineteen pieces, fragments, and bits of the fabric. The

long, narrow cover or veil so constituted does not show the complete pattern of the fabric or fabrics from which its parts were cut.

Illustrations of what appear to be relatively intact lengths of the lace show the pattern in its entirety (see notes 1, 5 and 6 below). In looking at the complete height of the pattern, which is eight to ten inches greater than the height of the Gardner fabric, one sees that the pattern unit featuring the seated female figure culminates at the top, above the crown, with the window, owls and medallions containing heads; at the bottom a smaller canopy covers a cartouche containing a five-petaled blossom and flanked by a pair of towers decorated with banners. The other main unit finishes at the top with a sun-face surrounded by rays under a canopy and above the bird with outspread wings (which now can be seen holding a branch with two leaves in its beak). It is also flanked by a pair of cartouches. A canopy above a five-petaled blossom flanked by bannered towers, the motifs at the base of the other main unit, completes this motif at the bottom. The intermediate units, featuring trees supporting trophies, finish at the top with other trophies and at the bottom with canopied cartouches, each of which contains a six-petaled blossom and is flanked by yet another pair of trophies; the complete pattern also shows that the objects tied to the tree trunks alternate regularly from trophies of banners to trophies of musical instruments.

In a letter written by Lady Kenmare from Killarney House, Killarney, to Mrs. Gardner on August 29, 1897, the former owner of this lace states that it "was *said* to have belonged to Marie Antoinette..." (Museum archives). The literature dealing with this and other laces showing the same pattern (see notes 1–4 below) suggests that it is the Dauphin (the future Louis XIV) who holds the scepter, that it was made on the occasion of the Dauphin's marriage, that it is Mme. de Montespan who is seated under the crown, or that the portraits and emblems in the pattern refer to the court of Louis XIV. Certainly the pattern reflects the taste and some of the favorite motifs of the court of the Sun King; it is possible, if not likely, that the representation of the royal crown and the sun's face refer to Louis XIV. However, the presence of the night

motif balancing the sun, and the generalized nature of the medallion heads and the male and female figures (the latter is not a female human at all but a female torso placed on a plinth) indicate instead that the pattern is allegorical rather than historical in intent. The pattern, and the lace itself, may have been commissioned by the king or an important member of his entourage, but there is nothing in the iconography of the design to prove such an assertion. Clearly the pattern celebrates a military victor or victory, but the reference is not specific.

The literature also suggests that the lace pattern derives from the work of Jean Bérain the Elder (1637–1711), an architect, draftsman, and engraver who was appointed by Louis XIV in 1674 as "dessinateur de la Chambre et du Cabinet du Roi."[1] Indeed the designer was inspired—by direct influence or through an intermediary—by patterns invented by Bérain or by the painter Charles Lebrun (1619–90), another of the king's favorite designers of decorations.

Other pieces of the same or similar lace are preserved in a number of collections, and still more are known from published and unpublished sources. The largest, most complete pieces are to be found in the Rijksmuseum at Amsterdam, the Cleveland Museum of Art, and the William A. Clark Collection in the Corcoran Gallery of Art, Washington, D.C. (which, unlike the others, does not show the pattern in relief).[2] Even the tallest of these examples seems to have at least a bit of the pattern missing along the top edge. A large fragment of the lace, showing some piecing, with almost the full height of the pattern and one of the major units, is in the Cooper-Hewitt Museum, New York.[3] A curved collar made up from a similar lace is preserved in the Victoria and Albert Museum (reg. No. T258-1922) and a small fragment of the lace is in the Brooklyn Museum.[4] Another large piece, showing almost the full height of the pattern, was lent to the Victoria and Albert Museum in 1932 or 1933 and is now in the collection of Miss Margaret Simeon.[5] Other laces with the same pattern—possibly including some of those cited above—have been published or photographed. One large piece was owned by the Baroness von Oldershausen in 1912,

another belonged to Mme. Dupré at Tours toward the end of the last century, and a third belonged to Duchess Parcent around the same time or somewhat later.[6]

Although a number of these examples have been referred to as flounces for albs, only some of them are approximately the right size for that use. One would have to postulate a set of matching albs if this were true; while such an assumption is not unreasonable, it seems at least equally plausible to regard all the surviving pieces as parts of one or more sets of furnishing flounces for use on dressing tables, beds, or other pieces of furniture.

1 G. Underhill, "An Important Gift of Needlepoint Lace to the Museum," *Bulletin of the Cleveland Museum of Art*, XVIII, 1931, p. 8, illus. p. 9.

2 See, respectively, *Sale of a Fine Collection of Seventeenth, Eighteenth, and Nineteenth Century Lace and Linen*, Christie's South Kensington, London, February 26, 1980, lot 122, and *Bulletin*, Rijksmuseum, Amsterdam, XXX, 1982, p. 28, fig. 11; Underhill, pp. 6ff., illus p. 9; D. Bowman, "William A. Clark, lace collection," *The William A. Clark Collection*, Corcoran Gallery of Art, Washington, D.C., 1978, p. 90, fig. 78.

3 "Recent Additions to the Collection," *Chronicle of the Museum for the Arts of Decoration of the Cooper Union*, II, 6, June 1954, p. 185, illus.

4 C.T.D.F., "The Woodward Collection of Old Lace," *Brooklyn Museum Quarterly*, II, 1915, pp. 323ff., illus. p. 329.

5 M. Simeon, *The History of Lace*, London, 1979, pl. 51; S. M. Levey, *Lace, a History*, London, 1983, figs. 226, 226A.

6 M. Schuette, *Alte Spitzen*, Leipzig, 1912, pl. XII; E. Lefébure, *Embroidery and Lace*, London, 1888, pp. 222ff., fig. 100; unpublished photograph from French and Company, New York, negative or stock number 6957.

Bibliography: (Mrs.) E. L. Lowes, *Chats on Old Lace and Needlework*, New York, 1908, p. 74, illus. p. 75. *General Catalogue*, p. 208. Hadley, pp. 184, 185.

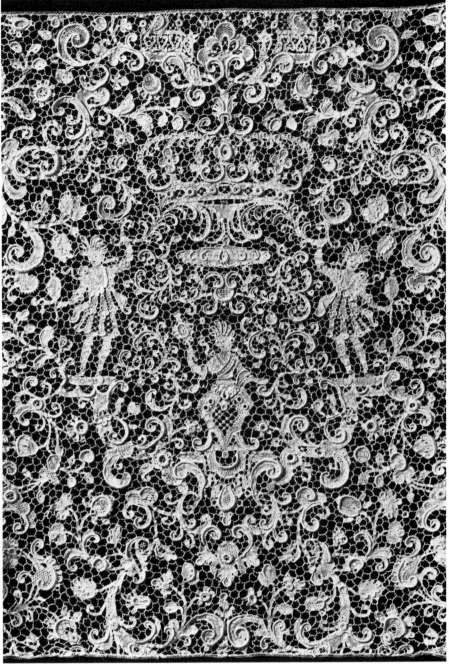

detail, 70

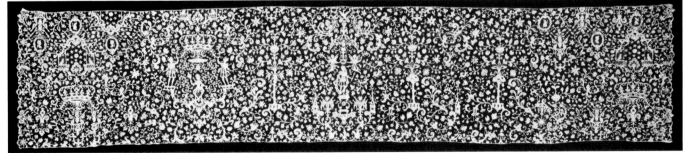

70

71
Flounce for an Alb F25nw51–B.85

French, 1675–1700
Linen. L. 116", W. 24½" (294.1 x 62.2 cm.)
Purchased from Enrique Gomez, Madrid, 1888

The lace shows an extraordinarily rich array of ornaments executed with a wide variety of filling stitches and raised outlines against a ground of hexagonal mesh whose bars have been further decorated with tiny loops or *picots*. The pattern consists of a row of tall, slender symmetrical units made of urns, lozenge medallions, curling leaves, fruits, and blossoms, chiefly roses, carnations and fanciful or highly stylized natural blooms. Mrs. Gardner told Morris Carter, who was to become the first director of the Museum, that the lace was said to have been made for Louis XIV to give to a Spanish cardinal (Museum archives).

Bibliography: *General Catalogue*, p. 207.

72
Border for a Corporal F25nw50–B.82

Italian, Venice, 1675–1725
Linen. L. 27⅛", W. 26³⁄₁₆" (68.9 x 66.5 cm.);
W. of border: 6" (15.2 cm.)
Provenance unknown

In its original context the lace border was applied to the edges of a small square of plain linen cloth that served as a corporal, or the linen cloth that was laid on the altar cloth under the ciborium, during the preparation of the Eucharist. The plain linen center has been removed; there remain sixteen lace points forming the border. Each point contains a representation of a human figure, all facing inward toward the center of the cloth. Scrolling leaves and stalks bearing paired roses, carnations or lilies surround each figure; inscribed on a bar at the center of each unit, under the figure, are letters forming the initials of each figure's name. Below each of these appears an angel's head and pair of wings.

One of the Evangelists is represented in each of the corner points. Each figure is accompanied by his attribute and the appropriate letters: St. Mark (SME, the E for Evangelist) with his lion, as well as a vase of flowers and a dove, St. John (SIE) with his eagle, St. Luke (SLE) with the ox, and St. Matthew (SME) with the angel. The other points contain representations of four different groups of figures; these are identified as follows: St. Paul (SPO), St. Peter (SPO) and St. John Baptist (SIB). There are three archangels: Raphael who guides Tobias across a stream (ADO?), Michael battling the devil (SRO, probably misplaced or incorrectly rendered), and Gabriel making his annunciation to the Virgin (SGA, for St. Gabriel Annunciate). These are followed by three female martyrs: St. Catherine with her wheel (SCVM, the V for Virgin), St. Ursula with her crown, staff and palm branch (SVVM) and St. Mary Magdalene kneeling before a cross (SMM). The last group represents three male saints: St. Carlo Borromeo as a pope (SCB), St. Jerome with lion and cross (SHO for St. Hieronymus) and St. Francis Xavier with a crozier (SFX).

Bibliography: *General Catalogue*, p. 207.

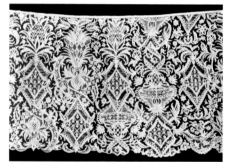

detail, 71

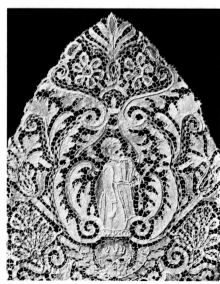

detail, 72

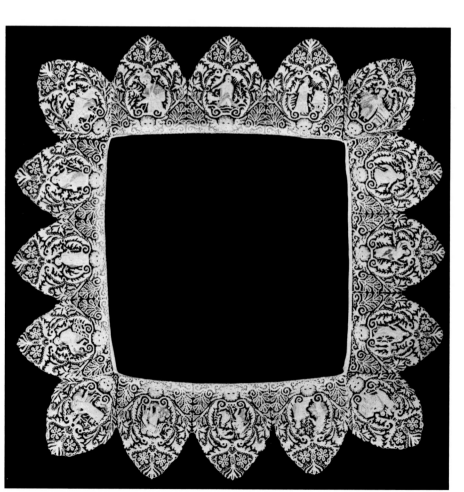

72

73
Flounce for an Alb F25nw51–B.79
Italian, Venice, 1700–25
Linen. L. 71½″, W. 12¼″ (181.6 x 31.1 cm.)
Provenance unknown

The construction of this lace, with its fine mesh ground and relatively flat surface, as well as its pattern, relate it very closely to contemporary French laces; it was probably made in imitation of them. The pattern shows rows of potted plants bearing fanciful lily-like blossoms and lanceolate leaves surrounded by more delicate and naturalistically rendered rose branches. The cuffs matching this flounce are also on view in the collection.

Bibliography: *General Catalogue*, pp. 206, 207.

74
Fichu F25nw51–B.80
French, Alençon, 1725–50
Linen. L. 63³⁄₁₆″, W. 5¾–2½″
(160.5 x 14.6–6.35 cm.)
Provenance unknown

The shaped scarf, which has a seam at the center, shows a complex and delicate pattern involving a multitude of floral motifs decorated with a variety of filling stitches, all displayed against a spotted mesh of the type known as *oeil de perdrix*. There are scrolling leaves alternating with flowering plants, baskets of flowers and nosegays tied with ribbons. Both inside and outside edges are scalloped.

Bibliography: *General Catalogue*, p. 207.

75
Garment Border F25nw50–B.76
Italian, Venice, Burano, 1750–1800
Linen. L. 18½″, W. 1¾″ (47 x 4.7 cm.)
Provenance unknown

The narrow strip shows the cloudy mesh ground characteristic of the fine needle-made laces of Burano, made in imitation of the now fashionable laces produced at Alençon in France. Scattered over the fine mesh ground are branches bearing blossoms and buds; along the lower edge a row of leaves forms scallops, inside which a variety of fancy filling stitches relieves the regularity of the mesh ground.

Bibliography: *General Catalogue*, p. 205.

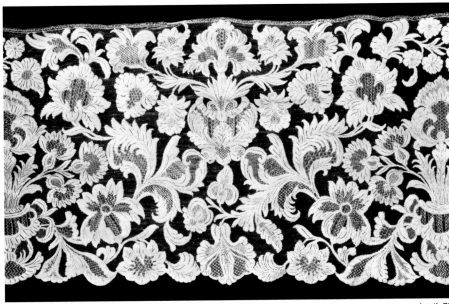

detail, 73

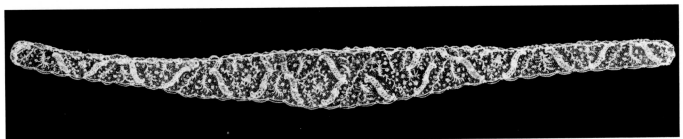

74

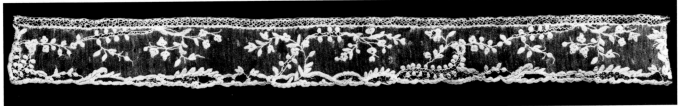

75

76–86
Eleven Examples of
Bobbin-Made Lace
Italian and Flemish, 1625–1850

Mrs. Gardner collected outstanding
examples of bobbin-made lace, and
while none of the individual exam-
ples is as sumptuous as the most
ambitious of the needle-made laces in
the collection, these pieces represent
the most important types that were
produced in Europe during the great
years of the lace-maker's art. In addi-
tion to the pieces listed here there are
other examples of the same and other
types on exhibition in the cases and
also in the storage cabinets of the
Veronese Room.

Like needle-made laces, most of
those made with the aid of bobbins

show yarns spun from linen fiber.
During the seventeenth, eighteenth
and nineteenth centuries it was not
uncommon to make bobbin laces
with silk, wool or even metal yarns.
The chief difference between the two
main methods of manufacture was
the tools employed. While makers of
needle laces used needles to make
the stitches that formed the sub-
stance as well as the decoration of the
finished piece, the other group used
numbers of bobbins. Placing her pat-
tern on a padded pillow, the maker of
bobbin laces inserted pins into cer-
tain points along the lines traced on
the pattern; with the yarns wound
round her bobbins, she plaited and
braided many threads at once around
and between the pins, building up
either the mesh of the ground, the

substance of the pattern, or both.
Thus in a sense bobbin-made laces
are "woven" with absolutely free
shuttles, just as needle-made laces
may be thought of as being "embroi-
dered" with absolutely free stitches.
The analogy may be carried further
to explain why bobbin-made laces
developed far more technical varia-
tions and procedures than needle-
made laces, just as complex figure-
weaving involved far more proce-
dures and manipulations of yarns
than the most elaborate kind of
embroidery did.

Each nation, as well as each region
within the lace-producing nations,
developed characteristic methods
of handling bobbins and building up
the pattern and ground either sepa-
rately or simultaneously.

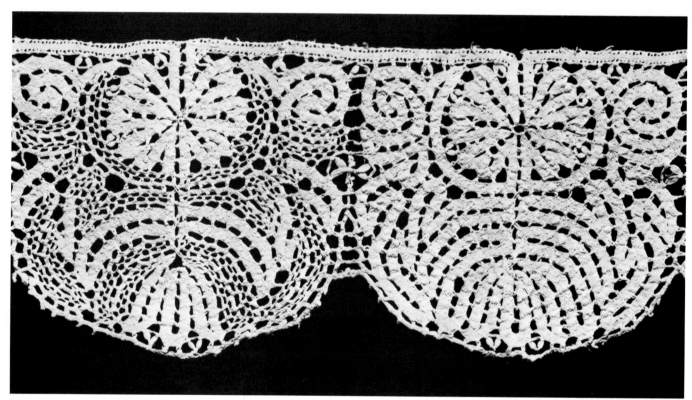

detail, 76

76
Border F25nw50–B.103
Italian, 1625–50
Linen. L. 69″, W. 4⅜″ (175.2 x 11.2 cm.)
Provenance unknown

The border has a straight edge along
the top and a scalloped lower edge;
the scallops are part of the lower con-
tours of two pattern units that alter-
nate along the length of the strip.

Both units show a conventionalized
carnation or chrysanthemum blos-
som in frontal view. The contours are
defined by tape-like bands of braid-
ing. Bainbridge (Museum archives)
identified this lace as having come
from Gessopalena in the Abruzzi.

Bibliography: *General Catalogue*, p. 206.

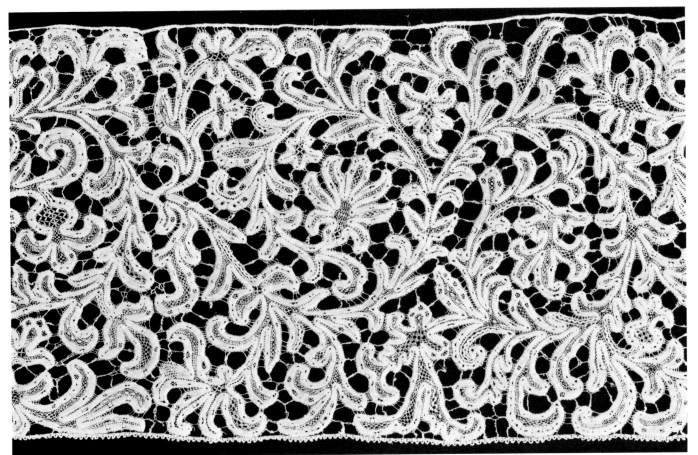

77
Border F25w48–B.87
Italian, 1650–75
Linen. L. 121½", W. 14" (303.75 x 35 cm.)
Provenance unknown

The border of lace of the Milanese type shows an overall pattern of scrolling branches among which appear fantastic and real flowers. Fine brides join the various motifs and form a sparse, irregular mesh ground. A row of small scallops finishes the lower edge of the border.

78
Flounce for an Alb F25w49–B.89
Flemish, Brussels, 1675–1700
Linen. L. 138", W. 9½" (350.6 x 24.2 cm.)
Provenance unknown

The pattern shows a scrolling vine bearing real and fantastic blossoms, all decorated with a rich variety of filling stitches, against a simple hexagonal mesh ground. Along the bottom edges, in open spaces in the scrollwork, appear emblems of the Passion, arranged in two different groups. One group contains the ladder, scourge, spear, sponge on a pole, rope and column; the other group shows the cross with nails in place, the scroll bearing the inscription INRI, the crown of thorns, hammer, pincers, cock, loincloth, dice and a hand. The matching cuffs (underneath the flounce) are shaped to form points under each hand when worn.

Bibliography: *General Catalogue*, p. 209.

79
Border F25nw50–B.104
Italian (?), 1675–1750, or later
Linen. L. 38½", W. 4" (97.7 x 10.2 cm.)
Provenance unknown

The lace is coarsely braided and consists chiefly of separate animal motifs connected with picoted brides. There are also narrow strips of fabric decorated with lozenge openwork along both ends. The pattern shows rabbits, dogs, serpents, birds, roses and lilies arranged haphazardly and without a repeat system. All the motifs have fancy openwork within their contours, which are outlined and emphasized by heavy cords. The work is provincial and may have been executed some time after similar kinds of lace passed out of fashion in urban centers.

80
Flounce for a Formal Gown
F25nw51–B.121
European, 1675–1775
Silk and silver wire. L. 175¾", W. 8½" (446.4 x 21.5 cm.)
Purchased from Enrique Gomez, Madrid, March 23, 1888

The lace is constructed of silver yarn (flat silver wire wound spirally on a core of white silk yarn). The ground shows an octagonal mesh; applied to it are motifs resembling tassels that are worked in relief with the same yarn. A border of narrow silver lace with a scalloped outer edge has been applied along the upper and lower edges of the strip.

Bibliography: *General Catalogue*, p. 207.

81
Crown of a Cap F25nw51–B.101
Flemish, Brussels, 1700–25
Linen. L. 11³⁄₁₆", W. 8¹⁄₁₆" (28.45 x 20.5 cm.)
Provenance unknown

At the center of the pattern is a vase of roses set in the middle of a cartouche defined by scrolling leaves; at the sides of the cartouche, other leaves set apart irregularly shaped compartments containing rose sprigs. Along the straight edge (which formed the back of the cap) are sprigs of carnations and roses. The curved edges (the sides and front of the cap) are finished with small scallops.

Bibliography: *General Catalogue*, p. 207.

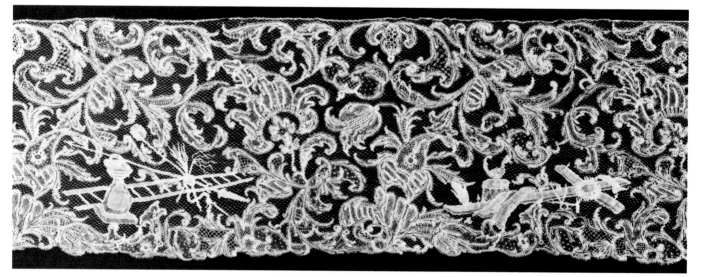

detail, 78

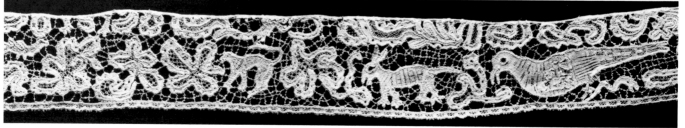

detail, 79

82
Lappet F25nw50–B.93A

Flemish, Brussels, 1700–25
Linen. L. 22½″, W. 5¾–4″ (57.2 x 14.6–10.1 cm.)
Provenance unknown

The lappet is one of two matching
strips of lace that were once sewn to
the back of the crown of a lady's cap
(see No. 81) and hung down the wear-
er's back. It shows four pointed ogi-
val compartments formed by scrolls
and leaves arranged along the central
axis; each compartment contains an
urn of flowers or a floral spray,
arranged alternately.

Bibliography: *General Catalogue*, p. 206.

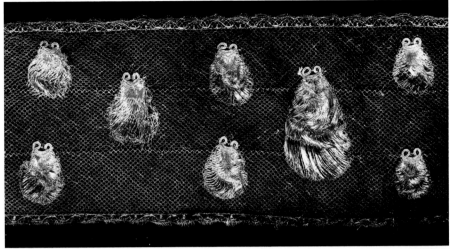

detail, 80

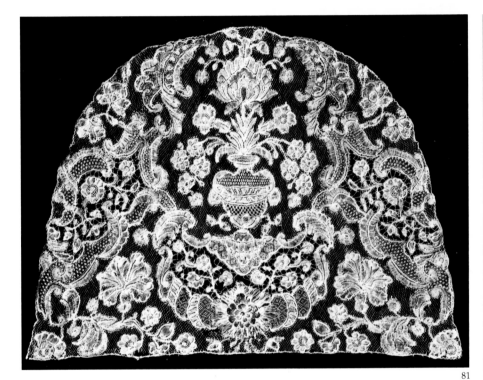

81

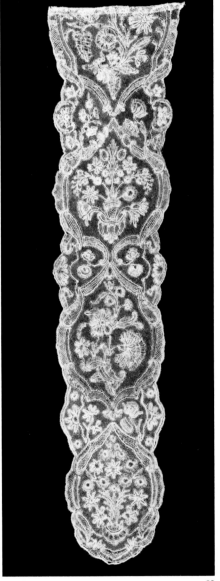

82

137

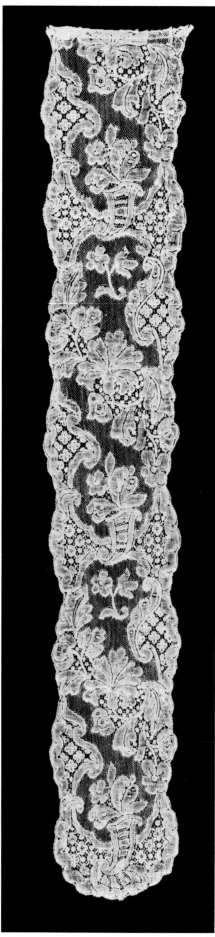

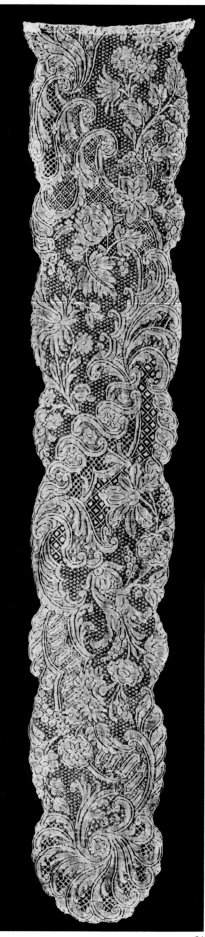

83
Lappet F25nw50–B.92
Flemish, Mechlin, 1725–50
Linen. L. 21", W. 3½–3" (53.3 x 8.9–7.6 cm.)
Provenance unknown

The lappet shows irregularly shaped compartments formed by meandering scrolls and leaves. Along the edges of the lappet, the compartments are filled with a variety of fancy filling stitches featuring rosette motifs. The compartments arranged along the central vertical axis show cornucopiae containing bouquets of flowers alternating with single rose sprigs against a mesh ground. Diagonal lines of rose and carnation blossoms meander from one side to the other among the various floral compartments.

Bibliography: *General Catalogue*, p. 206.

84
Lappet F25nw50–B.91
Flemish, Binche type, 1725–50
Linen. L. 24½", W. 5–4" (62.2 x 12.7–10.15 cm.)
Provenance unknown

The pattern shows an extraordinarily complex arrangement of C and S scrolls combined with leaves and blossoms moving in endless counterpoint. The units are arranged either in meandering lines that cross from side to side as they wander upward, or as sprigs set at different angles against the various grounds, which show a variety of textures and filling stitches. The chief flowers are roses, lilies, and daisies; most of the ground patterns feature lozenge shapes. The pattern is very closely related to that of the most fashionable French silks of the period.

Bibliography: *General Catalogue*, p. 206.

83

84

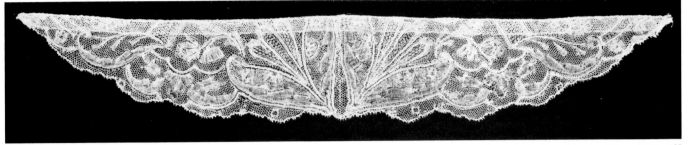

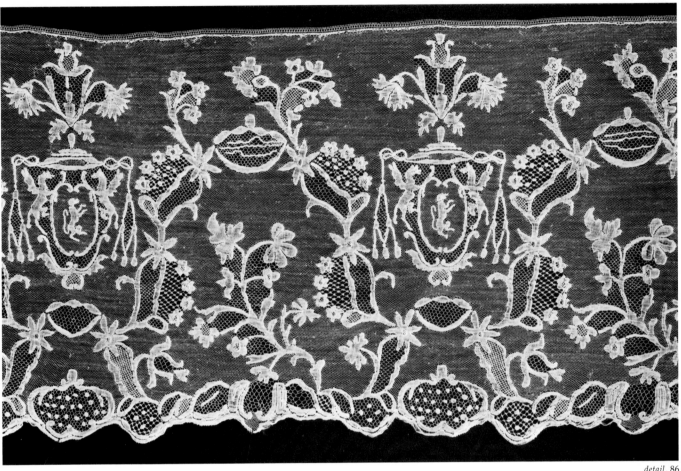

detail, 86

85
Sleeve Ruffle F25nw50–B.97
Flemish, 1725–50
Linen. L. 15″, W. 2⅜″ (38.1 x 6 cm.)
Provenance unknown

The lace shows a fine, diaphanous pattern of leaves symmetrically arranged around a central stalk running at right angles to the straight edge. The shape of this piece indicates that it was made to serve as an *engageante,* gathered along the straight edge and sewn to the elbow-length cuff of a fashionable gown to form a ruffle. *Engageantes* were often used in groups of two or three of different lengths to form a cascade of ruffles.

86
Flounce for an Alb F25w49–B.88
Flemish, Mechlin, 1750–1800
Linen. L. 134″, W. 10″ (340.4 x 25.4 cm.)
Provenance unknown

The flounce shows a series of symmetrical units repeating horizontally along its length. Pod-like shapes containing a variety of fancy filling meshes form the lower border of the piece and also the compartments containing a bishop's coat of arms. The shield is supported by a pair of winged horses facing inward and it is surmounted by a bishop's hat with six tassels at either side. The simple arrangement of the units and their relatively uncomplicated forms indicate that the flounce dates from the end of the rococo period.

Bibliography: *General Catalogue,* p. 209.

87
Scarf F25nw51–B.83

Flemish, Brussels, 1850–75
Linen: mixed bobbin and needlepoint lace.
L. 43¼", W. 4⅝–3⅜" (121 x 11.56–8.44 cm.)
Provenance unknown

The scarf, known as a *barb* when it was in fashion, is a later form of the shaped *fichu* of the preceding century (see No. 74). Unlike the laces cited thus far in this catalogue, this scarf shows pattern motifs worked with bobbins and combined with a needle-made mesh ground. Floral sprays fill the field; around it, a row of compartments, edged with scrolling leaves and filled with a sprig of roses, forms a border. At the very edges of the lace there is a border of tiny scallops.

Bibliography: *General Catalogue*, p. 207.

88
Orphrey with Scenes from the Life of Christ T16s28

Italian, Florence, 1375–1425
Linen tabby embroidered with silk yarns in split and long and short stitches and with gilt yarns in fancy couching stitches.
Front section, horizontal: H. 8", W. 20¼–22¾" (20.3 x 51.4–57.8 cm.), vertical: H. 29¾", W. 8" (75.5 x 20.3 cm.)
Back section: H. 45⅜", W. 7⅞" (115.25 x 20 cm.)
Purchased from Villegas, Rome, 1895

The orphrey has been mounted on a chasuble that is now covered with a compound satin showing a pattern of flowers in urns within ogival compartments formed by a system of acanthus leaves. The ground is of red satin weave, rising in slight relief above the pattern elements that are rendered in yellow and white silk yarns bound in weft twill weave. This fabric, which dates from the second half of the sixteenth century, replaces the early fifteenth-century voided velvet that originally covered the chasuble (fragments in storage); the same satin has been used elsewhere in the Museum (see No. 127).[1]

Although the orphrey has been adapted for use on the chasuble, the conformation of its parts proves that it was made as the orphrey for a cope. In that form, it consisted of two strips of five scenes each, depicting incidents in the life of Christ. The strips would be joined at the top to the ends of a central strip (parts of which are now on the front of the chasuble) that rested on the back of the celebrant's shoulders. A hood, now missing, would have been attached to the lower edge of that central section.[2] The hood missing from the orphrey in the Gardner, like hoods from related copes, would have shown a single majestic composition, for example, the Crucifixion, Deposition, Resurrection or Last Judgment. For a comparable hood, which shows the Coronation of the Virgin and is now associated with an orphrey showing scenes from the life of Christ, see No. 37. Embroidered scenes, such as those on the orphrey, were also made to serve as superfrontals for antependiums, with the rectangular compositions arranged horizontally rather than vertically.[3]

A number of similar orphreys for copes have survived and in most cases they too have been converted for use on chasubles.[4] All of them show scenes from the life of the Virgin or of Christ and all the compositions derive more or less directly from one of the great fresco cycles painted by Giotto's followers, Giovanni da Milano (act. 1350–69), Taddeo Gaddi (d. 1366) and Agnolo Gaddi (ca. 1350–96) in the Rinuccini and Baroncelli Chapels in Santa Croce, Florence, and in the Chapel of the Holy Girdle in the Cathedral at Prato. These frescoes all date between 1332 and 1396.[5]

The designs for these compositions travelled among the workshops of Florence in the form of painters' pattern books; Cennino Cennini's *Il libro*

dell'arte, which treats the craft of painting as it was practiced in the fourteenth century, gives painters detailed instructions on how to draw patterns on linen for embroiderers.[6] Clearly, a link existed between the crafts of fresco painting and needlework. It is equally clear that certain generic compositions, shared by artists in both mediums, were current from the second quarter of the fourteenth century into the first part of the next century. While the specific sources of the compositions on the Museum's orphrey have not yet been identified, they date from this period. As for the needlework itself, we can only conjecture that it must be dated in the early years of the fifteenth century, both because the pictorial sources date from 1325–1400 and because the embroiderers had mastered the pictorial style of the early Renaissance.[7]

The section of the orphrey that is now mounted on the back of the chasuble shows five scenes. From top to bottom they are as follows: the Annunciation, Nativity, Circumcision, Baptism and (perhaps) Christ Appearing to the Magdalene and Apostles. The part of the orphrey that is now mounted on the front of the chasuble (illus.) as the horizontal arm of the cross shows (left to right) John the Evangelist, an unidentified male saint, and John the Baptist. The compartments containing these figures have been cut apart and rearranged, and fragments of two narrative scenes have been attached to the ends of this section, which originally passed behind the shoulders when it was mounted on the cope. The fragment at the left end is part of a Visitation, while the fragment at the right end cannot be identified at present. The vertical section of the orphrey on the front of the chasuble shows, from top to bottom: the Adoration of the

Kings, Christ among the Doctors and Christ in the House of Mary and Martha.

The scenes worked on the vertical parts of the orphrey appear never to have been cut apart and rearranged. Since we know that when mounted on a cope compositions like these were meant to be read in chronological order, from side to side, and either top to bottom or the reverse,[8] we can reconstruct the orphrey as it was on the cope. The sequence would have proceeded from top to bottom and either left to right or right to left, as follows: the Annunciation, Visitation, Nativity, Adoration of the Kings, Circumcision, Christ among the Doctors, Baptism, Christ in the House of Mary and Martha, Christ Appearing to the Magdalene and Apostles(?), and an unidentified subject (the fragment at the right end of the horizontal arm of the cross on the front of the chasuble).

The silk and gilt needlework bordering the neckline, imitating a gold collar set with gemstones, would not have been used with the orphrey in its original context and is of indeterminate origin.

The chasuble in this form was exhibited at the *Exposition de Rome* in 1887 by Prof. J. Villegas, who then owned it.[9] At that time it was covered with the voided velvet of the early fifteenth century.

1 The velvet that covered the chasuble when it was bought in Rome is illustrated in de Farcy, I, pl. 58.

2 A.S. Cavallo, "A Newly Discovered Trecento Orphrey from Florence," *Burlington Magazine,* CII, 1960, pp. 505–10, fig. 4.

3 See an example with five scenes from the life of Christ, sold from the Robert von Hirsch collection, Sotheby Parke Bernet & Co., London, part II, June 22, 1978, lot 266, illus. p. 91.

4 Cavallo, pp. 505ff., figs. 3, 5, 6.

5 *Ibid.*, pp. 506 ff., figs. 7–15, 17–20.

6 *Ibid.*, pp. 509, 510.

7 *Ibid.*, p. 510.

8 *Ibid.*, pp. 505, 506.

9 See de Farcy, I, pl. 58.

Bibliography: L. de Farcy, *La Broderie du xi* *siècle jusqu'à nos jours . . .*, Paris, 1890 and later, II, pl. 58 (back only), I, p. 129, No. 58. *General Catalogue*, p. 108. Stout, pp. 124, 125, illus.

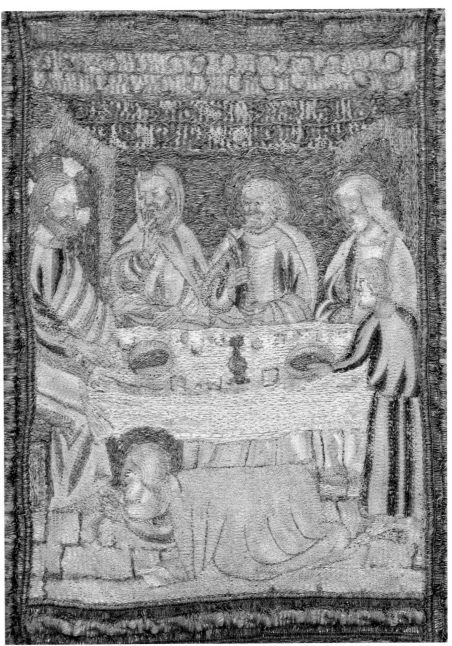

detail, 88

89

89
Coverlet

Italian or Spanish, 1450–1600
Silk tabby, quilted. L. 98″, W. 81″
(248.9 x 205.7 cm.)
Purchased from Emilio Costantini, Florence, 1897

One surface of the coverlet is made of yellowish green silk, the other surface of silk of the same fine, even texture but dyed pale crimson. There is no interlining fabric. The two silks have been quilted through both thicknesses with fine yellow silk worked in running stitches. The spaces between the parallel rows of stitches have been filled with cotton wadding, so that the linear pattern stands in relief against the unwadded ground. The coverlet is completely reversible. The edges show simple reversed seams with no applied binding. The field shows a network of interlaced hexagons formed by pairs of tendrils; a rosette appears in the center of each compartment. The wide border shows a row of similar units with single lilies in the corners; guard bands containing a guilloche pattern flank the border.

Coverlets of this kind were made during a long period of time and it is difficult, if not impossible, to date them precisely. Similar quilts appeared at least as early as the mid-fifteenth century; for instance, a closely related example in white can be seen on the bed in Bartolomé Bermejo's *Death of the Virgin* of 1460–62 (now in the Staatliche Museum, Berlin).[1] Both the pattern and the colors of the coverlet in the Gardner would have been fashionable up to, but not much after, the year 1600.

1 E. Young, *Bartolomé Bermejo. The Great Hispano-Flemish Master,* London, 1975, illus. in color opp. p. 16.

90
Fragments of an Orphrey T17w15, T20w7

Italian, 1525–50
Linen tabby, embroidered with polychrome silk yarns and gilt and silver yarns.
a. L. 44", W. 8" (111.75 x 20.3 cm.)
b. L. 36¾", W. 7⅞" (93.3 x 20 cm.)
Provenance unknown

The two fragments have been cut down from longer strips, probably the vertical sections of an orphrey for a cope. In their present condition they served as the front and back orphrey of a chasuble.

Both pieces show grounds of plain green cut velvet covered with applications of embroidered silk satin (the ornaments) or linen cloth (the human figures). The pattern is symmetrical on the vertical axis. It shows a unit comprising an urn flanked by leafy scrolls terminating in busts surmounted by a strapwork cartouche. A crowned mask supports a garlanded plinth flanked by swans and supporting a platter of fruits and leaves. These units alternate with circular medallions containing representations of holy personages worked in polychrome silks and couched gilt and silver yarns; the frames of the medallions are made of couched gilt yarns worked over thick plied cords, bordered with finer silver cords. The main sections are flanked by narrow guard bands showing arabesques of leaves and worked in the same way as the other ornaments, with polychrome silks and couched gilt cords.

The medallions in the longer piece show, from top to bottom: a three-quarter length figure of the Madonna seated against an aura and above a silver crescent, a half-figure of a bishop saint in a landscape, and a full figure of the Archangel Michael standing against a starry sky vanquishing the devil and holding the scales in his left hand. The shorter piece shows figures of St. John Baptist and St. Barbara.

The fragments show a kind of work and ornamental pattern that was fairly common in its time. Most of the other examples that have survived are in the form of furnishing fabrics and apparels on altar hangings; similar work has survived on other orphreys.[1]

1 See L. de Farcy, *La Broderie du xiᵉ siècle jusqu'à nos jours...*, Paris, 1890 and later, II, pl. 92, I, p. 132, No. 92.

Bibliography: *General Catalogue,* p. 173.

90a 90b

Dossal and Canopy T27e4

Italian, probably Rome, 1560–70
Cut silk velvet; silk and metal tabby; silk and metal cords executed in applied work.
Dossal: H. 190½″, W. 105¾″ (483.87 x 268.6 cm.)
Canopy: H. 24¾″ (62.87 cm.)
Purchased from Belisaris, Rome, through Ralph W. Curtis, 1895

Various textiles have been arranged to form a dossal and a long narrow valance. As installed in the Museum, the central section of the valance hangs outward from the wall to form a canopy over the dossal; the ends of the valance hang flat against the wall at right and left. The pattern does not finish neatly at the ends of the valance or at the ends of three more sections of the same or a similar valance that have been cut to fit the lower part of the dossal. The pattern is not properly finished at the lower ends of the matching arch-shaped enframement that surrounds the dossal at the top and sides. The design in the field of the dossal is not centered precisely. Taking these discrepancies into account, along with the difference between the velvet ground of the valance and frame of the field and that

of the applied motifs in the central field of the dossal, it seems that the various parts of these hangings were not made to be used in this way. The sections of valance probably once served as frieze elements on the walls of a room, and the matching piece now used as a frame for the field of the dossal may have originally enframed a door or window. The field of the dossal, which matches the other elements neither in color nor in pattern, but is closely related to them in material and technique, is probably part of a hanging from another suite of room furnishings. A set of applied work hangings of the same period, and related generically to the Gardner's dossal and canopy, was preserved at Kimberley House in Norfolk and is now in the Burrell Collection, Glasgow.[1]

It is believed that the latter hangings were made originally for a bed and later reworked to form a dossal, canopy and bench ("throne") cover. According to tradition, this cover served as a throne for Queen Elizabeth I when she visited Kimberley on a progress in 1578. Like the example

from Kimberley House, this dossal and canopy have been arranged to suggest a throne of state, and similarly this setting had been associated with a person of historical importance, in this case Francesco Cenci, Prince of the Holy Roman Empire and father of Beatrice Cenci.[2] However, since then it has been observed that there is an applied work coat of arms placed in the center of the valance.[3] The armorial motif comprises a shield bearing the arms of Giovanni Angelo Medici (1499–1565) as Pope Pius IV (1559–65) supported by the keys of St. Peter and surmounted by the papal tiara. Although the armorial bearings are superimposed on the valance without reference to the knotted cord pattern they interrupt, they are nevertheless made of the same materials that served for the central section of the dossal and might well have been made in association with it. If that is true, the initials C and F might reasonably be interpreted as a reference to Prince Fabrizio Colonna, nephew to Pius IV through his marriage to the Pope's niece Anna Borromeo. In 1567 the Pope's palace on the via Flaminia

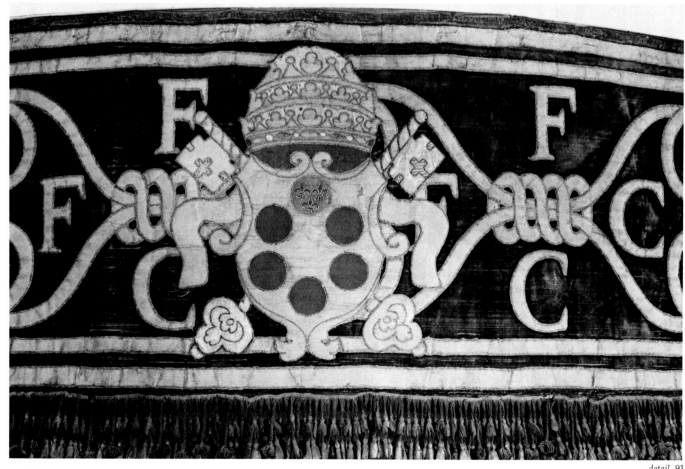

detail, 91

passed to the Colonna family by virtue of this marriage.[4] It is reasonable to suggest that furnishings from this or other residences also went to Fabrizio Colonna at that time, among them hangings later combined with Colonna hangings to form the dossal and canopy in the Gardner Museum.

The valance and borders of the dossal are made of dark purplish red velvet decorated with applications of ivory-colored silk ribbed tabby, edged with couched gilt cords. The pattern shows a laterally bisymmetrical arrangement of undulating and looping ropes tied with cords at their points of contact. The letters C and F appear next to the loops and points of binding, regardless of whether the orientation of the pattern is horizontal (valance) or vertical (side borders of the dossal). The field of the dossal shows a different pattern worked in applied motifs of a brighter red velvet, edged with red silk cord and heightened with pieces of gilt-shot silk tabby and touches of blue silk needlework. Branches with cut ends form a network of lobed and pointed ogival compartments that contain rows of lily blossoms, alternating with rows of vases holding leaves and rosettes and flanked by lilies. Where the branches converge, the points of contact are encircled by crowns or circlets of shells. The original ground fabric has been replaced with a modern silk corded tabby fabric corresponding in tone to the color of the fabric used for the initials and cords in the valance and borders of the dossal.

1 W. Wells, "Heraldic Relics from Kimberley," *Scottish Art Review,* VIII, 1962, pp. 17–21, 31.

2 *General Catalogue,* p. 234.

3 The author is indebted to Candace Adelson who first brought this motif to his attention.

4 U. Iandolo, *Il Palazzo di Pio IV sulla via Flaminia,* Milan and Rome, 1923, p. 36.

Bibliography: *General Catalogue,* p. 234.

91

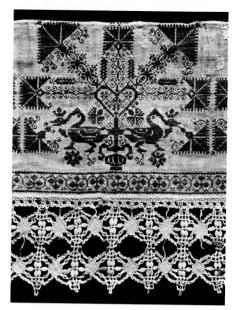

93

detail, 92

92
Fragment of a Cover F25nw50–B. 105
Italian, 1550–1600
Linen tabby embroidered with crimson
cotton, chiefly in cross and Holbein stitches.
L. 55½", W. 12¾" (141 x 32.4 cm.)
Provenance unknown

The border shows two versions of a
unit involving a vase of carnations
flanked by a pair of addorsed
crowned swans; in one instance the
unit is designed with its axes parallel
to those of the cloth. In the other
cases the axes have been shifted to
the diagonal in order to adapt the
unit to serve as a corner motif. Since
two corner units are now next to each
other and flank a seam at one end of
the cloth, it is clear that the cover has
been altered. A pattern for a pair of
addorsed swans related to these
appears in Johan Siebmacher's *Newes
Modelbuch*.[1] A related vase containing
blossoming stalks appears in Gio-
vanni Ostaus' *La vera perfezione del
disegno per punti e ricami*.[2]

1 J. Siebmacher, *Newes Modelbuch*, Nuremburg,
1604, p. 2.
2 G. Ostaus, *La vera perfezione del disegno per
punti e ricami*, Venice, 1561, pl. LXXIII.

93
Motif for Application T27w1
Italian, 1550–1600
Silk satins embroidered with polychrome
silk yarns and gilt yarns. H. 28", W. 24½"
(71.12 x 62.23 cm.)
Provenance unknown

The applied work motif has been
removed from its original context and
mounted on a plain blue fabric. It was
made as part of the ornamentation of
an ecclesiastical hanging (perhaps an
altar frontal or dossal) or banner. It
comprises an oval medallion set in
the center of a strapwork cartouche
that was originally covered with
pieces of red, green and white
(shaded with blue pigment or dye)
satin. The ground of the medallion
may have been covered with white
satin but it is so worn that an iden-
tification cannot be certain. The
cartouche is covered with red satin,
decorated with white satin rosettes
and volutes and edged with leaves of
green satin. All the main contours are
heightened with couched gilt yarn,
now much tarnished. In the center of
the medallion two hovering angels
face each other and raise a mon-
strance between them. Their robes
are worked with green or blue yarns
that are so much worn that the
stitches cannot be identified; their
wings and the monstrance are
worked with couched gilt yarns.

Bibliography: *General Catalogue*, p. 254.

94
Cushion Covers
Italian, 1550–1600
Linen tabby embroidered with crimson silk
yarn entirely in double running stitches.
a. L. 20¼", W. 14¼" (51.4 x 36.1 cm.)
b. L. 20⅞", W. 14½" (50.5 x 36.8 cm.)
Provenance unknown

Each cover consists of two parts that
are the same size but not precisely the
same in decoration; one piece covered
the top of the cushion, the other the
bottom. They buttoned together
along the edges by means of frogs
and loops sewn to one or the other
and made of silk braid and tufting
matching the silk used for the
embroidered patterns. These are,
then, loose covers that could be
removed for washing rather than per-
manent covers meant to be uphol-
stered in place. Each of the four
pieces is rectangular in shape and
shows a narrow border of needlework
around the edges and, in one case, a
motif in the center of the field of plain
linen. Except for this motif, all pat-
terns were worked so that the covers
are completely reversible, the needle-
work on one face as neatly finished as
on the other.

The border of the half of No. 94a that
is edged with loops shows a row of
regularly inverting units comprising
an artichoke on a stalk flanked by
intertwined leafy tendrils and guard
bands of acorn sprigs. The other half
has a narrower border showing inter-
twined and regularly inverting pairs
of tendrils with fewer leaves and
guard bands of sickle-shaped leaves.
Both centers are unornamented.

The borders of both halves of No. 94b
are alike and show rows of regularly
inverting units comprising an oak
leaf or small tree flanked by pairs of
S-scrolls tipped with leaves; the
guard bands show rows of tiny leaves
or birds alternating with rosettes.
The center of one piece contains a
spotted and leafy wreath surround-
ing an oval cartouche within a strap-
work frame; the diagonal bar across
the oval shield contains three trefoils
worked in green silk. The other
embroidery yarns in all four pieces
are of crimson silk.

94a

94b

95
Apparels T16e8
Italian (?), 1550–1600
Linen tabby and silk velvet embroidered with polychrome silk yarns and gilt yarns. Together: H. 18″, W. 43″ (45.72 x 109.22 cm.)
Provenance unknown

The two small panels, now mounted together, were made as motifs to be applied to an ecclesiastical vestment, probably a dalmatic, or perhaps to an altar frontal or dossal. Each one shows a central circular medallion placed over a rectangle on a ground of red velvet. The borders are worked with gilt yarns couched over padding in a pattern of bars alternating with bricks. The fields and frames of the medallions are decorated with strapwork, scrolling leaves, and bouquets in urns, all worked with gilt yarns couched over padding, couched gilt cords, and what appear to be vestiges of *or nué* embroidery (polychrome silk yarns over gilt yarns, giving an effect similar to that of enamel). The circular medallions are worked with polychrome silk yarns chiefly in long and short and laid stitches and with couched gilt yarns. They contain representations of a bishop with miter and crozier or a pope with tiara and staff. Both figures are seated before brick or masonry walls; the sky and hills appear beyond the walls.

Bibliography: *General Catalogue,* p. 116.

96
Furnishing Fabric T21e11, T21e13
Western Europe, 1550–1600
Silk velvet, cut; embroidered with couched silk cord and blue silk yarn. L. 54½″, W. 10¾″ (138.4 x 27. 3 cm.)
Provenance unknown

These strips of needlework may have been taken from the border or the field of a curtain, wall hanging, *portière* or other furnishing fabric. Pieces of similar needlework (or embossed and painted or gilt leather imitating needlework) were also used to upholster the backs of chairs; see, for example, the portrait of Queen Mary of England from the studio of Anthonis Mor van Dashorst dating from 1553–58 and hanging in the same room.[1]

The strips show a regularly inverting unit made up of branch and leaf arabesques running vertically between guard bands containing undulating leafy vines. The ends of each strip have been cut and the sides bound with a galloon of ivory silk that may once have been heightened with gilt yarns.

1 See Hendy, pp. 165–68, illus. p. 167.

detail, 96

97
Pennant T30e23

Spanish, 1592–1605
Silk: cut plain velvet with applications of
linen tabby worked with silk yarns chiefly in
laid work and couched metallic yarns.
H. 43″, W. 56″ (109.22 x 142.24 cm.)
Purchased from Villegas, Rome, 1895

The presence in the lower right corner of a shield bearing the arms of Aldobrandini surmounted by the papal tiara and crossed keys provides internal evidence for dating the banner in the reign of Ippolito Aldobrandini as Pope Clement VIII (1592–1605). The coats of arms in the lower left and upper right corners have not been identified. The fourth shield, in the upper left corner, bears the arms of the church of St. John Lateran at Rome. It shows the papal tiara and crossed keys in the upper half of the field and, in the lower half, the inscription SACROSANC/TAE LATERA/NENSIS EC/CLESIAE/. A stylized leafy vine between narrow guard bands borders the five sides of the pennant. Four six-pointed stars are ranged along the indented edge and what appears to be a cross with annulated tips at top and bottom occupies the left end of the field.

The central oval medallion, enframed by leafy scrolls, shows a statue of the Virgin holding the Christ Child, the dove of the Holy Spirit in the clouds above her crowned head. The statue is set in a landscape scattered with tents. A male figure, presumably a military man, kneels in prayer at the left side of the pedestal on which the figure of the Virgin stands. In the foreground are two quadrupeds near a tent. Above and below the medallion are inscribed the words ALMO-DOBAR/DEL CAMPO. The indented right end of the pennant is trimmed with red and white silk fringe.

Almodóvar del Campo (from the Arabic *al-mudawwar,* for round, or round place), a town in the province of Ciudad Real in south central Spain, was a Muslim fortress in the Middle Ages. During the period when this banner was made, the Counter-Reformation was in full progress and the Papacy was still supporting Spain as it moved simultaneously closer to alliances with France. The reference in this banner to Almodóvar del Campo is at present enigmatic. It might have been made in connection with a specific battle or campaign carried out in that town at the end of the sixteenth century, or alternatively it might represent a general allusion to the victory of Christendom over Islam in Spain. Similarly shaped pink (perhaps once red) pennants are shown flying from the tops of the tents in the medallion landscape; it may be that this was such a pennant and that it was flown at Almodóvar del Campo.

Bibliography: *General Catalogue,* p. 264.

97

98
Cover or Hanging

Swiss, dated 1593
Linen tabby embroidered with brown, white and blue linen yarns in a variety of elaborate outline and filling stitches. L. 76", W. 44" (193 x 111.7 cm.)
Purchased from A. Pickert, Nuremburg, September 19, 1897

The yarns in both the foundation fabric, which was used in the full loom width, and in the embroidery are heavy and coarsely spun. The pattern is oriented toward one long side of the piece, which suggests that the cloth was meant to be seen either hanging or lying flat on a table (and primarily from one side of the table only). Embroideries of this kind and size were also occasionally used to cover the top of a bed frame, to be seen from inside the bed curtains; however, the orientation of this pattern seems to argue against such a use. The edges of the fabric are turned under and overcast to form simple hems on the back.

A circular wreath in the center contains representations of a tree with a serpent coiled around the trunk, a bird perched at the top, and a rabbit on the ground at the lower right. A nude Adam, wearing a leaf, stands at the left; Eve, also nude, stands at the right. The date, 1593, is inscribed left and right of the tree's base, and an inscription at the top of this compartment follows the interior curve of the wreath. It reads as follows:
Die Schlang die ist listig und wijss Vergünt Adam unnd Eva das Paradiss (The serpent is crafty and wise she grants Adam and Eve their paradise). Scrolling branches bearing leaves and blossoms extend outward from the sides of the wreath across the field and into each of its four corners. Figures of animals, birds, and human beings are scattered over the field. These include: three dogs, a goat, a unicorn, a deer, two birds, a peacock, a hunter with spear, a man and woman in contemporary civilian dress, and a boy and a girl riding hobby horses. The hunter, one of the dogs, and the deer are arranged at the top of the cloth in such a way as to suggest that they represent a hunting scene; otherwise, there appears to be no narrative intent in the choice or placement of the figures. In the upper right section of the field there are representations of a pelican and a bunch of grapes. These motifs may have been intended to have Christian meaning as do many of the representations on Swiss embroideries of this period and style; however, they are not important enough in this pattern to indicate that the cloth may have served as an ecclesiastical hanging. Embroideries for domestic use in this period often show figures and incidents drawn from Old or New Testament sources.

99
A Man and Woman in a Garden
T21e3

English or French, 1590–1610
Linen (?) tabby embroidered with polychrome wool silk yarns in tent stitches. H. 75", W. 111½" (190.5 x 279 cm.)
Purchased from Antonio Carrer, Venice, through Ralph W. Curtis, 1893

The textile is in essence a needleworked tapestry and was probably meant to be hung on a wall. Although numbers of similar embroideries were made as table covers (carpets), this example differs from those in having a pattern whose motifs in both field and border are oriented in a single direction rather than nondirectionally or unidirectionally in the field and toward the sides or center in the border.[1] A large needlepoint panel in another collection shows a very closely related pattern with all motifs in the field and border oriented toward one long side, except for human heads in the corners of the border that are oriented inward toward the center. Because of this pattern orientation, Swain suggested that this example may have served as a coverlet.[2] The unidirectional orientation of all border motifs in the Gardner piece suggests that it was not used as a coverlet, or in any context in which it would have been looked at on the horizontal.

The field shows a man and a woman dressed in fashionable clothes of the late sixteenth or early seventeenth century, walking through a garden in which creatures of many kinds abound. There are dogs, deer, sheep, rabbits, squirrels, monkeys, owls, a lion, a lizard and a unicorn. Except for the presence of a young man, seated at the base of a tree in the middle distance at the left and playing bagpipes, this might be the garden of Eden.

The border is divided into lobed rectangular compartments by meandering straps that contain vines bearing a variety of blossoms, bunches of grapes, pomegranates and other fruits. Single fruit trees flanked by a wide variety of beasts appear in the center of each of four compartments at top and bottom; the compartment in the left border contains a pond with three geese between a rosebush and a cock; the compartment at the right contains a similar pond motif between plants, bearing daisies, jonquils and carnations, and a peacock. Female figures, dressed in fashionable costume of the period, are seated in the corners; their attributes are (clockwise from the lower left): a lance and shield (Minerva?), a peacock (Juno?), a pruning knife and sheaves of wheat (Ceres?), and a vase of flowers (Flora?). The pattern may have a subject no more obscure than that of a lady and gentleman walking in the park of a great house. See, for example, the aristocratic figures taking their ease in such parks or gardens as are represented in the four woven tapestries in Fenway Court (No. 14). However, it was common at the time this needlepoint hanging was made to represent figures from literary sources in contemporary clothes; see, for example, a long cushion cover or valance in the Irwin Untermyer collection showing an episode from the story of Esther and Ahasuerus of a valance in the same collection representing scenes from the story of Philomela in Ovid's *Metamorphoses*.[3]

Figures similar to those of the lady and gentleman in the Gardner hanging appear relatively often in related pieces of needlework. Other examples are the two figures in a detail from the Philomela valance and another couple represented on a valance showing fashionable people in a garden.[4] The figures, if not the entire setting in the field of the Gardner Museum hanging, were probably designed after a print; if the source is discovered the subject may be revealed. Although it is believed rightly that the figures in embroideries of this kind were copied or adapted from engraved or woodcut illustrations for books, few instances have been documented. The most impressive is the case of three of the main figures, taken from an engraving of the same subject by Philip Galle (1537–1612), in the field of the Victoria and Albert Museum's coverlet showing *Lucretia's Banquet*.[5]

The elegant clothes that the lady and gentleman in the Boston hanging are wearing would have been fashionable in the French court under Henry IV or during parts of the reigns of Elizabeth I and James I in the court of England. The embroidery style was also international at that time, and we have no criteria (other than an inscription in one language or the other) for attributing examples of needlework like this to one nation or to the other.

1 J.L. Nevinson, *Catalogue of English domestic embroidery of the sixteenth and seventeenth centuries*, Victoria and Albert Museum, Department of Textiles, London, 1938, pp. 4–8, pls. I–IV.

2 M. Swain, *Figures on Fabric*, London, 1980, pp. 60–61, pl. 29.

3 Y. Hackenbroch, *English and Other Needlework in the Irwin Untermyer Collection*, Cambridge, Mass., 1960, pp. 157, 17, figs. 180, 29.

4 *Ibid.*, fig. 35.

5 Swain, p. 60, pls. 29, 30.

Bibliography: *General Catalogue*, p. 174. Stout, pp. 150, 151, illus. Hadley, pp. 180, 181.

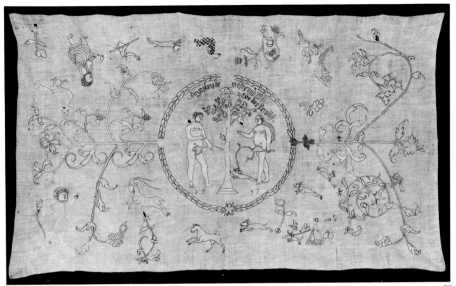

98

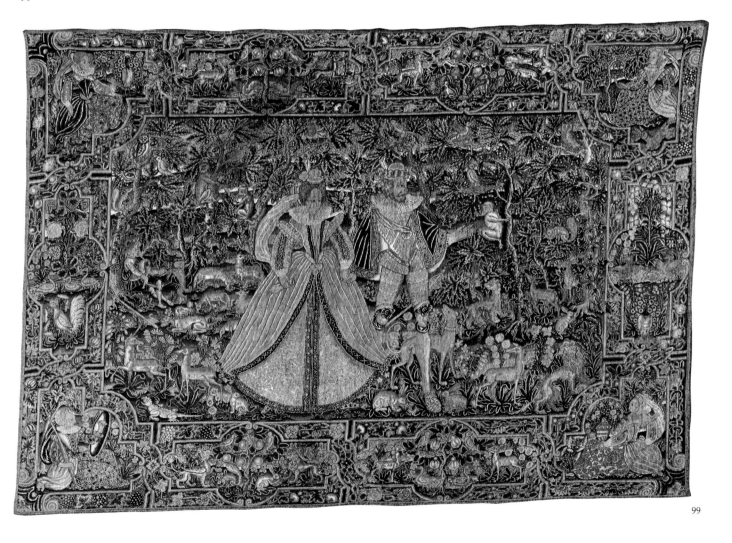

99

100
Cushion Cover T17w23

Italian (?), 1600–50

Silk satin embroidered with polychrome silk yarns in long and short, split, satin and stem stitches and with couched gilt and silver yarns and cords. H. 20¼", W. 21½" (51.4 x 54.6 cm.)
Provenance unknown

The cover is made in the form of a rectangular case with matching silk and gilt tassels at the corners. The foundation for the needlework is crimson satin; where the embroidery yarns have worn off, the underdrawing, executed with black pigment, is exposed. A coat of arms is set in the center of the field. It shows an oval shield with quartered arms worked in silk, silver and gilt yarns; a scrolled cartouche frames the shield and a helmet with mantling and a bird crest surmounts the frame, while ribbons flutter at the sides. All of these motifs are worked with couched metal yarns and touches of silk yarns. Sprigs bearing roses and other blossoms are set in the corners of the field and four smaller sprigs are set in the intermediate spaces. The border contains an undulating vine bearing roses, carnations, lilies and other blossoms and leaves. The satin, which is set at right angles to the edges, forms the thickness of the case; it has been decoratively slashed in a series of chevron forms decorated with gilt cords and leaf motifs.

The date suggested here is based on the character of the floral motifs and on the form of the frame for the oval shield, which seems later than the vigorous strapwork cartouches of the preceding century.

101
Medallion from an Orphrey or Apparel T18s9

Italian, 1600–50 (?)

Linen tabby embroidered with polychrome silk yarns chiefly in long and short, satin and stem stitches, and with couched gilt yarns. H. 7⅝", W. 6½" (19.3 x 16.5 cm.)
Provenance unknown

The small oval medallion shows the Archangel Michael overcoming the dragon. It has been removed from its original context, where it would have served as one in a group of related representations on an orphrey or apparel (see Nos. 90, 95). The angel is dressed in classical armor and stands in the center of the space in a landscape with the sun and clouds above and rocks in the distance. He tramples on the dragon that is represented with the devil's head, white bat wings and a long green tail. Michael holds a gilt sword in his right hand and gilt scales in his left. A narrow border of gilt braid frames the medallion.

101

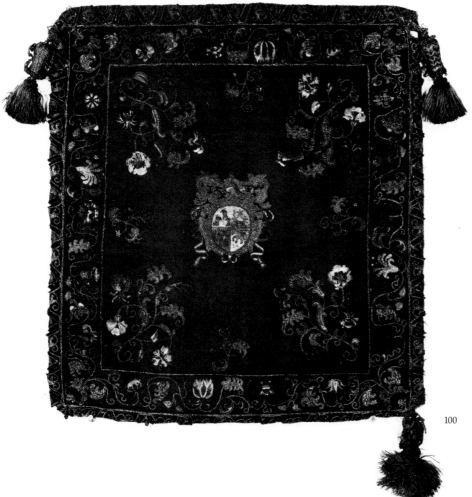

100

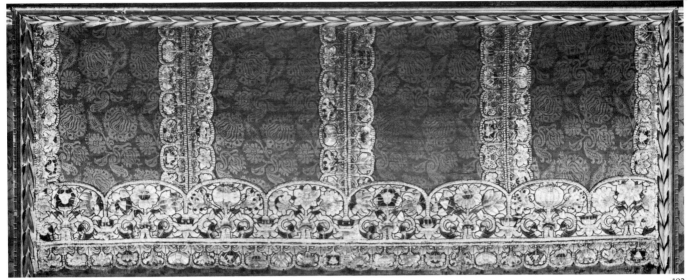

102

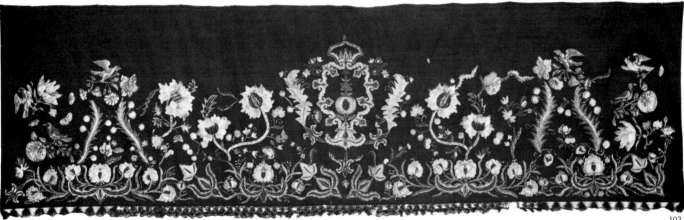

103

102
Valance T21n9
Spanish or Italian, 1625–50

Silk damask, with applications of linen (?) tabby embroidered with polychrome silk yarns chiefly in laid work. L. 80″, W. 31″ (203.2 x 78.74 cm.)

Provenance unknown

The valance shows four rectangles of olive-green silk damask framed at the sides and bottom by bands of embroidered floral ornament. The outer borders and the partitions between the rectangular compartments are simple straight bands with grounds of white silk laid work richly covered with floral sprays executed in polychrome silk laid work. Inside the bottom border there is a row of arched compartments containing blossoming sprigs worked in the same way. The floral units are accented with couched ivory silk cord and satin stitches in various colors worked over padding.

The valance probably once formed part of a set of bed hangings, attached to either the lower or upper frame; or, it might have served as a window valance.

103
Border from a Dress or Furnishing Fabric
Italian, 1650–1700

Silk: tabby embroidered with polychrome silk yarns chiefly in long and short stitches. H. 29″, W. 86″ (73.66 x 218.4 cm.)

Provenance unknown

In 1925 the needleworked motifs were cut from the original foundation material, which had disintegrated. They were mounted on the grayish green, tabby-woven silk that now serves as the foundation. The pattern shows a bilaterally symmetrical arrangement of floral sprays, bouquets, leaves and birds, with a floral border at the bottom. The motifs are rendered with great naturalism through the use of "needlepainting" with long and short silk stitches. A narrow border of fringed metallic lace is sewn along the bottom edge.

Although the border may have been taken from a wall, window or bed hanging, it shows at its center a pomegranate enclosed in a leafy cartouche surmounted by a crown,

which can be interpreted as a reference to the Virgin, indicating that the border was probably taken from the skirt of a gown for a statue of the Virgin. Another border from the same fabric (T2w1) is on view in the Museum.

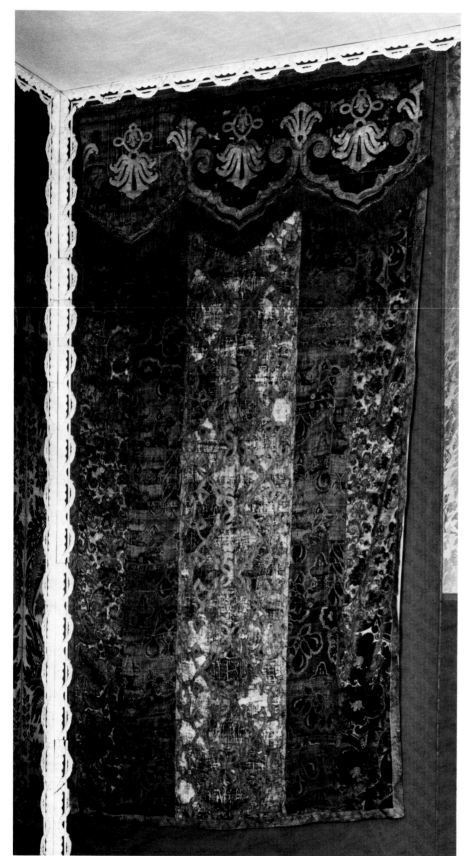

104

104
Curtain with Attached Valance
T16s4

Italian, 1650–1725
Silk: plain and voided velvets, both cut;
applications of gilt cloth, galloon and fringe.
H. 128¼″, W. 61½″ (325.76 x 156.21 cm.)
Provenance unknown

The valance of solid red cut velvet has
a straight top and a lower edge cut
into three curved points, these con-
tours being repeated in the lines of
the applied gilt galloon and fringe
that border the lower edge. Three
large stylized acanthus leaves or
anthemion lilies, worked in applied
gilt cloth, occupy the centers of the
points.

The curtain is made of five strips of
three different kinds of velvet. The
central and widest strip is made of
solid cut red velvet with an applied
pattern of gilt galloon strap and floral
motifs. The two narrow strips flank-
ing the center are made of red cut
voided velvet showing a scatter of
pear branches on a red chevron
ground. The two outer strips are also
made of cut voided velvet and show a
pattern of scrolling branches with
acanthus leaves and fantastic blos-
soms in two heights of red pile on a
white silk ground that may have been
covered with silver yarns.

Originally there were two such cur-
tains in the Museum's collection, but
only the valance of the second one
has been preserved (now in storage).

Bibliography: *General Catalogue*, p. 112.

105
Border From a Furnishing Fabric
T1w2

French or Italian, 1675–1725
Silk tabby embroidered with polychrome silks
chiefly in long and short, satin and stem
stitches and fancy couching work. H. 31¼″,
W. 63½″ (79.37 x 161.29 cm.)
Provenance unknown

The foundation is a ribbed cloth
with fine alternating pink and white
stripes in the weft direction. The pat-
tern shows a row of units comprising
irregularly shaped strapwork com-
partments containing bouquets of
flowers and separated by shells along
the lower edge; a garland of flowers
undulates along the tops of the units.
The carnations, roses and petunias
are rendered in natural colors; in
addition there are fantastic blossoms
in many colors and scrolls worked

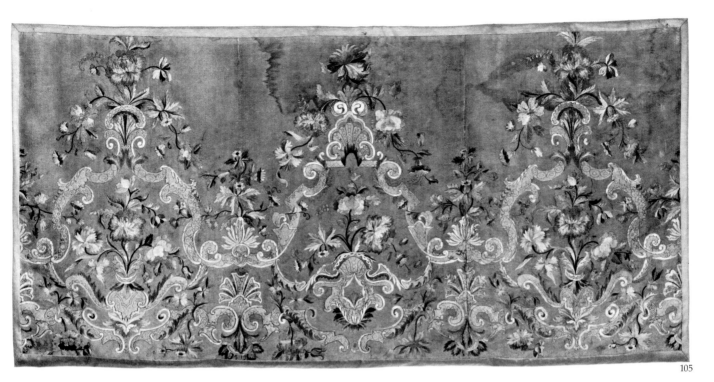

chiefly in ivory. The original fabric in its full length showed eight units; two of them were removed in 1974 due to deterioration, leaving two panels of three units each. Before alteration the border measured fifteen feet nine inches in length, which suggests that it may have served as the upper or lower valance for a bed or perhaps as the lower border of a wall panel.

Bibliography: *General Catalogue*, p. 16.

106
Furnishing Fabric T18s30
French, 1675–1725
Linen tabby embroidered with polychrome wool and silk yarns in large and small tent stitches. H. 18⅝″, W. 21¾″ (47.2 x 55.2 cm.)
Provenance unknown

The fashionable gown worn by the figure of Flora in the center of the composition indicates a date in the late seventeenth or early eighteenth century. At some later time this fabric, which might have been part of a furniture cover or a hanging, apparently was cut down to fit the back of a chair. The figure appears against a ground of dark brown that was perhaps once black; fantastic blossoms surround her and a palm tree is at the left. She wears a crown of flowers and holds a rose branch in her right hand.

Bibliography: *General Catalogue*, p. 148.

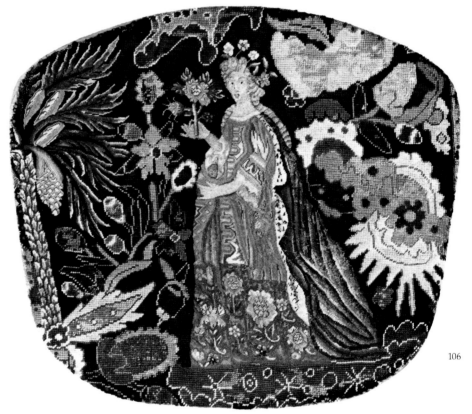

107
Hanging or Cover T15e16
Italian (?), 1675–1750 and later
Linen (?) tabby embroidered with polychrome
silk yarns entirely in Hungarian stitches.
Left panel: H. 75½", W. 23½" (191.77 x
59.69 cm.)
Right panel: H. 75⅝", W. 23½" (192.08 x 59.69 cm.)
Provenance unknown

The green silk damask that originally
formed the central field of this hang-
ing or cover (left panel illus.) was
removed in 1976 due to its deterio-
rated condition; it was replaced with
a modern cotton damask. At each
end is a strip of needlework showing
the typical "flame" pattern associated
with Hungarian stitch work. The
chevron patterns are rendered with
white, pink, orange, yellow, green
and black silk yarns. Since the
embroidery has been used on its side,
both the stitches and the chevrons
are oriented horizontally rather than
vertically as they would have been in
their original context. The needle-
work strips were probably cut from a
window or bed curtain.

Bibliography: *General Catalogue*, p. 90.

108
Part of a Furnishing Fabric
Spanish, 1675–1725
Silver shot silk tabby, with applications of gilt-
shot silk tabby, embroidered with polychrome
silks in laid, split and stem stitches. H. 35",
W. 38" (88.9 x 96.5 cm.)
Provenance unknown

The fragment is now made up as a
small cover, but was probably taken
from a curtain or hanging. The sym-
metrical pattern shows a central stalk
bearing scrolling acanthus leaves
applied in gilt cloth and shaded with
brown paint and a variety of flowers
worked with bright silks in laid and
other stitches. The silver ground was
patched at one end before it was
embroidered. A blue and white silk
fringe has been sewn to all four sides.

109
Part of a Furnishing Fabric
Spanish, 1675–1750
Silk tabby embroidered with polychrome
silk yarns in laid stitches. H. 31", W. 41½" (79 x
105.5 cm.)
Provenance unknown

The pattern suggests that the frag-
ment was taken from a coverlet or
curtain. It shows a row of bouquets
in the center, flanked by scrolling
vines bearing blossoms in brilliant

colors and leaves; two birds are
perched on the vines. The fine silk
foundation preserves its full loom
width. Because the binding yarns
have worn almost entirely away, the
laid work now resembles long float-
ing satin stitches.

110
Furnishing Fabric T18s32
French (?), 1675–1750
Linen tabby embroidered with polychrome silk
and wool yarns in Gobelins, tent, stem and
long and short stitches. H. 33½", W. 31¼"
(85.05 x 79.3 cm.)
Provenance unknown

The size of the piece and character of
its pattern suggest that it was made
to cover the back of a chair or the
panel of a firescreen. A wide border
of needlework frames the central
panel; it is executed with silk yarns in
Gobelins stitch and shows a basket of
fruit and flowers at the top and scroll-
ing acanthus leaves with roses and
daffodils at the sides. The central
panel shows a formal garden beyond
a balustered wall and a peacock, rab-
bit and parrot in the foreground; this
section is executed with wool and silk
yarns in tent, stem, and long and
short stitches. The fabric shows a
cut edge at the bottom where there is
no border; the portion of the fabric
below the panel has not been embroi-
dered. There is also a narrow border
of unworked linen foundation
around the other three sides of the
piece.

111
Fragments of a Chasuble
Italian or Spanish, 1700–25
Silk: silver-shot tabby embroidered with
polychrome silk yarns chiefly in long and short
and stem stitches. L. 45", W. 26" (114.3 x 66 cm.)
Provenance unknown

The fabric shows a symmetrical pat-
tern of scrolling vines bearing roses,
lilies, tulips, daffodils, carnations
and fanciful blossoms worked in
polychrome silks on a foundation of
silver-shot (tinsel) white silk cloth.
The orphrey on both front and back is
defined by strips of gilt galloon; the
edges of the vestment are trimmed
with narrower galloon.

The front of the chasuble (T25w8, not
illus.) has been mounted in the cen-
tral panel of a three-fold screen; the
back (illus.) has been placed in
storage.

Bibliography: *General Catalogue*, p. 211.

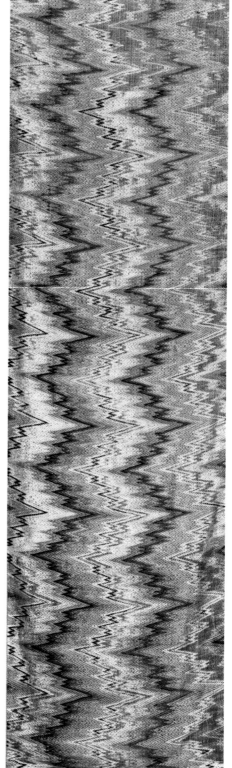

left panel, 107

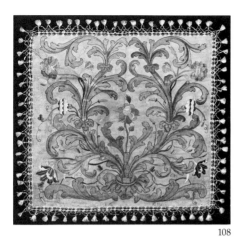

108

109

110

111

112
Part of a Furnishing Fabric T1s9
French or Italian, 1725–50
Silk: tabby embroidered with silk yarns chiefly in long and short stiches. L. 86″, W. 22¼″ (218.44 x 56.51 cm.)
Provenance unknown

The fabric appears to have been a valance or the border of a hanging. It shows a pattern of large flowers, trees and buildings in landscape settings worked in red, yellow, green and blue silks on a gray foundation.

Bibliography: *General Catalogue*, p. 21.

113
Hanging T26n6
Italian, 1738–75
Silk: plain cut velvet with applications of various foundation fabrics embroidered with silk and metallic yarns. H. 99½″, W. 79⅜″ (252.7 x 201.6 cm.)
Provenance unknown

The wall hanging, *portière* or curtain (see T26s4 and T26n18 for other eighteenth-century examples, and T16e5-s and T16e15-s for borders removed from their original foundations) of red velvet bears a single armorial motif in the center of its upper half and two smaller and different armorial motifs, mirror-images of each other, at right and left in its lower half. Flowering scrolls worked with couched silver and/or gilt yarns, which have darkened to the point of making their colors indistinguishable, form a border on all four sides.

The large shield at the top, set against a composition of military trophies and surmounted by an open crown denoting a rank tentatively identified as that of marquis, is charged with an eagle facing sinister. A closed crown is on its head and a shield encircled by collars of the orders of the Golden Fleece and of San Gennaro is on its breast. The chivalric Order of San Gennaro (St. Januarius, Bishop of Benevento, martyred at Pozzuoli in 305 A.D. and principal saint of Naples) was instituted by Charles III of Bourbon, King of Naples, in honor of that saint, on July 3, 1738. The presence of the collar of the Order establishes a *terminus post quem* for dating this hanging.

Each of the two smaller shields below is charged with the figure of a crowned erect lion and a tower; each shield is enframed with scrollwork and surmounted by the same kind of crown that surmounts the main shield above. All three shields are worked over thick padding and stand out from the surface of the foundation velvet in relief.

Bibliography: *General Catalogue*, p. 228.

114
Hanging or Curtain T21n4
Italian, 1725–75, altered later
Silk: cut plain velvet embroidered with silk yarns in long and short stitches and with couched silver and gilt yarns. H. 86¼″, W. 56⅝″ (219 x 143.8 cm.)
Provenance: San Donato Collection, Florence. Purchased from Sypher and Company, New York, October 20, 1880

This wall hanging, *portière* or curtain shows an exuberant pattern of scrolling leaves and floral sprays arranged in a bilaterally symmetrical composition around a central shield-shaped cartouche showing the Archangel Michael overcoming the Devil. The foundation for the main part of the hanging is of red velvet; the cartouche on which the figures are represented is a violet velvet that is of a later date. The vegetable motifs and the figures were worked on other foundations with backings of coarse linen tabby and then applied to the velvets, which were already worn when they were put to this use. All the ornamental motifs are worked with silver and gilt yarns of various types and sizes couched with blue (for the silver) or yellow (for the gilt) silk yarns; the two metals were used together, thus giving the pattern a particularly sumptuous effect. The figures are worked with polychrome silk yarns on a red satin foundation backed with the linen tabby. The Archangel's wings are rendered with white and pink silks edged with gilt yarns. His breastplate is made of white and blue silk yarns that have worn off almost entirely; his gorget and the lambrequins of his kilt are rendered with silver yarns. Beige (originally yellow?) silk yarns are worked in knotted stitches to represent his hair. Some golden yellow silk stitches remain on the Devil's body, but most of the surface has worn through to the red satin and linen backing. When it was sold from the San Donato Collection in 1880 the

hanging was lined with gold-figured white satin and edged with gilt "Venetian lace" (galloon?), neither of which is now present.

Bibliography: A.N. Demidov (Prince of San Donato) Sale, Palazzo San Donato, Florence, April 12–22, 1880, No. 865. *General Catalogue*, p. 178.

115
Motif for Application T15e12
Italian, 1700–1800 (?)
Silk: tabby with applications of painted and embroidered silk tabby. H. 31″, W. 23½″ (78.7 x 59.7 cm.)
Provenance unknown

The motif shows a large armorial shield with a quartered field. The animals, landscape elements and other charges are made of pieces of colored silk that have been painted to show interior details and shading. The linear details in the field are rendered with silk stitches; all the elements are outlined with couched silver or gilt cords that have darkened to a uniform tone.

116
Cover or Hanging T2w2
French, 1780–1800
Silk twill adhered to linen tabby, embroidered with bluish green, pink and yellow silk chenille yarns in knotted stitches and couched work with applications of brown silk gauze. H. 16⅝″, W. 46½″ (42.2 x 118.1 cm.)
Provenance unknown

The cover's pattern is worked on a pinkish tan silk ground. The center is occupied by a trophy of olive and oak branches, banners on staffs, bugles, and fork-ended bars suggesting rays of light arranged in an arc. The border shows a pair of spiraling ribbons tied at frequent intervals around the stems of oak sprigs. These motifs are worked with chenille yarns in knotted stitches (pink) and couched work (green and yellow). The size, materials and disposition of pattern suggest that it may have served as a cushion cover, wall panel or possibly the end valance for a narrow bed. An identical cover is preserved in storage.

Bibliography: *General Catalogue*, p. 24.

112

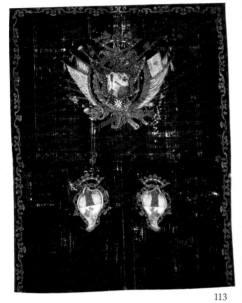

113

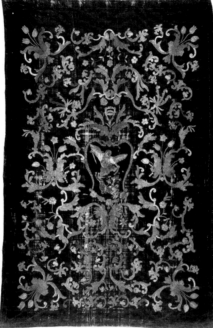

114

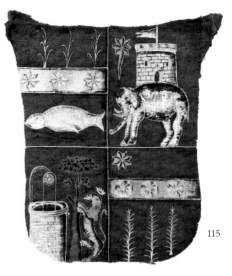

115

116

117
Eagle, Staff, Flag and Cravat: Insignia of the First Regiment of Grenadiers of Foot of Napoleon's Imperial Guard T17s1

French, 1813–14

Red, white and blue silk tabby, embroidered over padding with silk and gilt yarns, chiefly in satin and stem stitches; with gilt sequins, bosses, and spiral wires, in couching stitches, and with applied bits of silk tabby.
Flag: H. 40″, W. 40¼″ (101.6 x 102.2 cm.)
Cravat: L. 48″, W. 31″ (121.92 x 78.74 cm.)

Provenance: San Donato Collection, Florence. Purchased from Sypher and Company, New York, October 20, 1880

The insignia figured in the sale of objects from the San Donato Palace, Florence, where they had apparently been part of the collection of Prince Anatolii Demidov, a collector of objects relating to Napoleon, and husband of Napoleon's niece, Mathile Bonaparte (the author is indebted to James Levinson, who generously shared with him, from unpublished notes, this information).[1]

The flag is composed of two embroidered panels mounted back to back. Each panel was made up of strips of lightweight red, white and blue silk tabby, joined with simple seams. They are oriented so that the blue strip falls closest to the flagstaff, the white strip next, and the red strip along the outside edge, hanging free. A short fringe of crimped gilt wires borders the field on all sides, its heading sewn between the two layers of silk. Both faces of the flag show: inscriptions contained within borders having an Imperial crown surmounted by a pair of stars in each upper corner, an eagle with lifted wings and facing inward in each of the lower corners, a leafy wreath enframing an exploding grenade in the center of the upper and lower borders with each wreath flanked by three rows of bees, and a similar wreath containing the capital letter N, in the center of the borders at left and right. These wreaths are separated from the corner motifs by pairs of symmetrical palmette and anthemion motifs.

Anthemions, bees and fringe also ornament the ends of the cravat. Its field shows the same arrangement of red, white and blue silk strips, seamed along the long dimensions. All the needlework is executed over padding, so that the relief is high and firm. The two large tassels at the ends

of the gilt cord that ties the cravat in place below the eagle's base at the top of the staff are completely covered with gilt yarns; they terminate in the same crimped wire fringe that trims the cravat ends. All motifs are worked in gilt yarns, wires or spangles except for the representations of gemstones on the band and branches of the crowns, which have been worked with red and green silk yarns, and also the inside surfaces of the bands, which have been rendered with bits of applied red silk tabby. The flag is in excellent condition; the cravat has deteriorated and the silk is brittle and broken.

The inscription embroidered on the obverse of the flag reads as follows: GARDE/IMPERIALE/L'EMPEREUR/NAPOLÉON/AU Ier RÉGIMENT/DES GRENADIERS/À PIED. The names of eleven battles that ended in victory for the Imperial army are inscribed on the reverse, as follows: MARINGO, ULM,/ AUSTERLITZ, JÉNA/EYLAU, FRIEDLAND,/ ECKMÜHL, ESSLING/WAGRAM, SMOLENSK/MOSKOWA, together with the names of four conquered capitals, VIENNE, BERLIN / MADRID, MOSCOU.

The gilded eagle perches on a plinth showing the number 1, indicating the regiment to which it belonged. Eagles like this, made in imitation of the design of the Seal of the Empire, were issued to the various regiments of the Imperial army after 1804, when the Empire was proclaimed, and they became more important than the flag itself. While tricolor flags showing this basic conformation were issued to line regiments in the Imperial army in 1812, it was not until 1813 that Napoleon issued similar flags to the units of the Imperial Guard.[2] In this issue of flags, the Emperor added to the existing list of victories those of Marengo, Smolensk, and Moskowa, as well as the names of the four conquered capitals Vienna, Berlin, Madrid, and Moscow.[3] The Gardner's flag and cravat correspond in all particulars to the detailed technical description of the regulation flags issued to regiments of the Imperial Guard from 1812 to 1814, as drawn by Hollander from contemporaneous documents.[4] Hollander also gives a description of an example of the flag for the First Regiment of Grenadiers of Foot to which he apparently had access. According to Hollander, this

was the flag that Napoleon was said to have given to Général Petit, Commander of the First Regiment of Grenadiers of Foot, at Napoleon's farewell at Fontainebleau in April, 1814, a ceremony represented in a painting by Horace Vernet.[5] According to tradition, that flag is the one that is now exhibited in the Musée de l'Armée in Paris (reg. No. Ba 117), having been inherited from Général Petit by his grandson M. Haton de la Goupillière, who then bequeathed it to the Museum.

While the flags in the Gardner Museum and in Paris agree in pattern and size, they are different in materials and technique. The Boston example has a foundation of finely woven silk tabby fabrics joined with simple seams, whereas the Paris flag is made of three strips of more loosely woven weft twill fabrics joined with welted seams (the colors of the Paris flag, now apparently much faded, read as mauve or bluish gray rather than red, white and blue). The needlework in the Boston flag is of the highest professional quality and uses gilt yarns and ornaments of several kinds, worked over shaped padding, whereas the Paris flag shows only three kinds of gilt yarn worked through the fabric or couched on the surface. Its needlework is loose and crude by comparison with that in the Boston piece. Two other regimental flags of this type are exhibited in the Musée de l'Armée and they agree technically with the Grenadiers flag in that collection. One of these, with its cravat, is described as a flag of the 1812 model for the Sixth Regiment of Light Cavalry (reg. No. Ba 11a), while the other (reg. No. Ba 124) is identified as a flag of 1815 of the Artillery Cavalry Regiment of the Imperial Guard. If these identifications are correct, then it is clear that at least some regimental flags issued between 1812 and 1815 were technically similar to the Paris Grenadiers flag rather than to the example in Boston.

The question remains: why is the Boston flag so different from the others? Is it perhaps a later copy, perhaps a commemorative piece, as the phrasing of the entry for it in the San Donato sale catalogue could be interpreted to suggest ("Aigle de l'empire (copie exacte)")? The literature on this subject is incomplete and in some cases contradictory. Given

the imperfect state of our information, it is not possible to interpret the differences between the Boston and Paris flags with any degree of conviction. The most that can be said is that the Boston example agrees more exactly than the other three do with the technical description of the official regimental flags as outlined in a letter written by Napoleon to his Minister of War around 1812. "... Il faut pour l'étoffe faire choix d'une double soie bien serrée et la faire broder avec soin. Ne regardez pas aux prix, etc... sur les deux faces de leur étoffe, une très riche ornementation consistant en une broderie d'or en relief d'une remarquable éxécution...."[6]

On the other hand, except for their size, which corresponds to the approximately 1.00m. dimensions of the Boston flag rather than to the 1.20m. Hollander gives for the later examples, the three flags in Paris correspond more precisely to the technical description that Hollander indicates for regimental flags made during the Hundred Days of Napoleon's power following his return from Elba in 1815: "... Cette ornementation est brodée directement sur la soie, mais les lettres des inscriptions, brodées en or sur drap noir découpé, sont rapportées sur l'étoffe, sans doute afin d'activer la confection des drapeaux, car ils furent éxécutés dans le délai très court d'un mois."[7] Certainly the flags in Paris look as though they had been made hastily, and many of the embroidery yarns pass directly through the fabric; however, neither their patterns nor their dimensions correspond to those described by Hollander for the 1815 flags. The question is reduced at present to a matter of conjecture. Is the Boston flag only one of many issued to the same regiment at different times, one that for some reason was kept intact, i.e. not used in battle? Or, is it a later commemorative piece, despite its precise correspondence to the descriptions of material, design and technique given for flags of this kind as early as 1812?[8]

1 A.N. Demidov (Prince of San Donato) Sale, No. 2190.

2 O. Hollander, *Nos drapeaux et étendards de 1812 à 1815,* Paris, 1902, pp. 22, 23, 81; K. Over, *Flags and Standards of the Napoleonic Wars,* London, 1976, p. 39.

3 Général J. Regnault, *Les aigles impériales et le drapeau tricolore 1804–15,* Paris, 1967, pp. 207, 208, figs. 36, 37.

4 Hollander, pp. 103, 104.

5 *Ibid.,* pp. 81, 82 n. 1; O. Aubry, *Napoléon,* Paris, 1936, p. 319.

6 Hollander, p. 103.

7 *Ibid.,* p. 201.

8 *Ibid.,* pp. 103, 104.

Bibliography: A.N. Demidov (Prince of San Donato) Sale, Palazzo San Donato, Florence, April 12–22, 1880, No. 2190. *General Catalogue,* p. 133.

front, 117

back, 117

118b

118
Pair of Hangings T16n2-s, T16n9-s

Italian, XVIII or XIX century
Silk velvet, cut; with applications of metal-shot silk cloths, ribbed silk cloth, and gilt cord, galloon and sequins.
a. H. 118½", W. 93½" (300.9 x 237.49 cm.)
b. H. 118¾", W. 94" (302.62 x 238.76 cm.)
Purchased from Galleria Sangiorgi, Rome, 1899

The two hangings show identical patterns. An ovoid shield occupies the center of the plain red velvet ground; from behind the shield appear a mantling of leaves, the four points of the cross of Malta, and the top of a patriarchal cross. A cardinal's hat surmounts the shield; it is made of red ribbed silk cloth shaded with black pigment and trimmed with gilt galloon. Because this silk does not appear anywhere else on the hangings, and because the velvet ground shows traces of the presence of other, and fewer, tassels at the sides of the shield where the fifteen red tassels now appear below each side of the cardinal's hat, it seems likely that the hat is not original. The shields, crosses and charges on the hangings are all made of cloth of silver or gold, with painted details. Each hanging shows a wide border of scrolling acanthus leaves, anthemions and rosettes made of cloth of gold and heightened with gilt cords and sequins couched into place.

The coat of arms has in the past been identified as that of Cardinal Prince Gustav Adolf Hohenlohe-Schillingfurst (1823–96), who held various important posts in the Vatican.[1] John Woodward gives the arms of "Hohenlohe" in reference to Joseph Christian, Prince Hohenlohe-Waldenburg-Bartenstein as "argent, two lions passant sable"; it is on the basis of this blazon that the hangings have been associated with Cardinal Hohenlohe.[2] However, the two animals represented on the coat of arms are not lions but tigers, and thus the identification seems erroneous. Because of this, and also because the cardinal's hat appears not to be an original element in the design, the hangings may be dated as early as the border pattern suggests, or to the first half of the eighteenth century, unless the coat of arms is more properly identified in the future as one belonging to an ecclesiastic who lived in the next century.

left panel, 119

right panel, 119

Used now as curtains flanking a fireplace, the hangings may originally have served as *portières*, as their size and character suggest.

1 *General Catalogue,* pp. 118, 119.
2 Woodward, p. 273.

Bibliography: J. Woodward, *A Treatise on Ecclesiastical Heraldry,* Edinburgh, 1894, p. 273. *General Catalogue,* pp. 118, 119.

119
Fragments from Bed Covers T3e1
Greek, Jannina, XVIII or early XIX century
Linen tabby embroidered with white, yellow, red, green, blue, and black silk yarns chiefly in Romanian and stem stitches.
Left panel: L. 78", W. 14¾" (198.1 x 37.5 cm.)
Right panel: L. 72¼", W. 14¾" (183.4 x 37.5 cm.)
Provenance unknown

The collection contains five panels of this needlework, each of which appears to be made up of parts of bed covers. Since this is traditional domestic work, the patterns varied little from one cover to another. The panels that are illustrated (actually joined together) contain parts of the field and border of one or more covers (two other panels are in storage; one more, T27w32, is in the Long Gallery).

The foundation fabrics in each instance are woven of fine, slightly overspun (thus almost creped) linen yarns. The silks, which are all used in the untwisted or floss state, are worked to represent large cone motifs filled with rosettes and flanked by large lanceolate leaves, with roses,

tulips and carnations scattered over the field between these motifs. The size of the cones indicates the original position of the fragment; large cones were used in the borders of the cover, smaller ones were reserved for the cover's field.

Bibliography: *General Catalogue,* p. 36.

120
Badge T11e15
French, about 1916
Linen tabby covered with silk tabby, embroidered with white silk yarns that show traces of metal covering, and brown silk yarns; details painted. L. 15¾", W. 2½" (40 x 6.4 cm.)
Provenance unknown

The long, narrow strip of cloth shows a painted representation of a blond warrior, wearing a coat and cape over armor, standing in the upper section against a ground of white and brown running stitches. He holds a sword in his right hand and a long narrow shield in his left hand; a crowned double-headed eagle is represented on the shield. Behind his head is a halo of long and short stitches worked in white silk. In the lower section of the piece is a painted inscription that reads as follows: GLOIRE/A LA SAINTE/A LA GRANDE/A LA HEROIQUE/RUSSIE/ 1914/1916. A narrow gilt galloon has been sewn across the top and bottom of the strip; from the bottom hangs a cinquefoil motif made of cloth of gold and gilt cord.

120

121 and 122
Two Woven Fabrics for Orphreys
Italian, Tuscany, 1450–1500

These are among the earliest silk weavings in the collection (see T17w38 and T17w39 for two further examples). The practice of making woven rather than embroidered orphreys had been established several centuries earlier in Spain, Sicily and Germany, but it was not until the silk weavers of central Italy incorporated into their work patterns inspired by the paintings of contemporary Florentine masters that woven orphreys showing essentially pictorial compositions rather than ornamental patterns were available. For subject matter the designers drew on incidents in the life of Christ or the Virgin, as the designers of embroidered orphreys had done (see No. 88). They also prepared patterns with devotional subjects, such as the Risen Christ, the Trinity, the Madonna in Glory, the Madonna of Mercy, and figures of saints. Most of the patterns were woven in several different versions.

This class of weavings, of which large numbers have survived, has been variously ascribed to Lucca, Siena and Florence, with no firm arguments favoring one city over another. The general attribution to Tuscany depends primarily on the similarity that the more sophisticated compositions bear to paintings by leading Florentine masters of the second half of the fifteenth century. Some of the fabrics were woven as compound satins with patterns rendered in several colors and gilt yarns; others were made in the same way but with a brocatelle effect (the satin weave portions slightly in relief) using only red silk and gilt yarns or pink and yellow silk yarns. Since in all but a few cases the width of the finished orphrey was less than the width or length of the fabric itself, several bands could be woven simultaneously side by side, or in horizontal rows and then cut apart after the fabric was taken off the loom, thus reducing the cost of production and presumably making the orphreys available to a wider market.

121
The Annunciation T17w37
Silk: compound satin with brocatelle effect.
L. 66½", W. 9¼–12¾" (169 x 23.5–32.4 cm.)
Purchased from A. Clerle, Venice, October 2, 1894

The Virgin, her arms folded across her breast, stands at the right; Gabriel kneels at the left and addresses her. The scene takes place in a paved courtyard with a portico beyond; in the distance trees rise above the top of a wall, and rays of light together with the dove of the Holy Spirit descend from a cloud. The pattern appears in silver yarns against a ground of pink silk satin, the satin areas in slight relief. A spiral ribbon with rosettes set at each turn runs along the left and right sides as a border.

This example comprises five segmented pieces of the orphrey; together, the pieces show eight complete or nearly complete pattern units plus parts of one more unit at the bottom and in the small fragment sewn to the upper left edge of the main piece.

The orientation of the composition is the reverse of that seen in most other surviving pieces, which show the Virgin at the left and Gabriel at the right.[1]

1 See Markowsky, fig. 64, for such an example.

Bibliography: *General Catalogue*, p. 122.

122
The Assumption of the Virgin
T17w36
Silk: compound satin with brocatelle effect.
L. 19", W. 25" (48.2 x 63.5 cm.)
Provenance unknown

The Virgin is seated on a cloud in the center of the composition; she looks down at the figure of St. Thomas kneeling beside an open sarcophagus and hands her girdle to him. The figure of God the Father, holding a crown, half emerges from a cloud above, and angels and cherubim attend at the sides. The figures are rendered in gilt yarns bound in weft twill weave against a ground of crimson silk satin that is slightly in relief.

There is a selvage along the left side and a cut edge along the right; the fabric might have contained two or three pattern units in its width. A narrow border made up of fragments

detail, 122

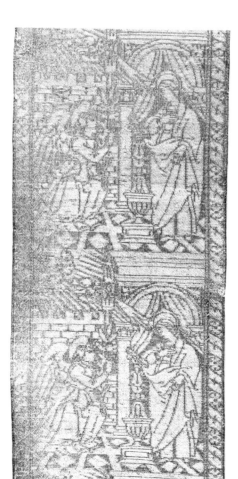

detail, 121

of contemporaneous red silk voided cut velvet of the *ferronerie* type (see No. 123) has been sewn to all four sides.

Bibliography: *General Catalogue,* p. 122 (where it is called "the Coronation of the Virgin").

123
Furnishing and Garment Fabric
T17w34

Italian, 1450–1500
Silk: cut voided velvet. L. 38½", W. 21½" (97.8 x 54.6 cm.)
Purchased from Emilio Costantini, Florence, October 6, 1897

The velvet shows another version of the *ferronerie* pomegranate pattern (see Nos. 30, 41). In this example, bifurcating leafy vines have been inserted between the rows of individual pomegranates in their lobed auras. This pattern, rendered here in blue, seems to represent an intermediate stage between the simpler *ferronerie* patterns with individual units and those in which the organization depends on a system of bifurcating vines that form ogival compartments enclosing the units (see No. 125). However, it is not clear whether the differences represent progressions in time or simply different forms of a class of pattern that was available in several degrees of complexity at the same time.

Bibliography: *General Catalogue,* p. 121.

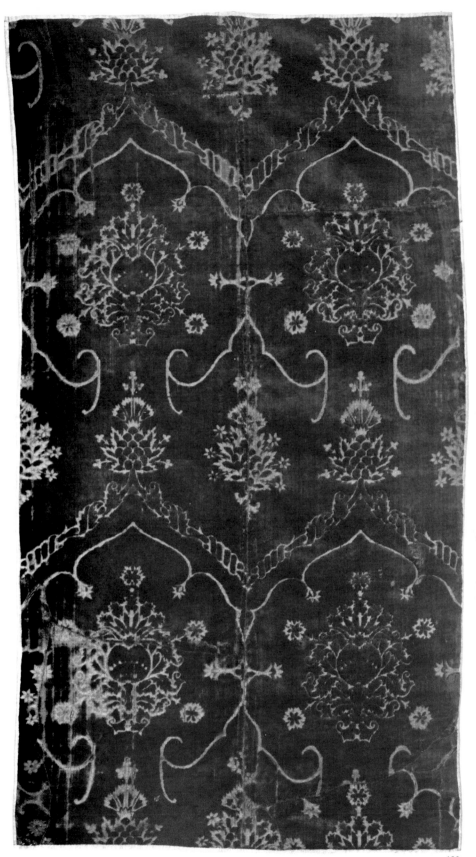

123

124 and 125
Two Examples of Gilt-Ground Furnishing and Garment Fabrics of the Classic Pomegranate Type
Italian, 1450–1525

These sumptuous silks (and others in the collection: see T27n1-s, T27n3-s, T27w78-s) represent one of the staples of the Italian weaving industry during the Renaissance. They are traditionally ascribed to the looms of Venice and Florence, and while the attribution is probably correct, there is no documentary evidence for it. Some velvets of this type also have been unconvincingly attributed to Spain. Paintings of the period from both northern and southern Europe frequently show gilt-ground velvets like these used as garments or hangings; it seems likely that most if not all of them were imported from Italy. Some of the more elaborate velvets of this class, particularly those incorporating silk yarns of more than one color along with the gilt yarns, have been regarded either as Turkish fabrics or Italian fabrics imitating Turkish prototypes. The question remains unsolved, although there are certain stylistic and technical peculiarities of Turkish velvets of this period that for the moment serve as fairly reliable guides to the proper attribution of the silks.[1]

All velvets of this class, and some related damasks, feature a bilaterally symmetrical vegetable motif that resembles either a pomegranate, an artichoke, a pineapple, or a rosebud, in each case encircled by a wreath of leaves, rosettes or carnations. In some examples, the main motif is placed in the center of a lobed leaf or aura that repeats along the length of an undulating vine moving parallel to the length of the fabric. Smaller pomegranates, leaves and blossoms fill the curved spaces between the vine and the edges of the fabric (No. 124). In other forms of the pattern, the main motif becomes more complex and is enframed in ogival compartments formed by bifurcating vines. In certain examples of this type (No. 125), a second system of vines and pomegranates runs in counter-rhythm to the first.

A number of paintings from both northern and southern Europe in the Museum's collection illustrate velvets of this kind. These include examples from the second half of the fifteenth century through the early years of the sixteenth century: *A Turkish Artist* attributed to Gentile Bellini;[2] *A Young Lady of Fashion* now attributed to the Master of the Castello Nativity (see fig. 2);[3] *Portrait of Battista, Countess of Urbino* after Piero della Francesca;[4] *The Madonna and Child* influenced by Mantegna;[5] *St. Michael* by Pedro García de Benabarre (where the velvet is used as a furnishing rather than garment fabric);[6] and *The Annunciation, German School* (see fig. 1).[7] Another painting in the collection, the *St. Engracia* by Bartolomé Bermejo, provides evidence that pomegranate velvets without the gilt ground (in this case the saint's green cut voided velvet cloak) were used, and presumably also made, simultaneously with the more elaborate gilt-ground examples (the saint's gown).[8]

1 N.A. Reath, "Velvets of the Renaissance, from Europe and Asia Minor," *Burlington Magazine*, L, 1927, pp. 298–304.

2 Hendy, pp. 16, 17, illus. p. 17 and color pl. VII.

3 *Ibid.*, pp. 267–69, illus. p. 268 and color pl. XIII.

4 *Ibid.*, pp. 183, 184, illus. p. 183.

5 *Ibid.*, pp. 156, 157, illus. p. 157.

6 *Ibid.*, pp. 93–95, illus. p. 94.

7 *Ibid.*, p. 100, illus. p. 100.

8 *Ibid.*, pp. 23, 24, illus. p. 25 and color pl. XXVII.

124
Furnishing and Garment Fabric
T17w10

Italian, 1450–1500
Silk: cut voided velvet, shot and brocaded with gilt yarn. L. 25⅛", W. 11⅜" (63.75 x 28.9 cm.)
Provenance unknown

A more elaborate version of other examples in the Museum (T27n3-s, T27n1-s, T27w78-s), this piece shows a particularly rich treatment of both the main pomegranate units and the subsidiary leaves and blossoms. The thick undulating vine is in crimson pile, ornamented with loops of gold, on a ground of yellow silk shot with gold thread.

Bibliography: *General Catalogue*, pp. 121, 122.

124

125

125
Furnishing and Garment Fabric
T27w62

Italian, 1475–1525
Silk: cut voided velvet, shot and brocaded with
gilt yarn. L. 60", W. 23" (152.4 x 58.4 cm.)
Provenance unknown

The pattern, rendered in crimson pile
against the flat yellow silk ground
that was originally covered with gilt
yarns, is bilaterally symmetrical. It
shows a main system of paired leaf-
covered vines that undulate along the
length of the fabric and form pointed
ogival compartments enframing sin-
gle pomegranate motifs with lobed
and leafy auras. A second system of
slimmer vines runs in counter-move-
ment to the first; it is this system from
which the pomegranates grow. The
points of confluence of both vine
systems are bound with leafy bands.
The centers of these bands, as well as
the centers of the pomegranates, are
enriched with dense passages of
looped gilt yarn. Gilt loops are used
sparsely in the areas of pile that form
the lobed auras and the leafy bands.
The pronounced clarity of the organi-
zation anticipates the classic form of
latticework pattern organization used
throughout the sixteenth and part of
the seventeenth centuries and sug-
gests that this velvet may be slightly
later than similar examples in the col-
lection. While bilaterally symmetrical
forms of the gilt-ground pomegran-
ate pattern are less often encountered
today than examples of the undulat-
ing single vine type, many other
examples of the former have survived
in other collections.[1]

John Singer Sargent used this velvet
as inspiration for the background in
his portrait of Mrs. Gardner in the
Museum (see frontispiece);[2] in his
rendering of the textile he enlarged
the scale of its pattern some two or
three times.

1 See, for example, F. Podreider, *Storia dei tes-
suti d'arte in Italia (secoli xii-xviii)*, Bergamo,
1928, figs. 145, 147; O. von Falke, *Kunstge-
schichte der Seidenweberei*, Berlin, 1913, II,
fig. 522; Mayer, p. 47.
2 Hendy, pp. 222–24, illus. p. 223.

Bibliography: N.A. Reath, "Velvets of the
Renaissance, from Europe and Asia Minor,"
Burlington Magazine, L, 1927, p. 303, pl. II,
fig. B. *General Catalogue*, pp. 237, 238.

126
Garment Fabric for Ceremonial Occasions T17w27

Italian, Venice, 1500–1750 (?)
Silk: cut pile-on-pile velvet.
Front: H. 25″, W. 21″ (63.5 x 53.3 cm.)
Back: H. 48½″, W. 30″ (123.2 x 76.2 cm.)
Provenance unknown

The fabric has been made into the front and back (illus.) sections of a chasuble. Its pattern, showing a bilaterally symmetrical system of bifurcating knotted vines supporting lobed medallions, rosettes, crowns and pomegranates, derives from the *ferronerie* class of pomegranate velvets of the fifteenth century (see Nos. 30, 41, 123). However, unlike those velvets, which show the pattern reserved in the ground weave against areas of cut pile, this example uses areas of two heights of pile, and no passages of the ground weave, to delineate the pattern elements. Many examples of this class of velvet have survived, almost all of them in red as is this one, but a few blue pieces are known.[1]

Velvets with this pattern were represented fairly often as robes or stoles of office worn by high officials of the Republic of Venice, specifically the Procurators of St. Mark, Senators, and members of the Council of Ten. Dated or datable portraits by Titian, Tintoretto, Leandro Bassano, Giovanni Battista Tiepolo and other Venetian painters provide visual evidence that the velvet was used in this context from the middle of the sixteenth century through the middle of the eighteenth century. We do not know whether the textiles shown in the later paintings were old velvets handed down to later generations or new velvets still being woven. In the Gardner collection, the *Portrait of Zacharias Vendramin,* from the studio of Tintoretto, portrays the robe and stole, made of this kind of velvet, of a Procurator of St. Mark; both the fragmentary *Portrait of a Procurator of St. Mark* after Tintoretto and an early eighteenth-century Venetian *Portrait of Alessandro Contarini* (?)—the sitter also was a Procurator—display similar velvet stoles.[2] See also a portrait of the Procurator Giovanni Querini wearing an analogous stole (Giovanni Battista Tiepolo, Galleria Querini-Stampalia, Venice).[3]

Although pile-on-pile velvets showing other patterns were woven in the fifteenth century,[4] velvets showing

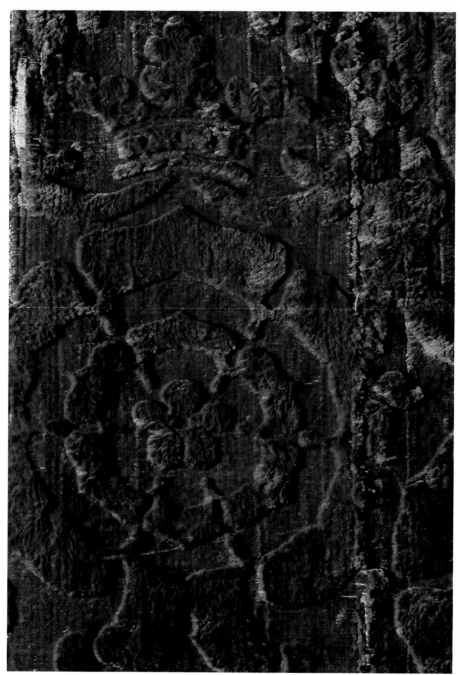

detail, 126

this pattern seem to have been reserved for the use of Venetian state officers. Other chasubles and copes made of this fabric have survived;[5] it seems certain that such vestments were made up from velvets given to churches for this purpose except perhaps for a few vestments that may have been made up in relatively recent times specifically for the art market.

1 Markowsky, fig. 88.
2 Hendy, p. 253–55, illus. p. 254; p. 255, illus. p. 254; pp. 280, 281, illus. p. 280.
3 R. Levi-Pisetzky, *Storia del costume in Italia,* Milan, 1967, IV, color pl. 122.
4 Markowsky, fig. 28.
5 Mayer, pl. 45.

127
Garment Fabric T26e20

Italian or Spanish, 1550–1600
Silk: compound satin with brocatelle effect.
H. 53″, W. 110″ (134.6 x 279.4 cm.)
Provenance unknown

The fabric originally showed a red and yellow pattern against a white ground. In its present condition, with most of the white and some of the yellow pattern wefts deteriorated and missing, the ground reads as red satin, scattered with touches of white and yellow wefts bound in weft twill weave.

The fabric has been made up into a cope trimmed with yellow silk gal-

loon along the outer edge and gilt galloon along the inner edge of the orphrey. Its pattern shows a network of ogival compartments defined by scrolling acanthus leaves alternating with crowns. A vase with gadrooned body and chevron-patterned foot, containing a bouquet of carnations and other flowers, occupies the center of each compartment. Another piece of the fabric (F16s5) lines the case on the south wall of the Raphael Room and a third is kept in storage.

Bibliography: *General Catalogue*, p. 218.

128
Garment Fabric

Italian, 1550–1600
Silk: compound twill. Each piece: L. 12″, W. 18″ (30.5 x 45.7 cm.)
Provenance unknown

The pattern shows single pomegranate motifs in the center of each ovoid compartment of a latticework, defined by the meanderings of bifurcating leafy vines. The motifs are rendered in red and yellow silk and gilt yarn against a ground of ivory silk and gilt yarn, all in weft twill weave. Most of the flat gilt wires have worn off the surface of the fabric.

There is another piece of the fabric, which is not frequently encountered, in the Kunstgewerbemuseum, Cologne, described as a brocatelle.[1]

1 Markowsky, fig. 99.

129
Furnishing Fabric T16n3

Italian, 1600–50
Silk: cut voided velvet shot with gilt yarn.
L. 65″, W. 25″ (165.1 x 63.5 cm.)
Provenance unknown

The orientation of the pattern, with its vertical axis parallel to the width rather than the length of the piece, indicates that the fabric was to be used as a border or frieze rather than as yardage for wall coverings or hangings. The motifs appear in reserved areas of the yellow silk ground (originally covered with gilt yarns, now lost) against the crimson velvet pile. A stylized rosette in frontal view, with smaller rosettes above, occupies the center of the field. Flanking the rosette is a pair of tree-like plants with roots represented as tassels and with branches that rise upward through open crowns and then undulate outward, bearing roses, lilies and leaves. Narrow borders containing rosettes on undulating vines frame the composition along the top and bottom.

Furnishing borders like this one were frequently woven during the second half of the sixteenth and the first half of the seventeenth centuries. Some show patterns oriented for use vertically[1] as well as horizontally,[2] and some were woven as brocatelles rather than as velvets.

1 Markowsky, figs. 205, 206, 208.
2 *Ibid.*, figs. 204, 207.

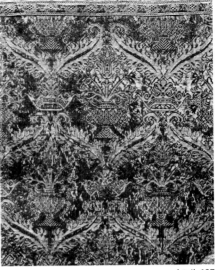

detail, 127

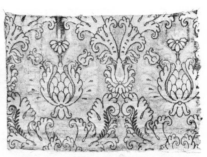

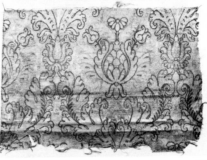

128

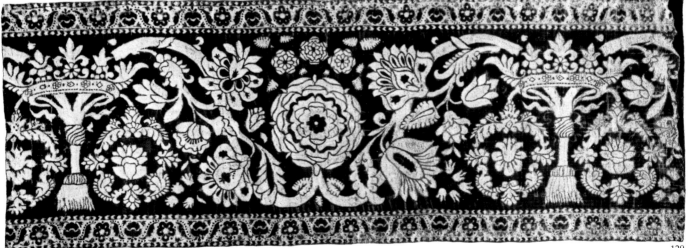

129

169

detail, 130

132

133

131

130–136
Seven Examples of Small-Figured Silk Velvet or Damask Garment Fabrics

Italian or Spanish, 1550–1650

The Museum's textile collection is particularly rich in silk fabrics decorated with small patterns that were intended for use in making fashionable garments. They differ from the majority of garment fabrics of earlier periods not only in the scale of the ornaments but also because the motifs, for the most part, have no clearly defined tops or bottoms or, if they have, they are frequently inverted in alternate rows. Whether or not intended, these characteristics made it possible to use less fabric in confecting garments than before. On one hand, the repeats could be matched across seams with little waste and, on the other hand, the fabric could be turned around easily when the pattern called for it and could even be pieced economically.

Small-figured silks of this kind are represented frequently as the stuff of garments worn by fashionable sitters in portraits of the latter part of the sixteenth and first part of the seventeenth centuries. They seem to have been especially favored in Spain and Italy. In this Museum two illustrations may be cited: first, the gilt-figured white silk (probably woven rather than embroidered, although embroidered garment fabrics followed the same fashion) worn by the subject in the *Portrait of Isabella Clara Eugenia, Archduchess of Austria*, painted by Frans Pourbus II at the end of the sixteenth century (see fig. 4),[1] and also the lady's polychrome-figured white stomacher (woven or embroidered?) in Rembrandt's *A Lady and Gentleman in Black*, dated 1633.[2]

1 Hendy, p. 191, illus. p. 190.
2 *Ibid.*, p. 201, illus. p. 202 and color pl. XXIX.

130
Garment Fabric T17w5
Italian or Spanish, 1550–1600
Silk: ciselé voided velvet shot with gilt yarns.
H. 34″, W. 94″ (86.3 x 238.7 cm.)
Provenance unknown

The pattern shows brick-pink pile motifs against a flat pale yellow ground; originally it may have appeared as red against a gilt ground, the gilt yarns having almost entirely disappeared.

Two small bouquets, one more elaborate than the other, alternate in rows within ogival compartments. These are defined by the undulations of pairs of leaves bound at their points of confluence by single blossoms or leaves. The pattern has survived in a number of variations.[1] All motifs have centers of cut pile and contours of uncut loops.

A second piece of this fabric (T30s26), used as a hanging on the south wall of the Gothic Room, has been given a border all around made of strips of a yellowish green small-figured velvet.

1 See Markowsky, figs. 109, 110, 113.

Bibliography: *General Catalogue*, pp. 134, 268.

131
Garment Fabric T17w6
Italian or Spanish, 1550–1600
Silk: ciselé voided velvet shot with gilt yarn.
L. 29½″, W. 7″ (74.9 x 17.8 cm.)
Provenance unknown

The pattern shows pale green pile motifs against a flat pale yellow ground; the flat gilt wires that originally covered the ground have almost entirely disappeared.

A slender leaf or bouquet set in an upright position alternates in rows with the same form inverted within cusped ogival compartments defined by a latticework of reversing scrolls and tendrils. All motifs have centers of cut pile and contours of uncut loops.

132
Garment Fabric T17w16
Italian or Spanish, 1550–1600
Silk: ciselé voided velvet. L. 22⅝″, W. 12⅝″ (57.5 x 32 cm.)
Provenance unknown

The pattern shows dark green pile motifs against a yellow-cream ground. A small plant with paired slender leaves and a large central blossom fills the centers of ogival compartments formed by a latticework of undulating tangent lanceolate leaves, bound at their points of confluence by single rosettes. There is a closely related velvet in the Kunstgewerbemuseum, Cologne.[1]

1 Markowsky, fig. 174.

133
Garment Fabric T17w13
Italian or Spanish, 1600–25
Silk: ciselé voided velvet. L. 39⅜″, W. 19⅜″ (100 x 49.2 cm.)
Provenance unknown

The pattern shows dark blue pile motifs against a flat ground of yellowish tan silk bound in satin weave; there is no evidence that gilt yarn was originally used in the ground weave.

A heart-shaped leaf repeats regularly in staggered rows across the width of the fabric, each row offset a half unit's width to the side. Single trefoils and cinquefoils and pairs of lanceolate leaves fill the spaces between the heart-shaped leaves. All motifs have centers of cut pile and contours of uncut loops.

The pattern is unusual but has a near counterpart in the Kunstgewerbemuseum, Cologne.[1]

1 Markowsky, fig. 253.

detail, 134

134
Garment Fabric T17w8

Italian or Spanish, 1600–25
Silk: ciselé voided velvet. L. 17½",
W. 15½" (44.4 x 39.3 cm.)
Provenance unknown

The pattern shows violet pile motifs against a flat ground of green silk bound in tabby weave with extra floats of green warp yarns outlining the pile motifs. While the presence of the warp floats distinguishes this piece from all others of its type in the Museum, the floats occur relatively frequently in related velvets preserved elsewhere. Often referred to as "false embroidery," the technique gives the effect of supplementary patterning by needlework.

A stylized dentated leaf occupies the center of each lozenge-shaped compartment formed by geometric bands moving in chevron conformation across the width of the fabric. Uncut loops form most of the substance of the bands, but the pile has been cut to delineate hyacinth sprigs along the centerline of each band and the points of confluence. The dentated leaves, like the motifs in the other velvets of this group, have centers of cut pile and contours of uncut pile loops. There is no indication that gilt yarns were used in the ground weave.

135
Garment Fabric T27w6
Italian or Spanish, 1600–25
Silk: ciselé voided velvet shot with gilt yarn.
L. 47½″, W. 28¾″ (120.6 x 73 cm.)
Provenance unknown

The pattern shows bluish green pile
motifs against a flat ground of tan
silk; the flat gilt wires that originally
covered the ground weave have
almost entirely disappeared.

A motif resembling paired leaves
sprouting from the sides of a cusped
rectangle runs in staggered rows
across the width of the fabric, tilted
toward the right in one row, toward
the left in the next. Double rosettes
alternate regularly with the leaf units
in each row. A second piece of this
fabric is in storage.

Bibliography: *General Catalogue*, p. 254.

136
Garment Fabric T26n13
Italian or Spanish, 1625–50
Silk: ciselé voided velvet. L. 23″, W. 15″
(58.4 x 38.1 cm.)
Provenance unknown

The pattern shows yellowish green
pile motifs against a flat ground of
silk of the same color bound in satin
weave. There is no indication that
gilt yarns (as are just discernible in
another example, T16e22, of this type
and date) were ever used in the
ground weave.

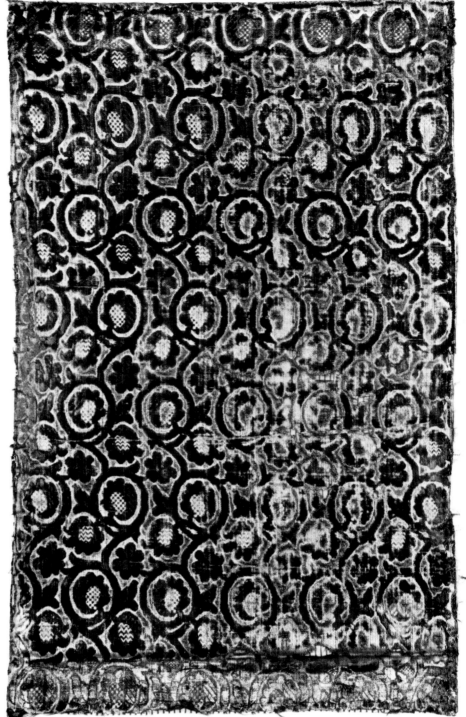

Slim serpentine vines run parallel to
the length of the fabric and at inter-
vals send out curling stems bearing
fruits resembling pomegranates and
blossoms of two kinds. Of all the
small-figured silks in the Museum's
collection this is the most unusual;
similar patterns are infrequently
encountered but not unknown.[1]

1 Markowsky, fig. 338.

Bibliography: *General Catalogue*, p. 226.

137–140
Four Examples of Silk Furnishing Damask

Italian, 1625–1700

The patterns in this small but choice group of damasks reflect some of the fashions in luxury furnishing fabrics during the seventeenth century. The patterns in the earlier pieces are characteristically smaller, more rigidly organized and more stylized in drawing than the later examples. In each piece the warp and weft are dyed the same color; therefore, the pattern is visible only by virtue of the contrast between the textures of the two weaves employed. Since the textures represent the face and back of a single weave, the damasks are reversible and show the same pattern on the front and back. Depending on the angle at which the light strikes either surface, the silks may show a light pattern on a dark ground or a dark pattern on a light ground.

Damasks like these were intended primarily for use as coverings for walls and seat furniture, as hangings for windows and beds and also as occasional covers for horizontal surfaces such as the tops of tables or chests. In Fenway Court they were used as covers for walls and tables.

137
Furnishing Fabric

Italian, 1625–50
Silk damask. L. 92⅛", W. 20½" (234 x 52 cm.)
Provenance unknown

This fabric formerly was used as a table cover in the Dutch Room. The warp and weft yarns are dyed light neutralized green. The pattern shows bands of pomegranate or pineapple motifs alternating with floral sprigs and connected by pairs of leaves having checkered centers and curling, dentated edges. In the horizontal course of each band of ornament, the major and minor motifs appear first upright and then inverted.

138
Furnishing Fabric

Italian, 1650–1700
Silk damask. L. 102⅛", W. 21" (259.7 x 53.2 cm.)
Provenance unknown

The pattern shows paired undulating vines bearing fanciful blossoms and acanthus leaves. Pairs of addorsed doves holding olive sprigs in their beaks perch on the vines at intervals

and alternate with pairs of peacocks bearing floral sprigs in their beaks. Along the vertical axis a motif combining a pomegranate with a spray of acanthus leaves alternates with a smaller unit showing a bouquet of tulips and roses. Halves of anthemion lilies appear below each peacock, between the edges of the fabric and the curves of the vines.

This fabric covered some of the walls in the Dutch Room when that gallery was originally installed. It has been replaced with a modern reproduction of the original damask. A variant of the original pattern, also green, and contemporary with the original damask, is preserved in the form of a scalloped valance (in storage).

139
Furnishing Fabric T21n21

Italian, 1650–1700
Silk damask. L. 41", W. 37" (104.1 x 94 cm.)
Provenance unknown

The pattern, in shades of yellowish green, shows an urn of flowers repeating along the vertical axis and flanked by pairs of plants bearing alternately roses and pomegranates. The ground between the major motifs is scattered with sprays of flowers and fruits. The conventionalized drawing of the urns is curiously at variance with the naturalistic drawing of the plants at the sides. While the latter motif suggests a date close to the eighteenth century, the treatment of the urns more strongly indicates the seventeenth.

140
Furnishing Fabric T18w22

Italian, 1650–1700
Silk damask. L. 81", W. 19" (206 x 48.5 cm.)
Provenance unknown

The two main units of the pattern alternate along the vertical axis of the fabric. One of the compositions shows acanthus leaves rising from the top of a pomegranate form; the other resembles a pine cone with leaves issuing from it. Scrolling acanthus leaves, floral sprigs, and large carnations, tulips and other flowers flank the main units.

The weave is very loose and shows fine yellow silk warp yarns sparsely covering the thicker, undyed weft yarns that appear to have been spun from undegummed silk or possibly a bast fiber.

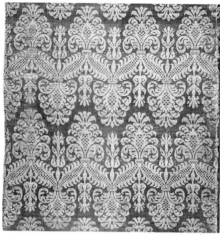
detail, 137

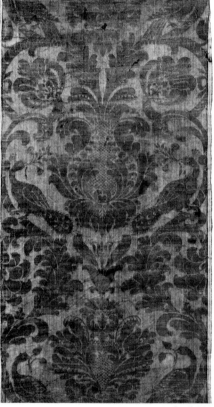
detail, 138

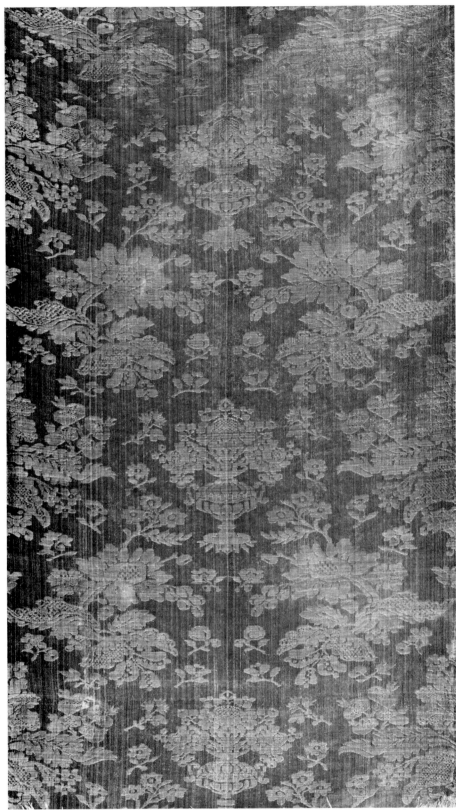

detail, 139

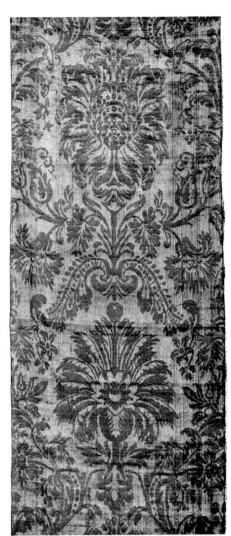

detail, 140

141
Furnishing Fabric T17n4
Italian, 1675–1700
Silk and linen brocatelle. L. 39", W. 24"
(99 x 61 cm.)
Provenance unknown

A system of sickle-shaped and scroll-ing leaves defines a latticework of ogi-val compartments filled in alternate rows by one of two different pineap-ple or pomegranate motifs, each hav-ing an aura of acanthus leaves. The motifs are rendered in crimson satin weave against a ground of weft twill. The pattern shows a somewhat paler color than the ground, due to the color of the undyed linen weft yarns that are visible between the fine warp yarns in the figured areas. The linen wefts also give the satin motifs their relief effect.

142
Garment Fabric T11n27
French, 1675–1700
Silk: satin, brocaded with silver and gilt yarns.
L. 33", W. 17¾–23" (83.8 x 45.6–58.4 cm.)
Provenance unknown

The pattern shows stripes running in the warp direction against a ground of plain satin weave. The stripes com-prise rows of scalloped fan and loz-enge motifs, worked in a variation of the ivory-colored ground weave, intertwined with undulating gilt rib-bons and counter-undulating silver stems bearing stylized silver blos-soms. These floral stripes alternate across the width of the fabric with straight silver lines decorated with silver scrolls and leaves. The essential conformation of the pattern shows marked similarities to striped silk patterns of the last quarter of the eighteenth century, but the hieratic drawing of the floral motifs and the limited color range indicate clearly that this fabric dates from the reign of Louis XIV rather than Louis XVI.

143–145
Three Examples of So-Called "Bizarre Silks"
French or Italian, 1700–25

The years immediately before and after 1700 saw the rise of a fashion for richly patterned and colored silk gar-ment and furnishing fabrics that used a completely new, fanciful and illogical ornamental vocabulary.[1] In an attempt to isolate, classify, and ultimately identify the source of these silks, scholars have grouped them in one category for which they coined the term "bizarre silks." The group includes more than one type of pat-tern, but all the types share a vocabu-lary of flowers that never existed, spatial relationships that defy logical definition, and shapes that vary little from shapes based on geometric forms as well as shapes that bear no relation either to nature or geometry.

Vilhelm Slomann demonstrated that many of these patterns seem to depend on prototypes found in cer-tain mordant-painted cottons from East India; he suggested that the silks also were made there.[2] Later it was recognized that many of the so-called "Indian" painted cotton patterns originated in Europe; while the locally altered forms of these motifs may have influenced the design of these silks, it is now generally accepted that "bizarre silks" were woven in Europe from around 1695 to about 1720 in France, Italy, England and possibly also in the Netherlands.[3] Although the silks are found today in the form of garments, as well as untailored pieces of various sizes, some chairs upholstered with related silks rich in metallic yarns have sur-vived from these and somewhat ear-lier years, suggesting that despite their rich metallic content, "bizarre silks" were sometimes used for fur-nishing as well as for dress.

1 R. Levi-Pisetsky, *Storia del costume in Italia*, Milan, 1967, IV, color pl. 24 (*Portrait of Conte Giambattista Vailetti*, 1710, by Fra Galgario, Galleria dell'Accademia, Venice; it shows a gold-ground silk waistcoat of this type).

2 V. Slomann, *Bizarre Designs in Silks, Trade and Traditions*, Copenhagen, 1953.

3 Thornton, pp. 95–101.

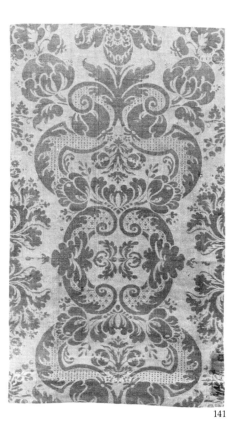

141

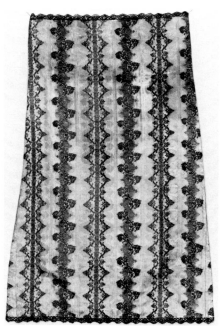

142

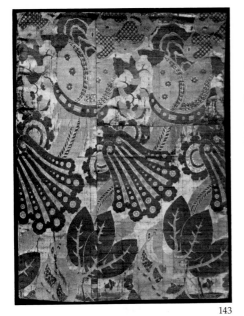

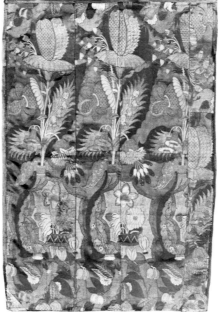

144

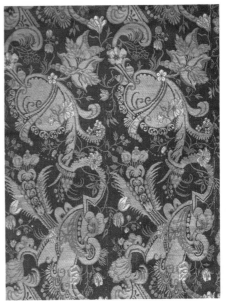

detail, 145

143
Furnishing or Garment Fabric
Silk: compound satin. L. 30″, W. 22½″
(76.1 x 57.1 cm.)
Provenance unknown

Three fragments of the silk have been
made into a small cover; there is no
complete pattern repeat. The motifs
include fantastic trees, leaves, flow-
ers, fruits, and cloud and wheel
forms in shades of yellow and green
bound in weft twill weave against a
ground of neutralized pink silk
bound in satin weave. The ground
weave has worn in some places and
allows the green pattern wefts to
show through; in these places the
pattern is somewhat distorted.

144
Furnishing or Garment Fabric
Silk: compound satin brocaded with silk, silver
and gilt yarns. L. 43″, W. 30″ (109.2 x 76.1 cm.)
Provenance unknown

Seven fragments of the silk have been
sewn together to make a small cover;
neither the pieces nor the cover as a
whole shows a complete repeat of the
pattern. Against a ground of pinkish
orange satin, fanciful motifs appear
in polychrome silks, silver, and gilt
yarns bound in weft twill weave; the
contours of the brocaded passages
are further emphasized by variations
in the ground weave from satin to
tabby. The pattern elements include a
bouquet rising from the neck of a
vase in front of which a lobed car-
touche encloses a low round urn that
contains flowers and fantastic fruits.
Branches bearing exotic fruits twist
across the field below the cartouches.

145
Furnishing or Garment Fabric
T26e11-s

Silk: compound satin brocaded with silk and
gilt yarns. L. 37″, W. 65″ (165 x 94 cm.)
Provenance unknown

Against a crimson satin ground
appears a variety of motifs in pink,
white, green and blue silk yarns and
gilt yarns, all bound in weft twill
weave. The pattern shows two differ-
ent large bouquets alternating in
rows across the width of the fabric.
One bouquet features a globular
fruit, the other a plume of peacock
feathers. While the main motifs are
fanciful, the individual tulips, carna-
tions, roses and primroses that
appear in the bouquets are rendered
naturalistically. This fabric covers one
table under Titian's *Rape of Europa*;
a second piece (T26e3-s) covers
its companion.

Bibliography: *General Catalogue*, p. 220.

146
Garment Fabric T18e11

Probably Italian or French, 1700–25
Silk: compound satin brocaded with silk, silver, and gilt yarns.
a. Hood: L. 19″, W. 19⅜″ (48.2 x 49.2 cm.)
b. Cope: L. 100⅝″, W. 18″ (281 x 47.7 cm.)
Provenance unknown

The fabric has been preserved as part of a cope (in storage) with its hood (T18e11, now separate) and also two fragments (T18e29 and T18s10). The extraordinarily complex pattern comprises a number of scenes involving figures in landscapes arranged so that each subject appears twice in a row in the width of the fabric, oriented either toward the right or left. The next subject below or above also appears twice in its own row but is oriented in the opposite direction from the subjects immediately below or above. Enormous tulips, carnations, roses and fanciful blossoms, completely out of scale with the figural compositions, accompany each scene.

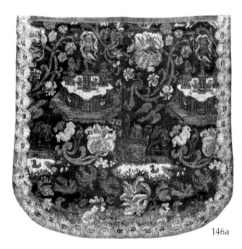

146a

The full repeat of the pattern involves seven major units accompanied by miscellaneous birds, beasts and flowers filling the interspaces. Four of the units have narrative subjects: a mounted rider wearing a coat and turban uses a lance to attack a boar while a spotted hound springs ahead; four spotted hounds attack a deer; a pair of peacocks draws a chariot in which rides a female figure (representing Selene or Diana) with a crescent moon on her head and a star in her hand; and finally, a crested bird attacks a butterfly in flight. The remaining major motifs show: a dog leaping toward a ruined fountain; a fountain whose basin contains a pair of mermaids flanking a female figure standing on a plinth in the center; and a castle with a garden. The pattern appears in white, pink, green, blue, rust and brown silks with touches of silver and gilt yarns, all bound in weft twill weave against a dark brown satin ground.

This silk belongs to a small but distinctive group of fabrics that shows related patterns, occasionally the same pattern elements, and in some cases technical peculiarities, as in the use of chenille yarns or the arrangement of the composition for use as friezes or borders, with narrow borders woven in above and below prescribed lengths of silk.[1] Where they can be identified, the narrative groups of figures derive from classical mythology, such as Selene and Endymion, Orpheus charming the beasts, Hercules fighting the Nemean lion, Pegasus on Mt. Helicon, the rape of Ganymede, and Narcissus at a fountain. The figures also derive, in at least one instance, from the Old Testament (Samson and Delilah).[2] While it is clear that the designer of the Gardner silk intended his peacock chariot to refer to Selene,[3] it is not certain that he intended his boar hunter to be Meleager or Hercules.

Because this group of silks stands outside the mainstream of pattern development, it was regarded as the product of places peripheral to the major centers of fine silk weaving in France and Italy, specifically Portugal and Andalusia.[4] However, it is now clear that other silks whose patterns involve both these pictorial subjects and more conventional floral motifs provide a bridge linking the group of silks discussed here with the main development of luxury textile design in France and in Italy in the early days of the eighteenth century.[5] It is likely that this group of silks simply represents one category of pattern that was fashionable then, and that the fabrics were woven in the main centers rather than in the provincial establishments to which they were formerly attributed.

Another piece of silk with the Gardner pattern was exhibited by Adolfo Loewi in Rome in 1937.[6]

1 e.g. Weibel, Nos. 272, 274.
2 *Ibid.*, Nos. 272–76 (for examples of both kinds of subjects).
3 *Ibid.*, No. 275 and p. 152 (for another version of the theme).
4 *Ibid.*, p. 152.
5 *Ibid.*, No. 260; Markowsky, figs. 537, 539, 545; Mayer, pls. 73, 79.
6 L. Serra, ed., *L'Antico tessuto d'arte italiano*, Rome, 1937, No. 212, p. 43, fig. 145.

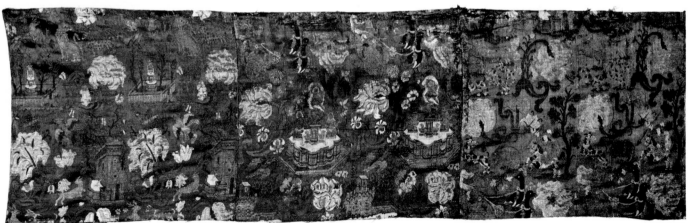

detail, 146b

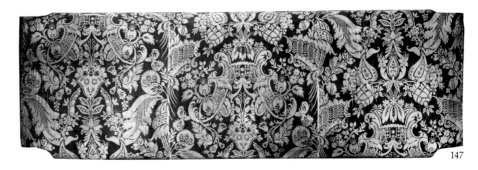

147

147
Garment Fabric F19w33–s

French or Italian, 1700–25
Silk: compound satin. L. 22¾", W. 62⅛"
(57.9 x 157.7 cm.)
Provenance unknown

The pattern appears in yellowish green tabby weave against a ground of blue-green satin. The decoration is bilaterally symmetrical and shows bouquets of flowers featuring tulips under canopies of scrolls and strapwork, as well as acanthus leaves, blossoms and berries. Arched compartments whose elements show lace designs complete the pattern. A second piece of the fabric (F19w45–s) also covers an Italian bench in the Tapestry Room.

148
Garment Fabric

French or Italian, 1700–25
Silk damask brocaded with silk and gilt yarns. L. 38½", W. 10⅝" (98 x 26.7 cm.)
Provenance unknown

The ground, which has faded to pink from its original deeper hue, shows a dense pattern of meandering pomegranate vines. A secondary floral pattern, both complementing the damask pattern and running counter to it, is brocaded in gilt and yellow silk yarns. Another piece of the fabric also is in storage.

149
Garment Fabric

Italian or French, 1700–25
Silk: compound satin. L. 55", W. 51⅜" (139.7 x 130.4 cm.)
Provenance unknown

The pattern shows a bilaterally symmetrical repeat of four different bouquets that alternate regularly, both horizontally and vertically; two of the units occupy the central axis while halves of the other two appear along the sides of the fabric and would have appeared whole when lengths of the silk were sewn together. The bouquets, which feature roses, primroses, petunias, poppies and fanciful fruits and berries, together with their leaves, are rendered in white, pink, yellow, green and blue silks bound in weft twill weave against the ground of salmon-pink satin (see F11e13 for another example of such a silk garment fabric, which has been made into a small table cover).

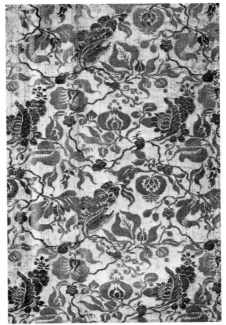

detail, 148

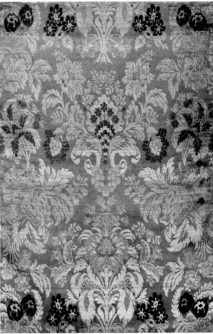

detail, 149

150 and 151
Two Examples of Furnishing Fabrics

Italian, probably Genoa, 1700–25
Silk ciselé voided velvet.

During the seventeenth century the patterns of luxury silks intended for house furnishings followed a different line of development from that of patterns for garment fabrics. By the end of the century a new class of large-scale, symmetrical, highly stylized floral compositions became the standard type of pattern. The Gardner has a number of important velvets of this kind, and whether by intention or by chance, they show patterns different from those usually encountered in public collections. There are also later versions of these furnishing fabrics woven as velvets or damasks (Nos. 152–54).

Genoese velvets and damasks are frequently mentioned in inventories and other documents associated with houses in which furnishing fabrics of this kind have survived. Thus, although there is no definite proof, it is thought that these fabrics were produced in Genoa (see also T28e21 and T17w21, the latter from the second quarter of the eighteenth century).[1]

1 See Thornton, pp. 49, 50, 139, figs. 112 and *passim*, fig. 114A.

150
Furnishing Fabric T17w11a

L. 31¾", W. 22⅜" (80.6 x 56.9 cm.)
Provenance unknown

There are two lengths (T17w11a, T17w35) and two small fragments (T17w11b, T17w11c) of this velvet in the collection. The pattern shows great bouquets of ears of wheat surrounded by fanciful dentated, pierced, and lanceolate leaves, all rendered in cut and uncut dark blue pile against a ground that is now tan but originally might have been pink or red.

151
Furnishing Fabric T17w12

L. 51", W. 20⅛" (129.5 x 51.1 cm.)
Provenance unknown

The pattern shows a great pomegranate surrounded by sprays of primroses and leaves in the center of an ogival compartment formed by the arms of a bifurcating vine. Sickle-shaped leaves occupy the top of the compartment below. Fanciful fruits, blossoms and leaves fill the spaces

between the undulations of the vine and the sides of the fabric. The motifs are rendered in cut and uncut dark blue pile on an ivory-colored ground that was once covered with, and has retained traces of, silver yarns. The striking degree of naturalism in the drawing of the vegetable forms suggests that of the two velvets discussed here, this one was designed and woven later.

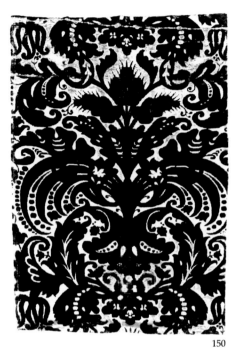

150

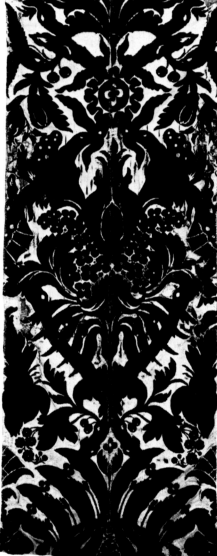

151

152
Furnishing Fabric

French or Italian, 1725–50
Silk damask. H. 112″, W. 100″ (284.4 x 254 cm.)
Provenance unknown

The pattern shows formal bouquets of roses and hyacinths within compartments loosely defined by the undulations of pairs of vines bearing roses and carnations. Halves of other bouquets, alternating in horizontal rows with the first one, appear along the sides of the fabric and would be seen complete when lengths of the fabric were sewn together. The warp and weft yarns are dyed golden yellow.

Like most furnishing fabrics of the first half of the eighteenth century, this example seems archaizing in its dependence on the bilaterally symmetrical latticework system of organization that developed during the preceding two centuries. However, the naturalistic drawing of the vegetable forms, and the unmistakable meandering of the vines, whose conformation suggests rather than defines the latticework, clearly places this pattern well within the eighteenth century.

This damask is one of the silks that originally covered the walls of the Yellow Room.

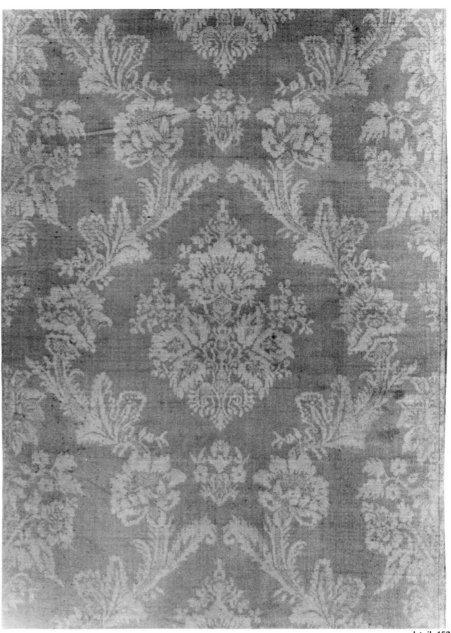

detail, 152

153 and 154
Two Examples of Furnishing Fabrics

Italian, probably Genoa, 1725–75
Silk damask.

The Museum's collection of eigh-
teenth-century furnishing silks
includes not only the velvets and
damasks treated earlier in this cata-
logue (Nos. 150–52) but also the
damasks discussed here that may be
of somewhat later date. Although silk
damasks of this type have been dated
to the latter part of the seventeenth
century, Thornton has shown that
they probably appeared in Europe
around 1725 and remained in fashion
until about 1775, and has suggested
that they were woven in Genoa.[1]
Damasks showing this kind of pat-
tern occasionally survive as covers on
seat furniture, as wall coverings, or as
window curtains. They also appear
as furnishing fabrics in paintings
showing European interiors during
the middle decades of the eighteenth
century. These fabrics were woven
in crimson, green, blue or yellow.
Damasks showing this style of pat-
tern were hung on the walls of the
Yellow, Raphael, Titian and Dutch
Rooms at Fenway Court when those
galleries were first installed.

These patterns share with the some-
what earlier furnishing velvets the
characteristic organization of the pat-
tern units in a bilaterally symmetrical
system; like the earlier silks, these also
feature large-scale real and fanciful
flowers, leaves and fruits rendered in
stylized rather than naturalistic form.
They also share with the earlier
pieces a preference for repeats meas-
uring as much as four to six feet in
length.

1 Thornton, pp. 49, 50, 139, fig. 114A.

154

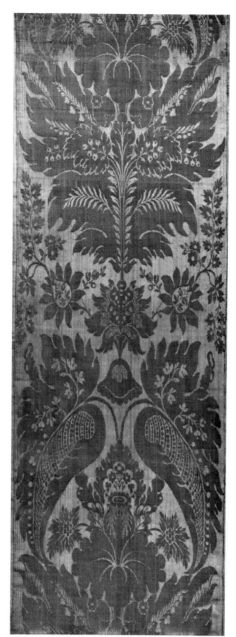

detail, 153

153
Furnishing Fabric T16e1

One repeat: H. 50½", W. 22" (128.25 x 55.9 cm.)
Provenance unknown

The pattern, in crimson, shows great
lanceolate leaves with decorative
veinings on either side of fanciful
floral units on the vertical axis.

A similar damask in green covers
a chasuble (see No. 32), stole,
maniple and burse in the Museum's
collection.

154
Furnishing Fabric

L. 22½", W. 20⁵⁄₁₆" (56.4 x 51.5 cm.)
Provenance unknown

The pattern, in green, shows great
star-shaped flowers on the vertical
axis flanked by globular fruits and
scrolling leaves.

155
Garment Fabric

French or Italian, 1730–40
Silk: tabby brocaded with silk and silver yarns.
Front: L. 30⅜", W. 15¼–26½"
(77 x 38.6–67.4 cm.)
Back: L. 47⅝", W. 28–31¼"
(120.9 x 71.1–79.3 cm.)
Provenance unknown

The fabric has been preserved in the form of strips covering the front and back of a chasuble; none of these pieces contains a full pattern repeat. It is clear, however, that the motif showing a tree bearing tulips, roses, and heavily seeded fruits, uprooted and floating free against a plain ground, was repeated vertically in a bilaterally symmetrical organization, and also that the motif that was centered on the vertical axis has not been preserved. The vegetable motifs are rendered in white, pink, yellow, green and rust silk yarns and silver yarns, all bound in weft twill weave against the ground of light blue silk bound in tabby weave.

This and the next entry (No. 156), along with T25w3 and T25w10, represent a group of fashionable garment fabrics that are termed informally as "island silks," because the major pattern elements are organized in units that have implied or expressed islands of earth at their bases and seem to float against a sea of undecorated silk. However, unlike most of the silks in this group the present example shows a symmetrical arrangement of units flanking a central axis rather than, as is the case with the others in this collection and elsewhere, two vertical axes that repeat side by side with the same left/right orientation across the width of the fabric.[1]

1 See Thornton, fig. 62A, for a classic "island silk" with bilaterally symmetrical repeat, suggested date 1731–32, and figs. 63A, 64A and *passim* for silks with the other kind of pattern organization.

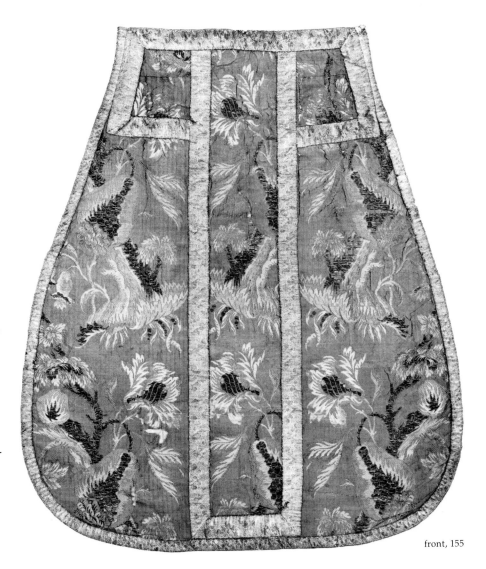

front, 155

156

156
Garment Fabric T18e28
French or Italian, 1730–40
Silk: compound satin brocaded with silk and
silver or gilt yarns. L. 47", W. 30½"
(119.5 x 77.5 cm.)
Provenance unknown

The fabric is now in the form of a val-
ance for a window or bed. Two large
bouquets of flowers and fruits are
arranged in the style of the "island
silks" and alternate in the vertical
direction. The pattern appears in
polychrome silks bound in weft twill
weave against the ground of pink
satin.

157
Garment Fabric T17w43
French or Italian, 1750–75
Silk: cut voided velvet shot with silver or gilt
yarn. L. 22⅝", W. 8" (57.5 x 20.3 cm.)
Provenance unknown

The pattern shows small bouquets of
roses within lozenge-shaped com-
partments defined by a system of
scrolling leaves. The motifs appear
in blue cut pile against a flat ground
of pinkish tan silk that retains traces
of the metallic yarns once covering
the ground weave. Velvets of this
kind were commonly used for gentle-
men's suits.

Bibliography: *General Catalogue*, pp. 121, 122.

158
Garment Fabric T18n18
French (?), 1755–65
Silk: compound tabby brocaded with silk and
silver or gilt yarns. L. 23", W. 25"
(58.4 x 63.5 cm.)
Provenance unknown

The pattern shows meandering
white lace ribbons intertwined with
sprays of yellow primroses and blue
hyacinths. There are touches of
metallic yarn in these motifs, but
since they have darkened it is not
possible to determine whether they
were originally silver, gilt, or both.
Sprigs of blue or pink roses fill the
spaces between the ribbons and face
left or right in alternate rows.

157

detail, 158

159
Garment Fabric T3w23

French, 1755–65

Silk: compound tabby brocaded with silver
yarns. L. 56½″, W. 41″ (143.5 x 104.1 cm.)

Provenance unknown

The pattern shows elongated blue
and white hexagons scattered over
the light blue tabby ground. On this
field are placed chrysanthemum
sprigs tied with ribbons that alter-
nate toward the right or left so as to
create the effect of a meandering rib-
bon moving in the warp direction.
The flowers are rendered entirely in
silver yarns of two sizes bound in
weft twill weave. A second piece of
the fabric is kept in storage.

160
Garment Fabric

French, 1765–75

Silk: compound tabby brocaded with silk and
silver or gilt yarns. L. 74½″, W. 33½″
(189.2 x 85.1 cm.)

Provenance unknown

Against an olive-green ground scat-
tered with metallic-shot lozenges, a
series of ribbons undulates in narrow
courses parallel to the warp. Rose
sprigs issue from the sides of the
ribbons, which themselves show
rosettes and narrow bars along their
centers. The floral ornaments are
rendered in floated yarns of white,
pink and green; the ribbons are also
defined by floated yarns of white silk
and silver. The green pattern yarns
are warp floats; all the others are weft
floats. Another piece of the fabric
(T19c8) is on view in the Tapestry
Room.

159

detail, 160

161

161
Furnishing Fabric

French or Italian, 1775–85

Silk: compound satin. L. 48⅜″, W. 35″
(122.8 x 88.9 cm.)

Perhaps purchased from A. Clerle, Venice, 1892

Against a ground of pale blue satin
appear meandering garlands of feath-
ers that form ogival compartments
containing two different bouquets of
blossoms and berries emerging from

clusters of acanthus leaves, arranged
to suggest the shape of urns. The pat-
tern elements are rendered with
ivory and golden silk yarns bound in
weft twill weave. The bouquets alter-
nate with each other in rows, offset
one half-unit to the side.

This is one of the silks originally used
to cover the walls of the Blue Room
when that gallery was installed.

162
Furnishing Fabric

French or Italian, 1780–90
Silk: tabby and satin. H. 4″, W. 10″
(10.15 x 25.4 cm.)
Provenance unknown

Narrow stripes of satin and watered
ribbed tabby weaves alternate regu-
larly across the width of the fabric,
separated from each other by nar-
rower stripes defined by weft floats.
Both warp and weft are dyed the
same pale blue tone; it is only the con-
trast of the three woven textures that
creates the striped effect.

This is one of the silks originally used
to cover the walls of the Blue Room
when that gallery was installed.

163
Furnishing Fabric

Chinese for the Western market (?), 1800–1900
Silk damask. L. 97″, W. 29¼″ (246.4 x 74.2 cm.)
Provenance unknown

The pattern shows a great pomegran-
ate motif surrounded by acanthus
leaves and supported on a bifurcating
vine, alternating on the vertical axis
with clusters of paired roses and
great leaves. This pattern derives
from those that were fashionable in
the second and third quarters of the
eighteenth century (see Nos. 153,
154). However, certain technical char-
acteristics, especially the unusually
wide dimension from selvage to sel-
vage, the narrow flat selvage, and
the curious strawberry red color com-
bine to suggest that this is one of the
group of silk damasks made in China
for export to the West during the orig-
inal fashion for such damasks, as
well as during its revivals in the nine-
teenth century. Chinese export dam-
asks of both periods are preserved in
The Metropolitan Museum of Art,
New York (reg. Nos. x.451.2a-f;
x.451.3; x.546; 56.236). Two of those
damasks have written or woven
inscriptions in Chinese associated
with them.

detail, 162

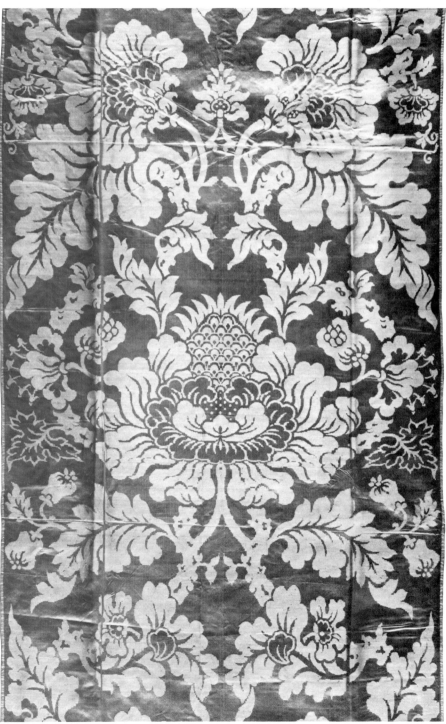

detail, 163

detail, 164

164
Garment Fabric T26e8

French, Lyons, 1885–95
Silk: compound satin with supplementary
wefts of silver yarns. L. 53″, W. 107″
(134.62 x 271.78 cm.)
Provenance unknown

The fabric shows a pattern of tassels
with bits of severed cord at their tops
arranged in rows across the width of
the silk; in one row the tassels tilt
toward the right, in the next toward
the left. The motifs are defined by

passages of ribbed tabby silk and
floats of silver yarns that otherwise
remain on the back of the fabric. The
satin weave of the ground, and the
variation of this weave in the tassels,
are constructed entirely with pale yel-
lowish green warp and weft yarns.

The silk has survived in the form of a
large tailored panel that is approxi-
mately the right size and shape for
the petticoat (skirt) of an evening
gown of the late nineteenth century.
It is the kind of silk that Charles

Frederick Worth used in his great for-
mal gowns, and it is likely that this
panel of silk comes from such a gar-
ment that Mrs. Gardner bought in
Paris.[1] Photographs in the Museum
archives in fact show Mrs. Gardner
wearing the gown whose fabric has
been preserved in the panel.

1 For related silks, see J.-M. Tuchscherer and
T. Sano, ed., *Étoffes merveilleuses du Musée His-
torique des Tissus, Lyon*, Tokyo, 1976, II, pls. 67,
86.

Bibliography: *General Catalogue*, p. 220.

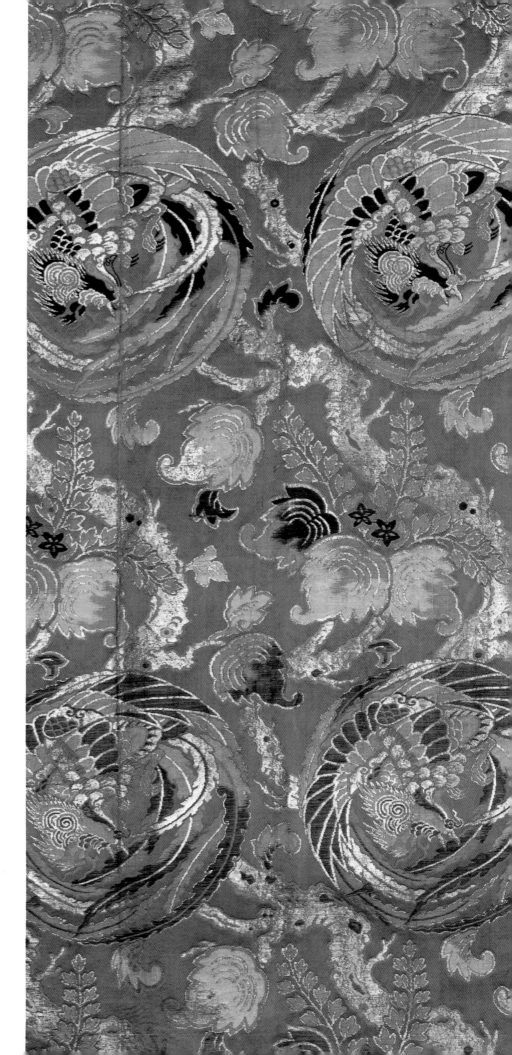

Eastern Textiles

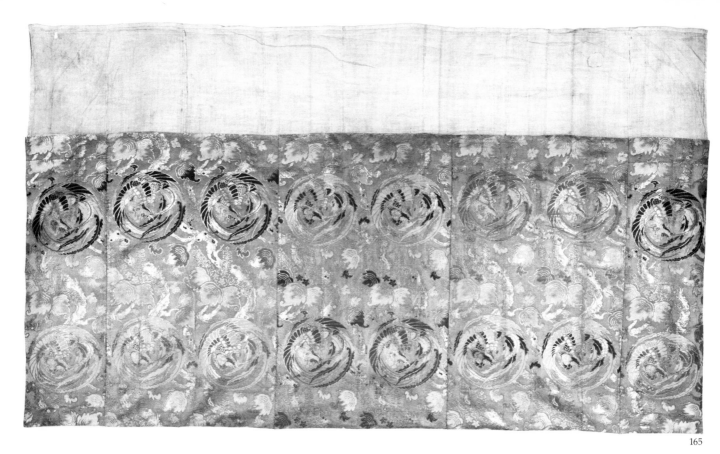

165
Frontal for an Altar Table

Japanese, 1750–1805

Silk: compound satin brocaded with silk yarns and gilt paper yarns. L. 58¾", W. 103" (149.2 × 261.6 cm.)

Provenance unknown

Nine lengths of a garment fabric were pieced together to form the face of this altar table frontal. An inscription written on the plain linen lining fabric states that the frontal was donated in memory of an unidentified person on the five hundred and fiftieth day after his or her death, by the chief mourner(s). It is dated in the summer, the sixth month of 1805.[1]

The pattern shows rows of pheasants whose bodies form circular medallions superimposed on a ground of undulating branches bearing paulownia blossoms and leaves. The motifs are rendered in light and dark blue, pale green and beige silk yarns, and gilt yarns, bound in weft twill weave on the ground of golden satin.

1 Translation kindly provided by Fumiko Cranston, Research Associate at the Harvard University Art Museums.

166
Part of a Garment Fabric T3e11

Chinese, 1750–1900

Silk: tapestry (*k'o–ssu*) with touches of gilt yarn and black dye or pigment.
L. 13½", W. 10¼" (34. 3 × 26 cm.)

Gift of Mrs. Hamilton Osgood

The conformation of the pattern suggests that this is a fragment from the lower border of a ceremonial court robe. It shows the stylized waves and clouds that appear in the lower sections of such borders below the mountain peaks representing the earth. The waves represent the water, and the clouds signify the heavens. The entire robe would have been made of the same fine slit tapestry silk fabric woven in shades of yellow, blue, brown and white (and possibly others that have faded to these tones), along with touches of gilt paper yarn and black brushwork that define the smallest forms. This fragment has been made into the cover for a writing pad.

167
Furnishing or Garment Fabric T3n6
Chinese, 1750–1900
Silk damask. L. 22″, W. 51″
(55.9 × 129.5 cm.)
Provenance unknown

Both the warp and weft yarns are
dyed the same yellowish green tone;
the pattern is made visible by virtue
of the contrast in texture between
the two weaves used for the ground
and the pattern elements. Stylized
chrysanthemum blossoms alternate
with equally conventionalized leaves
and rosettes in an all-over pattern
arranged with geometric precision.
Other pieces of the fabric are in
storage.

168
Furnishing or Garment Fabric
Chinese, 1750–1900
Silk damask. L. 9¼″, W. 9″
(23.5 × 22.8 cm.)
Provenance unknown

The pattern of chrysanthemum
sprigs, alternating with lily sprigs
in rows against a fretwork ground,
is visible only because of the contrast
between the two weaves in which
the white warp and weft yarns are
bound. Two other pieces of the fabric
are on view in the Veronese Room
(T25s3, T25n14).

169
Furnishing or Garment Fabric
T11s14
Chinese, 1800–1900
Silk: cut voided velvet. L. 44″, W. 22¼″
(111.7 × 56.5 cm.)
Provenance unknown

The pattern, rendered in dark blue
cut pile against a flat ground of the
same color, shows rows of medallions
containing five-clawed dragons flank-
ing a flaming pearl; these are sepa-
rated from one another by other
flaming pearls or pairs of lozenges,
alternating with rows of symbols.
Among the latter may be identified
clouds, double lozenges, umbrellas,
and forms resembling the water-
weed, sacred fungus and double-
headed axe, all auspicious in their
meaning. Other pieces of the fabric
are respectively on view in the Long
Gallery (T27w58) and in storage.

detail, 168

detail, 167

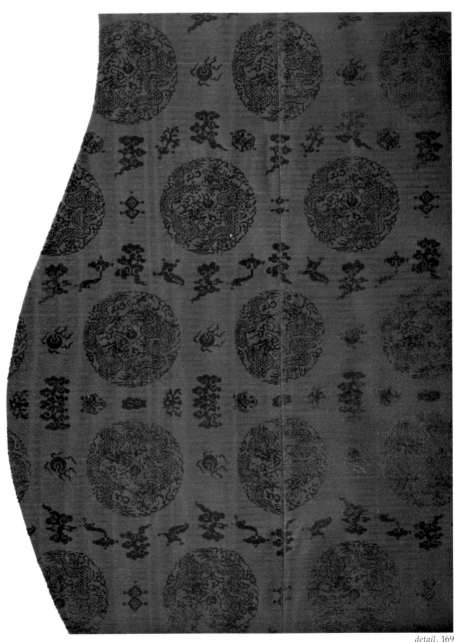

detail, 169

detail, 170

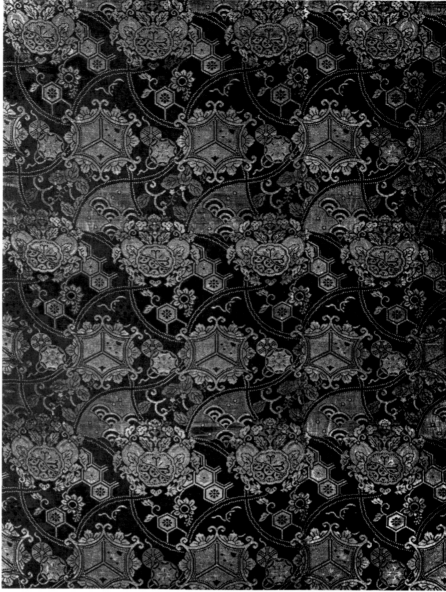

detail, 171

170
Garment Fabric

Chinese, 1800–1900
Silk: compound satin. L. 12″, W. 11½″
(30.5 × 29.2 cm.)
Provenance unknown

The pattern elements appear in
white and pink silk yarns bound in
weft twill weave on the dark blue
satin ground. Against a background
of swastikas contained within the
compartments of a lozenge lattice-
work appear rows of medallions con-
taining cranes. The medallions are
separated from each other by motifs
that are meant to represent either
butterflies or blossoms. Another
piece of the fabric is on view in the
Tapestry Room (T19e27).

171
Garment Fabric

Japanese, 1800–1900
Silk: compound tabby. L. 81½″, W. 26¾″
(207 × 67.9 cm.)
Provenance unknown

Against a ground of dark blue ribbed
tabby weave the pattern elements
appear in pale blue, tan and yellow
silk yarns bound in weft twill weave.
Rows of cusped hexagonal medal-
lions edged with petals and tendrils
alternate with rows of bouquets con-
taining flowers and fruits. These
seem to hover above a ground show-
ing a complex arrangement of arcs
enclosing blossoms, leaves, tendrils,
hexagons, and segments of circles.

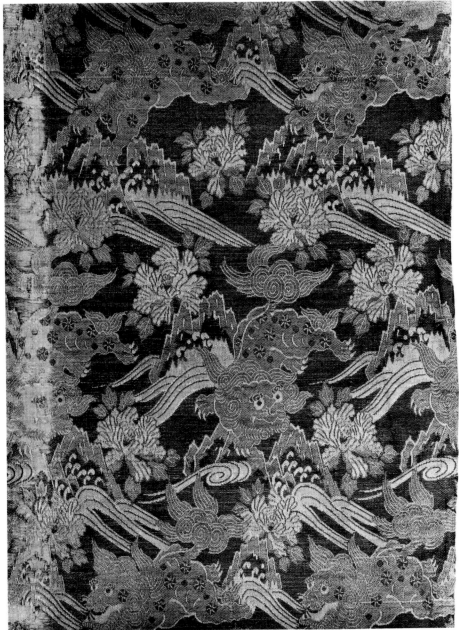

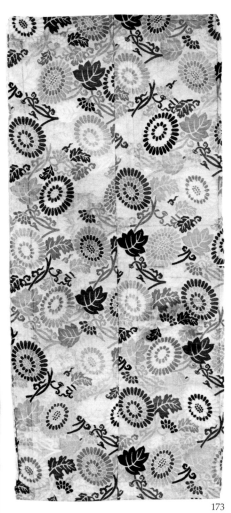

detail, 172

172
Garment Fabric T11w6

Japanese, 1800–1900
Silk: compound tabby. L. 24⅝", W. 48½"
(62.5 × 123.2 cm.)
Provenance unknown

The pattern shows male lions flying
through the air above craggy moun-
tain tops awash with swirling, break-
ing waves. Large peony blossoms fill
the spaces between the major ele-
ments. The motifs appear in two
shades of tan and a third, darker tan
that may once have been silvered
or gilded, against a rust-colored
ground.

173
Garment Fabric

Japanese, 1800–1900
Silk: twill brocaded with polychrome silk
yarns. L. 60¼", W. 27½" (153 × 69.8 cm.)
Provenance unknown

This fabric differs from the other Jap-
anese pieces in the collection. The
pattern is rendered entirely in bro-
caded yarns, rather than in yarns that
pass in the foundation weave from
selvage to selvage as do the pattern
wefts in the other silks. The pattern
in this example shows two different
chrysanthemum sprigs arranged
alternately in rows. The regularity of

the design is disguised by the use of
different colors for the same motifs in
the different rows. The flowers and
their leaves are rendered in white,
ivory, tan, pink, yellow, green, blue,
and violet silk yarns bound in weft
twill against the ground of ivory silk
warp twill.

174

174
Furnishing or Garment Fabric T26n2
Persian, 1550–1600
Silk: cut voided velvet shot with gilt yarn.
L. 22¼", W. 13" (56.5 × 33 cm.)
Purchased from Villegas, Rome, 1895

The pattern shows stylized blossoms
and leaves in white, pink, russet, tan,
yellow, green, blue, and black silk
pile arranged in a bilaterally sym-
metrical composition against a flat
ground of pale yellow silk yarns;
these were originally covered with
a spiral wrapping of gilded flat
wire, only traces of which remain.
The yarns of the ground fabric are
bound in weft twill weave. Except for
the black pile warp, which is used
throughout the pattern to define con-
tours, the various colored pile warps
do not extend the full length of the
piece but are inserted into the ground
weave only where their colors are
needed for the velvet pattern. This
manipulation enabled the weaver to
change the color of any motif at will,
and, by varying the colors of corre-
sponding motifs in successive repeats
or on opposite sides of the central
axis, to create an illusion of greater
variety in the pattern than actually
exists.

The scrolling lanceolate leaves veined
with primrose sprigs, the stylized
rosebuds, and the fanciful bouquets
shaped like artichokes all recall
motifs found in both earlier and later
Turkish velvets (see No. 175). How-
ever, the sophisticated arrangement
of the forms creates a secondary ara-
besque system superimposed over
the main one. Together with the mel-
lifluous drawing of the floral motifs,
this clearly relates the velvet to the
great arabesque carpets that were
woven for the Safavid court at Herat
at this time and also somewhat later.
Luxurious velvets like this one were
intended for use in making sump-
tuous robes or hangings for the inte-
riors of important buildings or tents.

Bibliography: *General Catalogue*, p. 227.

175
Furnishing or Garment Fabric T27e8
Turkish, 1600–1700
Silk: cut voided velvet shot with gilt yarns.
L. 63¼", W. 23½" (160.6 × 59.7 cm.)
Provenance unknown

The ground of the fabric now shows
yellow silk yarns bound in weft twill
weave; there are traces of the flat gilt

wires that were originally wrapped
spirally around these silk core yarns.
There are also traces of white silk
yarns bound in the same twill weave
in the crown motifs, the main rosettes,
the smaller blossoms, the tulips and
the narrow stalks. Therefore it is clear
that the pattern elements originally
appeared in gold and white, with
touches of crimson pile, against the
field of crimson pile. The pattern
shows a pair of counter-undulating
gilt vines joined at their points of con-
tact with white crowns; these form
ogival compartments in which
appear triple rosettes surrounded by
serrated leaves. A pair of tulips grows
from the top of the leafy aura, one at
either side, and five small rosettes
surround it.

Bibliography: *General Catalogue*, p. 234.

176
Furnishing Fabric
Turkish, 1600–1700
Silk: cut voided velvet. L. 47", W. 23"
(119.4 × 58.4 cm.)
Provenance unknown

Since this fabric was woven to be
used as a cushion cover rather than
as yardage, its pattern is organized as
a self-limiting unit rather than as a
continuing repeat. The motifs are
rendered in red and green cut pile
against a flat ground of beige silk that
may once have been shot with gilt
yarns, although no traces of metallic
components are visible. The major
motif is an ovoid sunburst with con-
centric red, green and beige rings at
the core, and red and green rays
spreading outward in all directions.
An undulating primrose vine serves
as a rectangular inner border, and
there is an outer border of scrolling
carnation and primrose sprigs, all in
red and green pile. At the two short
ends of the field are narrow bor-
ders containing roses and fanciful
blossoms.

The long cushions that were covered
with velvets like this were placed
against the wall above a dais to form
the back of a seating platform or
divan.

175

176

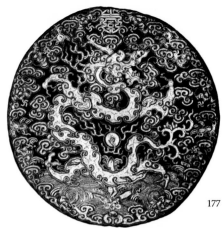

177

177
Pair of Medallions for a Ceremonial Coat or Jacket T18e37
Chinese, 1800–1900
Silk: satin embroidered with couched silk, silver and gilt yarns. Diam. 11⅜" (28.85 cm.)
Provenance unknown

The two medallions are identical. Each shows a dragon facing right accompanied by a flaming pearl, waves, and clouds within a narrow border that contains a Chinese character at the top center. The motifs are worked with gilt and silver yarns (papers over silk cores) and edged with plum silk yarns, all on the plum satin foundation fabric.

The medallions were meant to be applied to a coat or jacket that would be worn over a dragon robe. Usually four medallions decorated such overgarments, one on each shoulder, one over the upper back, and one over the chest.

178
Fragments of a Dragon Robe, Made into a Lettercase F25n14
Chinese, 1800–1900
Silk: tabby embroidered with polychrome silk yarns chiefly in long and short and encroaching satin stitches and with couched gilt yarns. H. 24", W. 17½" (60.96 × 44.45 cm.)
Given to Mrs. Gardner by Mrs. Fiske Warren, her mother Margaret Osgood, and her daughters Molly, Rachel and Marjorie Warren

A letter preserved in the case indicates that it was made by Mrs. Osgood, with a few stitches by her daughter and granddaughters, "out of an old Chinese coat." The outer surface is covered with a fragment from the lower front or back center of a dragon robe; the inner surface is covered with two sections of the lower border and a third section that was taken from the main body of the garment. The three sections inside are bound around with strips of dark blue compound satin decorated with a small floral pattern rendered in gilt yarns. The foundation fabric, now shredded and broken in places on the outside but intact inside, is of dark gray silk tabby. The main panel, mounted outside, shows a great five-clawed dragon rendered in couched gilt yarn (gilt paper strips wrapped around a silk core) and touches of silk yarns; its body occupies the center of the field and guards the flaming pearl or Jewel of the Law. Below the dragon, three mountain peaks rise from a striped hillock representing

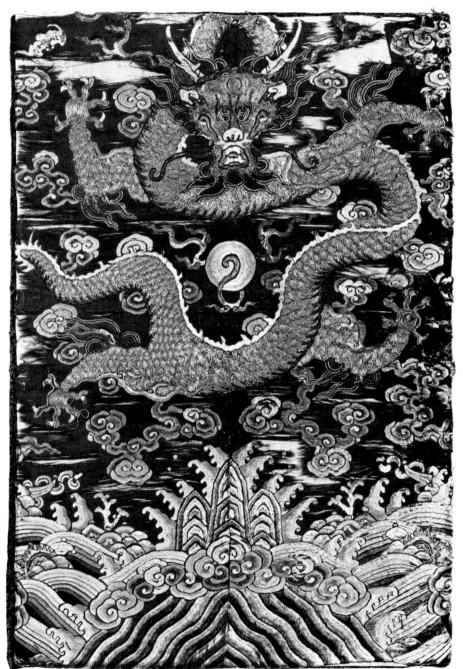

178

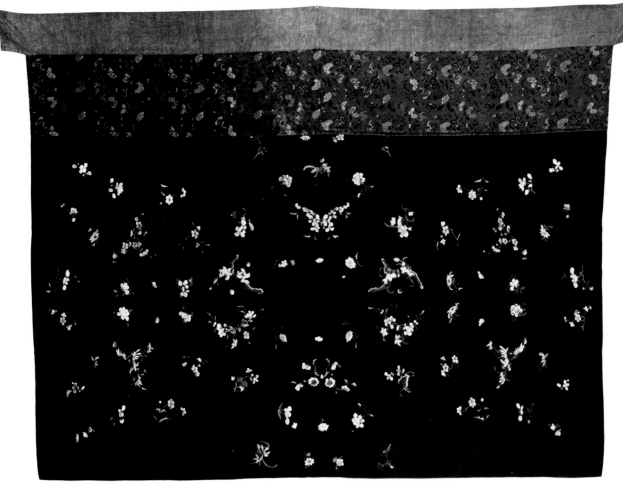

the earth; clouds surrounding the base of the peaks represent the sky; and waves flanking the hillock and breaking against the mountain peaks represent the sea. Clouds, representing the sky, surround the dragon. The two end sections of the interior show more earth, sea and sky motifs; among the other symbols floating in the waves may be recognized the ball-tipped pointed rhinoceros horn cups that represent happiness. The bats accompanying the clouds in the central section of the interior symbolize longevity and prosperity as well as happiness.

179
Table Frontal

Chinese, 1800–1900

Silk: compound satin and plain satin embroidered with polychrome silk yarns chiefly in long and short, split, and knotted stitches. H. 37", W. 51–46½" (94 × 129.5–118.1 cm.)

Provenance unknown

This frontal, made to hang in the open space between the front legs of a table, is constructed with two strips of fabric sewn to each other and to the top of the main panel. The panel shows floral sprigs, some resembling butterflies, embroidered with poly-chrome silk yarns on the dark brown satin foundation. The disposition of the floral elements, arranged in the shape of a Maltese cross with a blank space in the center, indicates that this panel was not designed as a frontal, but as the fabric for a woman's coat, robe or jacket, the two wider arms of the cross serving as the front and back of the garment and the two narrower arms serving as the sleeves. The undecorated center would have been cut out to provide the opening for the head and neck. Sewn along the top of this main panel is a strip of compound satin showing a scatter of peony sprigs, tendrils, lotus pods, bats, and butterflies rendered with white, pink, green, and blue silk yarns bound in weft twill weave on the yellowish brown ground. Above that has been sewn a band of plain blue tabby cotton with tying tabs at each end.

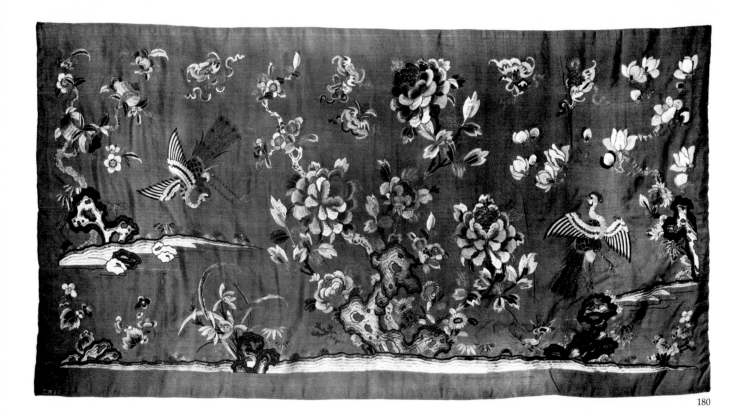

180
Furnishing Fabric

Chinese, 1800–1900

Silk: plain satin embroidered with polychrome
silk yarns chiefly in satin, encroaching satin,
split and knotted stitches and also with
couched gilt yarns. H. 22″, W. 41¾″ (55.9 x
106 cm.)

Provenance unknown

The size of the panel and the disposi-
tion of the pattern suggest that it was
intended to serve as a frontal for a
table or platform *(k'ang)*, or perhaps
as a valance or part of the upper or
lower border of a large hanging.

The motifs, embroidered in poly-
chrome silk yarns and gilt yarns (gilt
paper strips wrapped on silk cores),
are arranged to suggest a landscape.
At the bottom, an irregular fore-
ground line serves as the springing
for several flowering plants and a
central peony tree. Four rocks rest
on the ground, two of them masking
the bases of plants and the largest
one, in the center, masking the base
of the tree. A peacock perches on the
rock at the right and another swoops
downward at the left. Two other lines
of earth appear in the composition,
one in the middle distance at the
right and another in the distance at
the left; rocks, plants and a tree rise

from these grounds. Delicate lines
suggesting rippling water surround
the lower edges of all the grounds,
and indicate the presence of a body of
water in the lower central section of
the composition. Bats and winged
insects fill most of the space repre-
senting the sky.

181
Furnishing Fabric T3n7

Chinese, 1800–1900

Silk: plain satin embroidered with silk yarns
in long and short stitches. H. 51″, W. 22¼″ (129
x 56.5 cm.)

Provenance unknown

The pattern elements have been
worked on the red-orange satin
foundation with polychrome yarns.
Because this is a fragment cut out of
a larger piece, probably a hanging,
the pattern is incomplete. At the top
appear a hill, a rock, water, and some
peonies and chrysanthemums; in the
field below are scattered two bats, a
bunch of peonies, and a rose sprig.
There is a wide border of cloth of gold
around the sides and an inner border
of figured silk galloon. The panel is
lined with another piece of the yel-
lowish green damask catalogued as
No. 167.

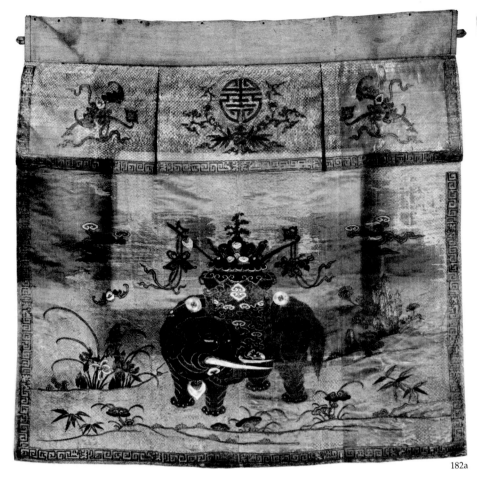

182a

182b

182
Table Frontal and Pair of Chair Covers

Chinese, 1800–1900

Silk: plain satin embroidered with silk yarns chiefly in long and short and encroaching satin stitches and also with couched gilt yarns.
a. H. 39″, W. 38″ (99 x 96.5 cm.)
b. H. 63¼″, W. 19⅞″ (160.5 x 50.5 cm.)
c. H. 63⅛″, W. 19⅞″ (160.2 x 50.5 cm.)

Provenance unknown

The table frontal (No. 182a), whose red-orange satin foundation has been heavily repaired with darning stitches that give much of the surface an unintended checkered texture, has been worked to show the elephant of strength, wisdom and prudence standing on a hill scattered with flowering plants, bamboo, and the sacred fungus of longevity. On his back are a blanket decorated with earth, waves and clouds symbolizing the universe, and a two-handled jar containing auspicious objects including the Eight Jewels, the lotus, scepter and jade gong. In the valance above this main field, worked in the same way, appears a pair of bats bearing scepters flanking a Chinese character,

probably a stylized form of the *shou*, for longevity. Narrow bands of couched gilt yarn worked in a fretwork pattern border the sides and bottom of the valance and the main field below it.

Each of the two chair covers (No. 182b, c), worked with the same materials and stitches as the frontal, shows the *shou* character for longevity at the top, beneath which are the same laden elephant shown on the frontal, a tree peony surrounded by leaves and tendrils, and, at the bottom, a silver pheasant perched on one leg on a rock among the waves. This bird is the emblem of Ch'ing dynasty (1644–1912) court officials of the fifth civil grade; it may indicate that this set of furniture covers was made for an official of that rank. When installed on a chair, the strip of embroidery would lie with its top, containing the *shou* character, falling over and behind the top chair rail, thus allowing the character, which is upside down in relation to the other motifs, to be read right side up. The elephant would appear against the

back of the chair, the tree peony horizontally on the seat, and the pheasant below, between the chair's front legs.

A nearly duplicate set of chair covers showing a lion in place of the silver pheasant is in the collection of The Metropolitan Museum of Art, New York (reg. No. 62.97.44, etc.).

199

183
Bed Cover T20e4

Bengal, Indian for the Portuguese market, 1600–50
Silk tabby backed with linen tabby, embroidered with Tussah silk yarn in chain stitches. H. 105″, W. 79″ (267 x 201 cm.)
Purchased from Emile Peyre, Paris, 1897

The cover shows a beige needle-worked pattern of wild silk embroidery yarns against a blue ground. Most of the thin blue silk that covered the surface of this quilted coverlet has worn off, leaving the heavier linen backing fabric to show through.

The organization of the pattern, with its large rectangular panel in the center surrounded by three figural borders with guard bands between, is one of the classes of pattern that are characteristic of these so-called "Indo-Portuguese" coverlets. A palace or church building with voluted pediment fills the central compartment; branches issuing from the sides of the building support eight oval medallions, each containing a bust of a crowned (except for one) male figure holding a scepter and posed against a starry sky. Figures of musicians playing horns and drums, together with plants and birds, fill the open spaces in the lower section of the field, while peacocks, pheasants, and birds of other breeds fly or perch among the branches in the upper section. At the very top of the field, medallions representing the sun and moon appear at the center and figures of the pelican feeding her young fill the two corners.

The innermost border contains figures of mermaids, mermen (some with heads of deer) and other fantastic sea creatures. The second border contains human figures (some of whom ride in carts having wheels that contain zodiac signs), animals and various imaginary beasts. In the center of each border is a cartouche containing figures of warriors in European costume; in the four corners are four more oval medallions containing male busts like those in the center field. The third and outermost border shows men in European costume hunting a variety of animals with guns, spears, and slings; in each of the corners is another pelican feeding her young.

The interpretation of the scenes represented on this and other quilts of

detail, 183

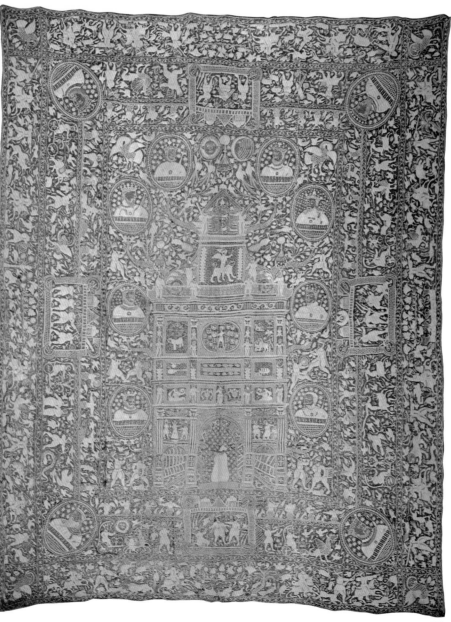

its kind is problematic. Some of the subjects that have been identified in related pieces, usually with the help of inscriptions, are drawn from the Old Testament (the story of Judith, the Judgment of Solomon), from classical mythology (the labors of Hercules, the story of Phaeton, the story of Arion, the Judgment of Paris), or from the iconography of Vishnu and Siva.[1] It is possible that some of the figures and compositions in the second border of the Gardner cover represent Phaeton or Hercules, but the references are not specific. The male busts, the figures and armorial shields shown in relation to the great building in the central field, the building itself, and the four scenes with warriors all await proper interpretation.

1 *Embroidered Quilts from the Museu Nacional de Arte Antiga—India, Portugal, China, Sixteenth to Eighteenth Century,* Kensington Palace, London, November, 1978.
Bibliography: *General Catalogue,* p. 171.

184
Wrap (Chadar)

Indian, probably Sind, 1850–1900
Cotton tabby embroidered with silk yarns, chiefly in split, satin, and buttonhole stitches.
L. 107½", W. 59½" (273 x 151.1 cm.)
Provenance unknown

The pattern elements, worked with white, yellow, green, red and black silk yarns on a foundation of coarsely woven brick-red cotton tabby, are organized to form a field with borders at the narrow ends. The field shows white and yellow petals or leaves arranged in diagonal rows; the borders show wide outer bands containing stylized plants under arches, then narrow bands with feathers or leaves set diagonally, and inner bands with upright feathers or slender trees. Narrow guard bands with undulating stems bearing white or yellow carnation blossoms flank the borders and the field.

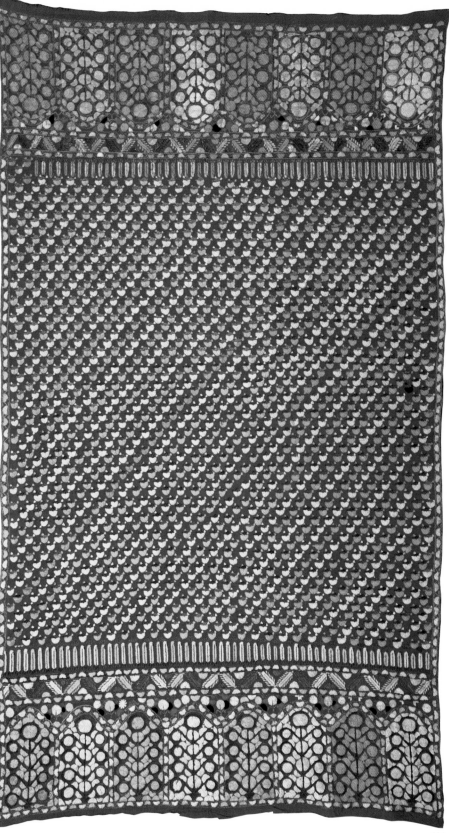

184

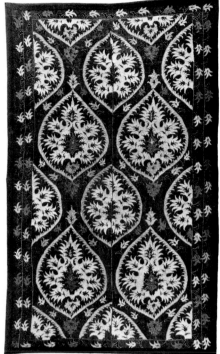

185

185
Hanging or Cover T16e24

Turkish, Asia Minor, 1600–1700
Silk: plain satin embroidered with silk yarns in laid work and with couched gilt yarns. L. 55", W. 34" (139.65 x 86.3 cm.)
Provenance unknown

The panel is made of two widths of rust-pink satin seamed down the center. The pattern, worked in ivory, pink, yellow and blue silk yarns with contours of gilt yarn, shows bifurcating vines forming ogival compartments. Each of these contains a great leaf with seven dentated lobes and a smaller leaf of similar shape superimposed on its center. Smaller leaves with five pointed lobes decorate the tips of the main leaves, the borders of the compartments, and the outer border that enframes the field.

The pattern derives from and imitates some of those found in contemporaneous Turkish velvets and brocades.[1]

1 Weibel, Nos. 154, 155 illus.
Bibliography: *General Catalogue*, p. 114.

186
Cover

Turkish, probably Asia Minor, 1800–1900
Silk: tabby embroidered with silk, silver and gilt yarns, in chain stitches. L. 50", W. 29" (127 x 73 cm.)
Provenance unknown

The foundation is a length of thin yellowish tan tabby-woven silk used in the full loom width. The unornamented central field is bordered by a row of rose, carnation, primrose and hyacinth bouquets tied with ribbons; narrow gilt guard bands enclose the floral border. While the shape and size of the piece suggest that it might have been made as a veil the needlework is not reversible. This suggests that it was made as a cover, with only one surface exposed.

186

187–189
Three Towels

Turkish, 1800–1900

All three examples show the characteristic form of a long narrow piece of cloth decorated at each end with a border of polychrome needlework; since the stitches used are double-faced and the work is finished as neatly on the back as on the front, the embroidery is reversible. Textiles like these were made in those parts of the Ottoman Empire that stretched from the Balkans to the eastern reaches of Asia Minor, and they served a number of purposes. Some pieces served as towels in the western sense on special ceremonial occasions like births, circumcisions and wedding nights, or as napkins or towels at table, after the hands had been washed in a basin of water. Others were used as head scarves, as wrappers for precious objects stored in chests, as gifts, or as covers for headstones at women's graves. A fourth towel (T3e10) is on view in the Blue Room.

187
Towel

Linen tabby embroidered with pink, bluish green, and olive-green silk yarns chiefly in double darning and stem stitches. L. 34½″, W. 19½″ (87 x 48.9 cm.)
Provenance unknown

The borders show stylized rose sprigs. The ends of the fabric, which preserves both selvages, are cut and whipped over with beige silk stitches. The foundation line shows two stamped inscriptions: one is the number 49 in blue, the other a hexagon containing Arabic characters, all in brown.

188
Towel

Linen tabby embroidered with blue silk and gilt yarns. L. 32⅝″, W. 15¾″ (82.2 x 40 cm.)
Provenance unknown

This towel is technically like No. 187 but with the addition of gilt and silver yarns. The narrow borders at each end show blue chevrons outlined with gilt yarns and rows of small gilt and silver sprigs. The foundation linen shows the number 39 stamped in blue.

189
Towel

Linen tabby embroidered with polychrome silk and gilt yarns. Each end (with fringe): L. 14″, W. 15¾″ (35.5 x 40 cm.)
Provenance unknown

The central section of this towel is missing, leaving just the two ends. The foundation linen shows a pattern of chevrons inlaid along the cut edges of each piece; the ends are finished with warp fringe. The borders show carnation and hyacinth sprays worked with pink, beige, blue, yellow, green and red silk yarns as well as with gilt yarns.

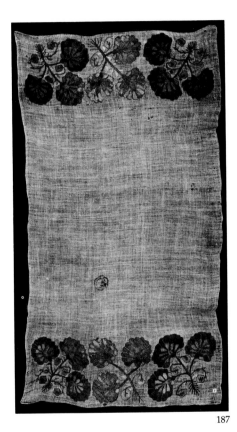

187

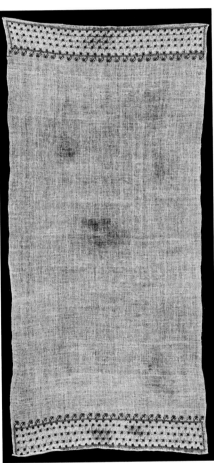

188

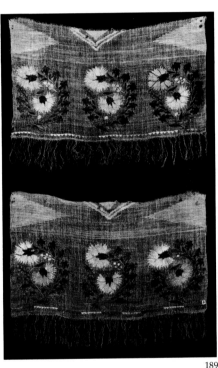

189

190
Ceremonial Coat for a Woman
Chinese, 1800–1900
Silk: cut voided velvet with applied medallions of silk satin embroidered with polychrome silk yarns chiefly in satin and encroaching satin stitches and with couched gilt yarns. L. 44¼" (112 cm.)
Provenance unknown

The coat is made of plum-colored velvet showing a pile pattern of intertwined peony and chrysanthemum sprays scattered over the flat ground of the same color in meandering paths and alternating with prunus blossoms, lily plants, and leafy twigs. The sleeve bands are made of the same velvet bordered with polychrome silk woven tape and strips of black satin. The coat is lined with blue silk damask showing a pattern of peony sprigs and other flowers arranged in alternate rows. The coat is slit to the waist at the sides and opens down the center front; it fastens with black silk loops sewn to either side of the opening.

Three medallions, the center one made in two sections to allow for the opening, are stitched to the coat over the chest and each shoulder. Normally coats of this kind have a fourth medallion at the center back; there is none present in this example. Each medallion shows a stylized *shou* character (for longevity) in the center, surrounded by five pink bats and clouds of various colors. The Eight Precious Things of Buddhist symbolism appear in a ring near the perimeter of each medallion. Reading clockwise from the top center, these auspicious signs are the canopy, umbrella, vase, fish, lotus, mystic diagram or entrails, conch shell, and wheel. Coats of this kind (*chi-fu-kua*) are believed to have been worn by wives of noblemen or court officials.

191
Informal Coat for a Woman
Chinese, 1850–1900
Silk: cut voided velvet. L. 42⅛" (107 cm.)
Provenance unknown

The coat is made of russet velvet showing a pile pattern of peony sprays alternating in rows with two different chrysanthemum sprays and butterflies; the flowers and insects are inverted and reversed in every other row. The sleeve bands are made of green velvet with a pile pattern of peonies, bats, butterflies, and vases, bordered on the inner edge with narrow orange silk tape and wider green satin bands. The same green banding, with an edging of blue rather than orange tape, also borders the asymmetrical closing across the breast but is missing from the neckline. The coat is slit to the waist at the sides; it fastens at the neck and right hip with green silk loops and globular pink glass buttons. It is lined with blue silk damask showing rows of chrysanthemum sprigs alternating with rows of butterflies against a ground of fretwork.

192
Part of a Skirt for a Woman
Chinese, 1850–1900
Silk: cut voided velvet. L. 35⅛", W. 58⅜" (89.2 x 148.3 cm.)
Provenance unknown

The front, left side and back panels (in storage) of the skirt have been kept intact as illustrated here; the right side panels were removed at some time and are preserved separately in the Museum (T15w6, used as a shelf lining). The light blue velvet shows a pile pattern of rows of peony sprigs and butterflies alternating with rows of paired peaches and bats, with other flowers scattered among these motifs. At the bottom of the center front panel this pattern ceases and is replaced by a fruit and flower still life composition with narrow borders at the sides and bottom. The sides and bottom of each skirt panel have been edged with folded strips of black satin.

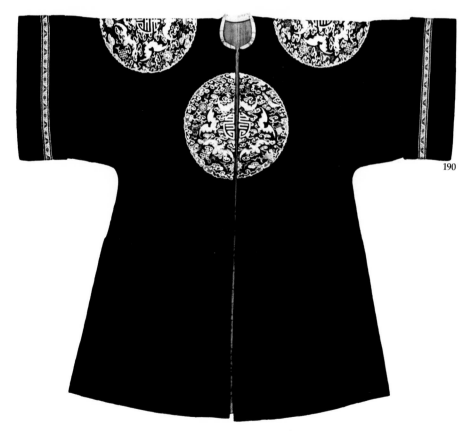

190

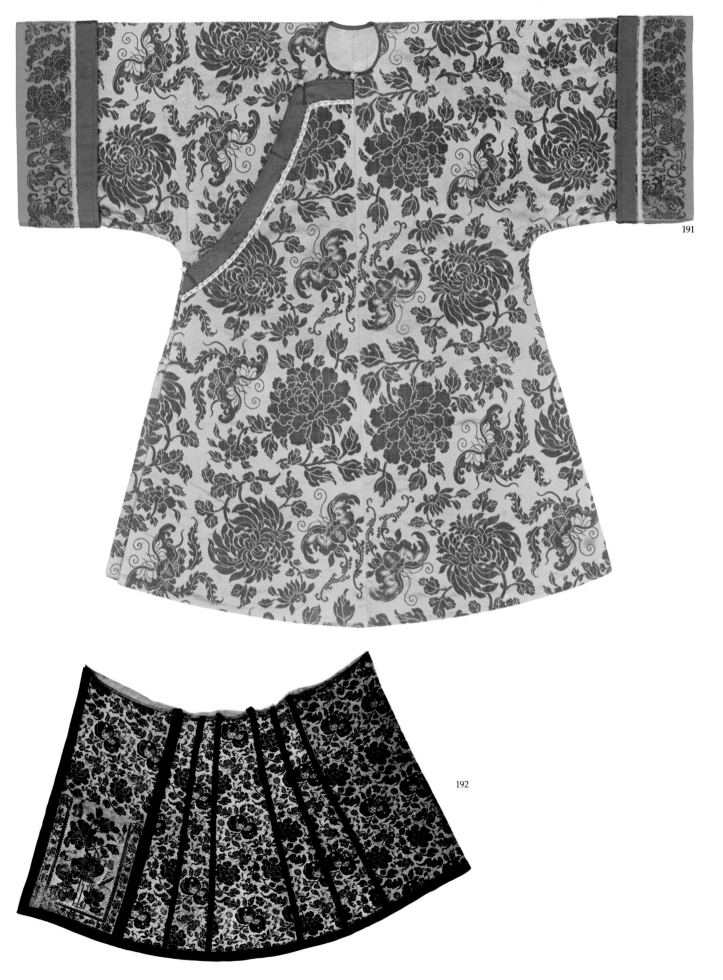

191

192

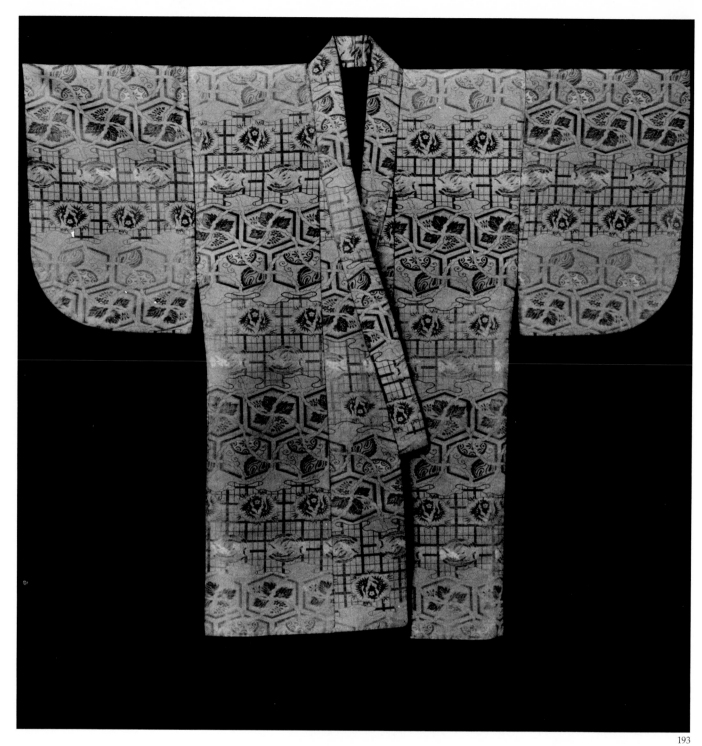

193
Kimono

Japanese, 1850–1900
Silk: compound tabby. L. 51¾", W. 52¼"
(131.5 x 132.7 cm.)
Provenance unknown

The garment originally may have
served as a robe for an actor in a Nō
play. The ivory ground weave fea-
tures a fine diapered texture worked
with warp floats. The figured decora-
tion involves two alternating bands
of ornament. One of these shows a
double row of hexagonal medallions
containing floral motifs shown
against a ground of mist and clouds;
the other shows rows of two different
oval medallions, both containing
paired birds, against a checked
ground. The pattern elements are
rendered in white, pink, rust, green
and blue silk yarns bound in tabby
weave. The robe is lined with brick-
red silk tabby that turns up and
outward at the bottom to form a dec-
orative band around the hemline of
the robe.

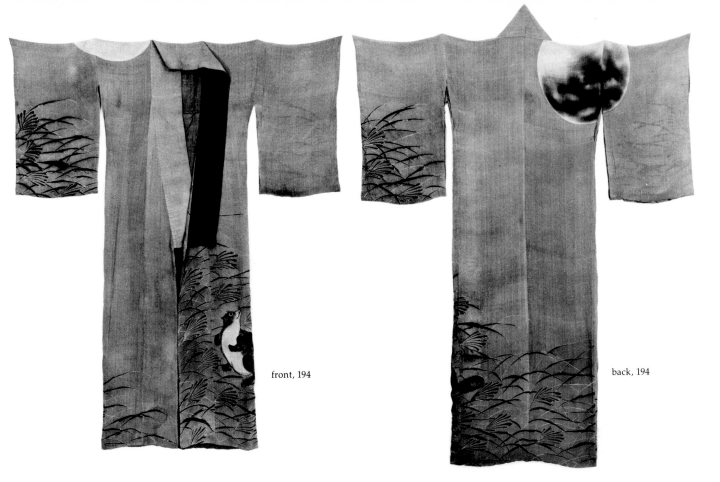

front, 194

back, 194

194

Kimono

Japanese, 1850–1900

Silk: tabby woven with creped yarns, resist-dyed and painted. L. 59", W. 49¾" (149.8 x 126 cm.)

Provenance unknown

The pattern on the garment is pictorial; it shows a badger in a marsh turning to look up at a full moon. Marsh grasses and reeds appear in a spiral mass descending from the left waistline in front around to the back of the robe and ending in front again, at the bottom of the hem at the right; the blades of grass and leaves appear again on the front and back surfaces of the left sleeve. The badger, painted in shades of mauve and gray on a reserved white ground, is represented at the turn of the lower left side of the robe, with his body on the front and his tail on the back. The moon, painted in shades of gray on another white reserve, appears at the top and back of the right shoulder and sleeve. The field shows a lighter tone of the greenish brown hue of the grasses, and the garment is lined with thin silk tabby, dyed the color of the grasses except for the collar and lapel band, which are lined with crimson creped silk tabby.

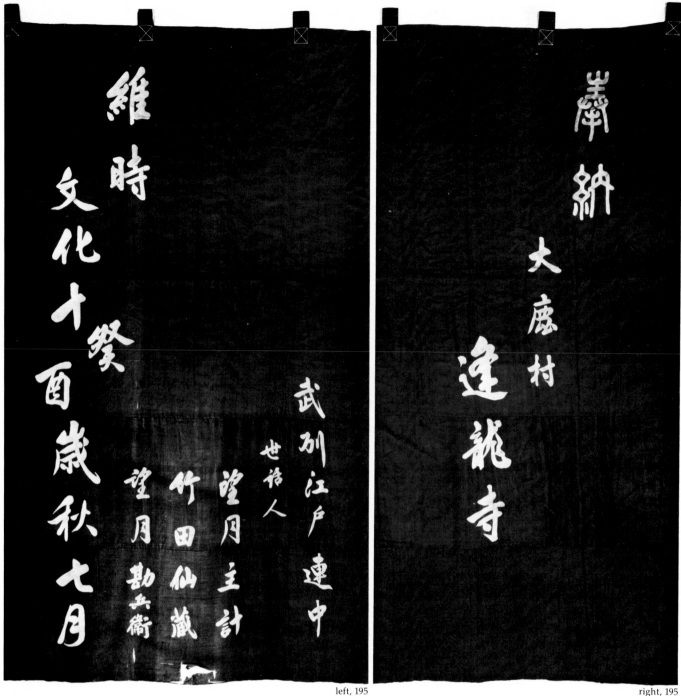

195
Banner

Japanese, 1813
Silk: tabby, resist-dyed. L. 519½", W. 65½"
(1319 x 166.3 cm.)
Left end: L. 38", W. 66¾" (96.5 x 169.5 cm.)
Right end: L. 31¼", W. 66¾" (79.3 x 169.5 cm.)
Provenance unknown

The banner is made of five widths of silk seamed lengthwise. A hem has been sewn along the top edge, and silk hanging tabs have been stitched to the hem.

The pattern shows seven stylized paulownia sprays set across the width of the main field. The left and right ends of the field contain inscriptions. The blossoms and inscriptions were reserved in the ivory color of the silk by use of a resist medium when the fabric was dyed its present aubergine color. A few errors in registration indicate that the five widths of silk were dyed separately before they were sewn together to make up the banner.

The inscription at the right end of the fabric indicates that the banner was to be given to the temple of Hōryu-jī in the village of Ōshika. The inscription at the left end mentions a group in Edo (Tokyo) and gives the names of the people in charge as Shukei Mochi-zuki, Senzō Taked, and Kanbei Mochizuki. It also refers to the date of the presentation which was in fall, the seventh month of Bunka 10 (1813).[1] The fabric has been stained and patched at the right end, suggesting that it was used for some time. Although the paulownia motif was used as an armorial crest by the Tokugawa shoguns (1615–1867), it was also used by many other families and does not in itself associate the banner with that imperial name.

1 Translation kindly provided by Fumiko Cranston, Research Associate at the Harvard University Art Museums.

196
Garment Fabric

Japanese, 1850–1900
Silk: tabby woven with creped yarns, painted.
L. 24″, W. 16½″ (61 x 42 cm.)
Provenance unknown

This fragment of silk for a kimono or
sash (obi) shows a pictorial pattern
that has been painted directly on the
ivory silk with yellow, green, blue,
violet and brown dyes. Five large
white cranes are shown flying with
smaller birds of different colors
across a violet sky.

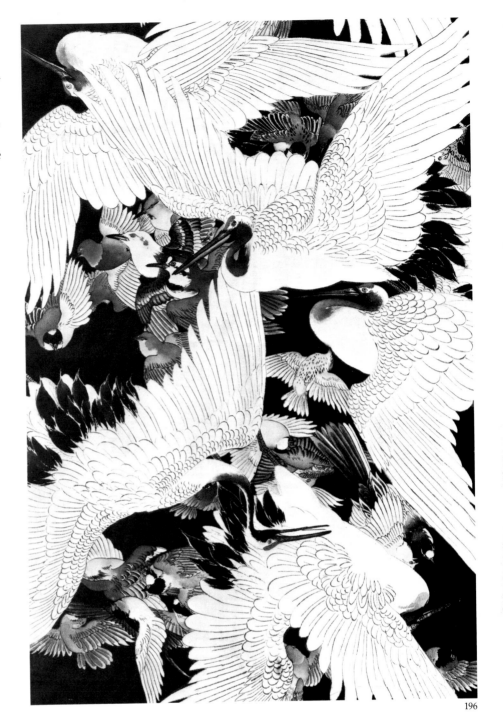

196

197
Wraps or Covers

Indian, 1850–1900

Cotton tabby, printed and painted.
a. L. 92⅛", W. 56⅜" (234 x 143.1 cm.)
b. L. 93¾", W. 56¾" (238 x 144.1 cm.)
Provenance unknown

Each of the wraps or covers is made of three lengths of coarse tabby-woven cotton sewn together; the complete fabric was then block-printed and painted directly with red, golden yellow, green, blue and black dyes. The patterns on the two pieces are identical except for the treatment of the central field and the corner motifs of the main inner borders. One example (No. 197a) shows a double bouquet in a central ovoid compartment and similar plants arranged to fill the L-shaped corners of the border. The other piece (No. 197b) shows a pair of stylized trees flanking a plant in a central arched compartment and star-shaped blossoms flanked by pairs of plants in the corners of the border. In both examples the remaining parts of the wide inner borders show rows of single arched compartments containing bouquets. Both pieces have narrow inner borders containing scrolling floral vines, narrower floral guard bands flanking the borders and the central field, and wide borders at each end of the fabric showing rows of cone motifs.

198
Skirtcloths (Sarongs)

Javanese, 1850–1900

Cotton tabby, resist-dyed.
a. L. 79¾", W. 41¼" (202.4 x 104.7 cm.)
b. L. 77¾", W. 42½" (197.5 x 108 cm.)
c. L. 74¼", W. 40¾" (188.5 x 103.5 cm.)
Provenance unknown

When worn by men or women, the two ends of the cloths were brought together and seamed, forming a tube of cloth that was draped around the body and tied at the waist. The central panel (kepala) of the pattern was worn in front. All three examples show the same organization of the pattern and differ from one another only in detail and color. All three

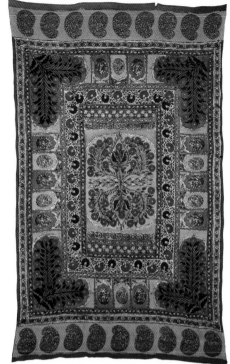

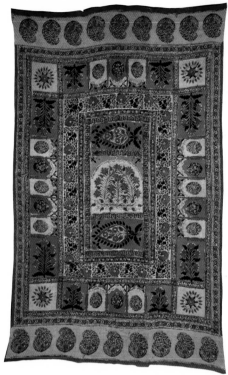

197a

197b

pieces were resist-dyed in shades of red and blue on the ivory grounds.

The ground of the central panel of No. 198a is dark blue, decorated with birds, butterflies and star-shaped blossoms; the points, each of which contains a representation of a bird and flower or floral spray, are alternately red, ivory and blue. The narrow vertical borders show pheasants alternating with floral sprays. The side panels contain diagonal bands showing, alternately, deer and flowers on ivory grounds, and fanciful beasts (the ch'i lin of Chinese iconography) on blue grounds.

The ground of the central panel of No. 198b is dark blue, decorated with birds, butterflies and blossoms; the points, each of which contains a floral spray, again are in colors of red, ivory, and blue. The narrow vertical borders show undulating floral vines. The side panels show rows of horses alternating with birds perched on flowering branches rendered in blue, red and ivory against the blue ground.

The ground of the central panel of No. 198c also is dark blue, decorated with round and star-shaped blossoms; the points, each containing a floral spray, are alternately blue and ivory in color. The narrow vertical borders show undulating floral vines. The side panels show rows of birds perched on flowering branches against red grounds.

199
Garment Fabric

Turkmen, present-day Uzbekistan Soviet Socialist Republic, 1875–1900

Silk: cut velvet, pile-warp-dyed. L. 269½", W. 13⅜" (684.25 x 33.9 cm.)
Provenance unknown

The pattern, showing two large stylized flowering plants flanked by pairs of stylized leaves and hands, in white, red, yellow and violet against a green ground, was tie-dyed on the pile warp before the fabric was woven. Similar velvets were made into festival coats for Turkmen women.[1]

1 For one such example, see L. Salmon, C. Kvaraceus, M.X. Kiernan, *From Fiber to Fine Art*, Museum of Fine Arts, Boston, 1980, No. 58.

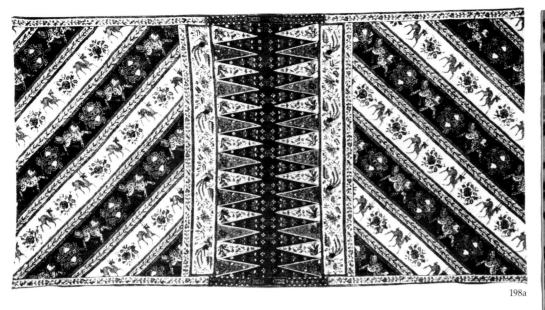

198a

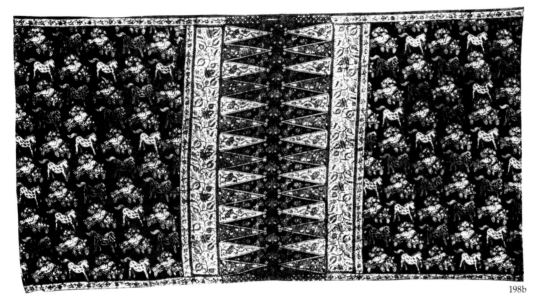

198b

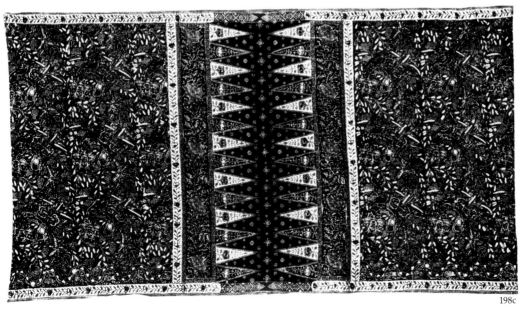

198c

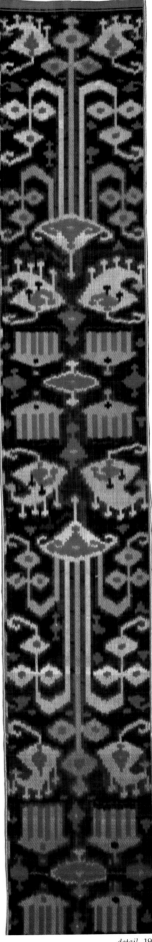

detail, 199

211

Checklist

200
Upholstery for a Table F19e39
Italian, 1675–1750
Silk damask. H. 23¼", L. 32¾", W. 26¼"
Made up as a table cover for Mrs. Gardner in
the late XIX century

201
Lining of a Sedan Chair F25c24
French or Italian, 1725–75, the carpeting possibly later
Silk velvet, cut; silk damask; wool pile carpeting. Chair: H. 59½", W. 32¾", D. 40½"
Purchased from C. McCarthy, Boston, 1892

202
Chasuble T16e23
Italian, 1450–1500 and later additions
Silk velvet, voided and cut; orphrey borders of
gilt galloon. L. 43¾", W. 28½"
Provenance unknown

203
Chasuble T1e13
Italian or French, 1725–50
Silk fancy compound cloth, brocaded. L. 41½",
W. 27½"
Provenance unknown

204
Cope T27w3
Italian, XV or XVI century
Silk velvet, cut; orphrey of embroidered linen
cloth. L. 54", W. 109"
Provenance unknown

205
Cope and Hood T26w4, T17w44
Italian, 1675–1750
Silk velvet, voided and ciselé.
a. Cope: L. 54", W. 114"
b. Hood: L. 20½", W. 25"
Provenance unknown

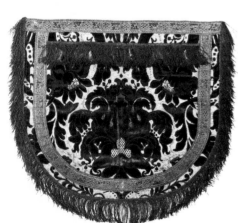

206
Maniples T17w22, T17w26
Italian (?), XVIII century
a. T17w22: L. 38¼", W. 4½–9½"
b. T17w26: L. 51¼", W. 3¾–8⅝"
Provenance unknown

207
Garment or Furnishing Border T6n2
Italian, 1525–75
Needlepoint lace, *reticella*. L. 95½", W. 3"
Provenance unknown

208
Altar Frontal T6n4r
Partly Italian, 1550–1600 (withdrawn element
sections only)
Strips of withdrawn element work combined
with pieces of linen cloth from other textiles.
W. of border 12", W. of five vertical bands 5"
each, W. of three vertical bands 2½" each (used
as alternate for T6n4; see No. 56)
Provenance unknown

The information for Nos. 209–34 is taken
entirely from the unpublished notes
of Mrs. M.F. Bainbridge (see Author's
Acknowledgments).

209
Superfrontal T28s4
Italian, Sardinia (?), XVI century
Darned netting, *punto a maglia quadra* (French
filet). L. 85½", W. 4½" (not including strip of
punto in aria lace finishing the netting)
Provenance unknown

210
Strip of Woven Network F25w48-B.28
Italian, Umbria (?), *buratto*, XVI or early XVII
century
L. 122", W. 6"
Provenance unknown

211
Strip of Darned Netting F25nw50-B.33
Italian, *punto a maglia quadra* (French filet),
XVII century
L. 32" (joined once), W. 9"
Provenance unknown

212
Strip of Darned Netting F25nw51-B.35
Italian, *punto a maglia quadra* (mezzo mandolina),
XVII century
L. 113", W. 5½"
Provenance unknown

213
Strip of Darned Netting F25nw50-B.34
Italian, *punto a maglia quadra* (French filet), XVII
and XVIII century
Fourteen squares, each 8" x 8"
Provenance unknown

214
Strip of Darned Netting F25w48-B.32
French filet, early XVIII century
L. 115", W. 7½"
Provenance unknown

215
Altar Frontal T28s3
Italian, Sicily, XV century
Withdrawn element work. L. 131", W. 38"
Provenance unknown

216
**Strip of Needlepoint Lace and
Embroidery** F25nw50-B.55
Italian, cutwork (*punto tagliato*) and *reticella*,
XVI century
L. 39", W. 4"
Provenance unknown

217
Strip of Needlepoint Lace
F25nw51-B.56
Italian, insertion and edge of *punto in aria*
worked in coarse *reticella*, XVI century
L. 75", W. 4"
Provenance unknown

218
Altar Frontal T28s3r
Italian, XVIII century
Needlepoint (with bands of *reticella*). L. 155",
W. 28" (used as alternate for T28s3; see No. 215)
Provenance unknown

219
Collar of Needlepoint Lace
F25nw50-B.74
Italian, Burano, *punto in aria*, XVIII century
L. 22", W. (at middle of back) 1½"
Provenance unknown

220
Strip of Needlepoint Lace
F25nw51-B.84
Italian, *punto in aria*, grounded Venetian point,
XVIII century
L. 146", W. 2"
Provenance unknown

221
Two Strips of Needlepoint Lace
F25nw51-B.81
Italian, *punto in aria*, grounded Venetian point,
late XVIII century
L. 280", W. 4"
Provenance unknown

222
Collar of Needlepoint Lace
F25w49-B.71
Flemish, Brussels, ca. 1860
L. 12½", W. 2"
Provenance unknown

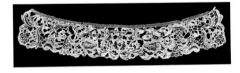

223
Strip of Bobbin Lace F25nw50-B.105
Italian, Genoa, XVII century
L. 57", W. 5"
Provenance unknown

224
Strip of Bobbin Lace F25nw50-B.95
Flemish, Mechlin, XVII century
L. 17", W. 2"
Provenance unknown

225
Strip of Bobbin Lace F25nw50-B.98
Flemish, Binche type, XVII century
L. 23", W. 1½"
Provenance unknown

226
Strip of Bobbin Lace F25nw50-B.93B
Flemish, Brussels, *point d'Angleterre*, late XVII
century
L. 49", W. 3½–2¼"
Provenance unknown

227
Strip of Bobbin Lace F25nw50-B.94
Flemish, Mechlin, late XVII century
L. 45", W. 2½"
Provenance unknown

228
Strip of Bobbin Lace F25nw50-B.96
Flemish, Mechlin, late XVII century
L. 18", W. 1¼"
Provenance unknown

229
Strip of Bobbin Lace F25nw50-B.99
Flemish, *trolle kant*, XVIII century
L. 26½", W. originally 1½"
Provenance unknown

230
Strip of Bobbin Lace F25nw50-B.100
Flemish, *point d'Angleterre*, XVIII century
L. 87", W. 2½"
Provenance unknown

231
Strip of Bobbin Lace F25nw51-B.102
Flemish, *trolle kant*, XVIII century
L. 133", W. 2"
Provenance unknown

232
Strip of Bobbin Lace F25nw51-B.118
Flemish, no date
L. 64", W. 4¾"
Provenance unknown

233
Piece of Gold Bobbin Lace
F25nw51-B.122
Italian (?), XIX century
L. 10½", W. 6"
Provenance unknown

234
Strip of Mixed Lace (*mezzo
punto*) F25nw50-B.77
Italian, late XVII century
Bobbin-made tape, needlepoint fillings. L. 76",
W. 2¼"
Provenance unknown

235
Motif from a Furnishing Fabric
T21e12
Western Europe, 1550–1650
Silk velvet, cut; applied motifs of linen tabby
embroidered with polychrome silk yarns and
gilt yarns in *or nué* stitches and couched silver
and gilt yarns. H. 17¾", W. 22¼"
Provenance unknown

236
Armorial Motifs for Application
Italian (?), 1600–1700
Various gilt-shot silk foundations embroidered
with silk yarns and couched silver and gilt
yarns.
a. T18s8-s: H. 7½", W. 7"
b. T18s8-s: H. 8", W. 6¾"
c. T18s8-s: H. 2¾", W. 2½"
d. T18s8-s: H. 2¾", W. 2¾"
e. T19e10: H. 7¼", W. 6¾"
f. T19e34: H. 5¼", W. 3⅞"
Provenance unknown

237
Garment or Furnishing Fabric T19c12

Western Europe, 1675–1725

Silk: plain cut velvet, embroidered with gilt yarns, purl and sequins in a variety of couching stitches, satin stitches worked over padding, and knotted stitches. H. 23″, W. 20″

Gift of Edwin Sherrill Dodge, 1921

238
Part of a Furnishing Fabric T16w5

Holy Roman Empire, 1675–1750

Silk cloth embroidered with polychrome silk yarns chiefly in long and short, satin and stem stitches and with couched metal yarns. H. 31⅞″, W. 19½″

Provenance unknown

239
Furnishing Borders T16e5-s, T16e15-s

Italian (?), 1675–1750

Silk satin (?) with applications of metal and silk cloths embroidered with couched gilt cords.
a. T16e5-s: L. 71¾″, W. 14⅝″
b. T16e15-s: L. 71⅛″, W.14¼″

Provenance unknown

240
Cushion Covers F16c2-s

Italian, 1675–1775 and later

Silk tabby embroidered with silk yarns in long and short stitches with couched metal and red silk yarns and cords.
a. H. 11¼″, W. 10¾″
b. H. 11¼″, W. 10⅝″

Provenance unknown

241
Hanging T26n18

Italian, 1700–75

Silk tabby with applications of embroidered silk. H. 77⅞″, W. 35⅛″

Provenance unknown

242
Hanging T26s4

Italian, 1725–75

Silk velvet, cut, with applications of linen tabby embroidered with silk and metal yarns. H. 100⅜″, W. 71⅝″

Provenance unknown

243
Embroidered Picture of The Virgin and Child in a Landscape T18s31

Western Europe, 1750–1800

Linen tabby embroidered with polychrome silk and wool yarns in tent stitches, with touches of metal yarns. H. 10½″, W. 9¼″

Provenance unknown

244
Woven Fabric for an Orphrey with The Annunciation T17w39

Italian, Tuscany, 1450–1500

Silk: compound satin. L. 9½″, W. 6¼″

Provenance unknown

245
Woven Fabric for an Orphrey with The Virgin and Angels Adoring the Christ Child T17w38

Italian, Tuscany, 1450–1500

Silk: compound satin. L. 10″, W. 9½″

Provenance unknown

246
Gilt-Ground Furnishing and Garment Fabric of the Classic Pomegranate Type T27n3-s, T27n1-s

Italian, 1450–1500

Silk: cut voided velvet, shot and brocaded with gilt yarn.
a. T27n3-s: L. 121½″, W. 21¼″
b. T27n1-s: L. 138″, W. 21¼″

Purchased from Villegas, Rome, 1895

247
Gilt-Ground Furnishing and Garment Fabric of the Classic Pomegranate Type T27w78-s

Italian, 1450–1500

Silk: cut voided velvet, shot and brocaded with gilt yarn. H. 15⅞″, W. 23″

Provenance unknown

248
Furnishing Fabric T17w42
Italian or Spanish, 1550–1600
Silk: compound satin. L. 25″, W. 17″
Provenance unknown

249
Garment Fabric T30s9
Italian or Spanish, 1600–25
Silk damask. L. 43″, W. 91¼″
Purchased from Miss Amy Pleadwell, Boston.
Made into a cope in 1964

250
Garment Fabric T16e22
Italian or Spanish, 1625–50
Silk: cut voided velvet shot with gilt yarn.
L. 68½″, W. 39½″
Provenance unknown

251
Chasuble and Furnishing Fabric
T16s18, F16w6
Italian, 1650–1700
Silk and linen: compound twill with brocatelle
effect.
a. Chasuble: L. 44½″, W. 29½″
b. Covering for F16w6: L. 82″, W. 26½″, and
three pillows each: L. 23″, W. 14″
Provenance unknown

252
Garment Fabric T11e13
Italian or French, 1700–25
Silk: compound satin brocaded with silk yarns.
L. 35½″, W. 24½″
Provenance unknown

253
Furnishing Fabric F19e29
Northern France, probably Rouen, 1700–25
Wool and linen: cut plain velvet. L. 19″, W. 19″
Provenance unknown

254
Furnishing Fabric T17w30
Italian, probably Genoa, 1700–25
Silk ciselé voided velvet. L. 40½″, W. 20–18″
Provenance unknown

255
Furnishing Fabric T28e21
Italian, probably Genoa, 1700–25
Silk ciselé voided velvet. L. 44½″, W. 24½″
Provenance unknown

256
Garment Fabric T25w3, T25w10
French or Italian, 1730–40
Silk: compound satin brocaded with silk yarns.
a. T25w3: L. 27″, W. 21½″
b. T25w10: L. 29″, W. 24½″
Provenance unknown

257
Furnishing or Garment Fabric
T17w40
Turkish, 1500–50
Silk: cut voided velvet brocaded with silk and
gilt yarns. H. 11″, W. 24″
Purchased from Emilio Costantini, Florence,
October 6, 1897

258
Floor Carpet T26c1
Persian or Indian, XVII century
Woolen pile on cotton foundation. L. 24′ 4″,
W. 11′ 11½″
Purchased from Benguiat Brothers, London,
1894 through John Singer Sargent

259
Floor carpet T25n12
Persian, XVIII-XIX century (?)
Wool cloth embroidered with polychrome wool
threads. L. 78″, W. 64″
Provenance unknown

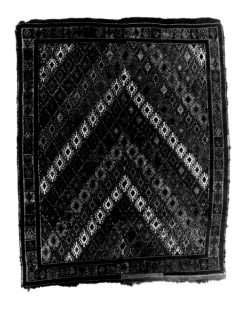

260
Garment Fabric T18e37
Japanese, 1800–1900
Silk: tabby, printed. L. 14½″, W. 10⅞″
Provenance unknown

261
Table Cover T28w1
Linen, with crochet work on one edge. L. 41½″,
W. 34¼″
Crochet work, with ISABELLA in the pattern,
by Isabella Stewart Gardner

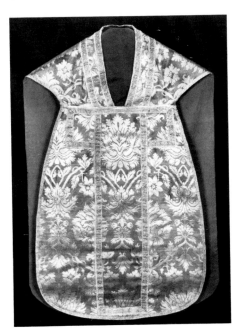

City and Weavers' Marks: Tapestries

9a T19w2-s: Brussels mark

9c T19w18-s: Brussels mark

9a T19w2-s: Jan der Moyen's mark

9e T19e36-s: Jan der Moyen's mark

9b T19e4-s: Weaver's mark

9c T19w18-s: Jan der Moyen's mark

10 T22s3: Brussels mark

9e T19e36-s: Brussels mark

10 T22s3: Andreas Mattens' (?) mark

11a　T19w56-s: Brussels mark

11d　T19e52-s: Brussels mark

11a　T19w56-s: Jan van Tieghem's (?)
mark

11e　T19n21-s: Jan van Tieghem's (?)
mark

11d　T19e52-s: Jan van Tieghem's (?)
mark

12　T18s1: Brussels mark

11c　T19w48-s: Jan van Tieghem's (?)
mark

11e　T19n21-s: Brussels mark

14a T18s5-s: Brussels mark

14c T18e5-s: Paris mark

14d T18e35-s: Paris mark

14a T18s5-s: Geubels shop mark

14c T18e5-s: Weaver's mark

14d T18e35-s: Weaver's mark

16 T22e4: Brussels mark

17a T31e4-s: Brussels mark

17c T27e31-s: Jasper van Bruggen's
mark

16 T22e4: Martin Reymbouts' mark

17b T14w5-s: Jasper van Bruggen's
mark

17c T27e31-s: Brussels mark

Dimensions of Illustrated Details

In the *Dimensions of Illustrated Details* listing, the first column numerals indicate the Catalogue Number.

Western Textiles

24	L.17¾″, W.21½″
48	L.19″, W.3½″
49	L.18″, W.3¾″
50	L.40″, W.27½″
52	L.50″, W.65½″
56	H.27½″, W.22½″
57	L.22″, W.13″
58	L.24¼″, W.10″
59	L.31″, W.23″
61	L.28½″, W.33½″
65	L.21½″, W.10¼″
66	L.28½″, W.6″
67	L.17½″, W.4″
68	L.26½″, W.11″
69	L.15″, W.10½″
70	L.11½″, W.16″
71	L.34½″, W.24½″
72	L.5½″, W.5″
73	L.21½″, W.12¼″
76	L.9½″, W.4¾″
77	L.20½″, W.14″
78	L.22½″, W.9½″
79	L.27″, W.4″
80	L.14½″, W.8½″
86	L.18″, W.10″
88	L.5¼″, W.3¹⁵/₁₆″
91	L.43″, W.20½″ (without fringe)
92	L.9½″, W.12¾″
96	L.15½″, W.10¾″
121	L.18½″, W.9¼″
122	L.12″, W.9″
126	H.7⅞″, W.3¾″
127	L.25″, W.21″
130	H.15¼″, W.19″
134	L.9¼″, W.7¼″
137	L.20⅝″, W.20½″
138	L.56⅜″, W.21″
139	L.34¼″, W.20″
140	L.41″, W.19″
145	L.36″, W.22″
146b	L.60″, W. 18″
148	L.14¾″, W.10⅝″
149	L.25⅜″, W.17½″
152	H.34″, W.20″
153	H.62½″, W.22″
158	L.17¼″, W.20″
160	L.15¼″, W.11¹¹/₁₆″
162	H.3½″, W.9½″
163	L.45½″, W.29¼″
164	L.23″, W.24″

Eastern Textiles

167	L.7¼″, W.5¾″
168	L.9¼″, W.9″
169	L.22¼″, W.18½″
170	L.12″, W.11½″
171	L.22″, W.18″
172	L.14″, W.10½″
183	H.10″, W.7½″
199	L.82″, W.13⅜″

Compendium of Identification Numbers

In the *Compendium of Identification Numbers* listing:
the first column numerals indicate the Catalogue Number;
the second column digits indicate the Museum Inventory Number;
and the third column digits indicate the following:
B. (Bainbridge) or S. (Siple) No. (Museum files; see Author's Acknowledgments).

Tapestries

1	T24w2	S.7
2	T24e5	S.3
3	T24w1	S.6
4	T30n10	S.15
5	T30w4	S.9
6	T24w3	S.1
7	T19s10	S.18
	T19s3	S.17
8	T30w13	S.13
9a	T19w2-s	S.19
9b	T19e4-s	S.1
9c	T19w18-s	S.23
9d	T19e57-s	S.14
9e	T19e36-s	S.10
10	T22s3	S.6
11a	T19w56-s	S.44
11b	T19w26-s	S.27
11c	T19w48-s	S.42
11d	T19e52-s	S.13
11e	T19n21-s	S.47
12	T18s1	S.26
13	T22w1	S.8
14a	T18s5-s	S.27
14b	T18w1-s	S.12
14c	T18e5-s	S.42
14d	T18e35-s	S.23
15	T22s1	S.5
16	T22e4	S.4
17a	T31e4-s	S.5
17b	T14w5-s	S.1
17c	T27e31-s	S.26
18	T14e4	S.2
19	T22e3	S.3
20	T27w11	S.46
21	T24e1	S.2
22	T19w36	S.37
23	T18w14	S.2

Western Textiles

24	F26s6	S.43
25	F21e23	S.5
26	F19w59	S.45
27	F26n82	S.27
	F26n83	S.24
28	F17w31-s-1	S.11
	F17w31-s-2	S.11

29	T19w24	S.26
30	T28w17	S.37
31	storage	S.15
32	storage	S.1
33	T16s17	S.38
34	storage	S.62
35	T16s19	S.40
36	T27w30	S.50
37	T27w29	S.49
38	T16s16	S.37
39	T3s24	S.15
40	T18w13	S.1
41	T27w4	S.41
42	T17w7	S.26
43	storage	S.65
44	T17w41	S.8
45	storage	S.126
46	storage	S.72
47	storage	S.74
48	storage	B.61
49	F25nw50	B.60
50	storage	
51	F25nw50	B.63
52	storage	B.53
53	storage	B.43
54	storage	B.42
55	F25w48	B.31
56	T6n4	B.21
57	F25nw50	B.2
58	storage	B.11
59	F25nw50	B.1
60	F25nw50	B.4
61	storage	B.24
62	T25c2	
63	storage	S.3
64	storage	B.129
65	F25nw50	B.126
66	storage	B.130
67	F25nw51	B.78
68	F25w48	B.70
69	F25w48	B.69

70	F25w49	B.72
71	F25nw51	B.85
72	F25nw50	B.82
73	F25nw51	B.79
74	F25nw51	B.80
75	F25nw50	B.76
76	F25nw50	B.103
77	F25w48	B.87
78	F25w49	B.89
79	F25nw50	B.104
80	F25nw51	B.121
81	F25nw51	B.101
82	F25nw50	B.93A
83	F25nw50	B.92
84	F25nw50	B.91
85	F25nw50	B.97
86	F25w49	B.88
87	F25nw51	B.83
88	T16s28	B.44
89	storage	S.120
90	T17w15	S.34
	T20w7	S.4
91	T27e4	S.10
92	F25nw50	B.105
93	T27w1	S.42
94	storage	S.104
	storage	S.105
95	T16e8	S.24
96	T21e11	S.3
	T21e13	S.3
97	T30e23	S.4
98	storage	S.112
99	T21e3	S.1
100	T17w23	S.45
101	T18s9	S.34
102	T21n9	
103	storage	S.1
	T2w1	S.1
104	T16s4	S.33
105	T1w2	S.2
106	T18s30	S.40
107	T15e16	S.20
108	storage	
109	storage	S.115
110	T18s32	S.41

111	storage	S.3
	T25w8	S.24
112	T1s9	S.6
113	T26n6	S.14
114	T21n4	S.18
115	T15e12	S.19
116	T2w2	S.2
117	T17s1	S.22
118	T16n2-s	S.9
	T16n9-s	S.13
119	T3e1	S.4
120	T11e15	
121	T17w37	S.4
122	T17w36	S.3
123	T17w34	S.1
124	T17w10	S.28
125	T27w62	S.58
126	T17w27	S.41
127	T26e20	S.35
128	storage	
129	T16n3	S.11
130	T17w5	S.24
131	T17w6	S.25
132	T17w16	S.35
133	T17w13	S.33
134	T17w8	S.27
135	T27w6	S.43
136	T26n13	S.19
137	storage	S.22
138	storage	
139	T21n21	S.20
140	T18w22	S.4
141	T17n4	S.14
142	T11n27	S.7
143	storage	S.132
144	storage	S.86
145	T26e11-s	S.30
	T26e3-s	S.29
146	T18e11	S.38
	T18e29	S.18
	T18s10	S.18
	storage	S.78

147	F19w33-s	S.34
	F19w45-s	S.38
148	storage	S.48
149	storage	S.47
150	T17w11a	S.31
	T17w11b	S.31
	T17w11c	S.31
	T17w35	S.2
151	T17w12	S.29
152	storage	S.1
153	T16e1	S.1
154	storage	S.48
155	storage	S.76
156	T18e28	S.19
157	T17w43	S.10
158	T18n18	S.10
159	T3w23	S.2
160	storage	S.2
	T19c8	S.52
161	storage	S.1
162	storage	S.1
163	storage	
164	T26e8	S.28

Eastern Textiles

165	storage	
166	T3e11	S.13
167	T3n6	
168	storage	S.64
	T25s3	S.9
	T25n14	S.9
169	T11s14	S.12
	T27w58	S.57
	storage	
170	storage	
	T19e27	S.6
171	storage	
172	T11w6	
	storage	S.3
173	storage	B.134
174	T26n2	S.13
175	T27e8	S.12
176	storage	S.44
177	T18e37	S.24
178	F25n14	S.10

179	storage	
180	storage	
181	T3n7	
182a	storage	
182b	storage	
182c	storage	
183	T20e4	S.1
184	storage	S.123
185	T16e24	S.31
186	storage	S.107
187	storage	S.109
188	storage	S.108
189	storage	S.111
190	storage	S.128
191	storage	S.127
192	storage	S.2
	T15w6	S.2
193	storage	S.2
194	storage	S.75
195	storage	S.73
196	storage	
197a	storage	S.103
197b	storage	S.103
198a	storage	S.58
198b	storage	S.58
198c	storage	S.58
199	storage	S.124

Checklist

200	F19e39	S.12
201	F25c24	S.16
202	T16e23	S.30
203	T1e13	S.5
204	T27w3	S.40
205a	T26w4	S.46
205b	T17w44	S.44
206a	T17w22	S.40
206b	T17w26	S.42
207	T6n2	B.65
208	T6n4r	B.25
209	T28s4	B.37
210	F25w48	B.28
211	F25nw50	B.33
212	F25nw51	B.35

213	F25nw50	B.34
214	F25w48	B.32
215	T28s3	B.20
216	F25nw50	B.55
217	F25nw51	B.56
218	T28s3r	B.66
219	F25nw50	B.74
220	F25nw51	B.84
221	F25nw51	B.81
222	F25w49	B.71
223	F25nw50	B.105
224	F25nw50	B.95
225	F25nw50	B.98
226	F25nw50	B.93B
227	F25nw50	B.94
228	F25nw50	B.96
229	F25nw50	B.99
230	F25nw50	B.100
231	F25nw51	B.102
232	F25nw51	B.118
233	F25nw51	B.122
234	F25nw50	B.77
235	T21e12	S.4
236a	T18s8-s	S.35
236b	T18s8-s	S.37
236c	T18s8-s	S.36
236d	T18s8-s	S.36
236e	T19e10	S.9
236f	T19e34	S.3
237	T19c12	S.54
238	T16w5	S.47
239a	T16e5-s	S.23
239b	T16e15-s	S.23
240a	F16c2-s	S.56
240b	F16c2-s	S.57
241	T26n18	S.23
242	T26s4	S.38
243	T18s31	S.39
244	T17w39	S.6
245	T17w38	S.5
246a	T27n3-s	S.6
246b	T27n1-s	S.4

247	T27w78-s	S.2
248	T17w42	S.9
249	T30s9	S.6
250	T16e22	S.29
251a	T16s18	S.39
251b	F16w6	S.48
252	T11e13	S.12
253	F19e29	S.7
254	T17w30	S.23
255	T28e21	S.32
256a	T25w3	S.2
256b	T25w10	S.4
257	T17w40	S.7
258	T26c1	S.49
259	T25n12	S.12
260	T18e37	S.24
261	T28w1	